培文·电影

电影史
双语读本

游飞 —— 主编

下册

北京大学出版社
PEKING UNIVERSITY PRESS

目录

下 册

第四章 革新时期 1967—1989

第一节	好莱坞的复兴	383
	1. "新好莱坞"	383
	2.《邦妮和克莱德》	390
	3. "美国作者"群像：库布里克、伍迪·艾伦和奥尔特曼等	392
第二节	新德国电影	400
	1.《奥伯豪森宣言》和克鲁格	400
	2. 新德国电影"四杰"：施隆多夫、法斯宾德、赫尔佐格和文德斯	402
第三节	东欧新电影	414
	1. 捷克新浪潮	416
	2. 波兰学派	420
	3. 匈牙利和前南斯拉夫	424
第四节	好莱坞"电影神童"	427
	1. 科波拉	429
	2. 斯科西斯	432
	3. 卢卡斯和斯皮尔伯格	434
第五节	第三世界民族电影	438
	1. 巴西新电影	441
	2. 拉美电影：古巴、阿根廷、玻利维亚和智利	445
	3. 非洲和阿拉伯世界电影	449

第六节	新中国电影与华语新浪潮	454
	1. 新中国电影	454
	2. 第五代：张艺谋、陈凯歌和田壮壮	465
	3. 香港电影新浪潮	475
	4. 台湾新电影：侯孝贤和杨德昌	480
第七节	美国先锋派电影	487
	1. 美国地下电影	487
	2. 梅雅·德伦	488
	3. 60年代美国另类电影	490
	4. 安迪·沃尔霍和"波普电影"	492

第五章　多元时期 1989—2010

第一节	好莱坞大片和全球化战略	497
	1. 好莱坞大片与卡梅隆	497
	2. 全球化战略和媒体帝国迪斯尼公司	501
第二节	美国独立电影	508
	1. 美国电影的独立传统	508
	2. 美国独立电影的繁荣	512
	3. 独立精神	517
第三节	英语世界电影	528
	1. 英国电影	528
	2. 澳大利亚和新西兰电影	533
	3. 加拿大	540
第四节	亚非拉民族电影	545
	1. 伊朗新电影与阿巴斯	545

	2. 韩国电影的异军突起	550	
	3. 日本新电影	555	
	4. 拉美电影新浪潮	561	
	5. 中东电影	571	
第五节	**欧洲新电影**	578	
	1. 回归俄罗斯传统：米哈尔科夫和索科洛夫	578	
	2. 北欧："道格码95"与拉斯·冯·提尔	587	
	3. 西欧：法国、西班牙、德国和意大利等	590	
	4. 东南欧：希腊、马其顿、波黑、匈牙利和罗马尼亚等	598	
第六节	**数字化多媒体时代**	602	
	1. 从机械复制到虚拟真实	602	
	2. 数字技术与电影	605	
	3. 展望未来	618	
附录	世界电影史一百部重要影片（按时间顺序）	625	

第四章

革新时期
1967—1989

第一节　好莱坞的复兴

1. "新好莱坞"

20世纪60年代的越南战争、民权运动和性解放风潮带来社会生活和价值观念的急剧变化,新一代的电影观众寻求能够反映现实的更自由、更刺激的电影内容,而欧洲艺术(作者)电影的影响和美国独立(地下)电影的兴起都成为20世纪60年代后期"新好莱坞"(New Hollywood)产生的缘由。

1968年,《海斯法典》最终被电影分级制度替代,而"新好莱坞"的核心也恰恰可以用"性与暴力"来加以界定。"新好莱坞"首先表现在对于性和暴力等禁忌话题的直接展现和渲染,其次是非英雄与反英雄的出现,第三是创作者的主体性和反省性的加强,第四是采用实景拍摄、强调自然光源以及声音运用的深化等。然而,"新好莱坞"毕竟是好莱坞的延续,在类型模式、叙事手法、主题呈现和制作标准等方面,仍然对好莱坞的优良传统进行了革新性、批判性的继承。

"新好莱坞"的代表作品包括阿瑟·佩恩(Arthur Penn)的《邦妮和克莱德》、麦克·尼科尔斯(Mike Nichols)的《毕业生》、丹尼斯·霍普(Dennis Hopper)的《逍遥骑士》和山姆·佩金帕(Sam Peckinpah)的《日落黄沙》等。

New Hollywood: American Cinema Renaissance (1964-1976)

It is not entirely certain when the old American movie reawakened as the new American cinema: Bonnie and Clyde (1967), Seconds (1966), The Crazy-Quilt (1966), The Pawnbroker (1965), Dr. Strangelove (1964), David and Lisa (1963), Lonely Are the Brave (1962), To Kill a Mockingbird (1962), The Hustler (1961), Psycho (1960), Hollywood arose for its fifth era, its renaissance, gradually, just as it had slipped into its transitional fourth phase—quite unlike its sudden leaps into the second era of the feature film and the third era of synchronized sound.

All ten of these films (of which only *Bonnie and Clyde* is in color) contain seeds of the period's values: the offbeat antihero protagonists; the sterile society that surrounds them; the explicit treatment of sexual conflicts and psychological problems; the mixing of the comic and the serious; the self-conscious use of cinematic effects (slow motion, quick cutting, stylized memory and dream sequences and so forth).

Most of the films give evidence of the two clichés that critics used to describe films of the era: sex and violence. But films have always used sex, whether it was the sexiness of Griffith's *Friendless One*, of Valentino's *Sheik*, of Dietrich's veiled face in a key light, or of bare breasts and buttocks in a Paris apartment. And films have always been violent—whether it was violent death on a Civil War battlefield in *The Birth of a Nation*, the violent death of a hoodlum on the cathedral steps in *Little Caesar*, or the violent deaths on the highway in *Easy Rider* (Dennis Hopper, 1969). The question is not whether a movie includes sex and violence but how it uses them. The graphic sex and violence of this "new" Hollywood cast a cynical look back on the genre films of the old Hollywood, suggesting that their assured and optimistic conclusions simplified the unresolved divisions in American life.

This new cinema in America evolved for several reasons. The first was a negative came: The old, regular movie patrons now stayed home to watch television. The industry had to find new regular customers, not those who would go to the occasional movie that seemed special enough but those who would go every week—who still liked movies and considered them important to their social and leisure experience, and who appreciated the adult dialogue and treatment TV was forbidden to offer.

For another, the new cinema of Europe eventually converted American producers. The innovations of Godard, Truffaut, and Antonioni, along with those of Kurosawa and Bergman, had already conquered the rising generation of young filmmakers and audiences at the art houses. Even more convincing, Truffaut and Fellini could make money. The years 1959-61 were as important as any to the

future American film: the years of *Breathless*, *The 400 Blows*, *L'awentura*, *La dolce vita*, *Through a Glass Darkly*, and *Hiroshima mon amour*.

Third, though Hollywood repeatedly scoffed at the Underground Cinema, the underground crawled up to enjoy the last laugh. Not only did underground filmmakers succeed financially—for example, Andy Warhol, Robert Downey, and Brian De Palma—but the underground films conditioned a whole generation of young filmgoers (precisely those who became the steady customers for Hollywood films) to understand and accept innovations in cinematic foml, visual stimulation, and elliptical construction.

Fourth, the film industry pushed its discovery of the elitism of the new film audience to its limits. Rather than attempting to make all of the films for all of the people, producers and exhibitors realized they must appeal to very special tastes. They made a few family pictures to serve that special need. They capitalized on the racial make-up of urban audiences by making "blaxploitation" cops-and-robbers films (Gordon Parks's *Shaft*, 1971, and its descendants). They made "sexploitation' films for that special audience—not "stag" shorts but full-tength movies: *The Devil in Miss Jones* (1973), *Deep Throat* (1972), and *Boys in the Sand* (1971) were three of the most commercially successful pornographic features. (For a horrifying account of the making of *Deep Throat*, read Linda Lovelace's autobiography, *Ordeal*.) There were even special cult films shown at midnight for late-night "film freaks" in the cities. Among the most popular of these cult films were Andy Warhol's *Sleep* (1963), Russ Meyer's *Faster, Pussycat! Kill! Kill!* (1966), Alexandro Jodorowsky's *El Topo* (1969), John Waters's *Pink Flamingos* (1971), Hal Ashby's *Harold and Maude* (1971), Jim Sharman's *The Rocky Horror Picture Show* (1975), and David Lynch's *Eraserhead* (1977). There were also old films that attracted cults (*Casablanca*) and cult films that never became "midnight movies".

In the same way, the American industry aimed its "art films" (those directed by Arthur Penn, Mike Nichols, and others) at the minority audience that liked such films. These films, however, found a wide audience and were precisely those that served as America's best examples of film art and the key representatives of its fifth era.

Finally, the values of these new American "art films" reflected the sexual and social values of American film audiences in the period. The American college student, the core of this audience, had discovered politics, drugs, and premarital sex, and protested against the covert and overt policies of the government as well as the racism, materialism, and hypocrisy of American society. The vision of reality on the screen did not entirely shape its audience; as in the 1930s, the screen still reflected the values of those who sat in front of it. Those values had changed.

Arthur Penn's *Bonnie and Clyde* was perhaps the first full statement of the

new cinema's values; it was so popular that many of its daring innovations became conventions in the years that followed. In most cases, the protagonists of the films were social misfits, deviates, or outlaws; the villains were the legal, respectable defenders of society. The old bad guys became the good guys; the old good guys, the bad guys. The surprising element in *Bonnie and Clyde* (and *Easy Rider, Coal Hand Luke, The Wild Bunch, Butch Cassidy and the Sundance Kid, Thieves Like Us*, etc.) was not simply that the protagonists were criminals, for films had depicted their Little Caesars arid Bonnie Parkers for decades. The surprise was that these new murderers were also charming, exciting, compassionate, and furmy—and that the violence was much more graphic. The pursuers with badges were the cruel ones; even the pursuers without badges—as in *The Graduate* (Mike Nichols, 1967) and *Easy Rider*—had no sense of humor, of fair-play, of love. The new obligatory ending was unhappy (*Joe*, 1970) or open (*Billy Jack*, 1971) rather than happily resolved (a rare exception among counterculture movies was Alan Myerson's *Steelyard Blues*, 1973).

The crucial things about the new antihero heroes were not that they died violently, nor that the Establishment vanquished them, but that how they lived and what they stood for were validated. Even if evil regularly triumphed over goodness, rationality, and freedom, the American film was still essentially romantic and Manichean, just as it was in the 1920s and 1930s. There were still film characters who lived beautiful lives and others who lived vile ones; it was clear who the good guys were, even if they would have been called bad guys in the 1950s and even if they lost.

Rather than effacing the film's artfulness, as a Ford or Hawks intentionally did, the new directors threw in as many cinematic tricks as possible, which both intensified the film's moods and reminded the audience that it was watching a film. Slow motion, grainy film stock, jump cutting, splitting the wide screen, self-conscious camerawork, mixtures of black and white and color were all standard tricks of the new trade. There was an emotional power in the visual assaults of the medium itself. And the flashes both forward and backward in time as well as into and out of a character's private mental experience broke down the definitions and distinctions of time and space, of now and then, of reality and fantasy, of "proper" linear continuity.

The new films played as trickily with sound as they did with images. Gone was the old principle of studio scoring—to underscore a scene with music that increases the action's emotional impact without making the viewer aware of the music's existence. In the new films, there was little of this kind of background music. If there was to be music, it had to be either clearly motivated (playing on a radio or record player nearby) or deliberately artificial (a song on the soundtrack that existed specifically to be noticed and played either in harmony with or in

counterpoint to the sequence's visuals). Coppola's *Apocalypse Now* (1979) starts with the Doors' "The End". In Haskell Wexler's *Medium Cool* (1969), the patriotic speeches and songs inside the Democratic Convention hall accompany the sounds of the riots in Grant Park. Most of the new films used rock music heavily (the scores of Martin Scorsese's *Mean Streets* and George Lucas's *American Graffiti*, both 1973, were anthologies of highly relevant rock hits), for rock was the other artistic and social passion of the young audiences who supported the movies.

Fewer films were shot on soundstages; directors preferred the authenticity of shooting on location. Whereas the old Hollywood style was devoted to eliminating the imperfections of reality-uneven lighting, unwanted noise—the new films required accident and imperfection for their visual style and human credibility. The lighting styles of Bergman's Sven Nykvist and of the New Wave cinematographers (Raoul Coutard, Nestor Almendros, Henri Decaë), who bounced light off the ceilings of rooms and caught it as it poured through windows, influenced a new generation of American cinematographers—Haskell Wexler, Gordon Willis, Vilmos Zsigmond, John Alonzo. Inside the old studios, the only light that poured through a window flowed from an electric pitcher.

The new American films were gladly influenced by French films, Italian films, Czech films, British flms, underground and avant-garde films, and even rediscovered films. Many of the new American films, like the new European films, depicted how actions felt, not just actions, so that character became more important than plot; they also tackled big issues, much as the Europeans did.

However Europeanized the fifth American era had become, it still maintained its old inclination toward rigid genres and marketable cycles. Producers still felt safer with a formula that had succeeded before, and so a series of films about compassionate thieves followed *Bonnie and Clyde*, a series of films about the last violent gasp of the old frontier followed *The Wild Bunch*, the chase scene in *Bullitt* was topped by the chase in *The French Connection*, and so forth. Despite their new experiential and stylistic commitments, the new films were descendants of the old genres: the western, the gangster, the *policier*, the screwball comedy, and the rest. The basic generic division in the new films was between city films and *country* films. Beyond these lay the road films (*Easy Rider*), the wilderness of horror (George Romero's *Night of the Living Dead*, 1968), and the world of fantasy (*Willy Wonka and the Chocolate Factory*, 1971, directed by Mel Stuart).

Many of the city films developed a thematic opposition between the unnaturalness and brutality of the city and the freedom and openness outside the city. While the *noir* city films shove law and crime, promise and corruption up against one another in tempting proximity, the city films of the "new" Hollywood suggest a seething human hell, augmented by location shooting and gory

"effects" make-up. The cities breed paranoid fantasies, whether the sounds of San Francisco (*The Conversation*, 1974) or the sights of New York viewed through a windshield—smoke, steam, and brimstone rising from the entrails of the city itself (Martin Scorsese's *Taxi Driver*, 1976).

Close cousins to the city films, thematically as well as geographically, were the suburb films—such as *The Graduate* and Romero's *Dawn of the Dead* (1978, released 1979). If, compared with the densely packed older cities, these suburb—cities were clean, bright, and new, they were also rootless and soulless. They lacked a center—either geographical or moral.

The new "experiential" western—for example, Sam Peckinpah's *The Wild Bunch* (1969) and George Roy Hill's *Butch Cassidy and the Sundance Kid* (1969)—was more violent, sensual, and antiestablishment than earlier westerns. For the new films, the vast plains and deserts were (like the highways in road movies) the last outposts of the free spirit of America. Both *The Wild Bunch* and *Butch Cassidy* were set in an era when the Old West was crumbling, when the city's values were swallowing the country's. The heroes of both films prefer to remain anachronisms rather than surrender to "decency" and the machine.

The new gangster film mirrored the same basic generic division between past and present, city and country, rural criminals and urban criminals. The country-crime genre was essentially a subgenre of the new western. Whereas the protagonists of the western depended on their horses, the central figures of *Bonnie and Clyde, Thieves Like Us*, and Terrence Malick's *Badlands* (1973) used the automobile as their means of slicing through the country. In *Easy Rider* they used motorcycles; the open road was romantic and fre, but sullied, and corruption and bigotry won in that movie's shockingly violent ending.

If the upsetting death sequence was obligatory in the western and country-crime films, as well as many urban dramas, the assaultive chase was obligatory in the city-crime films. The essential technical tool of the city film was editing—rather than composition as in the country films—and a familiar subjective device was the violent rushing of the traveling or handheld camera. Cops in the city-crime films (Peter Yates's *Bullitt,* 1968; William Friedkin's *The French Connection*, 1971; Don Siegel's *Dirty Harry*, 1971) usually faced two sources of tension: within themselves (are they just doing their job or are they neurotically driven to violence and sadism?) and within their own departments (the pressures of politicians, bureaucrats, and incompetents). The *film noir* of the Transitional Era (for example, Lang's *The Big Heat*, 1953) was a truly transitional link between the detective films of the Studio Era in which the cop fought crime and of the new era in which a cop fought himself and cops fought each other (Lumet's *Serpico* and *Prince of the City*).

The most obvious link with the old Hollywood was the one "new" genre

of the 1970s—what might be called the genre genre. These Postmodern films parodied the plots, conventions, and stars of Hollywood Past, usually by compiling a reflexive catalogue of Studio Era clichés—the Neil Simon—Robert Moore comedies (*Murder by Death*, 1976), Stanley Donen's *Movie Movie* (1978), some of the early Woody Allen films (*What's Up, Tiger Lily?*, 1966; *Take the Money and Run*, 1969; *Play It Again, Sam*, 1972, written by Allen but directed by Herbert Ross), and, of course, almost everything by Mel Brooks, the writer-director of *The Producers*, 1968; *Blazing Saddles*, 1974; *Young Frankenstein*, 1974; *Silent Movie*, 1976; and *High Anxiety*, 1977.

If a single American film of the 1970s put all these themes together, it was *Chinatown* (1974). Like many of the most perceptive film dissections of American society—from Chaplin's to Lang's to Hitchcock's—*Chinatown* was not directed by an American. Roman Polanski—whose view of life, American or otherwise, stretched fromn the concentration camp where his mother died to Bel Air and the brutal Manson murder of Sharon Tate, Polanski's wife—directed the film from a masterful script by Robert Towne. The film explored American political and sexual corruption in a supposedly saner, cleaner social era of "wholesome values"—the 1930s of Frank Capra and the New Deal. While the 1930s films reaffirmed the myths of American purpose and destiny (after serious setbacks and struggle), *Chinatown* exposed the myths themselves as naïve falsehoods.

The period that began with the assassination of one president ended with the disgrace of another. The national mood of anger, doubt, and distrust understandably differed from the optimism, commitment, or vigilance of prewar, wartime, and postwar America. Not every American shared that mood, but the most vocal Americans against the war in Vietnam and in favor of civil rights—who marched on Washington in immense numbers and disrupted college campuses—were the ones who went to the movies. The American film business—much leaner than it had been a decade earlier—could afford to play a central role in this national debate.

Not coincidentally, the old Hollywood Production Code, which had always been a hypocritical compromise between the facts of life and the pressures of public opinion, came to an end as this era began. After several years of hedging, of making exceptions for prestige films like *Lolita* (1962) or *Who's Afraid of Virginia Woolf?* (1966), in 1968 the Motion Picture Association of America (MPAA, formerly the MPPDA) finally replaced the PCA (Production Code Administration) with the CARA (Classification and Rating Administration). The new board—which, as a service to parents, rated the "level of maturity" a film assumed of its audience rather than prohibited certain kinds of material altogether— instituted four categories: originally, G (for all audiences), M

(suggested for mature audiences—which became GP, then PG), R (restricted to audiences of 18 years and older, except when accompanied by an adult), and X (restricted to audiences of 18 and over). PG-13, a warning stronger than PG (parental guidance suggested) but weaker than R, was added in 1984. In 1990, the new NC-17 (no children under 17) rating replaced the X. In CARA'S first 20 years, half of the nearly 9,000 features rated received an R, one third a PG.

While the new MPAA ratings system unleashed more explicit sexual talk and activity and a more open critical attack on society's norms than had ever been seen in American movies before, there was still plenty of uncertainty, bargaining, and hypocrisy. Who was to say what a 17-year-old did or should know? CARA repeatedly revised the guidelines and the age limits. Since young people made up such a large share of the movie audience, just to drop the cutoff age one year, from 18 to 17, translated into a major increase in a film's potential audience. There was considerable bargaining between film producers and CARA over what a film might cut to receive a more commercially "desirable" rating—just as there had always been bargaining between producers and the PCA over what a film could show or say.

To distinguish rated films with adult content from unrated films brimming with prurient sex, the MPAA instituted the NC-17, hoping that certain films could be rated "adults only" without falling prey to the many ordinances that prohibited X-rated films from advertising in local papers or playing in local theatres. But many organizations simply boycotted NC-17 films. Another 1990 change in the ratings system was that CARA was required to give the reasons (sex, violence, language) a picture had been rated R. The industry's new rating system changed the shape of public debate about personal morality and public exhibition but certainly did not end the discussion.

2.《邦妮和克莱德》

阿瑟·佩恩的《邦妮和克莱德》是根据20世纪30年代中西部一对年轻抢劫杀人罪犯的真实故事改编而成，将暴力、喜剧、浪漫爱情和社会政治批判完美地结合在一起，成为"新好莱坞"电影最典型、也最完美的代表。杀人越货的强盗因反抗社会体制（银行和警察）而成为英雄；结局高潮段落慢镜头、多角度强化的暴虐惨死，不但展示了"新好莱坞"的暴力渲染倾向，而且体现了好莱坞道德主义的胜利，更将男女主角塑造成悲情的神话式传奇。《邦妮和克莱德》在主题内容和表现形式两方面都引发了激烈的争论，并为道德、社会压迫和自由表达提供了新的阐释。

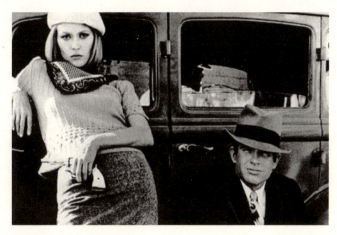

《邦妮和克莱德》的雌雄大盗

The Impact of *Bonnie and Clyde*

A new American cinema and a new American film audience announced themselves emphatically with the release in 1967 of Arthur Penn's *Bonnie and Clyde*. This film, which was universally attacked by the critics when it opened in August, had by November become the most popular film of the year. It would subsequently receive ten Academy Award nominations and win two awards (Best Cinematography: Burnett Guffey; Best Supporting Actress: Estelle Parsons), win the New York Film Critics' Award for Best Script (David Newman and Robert Benton), and be named the Best Film of 1967 by many of the critics who had originally panned it. Most triumphant of all, perhaps, *Bonnie and Clyde* is the only film ever to have forced the public retraction of a critical opinion by *Time* magazine, which dismissed the film in a summer issue and in its issue of December 8, 1967, ran a long cover story on its virtues. Indeed, the phenomenal success of *Bonnie and Clyde* caused many retractions on the part of veteran film critics who, on first viewing, had mistaken it for a conventional, if gratuitously bloody, gangster film. *Bonnie and Clyde* was in fact a sophisticated blend of comedy, violence, romance, and—symbolically, at least—politics, which borrowed freely from the techniques of the French New Wave (it was originally to have been directed by Truffaut and then Godard) and which perfectly captured the rebellious spirit of the times.

Based on the real-life career of Bonnie Parker and Clyde Barrow, the film tells the story of two young and attractive small-time criminals (Warren Beatty and Faye Dunaway) from the Midwest who during the Depression fall in love,

go on a spree of robberies and killings, and become national folk heroes in the process. Their targets are not the common people but the avaricious banks and the armies of police that protect them—in other words, "the system." Bonnie and Clyde were thus prototypes of the anti-establishment heroes who have come to dominate so many American films since, and they resonated perfectly with the revolutionary tenor of the late sixties. ("They're young! They're in love! And they kill people!" the advertising copy proclaimed.) By mid-film the lovers are clearly doomed, but nothing could prepare audiences in 1967 for the apocalyptic violence of the ending, in which Bonnie and Clyde are ambushed after a romantic interlude and their bodies ripped apart by machine-gun slugs in a protracted ballet of agony and death. Penn shot this conclusion with four cameras running at different speeds and with different lenses, and intercut the footage into a complex montage sequence which gives the deaths a mythic, legendary quality: Bonnie and Clyde are not simply killed; they are destroyed. Even today the sequence has an almost unbearable intensity because our dramatic identification with the characters is so complete. In the social climate of the times, however, the new American audience identified with Bonnie and Clyde less as dramatic characters than as types of romantic revolutionaries. And the tense, nervous texture of the film, with its unpredictable shifts in mood and its graphic, sensual depiction of violent death, was as revolutionary in 1967 as were its protagonists. The form of Bonnie and Clyde has been imitated so many times by hundreds of "criminal couple" and "road" pictures since 1967 that it is hard for contemporary audiences to comprehend the originality of the film when it was released. But in 1967 it was clearly subversive in both form and content, and the angry critical debate it caused in the United States was, in many ways, less about a pair of thirties gangsters than about the morality of violent dissent against an oppressive social order.

3. "美国作者"群像：库布里克、伍迪·艾伦和奥尔特曼等

受到法国"新浪潮"作者理论的影响，"新好莱坞"时期涌现出一大批"美国作者"（American Auteurs），他们拥有经典好莱坞时代无法想象的创作主导权、可以充分展示自己的艺术个性，成为美国电影中闪亮的金字招牌。

斯坦利·库布里克（Stanley Kubrick）作为"美国作者"的代表人物，20世纪60年代初即脱离好莱坞体制移居英国拍片。库布里克是著名的完美主义者，作品不多却字字珠玑；他执导的科幻片、剧情片、战争片、黑色喜剧片、恐怖片和社会暴力片等各种类型均成为极品，这足以与经典大师比利·怀尔

库布里克的《奇爱博士》

伍迪·艾伦的《曼哈顿》

罗伯特·奥尔特曼的《纳什维尔》

德媲美。库布里克执著于"男人的致命迷恋"这一主题，将人类本能和杀戮本性延伸到爱国主义、军法审判、权势或国防等社会机制领域。库布里克是将玩世不恭、放荡不羁和冷嘲热讽等融于一炉的著名社会批评家，更是将奇观、动作、节奏和张力完美结合的视觉电影大师。黑色喜剧片《奇爱博士》、开创性的科幻片《2001年：太空遨游》和社会暴力片《发条橘子》是库布里克巅峰时期的代表作品。

伍迪·艾伦（Woody Allen）作为美国的喜剧作者继承了以卓别林等为代表的喜剧传统，又融入自身犹太知识分子的神经质特性，坚持表现当代纽约人亲密又纠结的两性关系，他的代表作品《安妮·霍尔》和《曼哈顿》等一直受到美国都市人和欧洲知识界的追捧。

罗伯特·奥尔特曼（Robert Altman）擅长于用集锦式的拼贴结构表达自己的社会观点，《陆军野战医院》是对朝鲜战争的嘲讽、《纳什维尔》是对美国竞选政治的说唱式抨击、而《大玩家》则是对好莱坞自身嬉笑怒骂式的无情解剖。奥尔特曼擅长使用后现代的手法，《麦科比和米勒太太》是对西部片的解构，而《长别离》则是对侦探片的戏仿。

同时代的彼得·博格丹诺维奇（Peter Bogdanovich）的《最后一场电影》、威廉·弗里德金（William Friedkin）的《法国贩毒网》、布赖恩·德·帕尔玛（Brian De Palma）的《魔女嘉丽》和特伦斯·马利克（Terrence Malick）的《天堂的日子》等也被认为是"美国作者"的代表作品。

American Auteurs

Like the film industries of Europe and Japan, the American cinema became more a directors' cinema, granting proven directors a higher measure of control over the scripting, production, and editing decisions, allowing them more freedom in selecting their projects and giving them more credit for their contributions than the studios once did in the era of the moguls. A film was frequently labeled by or of its director, whose name often appeared above or before the film's title. The American director became one of the film's stars, and it is significant that many 1970s directors were allowed to make films without any major star at, all (*The Last Picture Show, Thieves Like Us, Days of Heaven*), an unheard-of practice for major studio films.

When François Truffaut in France and Andrew Sarris in America developed the "*auteur* theory" (or *auteur* policy), they did so as a means of distinguishing directorial individuality in the Studio Era, since individuality was often buried beneath the decisions of producers and the scripts of the story department. The new

American *auteurs* are film authors in the full sense of a Griffith, Gance, Dreyer, Ford, Hitchcock, Godard, Fellini, Bergman, or Kurosawa—the ones who control the responsibility for the entire project so that their own personal visions and visual styles get recorded on film. Though the following list of American auteurs must necessarily be tentative (some of them are still in midcareer), each has created a large body of work that demonstrates considerable power and imagination as well as a clear consistency of style and vision.

Stanley Kubrick

Discussions of science fiction in this period inevitably come around to one film: Stanley Kubrick's (1928-1999) *2001: A Space Odyssey* (1968), released one year before the first moon landing but still offering a completely realized vision of outer space—which is not surprising, since Kubrick was always such a meticulous and demanding artist. In the early 1960s, Kubrick detached himself from the constraints of American studios to produce films in England, where he died in 1999. A perfectionist who decided on every detail of the film himself, from scripting to editing—with the advantage of being his own producer—Kubrick worked very slowly. His reputation rests on only ten films: *The Killing* (1956), *Paths of Glory* (1957), *Lolita* (1962), *Dr. Strangelove Or: How I Learned To Stop Worrying And Love The Bomb* (1964), *2001*, *A Clockwork Orange* (1971), *Barry Lyndon* (1975), *The Shining* (1980), *Full Metal Jacket* (1987), and *Eyes Wide Shut* (1999), Kubrick's early films, *Fear and Desire* (1953) and *Killer's Kiss* (1955), are melodramatic apprentice work, and on *Spartacus* (1960) Kubrick was not the primary director, having been brought in halfway through production by Kirk Douglas.

From the *noir* world of *The Killing* to the military world of *Full Metal Jacket*, the essential Kubrick theme is man's love affair with death. Kubrick seems to be a social critic in that his films consistently rip apart the hypocrisies of polite society: the military society of World War I France (*Paths of Glory*), the pseudointel-lectual society of suburbia (*Lolita*), the political society of the White House and Pentagon (*Dr. Strangelove*), the sterilized banality of a society of the future (*2001* and *A Clockwork Orange*), the elegant hypocrisies of Europe's 18th-century aristocracy (*Barry Lyndon*). As with Renoir, Kubrick's social evils are human evils; the problem is with human nature. Without a society, men slaughter each other individually, as they do in "The Dawn of Man" sequence in *2001* after the first ape/man discovers the use of a weapon. With society, men slaughter each other *en masse* under the pretext of patriotism, military justice, potency, or national defense.

Kubrick's great cinematic gift is not just his ability to develop this bitterly ironic theme but his gift for finding the right ironic tone—part horror, part humor, a cold mixture of burlesque and Grand Guignol—for developing it. Unlike Renoir, Kubrick does not always appear to care about his characters; sometimes it is as if he puts them in boldly decorated freezers, to calculate their behavior and cackle at their struggles. But there is compassion, even vulnerability, in his long look at the married couple in *Eyes Wide Shut*; there is sorrow in *Full Metal Jacket*, rage in *Paths of Glory*, awe in *2001*. There is a tone of sympathy in *Barry Lyndon* that modifies the cold irony—but the merciless, cynical, sardonic, ironic tone is relentless in *Lolita*, *A Clockwork Orange*, *The Shining*, much of *2001*, all of *Dr. Strangelove*, at the end of *Full Metal Jacket*, and wherever else it pleased Kubrick to weave it into his work, from the cold vantage point of his masterfully controlled compositions.

Dr. Strangelove is the fullest and the least ponderous expression of the Kubrick theme and tone. The film begins with an audacious visual joke: Two jet planes, one refueling the other in midair, appear to be copulating. Kubrick emphasizes the gag by underscoring the planes' passion with a lush romantic version of the popular tune, "Try a Little Tenderness". As it turns out, the whole film synthesizes copulation and death. The American general, Buck Turgidson (George C. Scott), acts the same in the bedroom with his sweetie as he does in the War Room discussing the bomb crisis. The crazed army commander, Jack Ripper (Sterling Hayden), develops his whole theory about the Commies attacking his "precious bodily fluids" with fluoridated water based on how depleted he felt after making love. The American pilots in the atomic bomber work feverishly to drop their bomb on the Rooskies although the plane has been critically damaged. When they finally succeed in dropping it, the plane's commander (Slim Pickens) rides the bomb down to his destruction, whooping like a cowboy on a bronco, the bomb looking exactly like an enormous surrogate phallus.

2001: A Space Odyssey (co-written by Kubrick and Arthur C. Clarke) really is two films, one mystical, one cynical, which Kubrick holds in balance. On the one hand, Kubrick's astronauts travel toward the meaning of life itself, the life force that has specifically planted metal slabs on Earth, beneath the surface of the moon, and near Jupiter at the "dawn of time", in order to influence human progress— and reward it at the correct stage, for in order to find the moon's monolith, human technology would have to have developed to the point of landing people on the moon. Thus the mysterious silent slabs are both beacons and goads, and the central theme of the film is evolution. The first slab provokes the discovery of the first tool, a discovery that culminates in the invention of rocket ships and computers. Kubrick's brilliant cut from the soaring bone to the floating space shuttle visually establishes the connection between these tools. The second slab provokes the

Jupiter Mission, which takes human beings to their next stage of evolution, "beyond the infinite". After some form of education and maturation in a strange room, the life mystery sends the reborn astronaut back to Earth in a different kind of space capsule—a womb-like bubble. Another stage of evolution begins with this starchild. This metaphysical theme necessarily remains elusive; the monoliths and the force behind them are never explained—which leaves the feeling of metaphysical mystery intact.

Woody Allen

Woody Allen (1935-) is the American comic *auteur* who is most conscious of the older American comic film tradition that he inherits. His glasses create a "glass character" who resembles Harold Lloyd, his physical clumsiness and unattractiveness parallel Harry Langdon's, and his dryly quiet, offbeat comic ironies suggest the flavor of Buster Keaton and the wit of Groucho Marx. But more than anyone else, Allen resembles Chaplin as an observer and chronicler of the contemporary American social scene. Although his characters wear different names (Fielding Mellish in *Bananas*, 1971; Miles Monroe in *Sleeper*, 1973; Boris Grushenko in *Love and Death*, 1975; Alvy Singer in *Annie Hall*, 1977), a device that parallels Keaton's different names and costumes, Woody Allen's comic persona is a single, familiar, established being, like Charlie, who wanders across the landscape of modem urban life, contrasting that persona. With the less observant, less sensitive—and probably married and employed—characters who surround him. One might call Woody Allen's entire *oeuvre* "Modem Times", and if the problem for Allen's city dwellers has shifted from the external one of finding a job and founding a home to the internal one of feeling secure enough to survive between appointments with the analyst, that shift is symptomatic of almost seven decades of change in American life. Like Charlie (the British tramp), Woody (the Jewish *schlemiel*) is out of tune and out of step with the society that threatens and excludes him but that he wants to join and comically reflects.

Allen's cinematic technique in his earliest films was casually flippant, and he leapt from gag to gag. But Allen's three late-1970s films (*Annie Hall*; *Interiors*, 1978; *Manhattan*, 1979) show far more care and consciousness of cinematic style and "art".

After *Love and Death*, Allen's movies became increasingly reflexive, committed to exploring the condition of comic movies rather than his own fixed comic persona. *Love and Death* alluded to Soviet cinema—from Eisenstein's images to Prokofiev's film scores— as often as to 19th-century Russian fiction. *Stardust Memories* (1980), like Fellini's $8\frac{1}{2}$, which it deliberately echoes, shows

the way a popular artist can be trapped by his own success and the expectations of fans and critics. *A Midsummer Night's Sex Comedy* (1982) combines Shakespeare's *A Midsummer Night's Dream* and Bergman's *Smiles of a Summer Night*. *Zelig* (1983) is virtually an entire movie in the style of *Citizen Kane's* newsreel—an ironic examination of the way American hype converts anonymous nonentities into media superstars. Some of his best later films are nostalgic and engaging looks at show business (*Radio Days*, 1987; *Bullets Over Broadway*, 1994) or formal experiments, but the major theme of his work since *Annie Hall* has continued to be the nature of contemporary intimate relationships (*Manhattan*; *Hannah and Her Sisters*, 1986; *Crimes and Misdemeanors*, 1989; *Husbands rind Wives*, 1992; *Mighty Aphrodite*, 1995; *Match Point*, 2005), with an emphasis on the problems of authenticity and performance.

Robert Altman

Robert Altman (1925-2006) made 15 feature films in the 1970s alone. His work comes in two narrative sizes. The first is a smaller, closer study of people who lead bizarre lives or are possessed by their dreams—the boy who wants to become a bird and fly in *Brewster McCloud* (1970), the thieves who want to rob enough banks to settle down to respectable lives in *Thieves Like Us*, Nixon in a room (*Secret Honor*, 1984).

The second Altman narrative structure requires a much larger canvas. It is a broad study of a particular American institution, built from a great number of interwoven characters, adding up to a cross-sectional view of American life. *MASH* (1970), Altman's first major success, used the sexy, funny, gory activities of a group of American medics in Korea to examine (at the height of the Vietnam crisis) American attitudes toward war, particularly wars against other races in distant parts of the world; the script was by Ring Lardner, Jr., one of the Hollywood Ten. *MASH* led to a hit TV series, *M. A. S. H*, and to more advanced experiments in complex film soundtracks. *Nashville* (1975), probably Altman's most solid and respected film, used the American country-and-western recording industry—and all people it touched or who wanted to be hed by it—to investigate American political, social, and economic structures, as well as the American dreams of fame and success.

One of Altman's consistent strengths is the compelling spontaneous authenticity of the moments of human interaction. Altman works improvisationally with his actors, and the scenes they build together (between Donald Sutherland and Elliott Gould in *MASH*, Julie Christie and Warren Beatty *in McCabe & Mrs. Miller*, Gould and Sterling Hayden in *The Long Goodbye*, Barbara Harris or Lily Tomlin and everybody else in *Nashville*) are hypnotic encounters with acting that

feels like life. That remains true throughout his career; the acting and the rhythm of events are assured and authentic all the way to *A Prairie Home Companion* (2006), the last film he released before his death in 2006.

Consistent with the spirit of the era, Altman's work attacked the myths of American life as articulated in the genres of American movies. *McCabe & Mrs. Miller* does to the western what *The Long Goodbye* does to the detective film: explodes its assumptions and picks up only a few of the pieces. In this ragged frontier town, ironically named Presbyterian Church, there is no mythic showdown between good and evil in the glaring light of high noon. The "good guy", McCabe, is a drunken profiteer from gambling and prostitution who shoots his assailants in the back; Mrs. Miller reveals no heart of gold when trouble comes but retreats into her opium haze.

This is a western concerned not with decency but with sanitation—obsessed with the way people smell, belch, fart, and rid themselves of bodily wastes. Despite the town's name, its church, that great icon of civilization in John Ford westerns, is only half-built. Its major purpose in the film is to catch fire and distract the town's citizens from the real battle between McCabe and the hired killers— just as western movies, Altman perhaps implies, distracted American citizens from political realities with mythic façades.

After the mid-1970s and the passing of that era's attack on movie myth, Altman found it increasingly difficult to finance projects and please audiences. His most ambitious and disturbing films of tile 1980s—*Jimmy Dean*, *Fool for Love* (1985, written for the screen by playwright Sam Shepard), and *Vincent & Theo* (1990, the story of the brothers Van Gogh)—attracted critics and audiences but still failed to convince producers that Altman could be trusted to turn out a commercially viable project; during this period Altman lost several assignments when he told studio heads that he intended to make an Airman film rather than, for example, an MGM film. But in 1992 he made a genuine comeback with *The Player*, a relentless satire of the Hollywood food chain.

第二节 新德国电影

1.《奥伯豪森宣言》和克鲁格

1962年26位德国青年导演的《奥伯豪森宣言》以"旧的电影已经死亡,我们相信新的电影"宣告"新德国电影"(New German Cinema)的诞生。新德国电影提倡作者电影和艺术电影,反对好莱坞和德国的商业电影。但它仍然受到德国电影传统和美国电影的重要影响,既注重电影整体的质感、间离效果和某种程度的反叙事倾向,又保持着完整的叙事情节、丰满的人物个性和深刻的现实内涵。

亚历山大·克鲁格(Alexander Kluge)既是《奥伯豪森宣言》的发起人,他的处女作《告别昨天》更是新德国电影的开山之作。

New German Cinema (das neue Kino)

For 35 years, from 1932 to 1967, Germany produced very few films of international significance. Among the scattered postwar German films to be exported were Kurt Hoffmann's *Aren't We Wonderful?* (1958), a terrific political comedy, and Swiss-born Bernhard Wicki's *The Bridge* (1959), the story of a group of German schoolchildren who were killed while defending a worthless bridge in the last days of the war. Volker Schlöndorff's *Young Törless* (1966), which parallels sadomasochistic torture in a boy's school with the moral and psychological conditions for Nazism in Hitler's Germany, was either the last of these occasional

German films to achieve international recognition or the first representative of the new and genuine German film movement.

In 1960 the German film industry produced some 70 feature films, almost exclusively for local consumption in their simple themes and conventional styles. The Oberhausen Manifesto, formulated by 26 German screenwriters and directors at the Oberhausen Film Festival of 1962, called for a "new German cinema", free from the stifling habits and conventions of the German film industry. Through its leaders, especially Alexander Kluge (*Yesterday Girl*, 1966; *Strongman Ferdinand*, 1975), the group successfully pressured the West German legislature to set up a film board and allocate subsidies for film production in 1967. The new German cinema flowed from these subsidies.

In the late 1960s and early 1970s appeared the first feature films of three young German filmmakers—Werner Herzog (*Signs of Life*, 1968), Rainer Werner Fassbinder (*Love Is Colder Than Death*, 1969), and Wim Wenders (*Summer in the City*, 1970; *The Goalie's Anxiety at the Penalty Kick*, 1971). All three were born within a few years of one another (Herzog in 1942, Wenders in 1945, Fassbinder in 1946); each was about 24 when his first feature appeared; each was supported by government subsidy, either directly through the Film Subsidies Board or indirectly through subsidized television production. These three directors, who steadily achieved international recognition, formed the nucleus of one of the most interesting and productive new national film movements since the French New Wave.

Although American and European critics and festivals had realized as early as 1972 that something important was happening in West Germany, American audiences did not take to the New Cinema (*das neue Kino*) as rapidly as they had to the films of the New Wave. The new German films were not more difficult to understand than previous European films, but they were difficult in a different way—colder, harder edged, more ironic, and less charming than the films of Fellini or Truffaut.

The surprising commercial success of Fassbinder's *The Marriage of Maria Braun* (1979) accompanied international financing for English-language productions by Fassbinder (*Despair*, 1977), Wenders (*The American Friend*, 1977; *Paris, Texas*, 1984), and Herzog (*Fitzcarraldo*, 1982). The major American publicity campaigns for these films, Wenders's collaboration with Coppola and playwright Sam Shepard, and the posthumous interest in Fassbinder's last films— from the epic *Berlin Alexanderplatz* (1980, 151/2 hours, made for TV) to *Querelle* (1982)—indicated that these filmmakers had attracted the critical attention and the audiences they deserved in the United States.

That the New German Cinema initially made little impact in America was ironic, for one of its traits was a conscious debt to the American cinema. Wenders,

Fassbinder, and Herzog all paid homage to American genres (melodrama, *film noir*; the western) and directors (Douglas Sirk, Nicholas Ray, Sam Fuller) in their movies. They acknowledged their debt to French filmmakers like Max Ophüls mid Jean-Luc Godard as well. But these three Germans also owed much to a native German film tradition—the Expressionist masterpieces of the 1920s. The Fassbinder films often evoke the stylized, statuesque, highly patterned visual world of Fritz Lang.

Herzog's works recall the spiritual, mystical aspects of such films as *Caligari*, *Destiny*, and *Nosferatu*—the last one quite literally, since Herzog modeled his *Nosferatu* (1979) on Murnau's.

Although Wenders is the most apparently realist of the three directors (in the sense that Fassbinder is theatrical and Herzog is visionary), his work can be compared with such German classics as the more realistic works of Murnau and Pabst. Yet only Fassbinder could present a world as grossly realistic as the opening of *The Love of Jeanne Ney*.

2. 新德国电影"四杰"：施隆多夫、法斯宾德、赫尔佐格和文德斯

沃尔克·施隆多夫（Volker Schlöndorff）1966年的处女作《青年特尔勒斯》（*Young Törless*）同样被认为是新德国电影的开山作品之一。施隆多夫早年曾就读法国高等电影学院，深受法国新浪潮电影的影响，追求大众媒介的通俗性，其电影兼具艺术性和商业性，将视听奇幻与思想内涵巧妙地结合在一起，执导过《丧失名誉的卡特琳娜·勃卢姆》和《锡鼓》等杰作。而他的前妻玛格雷特·冯·特洛塔（Margarethe von Trotta）也是拍摄《德国姊妹们》的新德国电影著名女导演。

赖纳·华纳·法斯宾德（Rainer Werner Fassbinder）是多产早夭的德国电影神童，他将德国室内剧传统、布莱希特间离戏剧和好莱坞类型电影的影响融为一体，以特殊甚至变态的人物关系和情境设定（吸毒、酗酒和同性恋等），表达反权力和反压迫的强烈社会政治讯息。《爱比死更冷酷》和《恐惧吞噬灵魂》反映人类关系中的孤独和绝望，而《玛丽娅·布劳恩的婚姻》和《薇罗尼卡·福斯的欲望》则为人性世界注入了丰富的社会历史内涵。

沃纳·赫尔佐格（Werner Herzog）的《生命的征兆》也是新德国电影的先驱作品，他继承了德国电影浪漫主义、表现主义和哲学思辨的传统，倾向于在异国情调（南美、非洲和澳洲等）的特殊环境设置中，表现人类疯狂的原始本能、神秘主义、先知和超验，揭示生命和世界的本质特征，进而探讨

人与环境的关系及其人类世界的悲观性宿命。《天谴》《人人为自己，上帝反大家》和《绿蚂蚁做梦的地方》是其公认的代表作品。

维姆·文德斯（Wim Wenders）深受美国电影和美国文化的侵染，对好莱坞的公路片和音乐片更是情有独钟。他热衷于开放式的叙事体系，喜欢"在电影中流浪"，并执著于旅行和寻找的主题。《爱丽丝漫游记》周游欧洲城市寻找亲人的小女孩、《德克萨斯州的巴黎》浪迹美国西部荒野寻找前妻的中年鳏夫、《柏林苍穹下》为求真爱不惜堕入柏林凡尘的痴情天使，在在都体现文德斯电影精致而淡泊的疏离感。

Volker Schlöndorff, Alexander Kluge, and Margarethe von Trotta

Historically, the New German Cinema movement can be said to date from the release of Volker Schlöndorff's (1939-) independently produced *Der junge Törless* (*Young Törless*, 1966), a psychologically detailed adaptation of Robert Musil's antimilitarist novel set in a boy's school before World War I, which won the International Critics' Prize at Cannes. Schlöndorff, who studied at IDHEC (Paris), had worked as an assistant to Louis Malle, Alain Resnais, and Jean-Pierre Melville before directing this feature. His next independent film was *Baal* (1969), an adaptation of Bertolt Brecht's first play, which was followed by *Der plöt-zliche Reichtum der armen Leute von Kombach* (*The Sudden Wealth of the Poor People of Kombach*, 1971), a bizarre parody of the *Heimatfilme* tradition in which a group of nineteenth-century peasants rebel against the degradation of rural life by becoming bandits and are put to death by the state. Other notable Schlöndorff films are *Coup de grace* (*Der Fangschuss*, 1976), a psychological drama set among German volunteers in the Baltic states at the end of World War I, and *Nur zum Spass—nur zum Spiel, Kaleidoskop Valeska Gert* (1977), in which a famous cabaret artist, shortly before her death in 1978, reminisces about her more than sixty years in show business. In 1979 Schlöndorff's adaptation of Güinter Grass's novel *The Tin Drum* (*Die Blechtrommel*) shared the Grand Prix at Cannes with the American director Francis Ford Coppola's *Apocalypse Now*, and in 1980 it won the American Academy Award for Best Foreign Film. Schlöndorff has worked frequently for the commercial studios, where he has collaborated with his wife, Margarethe von Trotta (b. 1942), the scenarist and actress, on a number of important films dealing with feminism and other social and political themes. Most notable among these have been *Strohfeuer* (*Summer Lightning / A Free Woman*, 1972), and *Die verlorene Ehre der Katharina Blum* (*The Lost Honor of Katharina Blum*, 1975); from the novel by Heinrich Böll). During the eighties, Schlöndorff produced *Die*

施隆多夫的《锡鼓》

Faelschung (*Circle of Deceit/The Forgery*, 1981), based on events in the Lebanese civil war, 1974-76, as they are experienced by a German photojournalist; *Un Amor de Swann* (*Swann in Love*, 1984), a lavish adaptation of the second part of the first volume of Proust's *A la Recherche du temps perdu* (sixteen volumes, 1913-27), shot on location in Paris and environs by Sven Nykvist; and an unusual version of Arthur Miller's *Death of a Salesman* (1985), with Dustin Hoffman as Willy Loman, produced for American television. More recently, he directed an adaptation of Max Frisch's 1957 novel *Homo Faber* entitled *Voyager* (1991).

Another founder of *das neue Kino* was Alexander Kluge (1932-), whose *Artisten unter der Zirkuskuppel: ratlos* (*Artists under the Big Top: Disoriented*, 1968) provided a metaphor for the plight of the serious film artist in Germany in the Godardian parable of a young woman who inherits a circus but cannot reform its deeply embedded traditions to create a new role for it in the "media world". Kluge, a practicing lawyer, novelist, legal scholar, and social theoretician, worked as an assistant to Fritz Lang during Lang's brief return to Germany in the late fifties, and he is the intellectual father of New German Cinema. As spokesman for the original Oberhausen *junger deutscher Film* group, he was responsible for convincing the federal government to establish the Kuratorium and the film schools in Munich and Berlin. Kluge's style is objective, coolly rational, and satirical. His films almost always involve the precise analysis of some social problem which besets contemporary Germany, focusing on a representative protagonist (often played by his younger sister, Alexandra Kluge). Kluge's most significant films of the seventies are *Gelegenheitsarbeit einer Sklavin* (*Part-Time*

Work of a Domestic Slave, 1974), which examines the issue of women's liberation and political organizing, and *Strong Man Ferdinand (Der starke Ferdinand*, 1976), a satirical allegory of fascism about an industrial security guard whose paranoid quest for order results in catastrophe for everyone around him. Kluge then brought together ten other New German filmmakers and the Nobel Prize-winning novelist Heinrich Böll to produce *Deutschland im Herbst* (*Germany in Autumn*, 1978) for the Filmverlag der Autoren. Highly reminiscent of SLON's *Loin de Vietnam* (1967), this semidocumentary cooperative feature is a rumination on the events of autumn 1977, when a public official was kidnapped and murdered by terrorists, and several of the terrorists later died under mysterious circumstances in prison. Kluge, expanding his contribution to *Deutschland im Herbst*, made *Die Patriotin* (*The Patriot*, 1980), a meditation on the teaching of German history both in and out of school. In other cooperative projects, Kluge, Schlöndorff, and two younger directors produced *Der Kandidat* (*The Candidate*, 1980), an ironic documentary portrait of Franz Josef Strauss, the right-wing challenger in the 1980 West German federal elections, and *Krieg und Frieden* (*War and Peace*, 1983), an omnibus work on the nation's peace movement. Kluge himself has produced and directed the documentary *Die Macht der Gefuehle* (*The Power of Emotion*, 1983), as well as *Der Angriff der Gengenwart au die übrige Zeit* (*The Assault of the Present upon the Rest of Time*, 1985) and *Vermischte Nachrichten* (*Odds and Ends*, 1987), the latter two composed of documentary-style vignettes about contemporary German life and attitudes.

Schlöndorff and Kluge remain important representatives of *das neu Kino*; in the late seventies and eighties their ranks were joined by Margarethe von Trotta (1942-) as a major director in her own right with the appearance *of Das zweites Erwachen der Christa Klages* (*The Second Awakening of Christa Klage*, 1978) and *Schwestern, oder die Bilanz des Glucks* (*Sisters, or the Balance of Happiness*, 1979), both concerned in different ways with the emergence of feminist consciousness. Von Trotta's break-through film, however, was *Die bleierne Zeit* (*The German Sisters / Marianne and Juliane*, 1981), a film about the coming to political awareness of two siblings in the late sixties and the radically different paths chosen by each. Based on the true story of a member of the Baader-Meinhof terrorist gang, *Die bleierne Zeit* became the second film by a woman to win the Golden Lion at Venice in thirty-nine years (the first was, ironically, Leni Riefenstahl's *Olympia*), but von Trotta was not so successful with her subsequent *Frauenfilme* ("women's films") *Heller Wahn* (*Sheer Madness*, 1982), *Paura e Amore* (*Three Sisters*, 1988), the latter vaguely adapted from Chekhov, and *L'Africana* (*The Return*, 1990). On the other hand, von Trotta's *Rosa Luxemburg* (1986), a biography of the revolutionary socialist leader and cofounder of the Spartacus League who was murdered by Freikorps troops in 1919, is regarded as a major work.

Rainer Werner Fassbinder

With Rainer Werner Fassbinder's (1945-1982) untimely death at the age of 37, New German Cinema itself seemed to have come to a premature end. The sheer quantity of his creative output—more than forty films and television productions within fifteen years—had won him an undisputed reputation as the 'heart' of New German Cinema; moreover his relentlessly critical perspective on West Germany made him appear as the 'conscience of his nation'. For *Le Monde* Fassbinder represented 'the rage of a young generation that opened its eyes in the 1960s and learned what his elders had left behind: the destruction of German identity through National Socialism'.

Fassbinder embodied a generation that, born at the end of the war, rebelled against 'the system'; the capitalist economy, conservative state, and an authoritarian older generation associated with the Nazis. The generational discontent exploded in 1967 when simultaneous protests against the Vietnam War, against the new state emergency laws, and against a right-wing mass-circulation press erupted with a force previously unknown in the Federal Republic. Fassbinder, whose career began in the mid-1960s, never departed from the radical utopiananarchic ideals of this period. They form the horizon against which the reality (and integrity) of his heroes and heroines is measured. It is no accident that all his films thematize the failure of these uncompromising ideals and the final shattering of illusions, They explore oppressive power relations and dependencies, dramatic emotions, hapless compromises, double and inescapable situations which more often than not end in suicide.

法斯宾德的《恐惧吞噬灵魂》

Born in Bavaria into a middle-class family, he dropped out of high school and took acting lessons, joining the action theatre group in 1967 and starting his own theatre company, the Antiteater, in Munich in 1968. In 1969 he embarked on a ten-year uninterrupted production of 35 mm. feature films that yielded between two and six films and TV productions per year in addition to theatre productions and occasional appearances as actor. In the last three years of his life the pace was even more frantic with the production of *Berlin Alexanderplatz* (1979-1980), a fifteen-hour TV film in thirteen parts and an epilogue, and four major international co-productions. The boundless energy and speed (in his later years druginduced) with which Fassbinder was able to work also had to do with the way he produced films: keeping a circle of collaborators around him, including Peer Raben, who wrote the scores to virtually all of Fassbinder's films; Harry Bär, his production assistant; a small number of cameramen (Dietrich Lohmann, Michael Ballhaus, Franz Xaver Schwarzenberger); and actresses and actors (among them Hanna Schygulla, Irm Hermann, Kurt Raab), with whom he worked in the style of a small repertory theatre. This arrangement also accounts for the unmistakable "took" of Fassbinder's films despite their wide generic and stylistic range.

From the beginning, Fassbinder experimented with radically different modes of filmmaking, He appropriated genre conventions of the American gangster film into a Munich underground milieu in *Liebe ist kälter als der Tod* (1969) and in *Der amerikanische Soldat* (1970). Stylistically on the other extreme, he used Brechtian distanciation effects and theatrical stylization in *Katzdmacher* (1969), his film about a Greek immigrant worker who exposes the exploitative and racist environment that the first generation of foreign workers encountered in Germany. The minimalist, self-reflexive filmic language in *Katzelmacher* (with Fassbinder playing the main part of the Greek worker) is indebted to Jean-Marie Straub, who briefly worked as guest director at Fassbinder's theatre.

In 1971 Fassbinder saw films by Douglas Sirk, the Hamburg-horn Hollywood director, for the first time, and was deeply impressed by Sirk's ability to make popular films without compromising a subversive, 'European' sensibility and an inimitable style; he 'adopted' the exiled German as his spiritual father, secretly hoping to be able one day to make a German Hollywood film. Fassbinder's *Händler der vier Jahreszciten* (*The Merchant of Four Seasons*, 1971) and *Angst essen Seele auf* (1973) consciously have recourse to Sirk's style. making use of melodramatic plots, unrealistic lighting, obtrusive camera movements, an artificial, highly stylized decor, and a highly intricate interplay of glances, gazes, and looks, expressing desire, recognition, and estrangement. Overly melodramatic music breaks the illusion, and a theatrical gestural language keeps the viewer at a critical distance despite the open display of unbridled emotions.

Fassbinder's historical films appeared in rapid succession after 1977: *Despair*

(1977), *Die Ehe der Maria, Braun* (1978), *Berlin Alexanderplatz* (1979/1980), *Lili Marleen* (1980), *Lola* (1981), and *Die Sehnsuchl der Veronika Voss* (1981). Against the backdrop of German history from the cynical 1920s to the garish 1950s, these films deal with the unfufilled desires of individuals, the exploitation and exploitability of their emotions, mid the destruction they bring down on themselves. In his adaptalion of Alfred Döblin's 1928 novel *Berlin Alexanderplatz* as a TV series. he shows a country slowly undergoing a change of identity. Berlin here represents the treacherous and inhospitable social space that determines the life and times of the reformed criminal Franz Biberkopf. Fassbinder's subsequent film *Lili Marleen* (1980) tightens the fit between the private and public realm: a cabaret singer, who hits big time with her home front song about Lili Marleen, becomes entangled in the cynical political machinations of both the Nazis and the organized Resistance. Fassbinder adopts the Nazi Ufa style in lighting, sets, costumes, and camera; exaggerating the glamour to the point of parody.

The period that fascinated Fassbinder most was the period of his own lifetime, i.e. the post-war era after the rupture of 1945, the time in which a new beginning seemed possible, even necessary. The Federal Republic was not yet firmly established, and in Fassbinder's view utopian hopes could be nurtured. The films of his Federal-Republic-of-Germany Trilogy (BRD-Trilogie) provide increasingly despondent pictures of West German misery as Fassbinder understood and felt it from the perspective of the 1970s: the subjugation of emotions to mercenary material greed in the reconstruction years (*The Marriage of Maria Braun*); the ubiquitous corruption one had to accept in the years of opportunistic conlormity (*Lola*); and the haunting memories of a traumatic past that had to be exorcized (*Veronika Voss*). The films show the inevitable conflicts that arose from a collective denial of the past; they end with annihilation (*The Marriage of Maria Braun*), cynicism (*Lola*), or utter resignation (*Veronika Voss*).

Fassbinder's late films on Germany operate within the "micro-politics of desire" (Guattari), showing how the hopes, aspirations, and frustrations of everyday people interrelate with concrete historical situations. Fassbinder's female protagonists shape their epoch as much as they are shaped by it, Their wishes contribute to, and implicitly criticize, the dominant mentality of their time. Fassbinder's films thus supplement official historiography with a psychological and utopian dimension. By the late 1970s, however, he had become convinced that the hopes he had for Germany were delusions, and his later films are expressions of that overriding despair. To the extent that Fassbinder's films are about human values and visions, they transcend his obsession with German history and identity. Ultimately, all of his films are about dreams and longings for an 'undamaged life' (Theodor W. Adorno).

Werner Herzog

Often called the romantic visionary of German cinema, Werner Herzog has become a symbol of the film-maker as adventurer, vagabond, and daredevil. Documentaries about Herzog (1942-), the most famous of which is Les Blank's *Burden of Dreams* (1982), invariably portray him as all obsessed, half-crazed *auteur* willing to risk his life for a film. His protagonists—rebellious dreamers and heretics, fanatics and maniacs—serve as doubles for the independent film-maker who seeks to realize his vision against all odds. All of his films explore and validate otherness; most take place in exotic settings—from the South American jungle (*Aguirre, Wrath of God*. 1972) to Africa (*Cobra Verde*, 1987). Even his native Bavaria in *Herz aus Glas* (1976) appears as a pre-modern far-away country. Herzog's embrace of the traditions of exoticism and primitivism implies a radical, often apocalyptic critique of western civilization and instrumental rationality.

Born Werner Stipetic in Munich in 1942, Herzog (his fictional name) wrote his first film script at 15, and, after a few years of studying at the university, became a selftaught film-maker using (allegedly) a stolen 35 mm camera. His powerful début, *Lebenszeichen* ('Signs of life', 1967), translates alienation, madness, and aggression into stark black and white images. The story follows a wounded young German soldier who is left on a Greek island to guard a useless ammunition dump. The barren landscape and the unrelenting sun trigger a nervous breakdown that expresses itself as rebeilion first against his military, superiors, but soon against the sun and the universe itself. The camera objectively records the buildup of the crisis and the explosion into madness in the style of a documentary, sparingly commenting on it with extreme wide-angle shots, jump cuts, and destabilizing hand-held camera movements.

Aguirre, der Zorn Gottes (*Aguirre, Wrath of God*, 1972), depicting the life of the sixteenth-century colonialist adventurer Don Lope de Aguirre, has a similar trajectory. In open and irrational defiance of nature and God, Aguirre (played by the inimitable Klaus Kinski, a Herzog regular) is determined to conquer the mythical kingdom of El Dorado. With its incongruous adherence to courtly grandeur in the midst of the Amazon jungle, the film is both a parody and criticism of colonialism. By means of extreme camera angles and long shots, Herzog visualizes primordial nature as an antagonistic and terrifying force that dwarfs and eventually destroys the colonizer.

In 1982, after four extremely difficult years in production, Herzog released *Fitzcarraldo* as another, even more darldy ironic version of the colonialist story. It chronicles the grotesque aspiration of a rich adventurer to bring Italian opera to the natives in the Peruvian jungle. Herzog critiques the colonizers' preposterous

arrogance, *naïveté*, and simple lack of respect for otherness. Ironically, his own project came under fire for precisely reenacting what the film meant to criticize. His crew's invasion of Indian territory and the exploitation of the native population made news after his camp was burned down in protest by native Indians.

Only a year later, Herzog explored the colonialist dream in economic terms. In *Wo die grünen Ameisen träumen* (*Where the Green Ants Dream*, 1984), modern-day *conquistadores*-the engineers ora mining company in search for uranium-destroy a site held sacred by the Australian aborigines. The natives lose the fight against industrial 'progress' and unscrupulous profiteering. Nature, denuded and depressingly barren, is here no longer romantically set against man; myth and modernity stare each other in the eye.

Herzog's unique blend of ethnographic and narrative film challenges all traditional genre divisions, particularly distinctions between documentary and feature film. *Fata Morgana* (1970) is an early example of Herzog's numerous documentaries that deconstruct the genre with their contradictory mix of filmic enunciations, Images of the litter-strewn desert are juxtaposed on the sound-track with Lotte Eisner's recitation of the creation myth, and intermittent off-screen comments by Herzog rupture any sense of objective truth. The film's perspective is that of *post-histoire* or the end of history, a mythical realm after progress and modernity have destroyed the planet.

Herzog's pessimistic view of civilization and social constrictions is also

赫尔佐格的《天谴》

repeatedly played out in his narrative films. *Jeder für sich und Gott gegen alle* (*The Mystery of Kaspar Hauser*, 1974) employs a lay actor, Bruno S., an illiterate and slightly deranged-looking Berlin street perllustrate the painful and unsuccessful integration of the wild Child Kaspar Hauser into an early nineentury German community. The film critiques the unctuous pomposity and ridiculous pedantry of the from the perspective of the natural man unspoiled by the phoney rites of "civilized" society. In *Stroszek* (1977) three outcasts—a man released from goal, a prostitute, and an whimsical old neighbour-try to start a new life in the American Midwest, which Herzog portrays as no less impenetrable and exotic than the Peruvian jungle.

Maladjusted citizens or outsiders in a fatal clash with society also appear in *Nosferatu, Phantom der Nacht* (*Nosferatu, the Vampire*, 1978), a remake of F. W. Murnau's celebrated silent vampire film of 1922. Similar to Murnau's Style, Herzog's film language oscillates between documentary' and dream-like passages, between ethnographic authenticity and surrealistic vision. A strong tension between picture and story is typical of all of Herzog's films: the rich imagery and the operatic staging tend to exceed the economy of a tight narrative. His recent, more straightforward documentations on nomads in the Sahara (*Wodaabe: die Hirten der Sonne*, 1989) or on Kuwait (*Lektionen in Finsternis*, 1992) let the powerful images carry the message, unencumbered by fictional characters and a story-line.

Wim Wenders

One of the first graduates of the Munich Academy of Film and Television, Wim Wenders (1945-) has concerned himself overtly with the theoretical issues involved in cinematic representation. His extensive essayistic writings stand in a symbiotic relationship with his films: they all revolve around the power of the image, the difficulties of storytelling, and the vicissitudes of perception. Wenders believes in film's ability to explore, rediscover, and thus redeem the physical world.

His early shorts *Schauplätze* (1967) and *Same Player Shoots Again* (1967) are formal experiments involving stasis and movement as if he wanted to discover for himself the medium-specific properties of the motion picture. Wenders always had a sceptical relationship to strong narratives-maybe out of fear that they might overpower the delicate imagery. Indeed, a highly self-conscious tension between story and picture runs through all of Wenders's work from his first feature, *Summer in the City* (1971), to *In welter Ferne, so nah* (*Far Away, so Close*, 1993).

Summer in the City (1971), dedicated to the Kinks, uses an alienated young man's search for his friends as a pretext to explore physical space in relation to

文德斯的《柏林苍穹下》

music and movement. Similarly, *Alice in den Städten* (*Alice in the Cities*, 1974) examines the nexus between perception, experience, and estrangement. A journalist is unable to write about America because he finds the innumerable polaroid pictures he has shot and collected more powerful and truthful than words. He ends up by accident with an abandoned 9-year-old girl, and his passive non-involvement as observer finally breaks down when the two return to Germany to look for the house of the girl's grandmother, of which they have only a photograph. In a wider sense, this road movie suggests a quest for the site of one's lost childhood, and of identity.

Falsche Bewegung (*The Wrong Move*, 1974), based on Handke's screenplay, which itself follows Goethe's *Bildungsroman Wilhelm Meiters Apprenticeship*, also invites the viewer to examine German landscapes and cityscapes. Wilhelm, a writer, undertakes an educational journey from northern to southern Germany and admits at the end that he made a "wrong move" by not listening to the story of one of his travel companions, Laertes, a former member of the Nazi Party, who embodies Germany's recent past. The Federal Republic appears in this film as a country of lost souls because of its history.

'The only thing, I was secure with from the beginning and felt had nothing to do with fascism was rock music,' Wenders said in a 1976 interview. In nearly all his films and writings, Wenders thematized the inexorable influence that America (through its popular culture) held over the German post-war generation. His position, however, was ambivalent. While he was drawn to America to the point of living for several years in New York and Los Angeles, a character in his road movie *Im Lauf der Zeit* (*King's of the Road*, 1976) also claimed that "the Yanks have colonized our subconscious". A tangible shift from adulation to scepticism occurred during the ill-fated production of *Hammett* (1982), for which he was hired

as director by Francis Ford Coppola. In production for almost four years between 1979 and 1982, the film had to be reshot and recut before it was deemed releasable for an American audience.

Both before and after *Hammett*, Wenders had made films either set in the United States or which explored the tension between Europe and America. The psychological thriller *Der amerikanische Freund* (*The American Friend*, 1977) deals with a shady American con artist (played by Dennis Hopper) who befriends and betrays an honest German craftsman. Wenders's experiences with the production of *Hammett* were the incentive for the semi-autobiographical black and white film Der *Stand der Dinge* (*The State of Things*, 1981), which reflects on the rift American and European cinema. The film ends with the protagonist, an independent German filmmaker killed on a Hollywood street.

Paris, Texas (1984), written by Sam Shepard, carries the tension between the old and the new world in its title. The film's first part belongs to Wenders's favourite genre, the road movie, with characters aimlessly driving in search of the past and the future, In the second part, the camera comes to rest in a peepshow, as the protagonist attempts to win back his wife through a window which doubles as a one-way mirror, Robby Müller (Wenders's cinematographer for the majority of his films) uses this set-up for highly evocative and self-referential camera work.

By the mid-1980s, as questions of national identity seemed to climax, Wenders returned to Germany to work on *Wings of Desire* (*Himmel fiber Berlin*, 1986-1987), a film about Berlin and Germany, its past and present. The narrative perspective is that of two angels who invisibly traverse the various urban spaces of modern Berlin (strikingly photographed in classical black and white by Henri Alekan). The film has often been cited as a post-modern text in its deconstruction of the time-space nexus (the angels exist outside time and place) and in its discontinuous and fragmentary narrative that incorporates depersonalized utterances. But *Wings* of Desire only radicalizes tensions present in Wenders's other films, between space and time, image and narration, aesthetics and ethics, history and identity, desire and action.

Untill lhe End of the World (1991), a $23 million, romantic. high-tech, science-fiction road movie, spans fifteen cities and four continents. It addresses the crisis of communication and memory in a technological environment in which video images besiege us from all sides; it also highlights a striking reversal in Wendcrs's old struggle to combine story and image. "I've turned from all image maker into a storyteller. Only a story can give meaning and a moral to an image."

第三节 东欧新电影

1945年之前的东欧电影基本不为人知,但"二战"的胜利和苏俄式社会主义政权在东欧的建立,导致东欧的电影教育和电影工业迅速成长,并随着东欧新电影的崛起而引发世界影坛的极大关注。

Eastern European Cinema, 1954-

Throughout the first years of the new revolutionary government in Russia, in the 1920s, considerable freedom and experimentation were present in the arts as well as in other aspects of life. With Stalin's consolidation of power, permissiveness and variety gave way to enormous monolithic control. By the early thirties "socialist realism" was the official and only state aesthetic. Prescribed content was locked into straightforward unambiguous narrative form. The seductive artistry of the Soviet silent films was replaced by the positive, wholesome, uplifting, and bland portrayal of Russian heroes whose lives might have some implication for the revolution, or by the presentation of ideologically "correct" modem peasants, workers, and professional people. *Chapayev* (1934) was the prototype. Until quite recently, with rare exceptions, Russian films aroused little interest in the West. Conversely, when Fellini's $8\frac{1}{2}$ was shown at the first Moscow Film Festival, in 1963, it was subjected to violent criticism as a decadent bourgeois work full of "vagueness and morbidity". Only after considerable argument and insistence on the part of the invited western judges was it awarded first prize. Neither it nor other of the new French and Italian films were shown

generally in the U.S.S.R.

In the communist countries the effect of a film on the audience's social and political attitudes is regarded as more important than the money it brings in. Given this concern, film content is carefully scrutinized and regulated to one degree or another by the state. Consequently film production in the Soviet bloc can be analyzed as a kind of barometer measuring political pressure operating within a society at any given time. A few months before the 1963 Moscow Festival, Communist Party Chairman Nikita Khrushchev delivered an important speech regarding his attitude toward the arts in the Soviet Union. He said, in part, "We adhere to class positions in art and resolutely oppose peaceful coexistence between socialist and capitalist ideologies. Art belongs to the sphere of ideology Abstractionism and formalism, whose right to a place in socialist art is advocated by some of their champions, are forms of capitalist ideology ...". Only within the last few years has the government position become less rigid. Russia will be returned to at the end of this chapter.

In the Eastern European countries within the Soviet sphere, the situation was not as consistently restrictive. On the contrary, the idealistic aspects of communism infused with an apparently unquenchable nationalism and exposure to the new films from the West accounted for fertile periods of creativity in the cinema of Poland, Hungary, Czechoslovakia, and Yugoslavia.

Prior to World War II the film production of the Eastern European countries was negligible in quantity and quality. Few of their films found audiences beyond their own borders, and the small national populations could not be counted on to return the profits necessary to private enterprise. With the establishment of communist governments in those countries immediately after the war, there were new incentives for production, like those in the Soviet Union earlier, and a new base for economic support. It took a few years for the ground to be prepared, but once the state film schools had begun turning out graduates, and film production, distribution and exhibition had been stimulated and coordinated, the Eastern People's Republics were ready to take their places in the international spotlight. The governments wanted films that would inform and indoctrinate, that would interpret events of the immediate past to give a sense of solidarity, and that would instill attitudes contributing to future progress. Replacing the subject of the Bolshevik Revolution, dealt with by the first Soviet film makers, was the resistance to Nazi Germany during World War II. Communism was represented as the only force with the people's interest at heart capable of opposing fascism effectively and offering an alternative, more democratic way of life.

1. 捷克新浪潮

捷克斯洛伐克被认为是 20 世纪被入侵、占领、瓜分和解放次数最多的国家（1993 年再次分裂为捷克和斯洛伐克两个国家），这就难怪短暂的"捷克新浪潮"（Czech New Wave，1961—1969）要将电影艺术与政治自由紧密联系在一起，而 1947 年布拉格戏剧电影学院（FAMU）的建立则是捷克新浪潮产生的重要前提。

20 世纪 60 年代中期，扬·卡达尔（Ján Kadár）、艾尔玛·克罗斯（Elmar Klos）的《大街上的商店》和杰里·闵采尔（Jiri Menzel）的《被严密监视的列车》相继荣获奥斯卡最佳外语片奖，标志着捷克新浪潮得到国际公认。但之前尤里·韦斯（Jirí Weiss）的《胆小鬼》和扬·南曼奇（Jan Nemec）《夜之钻》也是捷克新浪潮的代表作品。

米洛斯·福尔曼（Milos Forman）可以算作捷克新浪潮的代表人物，他以《消防员的舞会》等影片独创一种针砭时政的喜剧风格，1968 年"布拉格之春"后移民美国，又执导著名的《飞越疯人院》和《莫扎特》，仍然延续着捷克时期对社会体制和精神奴役的批判。

The Czech Golden Age

No cinema better demonstrates the interrelationship of film art and political freedom than the cinema of Czechoslovakia, a country that may have been invaded, occupied, and liberated more times in the 20th century than any other. In January 1993, it became two countries: the Czech Republic and Slovakia; though the Czech Republic now has the more active industry, both parts of the former Czechoslovakia contributed to its Golden Age. The Czech Golden Age of cinema (or "Czech film miracle" or "Czech New Wave" as it has also been called) was an extremely short one—roughly, 1961 to 1969—during which time over a dozen Czech films won major awards at the important international film festivals, including the Academy Awards for Best Foreign Language Film of 1965 (*The Shop on Main Street*) and 1967 (*Closely Watched Trains,* Czech release 1966). The years of Czechoslovakian film mastery coincided with the only years since the Munich Agreement of 1938 that the Czech people and Czech artists enjoyed a measure of intellectual mad creative freedom. Before this brief eruption, the Czech cinema was one of promising beginnings cut short by political repression and atistic censorship.

During the decades of occupation and repression, two significant institutions were founded that would later contribute to the greatness of the Czech film. The

《被严密监视的列车》

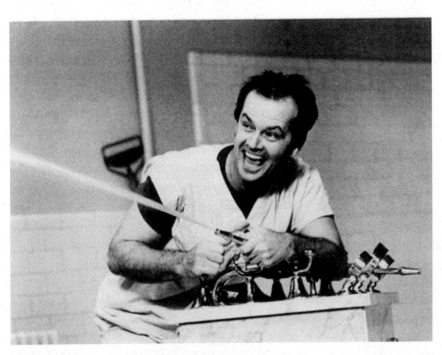

《飞越疯人院》

noted Czech film school, the F.A.M.U., was founded in 1947, and the Barrandov Studios were built into one of the best-equipped production facilities in Europe during the Nazi occupation. (Both were in Prague.) The great Czech films and filmmakers would come from this film school (five intensive years of training at state expense) and film studio as soon as the filmmakers were free to combine their artistic imaginations with their technical capabilities.

The Czech masterpieces were of four general types, including two that had undergone a transformation in the previous years of Soviet repression. First, there was the tale centered on resistance to the Nazi occupation, a safe subject in the Stalinist era since opinion of the Nazis was quite unanimous. But under the Soviets, the Czech resistance film mirrored the values of Socialist Realism, primarily by presenting a positive, heroic, almost superhuman figure as the embodiment of political resistance—like Shchors and Chapayev in those Stalinist Soviet sound films. In the mature Czech films of the 1960s, however, the central figures of resistance are frequently weak, lazy, and comic—nonheroic, ordinary, all-too-human figures who eventually choose or are forced to take a political stand. Such a study of the comic antihero confronted by the demands of war is a tradition in Czech literature, perhaps most memorable in Karel Hašek's novel *The Good Soldier Schweik*.

Such are the "heroes" of Jiří Weiss's (1913-2004) *The Coward* (1961), the study of a cowardly rural schoolteacher who eventually decides to sacrifice himself rather than to select ten of his fellow townspeople to be slaughtered by the Nazis, and of Zbyněk Brynych's *The Fifth Horseman Is Fear* (1964), the story of the tenants of an apartment house in Nazi-occupied Prague, particularly an old Jewish doctor who must choose between protecting himself and helping a fugitive who has dedicated himself to helping the doctor's people.

A second genre, the historical costume drama, also popular during the years of suppression, was less popular in the 1960s. As in Hitler's Germany and Mussolini's Italy, a film could avoid delicate political issues by avoiding contemporary life altogether. In the 1960s this escapist tendency continued, but of special note are František Vláčil's *Marketa Lazarová* (1967), a manunoth and care fully detailed historical spectacle set in 13th-century Bohemia, mid Jiří Weiss's *The Golden Fern* (1963), a beautiful adaptation of a Czech fairy tale.

The third of the Czech genres of the 1960s—the film of contemporary life—had a very different analogue in the era of Soviet suppression. Under the Soviets, Czech cinema eulogized the noble worker, sang the praises of the collective society, depicted the beauty of the factory, and dedicated itself to the proposition that with hard work and cooperation Life Would Be Beautiful. The mature Czech films of the 1960s doubted the values of collectivization, suggested that work did not equal happiness, refused to glamorize the everyday, and implied that the

essential human problems were personal rather than societal.

Věra Chytilová, among the most important and accomplished women directors of postwar Europe, made careful studies of feminist problems (*Ceiling*, 1962; *Daisies*, 1966; *The Fruit of Paradise*, 1970). *Daisies* is her most entertaining film; a bold, visually inventive satire, it is the story of two young women who decide to "go bad". A picture with creative energy to burn, *Daisies* can cut from a shot of green apples to a shot taken through an apple-green filter; it can make its characters squeak like dry wood when they move. It was banned.

A strong tendency of the of the contemporary films is to concentrate more on character than on politics, to study the human comedy. These "experiential" films—studies of experience— represent one of the truly unique and most influential accomplishments of the Czech cinema: personal, subtle, touching, probing. The purest expressions of these "experiential" films are the sympathetic satires by Miloš Forman (*Black Peter*, 1963; *Loves of a Blonde*, 1965; *The Firemen's Ball*, 1967) and the delicate, perfectly coustructed comedy *Intimate Lighting* (1965), by Ivan Passer.

The fourth genre of Czech films of the period was the surreal or futuristic allegory. Jan Schmidt's riveting, post-apocalyptic *The End of August at the Hotel Ozone* (1966, released 1968) is a brutal and frightening odyssey of survivors of an atomic holocaust, all of them women, roaming about the countryside on horseback, killing.

Perhaps the most anarchic and surreal director of the era was Juraj Jakubisko, a Slovak. Like some of the works of Dovzhenko, Jakubisko's films (*Deserters and Nomads*, 1968; *Birds, Orphans, and Fools*, 1969) seem anarchically poetic: a series of striking images that mix a blunt sexuality, politics, religion, audacious visual stunts, and experiential frenzy, cohering neither in plot nor in temporal continuity. As in many Czechoslovakian films there is also an undercurrent of fatalism and nihilism in Jakubisko. It is no wonder that Juráček and Jakubisko, two of the most daring and pessimistic of the period's directors, were not permitted to make films by the new authorities.

Although the Czech filmmakers usually preferred to shoot in real locations, the dominant imagery of this cinema is not nature but the human face. By keeping the camera much closer to the faces of the actors, who were often nonprofessionals, the Czech films achieved a feeling of naturalness, imperfection, spontaneity, and authenticity.

Another trait of these films is their intermingling of humor and seriousness, producing films that were quite remarkable in their range of emotions, from hilarity to pathos to sudden horror. In their seriocomic blend the Czechs distilled the tragic modern history of their tyrannized nation into a positive vision of life that saw humor in even the darkest moments and that (with a few exceptions) refused to

surrender its faith in exertion, commitment, and integrity.

Jiří Menzel's *Closely Watched Trains* (1966) is a good example of this Czech spirit. The film's story (scripted by Bohumil Hrabal, from his short story) is of a comical young man, Milos Hrma, who has taken a job as an apprentice at a train station during the Nazi occupation—primarily to avoid any serious or difficult labor. Despite its wartime setting and sad ending, the film is a sex comedy, concentrating on the failures and fears of the inexperienced boy.

Of the pure comedies, Milos Forman is the master. An affectionate satirist who pokes fun at human folly, he also realizes that folly is what makes people human. Two of Forman's Czech films *(Black Peter, Loves of a Blonde)* and three of his American films *(Taking Off*, 1971; *Hair*, 1979; *Amadeus*, 1984) are youth films that deal with self-discovery and the generation gap. His other major films, *The Firemen's Ball* and *One Flew Over the Cuckoo's Nest* (1975), as well as the Later *Ragtime* (1981), *The People Vs. Larry Flynt* (1996), and *Man on the Moon* (1999), keep in touch with the bad-boy spirit of *Black Peter* while they examine the follies of adulthood.

One further contribution of the Czech cinema that cannot be overlooked is its accomplishments in cel animation and in puppet cinema, most notably the work of Jiří Trnka (*The Hand*, 1966), Kin'el Zeman (*Christmas Dream*, 1945; *On a Comet*, 1970), and Jan Svankmajer (*Dimensions of Dialogue*, 1982; *Conspirators of Pleasure*, 1996).

2. 波兰学派

1948年波兰建立了著名的洛兹电影学院（Lódź Film School），在50、60年代培养出瓦伊达（Andrzej Wajda）、蒙克、波兰斯基、斯克利莫维斯基和基耶斯洛夫斯基等一批享誉全球的杰出导演，在1955—1964年间形成闻名遐迩的波兰学派（the Polish School）。

波兰学派的创始人安杰伊·瓦依达既是"波兰电影之父"，也是"波兰的良心"。以《钻石与灰烬》为代表的"战争三部曲"反映战时波兰的绝望和抵抗，《大理石人》表现社会体制下生命的道德焦虑感，而近作《卡廷惨案》则是对灾难深重的波兰民族和导演身世的残酷检视。

早慧的罗曼·波兰斯基（Roman Polanski）一生经历过纳粹集中营、叛逃西方、爱妻遇害、强奸定罪和逃亡欧洲等一系列灾难，这赋予他的电影一种阴郁、悲观甚至毁灭性的宿命气质。成名作《水中刀》在限定空间展示两性人物三角关系强烈的情节和心理张力，惊悚恐怖片《魔鬼圣婴》尽显都市

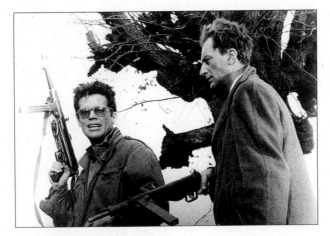
《钻石与灰烬》

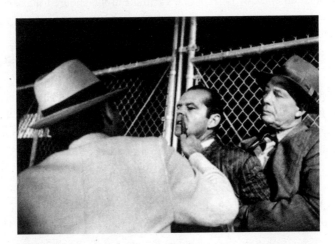
《唐人街》

《十诫:爱情短片》

生活的人情冷暖和灵异诡谲，《唐人街》因故事情节和人物关系的完美契合成为黑色侦探片的名作，而文学名著改编的《苔丝》无疑又是传统精致电影的典范。

大器晚成的克里斯托夫·基耶斯洛夫斯基（Krzysztof Kieslowski）从纪录片过渡到故事片，直到 1988 年才因《圣经》题材的短片集《十诫》声誉鹊起，其中单独成片的《爱情短片》更是探讨两性情感关系的经典杰作。基耶斯洛夫斯基移居法国拍摄的《薇罗尼卡的双重生命》和《三色：红、白、蓝三部曲》也是展现自由、平等、博爱和命运等普世价值的上乘之作。

Poland

The other cinemas of Eastern and Central Europe endured the same Stalinist and anti-Stalinist twists and turns as the Czech cinema, producing similar periods of fertility and barrenness.

The most fertile period of the Polish cinema preceded the Czech era by almost a decade (1955-1964), produced primarily by the founding of another major film school (the Lódź Film School in 1948) and the splitting of the Polish industry into individual artistic production units in 1955. (One of the greatest films made before these changes was *The Last Stop*, 1947, which Wanda Jakubowska shot in Auschwitz—where she herself had been a prisoner) These smaller production units granted the Polish directors a new freedom and allowed the exercise of more individuality; the two most talented directors, Andrzej Wajda (of the KADR unit) and Roman Polanski (of the KAMERA unit), took advantage of this new opportunity.

As in Czechoslovakia, the Nazi occupation and the resistance to it were favored subjects of the Polish cinema, and no one made more powerful films on the Occupation era than Andrzej Wajda (1926-), whose first feature, *Generation* (1955), became the first work of the new "Polish school". As opposed to the seriocomic, intimate style of the Czech war films, Wajda's style is more active, more violent, more baroque, and less internalized. The greatest early Wajda films (*Kanal*, 1957: *Ashes and Diamonds*, 1958) consistently use arresting, grotesque visual imagery (for example, the claustrophobic Warsaw sewers in *Kanal*), often dwelling on shots of rubble, ashes, and garbage, but these images can turn suddenly beautiful and unforgettably disturbing, as do the sheets hung out to dry in *Ashes and Diamonds*, which become a deadly labyrinth even as they wave neutrally in the breeze.

Wajda's filmmaking career is itself a miniature of the political history of Poland over four decades. With the constriction of Polish freedoms in the mid-1960s, Wajda's work became more introspective and more ambiguous in its

treatment of politics. But with the return of Polish dissent in the 1970s, symbolized by Lech Walesa's Solidarity organization of workers and intellectuals, Wajda's films again became openly political. He identified strongly with Solidarity in *Man of Marble* (1977) and *Man of Iron* (1980).

Roman Polanski's (1933-) career represents another kind of historical metaphor, centered on horror; though he has attempted to flee from it and deny its power, along with that of the state, horror and trouble have found him in one country after another. From *Repulsion* to *Rosemary's Baby*, his characters don't escape, and as in *Chinatown*, the state is too corrupt to do any good. Even in his early Polish films, Polanski's primary theme is not the rubble of war but the ominousness of the universe itself. Polanski's black-and-white films use a simple situation and very few characters (two men carry a wardrobe out of the sea in *Two Men and a Wardrobe*, 1958; three people sail a boat out to sea in *Knife in the Water*, 1962). But Polanski charges the universe with a menacing spirit that turns the simplest events into terrifying combats of great magnitude.

Polanski's parents were taken to a concentration camp when he was eight (his mother died there). He was on his own for the next four years, first in the ghetto and then in the countryside, where he found, on the one hand, families that would put him up for awhile and, on the other hand, German soldiers who shot at him for fun. The visions he developed as an adult—of cosmic malevolence, mortal power games, and psychological ambiguity—were incompatible with any socialist theow of justice. Polanski could resolve his nihilistic conflict with a repressive state only by escaping to a more indulgent West to make films in England, France, and the United States *(Repulsion*, 1965, made in England; *Cul-de-Sac*, 1966, a devastating black comedy; *Rosemary's Baby*, 1968, a straightforward, glossy horror film and his first American picture; *Macbeth*, 1971, a version of Shakespeare's play that is short on poetry and— perhaps because it was the first film he made after his pregnant wife, Sharon Tate, was murdered by the Manson "family"—long on violence; *Chinatown*, 1974, a classic mystery and a latterday *noir*, *Tess*, 1979, from the novel by Thomas Hardy; and *Death and the Maiden*, 1994, a tale of political revenge).

Jerzy Skolimowski (1938-) was, like Polanski, a younger-generation filmmaker who fled Poland. After serving as scriptwriter for both Wajda and Polanski, he wrote and directed *Walkover* (1965) and *Borrier* (1966) in Poland, *Le Départ* (1967) in Belgium, *Deep End* (1970) in Germany, and *Moonlighting* (1982) in England.

An intellectually demanding director whose films explore moral and philosophical dilemmas, Krzysztof Zanussi (1939-) is, after Wajda, the most important Polish filmmaker still working in the country (though he was forced out of Poland after the fall of Solidarity and worked in Germany for much of

the 1980s). His characters—often scientists (Zanussi's degree was in physics)—struggle with ideas and intuitions within networks of social and moral codes; his major works include *The Death of a Provincial* (1966), *Camouflage* (1977), *The Constant Factor* (1980), *Contract* (1980), and *Life As a Fatal Sexually Transmitted Disease* (2000).

For various reasons, by choice or compulsion, the three most important new Polish filmmakers of the 1980s and 1990s did not work in Poland. For directing *Interrogation* (1982) the relentless, compelling story of a woman (Krystyna Janda) who is imprisoned and questioned for years and develops a complex relationship with her Stalinist inquisitor—Ryszard Bugajski found his film immediately banned, not to be shown until 1990, and himself a political exile. Working in Canada, he made such important films as *Clearcuts* (1991). Agnieszka Holland studied under Forman, was jailed in 1968 after the Prague Spring, collaborated on several films with Wajda, and then became internationally famous with *Europa Europa* (1991), a French-German co-production that told the true story of a Jewish youth who survived the war by pretending to be an Aryan Nazi. Her next films were made in France (*Olivier Olivier*, 1992) and America (*The Secret Garden*, 1993).

Krzysztof Kieślowski also made important films in Poland before finally settling in France: *Camera Buff* (1979) and the ten-part *Dekalog* (*The Decalogue*, 1988, for TV), each of whose probing and ironic, roughly hour-long tales was based on one of the Ten Commandments. Working in France and Poland, Kieślowski and his regular co-writer, Krzysztof Piesiewicz, went on to make *The Double Life of Veronique* (1991), an intuitive study of two women, living in different countries, who are virtually identical. They climaxed their exploration of the almost inexpressible connections between people with the Swiss-French-Polish trilogy *Three Colors*, whose parts—*Blue* (1993), *White* (1993, released 1994), and *Red* (1994)—are named after the colors of the French flag and ironically investigate liberty, equality, and fraternity. Color-coded to the core and insightfully interrelated, these three films marked Kieślowski as the long-sought heir of Antonioni and Bergman—but at the premiere of *Red*, he announced his retirement. He died in 1996.

3. 匈牙利和前南斯拉夫

米克洛什·扬索（Miklos Jancsó）是匈牙利电影的标志性人物，他在《红军与白军》和《红色赞美诗》等影片中将民族文化历史和从容优雅的运动性长镜头完美地结合在一起，创造出令人心醉的诗意美感。卡罗利·马克

（Károly Makk）的《爱情》大胆触及匈牙利社会的专制苦难，而伊斯特万·萨博（Istvan Szabo）的《梅菲斯托》则对扭曲的人性精神进行着冷峻的挖掘和剖析。

前南斯拉夫塞尔维亚裔导演杜尚·马卡维耶夫（Dusan Makavejev）擅长非常规叙事嘲讽社会政治禁忌，《WR：高潮的秘密》就是杰出代表。而波斯尼亚裔穆斯林导演埃米尔·库斯图里卡（Emir Kusturica）则对前南斯拉夫的政治压迫和人性扭曲进行了深刻而有趣的揭示，他的《爸爸去出差》和《地下》两度获得戛纳电影节"金棕榈奖"。

Hungary

The best-known international representative of the new Hungarian cinema of the 1960s and 1970s was Miklós Jancsó (1921-, *Cantata*, 1962; *The Red and the White*, 1967; *The Confrontation*, 1968). Jancsó's films combine Hungarian folktales and history with extremely lengthy and carefully planned tracking shots that choreograph cinema space as complexly as those of Orson Welles; his use of the wide screen, especially in *The Red and the White*, is among the most impressive in the history of the art. István Szabó, originally a member of Balázs's experimental workshop, makes psychologically detailed portraits of citizens who must make difficult choices between the personal and the political. The actor of *Mephisto* (1981, starring Klaus Maria Brandauer) refuses to take a stand against the Nazi oppressors because he's "only an actor." He indeed becomes the slave of his satanic role, both onstage and off. *Colonel Redl* (1985), the next film in a Brandauer trilogy that concluded with *Hanussen* (1988), explores what it means to care only about power.

Béla Tarr (1955-) makes long, slow films. *Damnation* (1988), for instance, consists almost entirely of carefully composed, slow-paced, long takes in sharp black and white; the film tells the story of a failed romance and a kind of spiritual espionage in a muddy town where there is little to do but watch the rain. In a 2001 interview, he said that his films are not about telling stories—which he keeps as banal as possible—but about getting closer to people. By understanding everyday life, he hopes, the films may achieve an understanding of human nature: "why we are as we are, how we commit our sins, how we betray one another, and what interests lead us". He said it about *Werckmeister Harmonies* (2000), but it applies to all of his films to date—including the eight-hour *Satan Tango* (or *Satan's Tango*, 1994)—whose shots spend a long time with characters, concentrating on their present-tense being in time and space until part of their nature is revealed.

One of Hungary's women directors, Ildikó Enyedi, achieved international

recognition with *My 20th Century* (1988), a playful, moving exploration of the nature of light (as starlight, electric light, movies) and communication (wireless telegraphy, homing pigeons) as two sisters lose and find each other while the young century also tries to find its way through a maze of sexual, political, and technological changes.

The former Yugoslavia

When it was still called Yugoslavia, the country built its international cinematic reputation with the productions of the Zagreb studio, the most innovative and influential source of animated films in the world since 1957. Its best known director of feature films, particularly in the late 1960s and 1970s, was the irreverent satirist Dušan Makavejev (1932-), whose movies resist narrative continuity and test taboos (*WR—Mysteries of the Organism*, 1971); he also made satiric montages that are primarily political (*Innocence Unprotected*, 1968) and sociopolitical tragicomedies full of unpredictable twists (*Montenegro*, or *Pigs and Pearls*, 1981).

In 1991 and 1992, the former Yugoslavia split into separate countries: Bosnia-Herzegovina, Croatia, Tfyrom (The Former Yugoslav Republic of Macedonia), Slovenia, and the Federal Republic of Yugoslavia (which included Serbia and Montenegro, which separated from each other in 2006). Ethnically driven civil wars broke out in 1992, and in the context of the new map it became significant that Emir Kusturica (1954-) was a Bosnian Muslim, Makavejev a Serbian. In Bosnia-Herzegovina during the 1990s, most of the filming was done by news cameras. Kusturica, who had won audiences around the world with two occasionally surreal coming-of-age films—*When Father Was Away on Business* (1985) and *Time of the Gypsies* (1989)—shot *Arizona Dream* (1993) in the United States. Like the most important Romanian film of the period (*An Unforgettable Summer*, 1994, the first film Lucian Pintilie had been allowed to make in 30 years) and the first film made in Tfyrom (Milcho Manchevski's circularly structured *Before The Rain*, 1994), *Arizona Dream* was a French co-production. Foreign money also helped Kusturica matke his next pictures in Prague and Belgrade (*Underground*, 1995) and on the Danube in Yugoslavia (*Black Cat, White Cat*, 1998).

第四节　好莱坞"电影神童"

20世纪70年代初，好莱坞电影开始触底反弹的复兴，究其原因则包括开创全美同步上映的市场战略、制作超越经典类型樊篱的综合类型电影，并启用与主力观众（年轻人）同呼吸共命运的青年导演，这就导致一批看好莱坞经典电影长大、且受过正规电影教育的"电影神童"（movie brats）走上美国电影、乃至世界电影的中央舞台。

The "Movie Brats"

In the early 1970s Hollywood began to recover from its economic crisis. A central factor was a significant shift in marketing strategy. For decades the film industry had followed a pattern of releasing films gradually, a few cities at a time. A film's run would last a year or more as it slowly passed through the exhibition system, from larger to smaller theaters. In the early 1970s, the studios started to utilize national television advertising, and they placed films in hundreds of theaters throughout the country simultaneously, so as to capitalize on the extensive coverage of their promotional campaigns. People in smaller towns could see first-run films at the same time as moviegoers in Los Angeles or New York. Though advertising and print costs were higher, studios could demand a greater percentage of the box office in return for making their top pictures available more widely.

Individual films rarely before had held the possibility of creating such an immediate nationwide mass impact. Could filmmakers create works that would justify the promotional effort and sustain audience interest? The revival of

（左起）科波拉、斯科西斯、斯皮尔伯格和卢卡斯欢聚在第 79 届奥斯卡金像奖颁奖典礼上

traditional genres was clearly linked, in part, to these new marketing techniques. But such genres now carried a greater weight than they had in the past. Instead of occupying a series of niches appealing to specific audience tastes (Westerns for men, melodramas for women, and so forth), they had to appeal broadly across the fragmented American cultural scene, and especially to the young people who made up the largest part of the audience.

To answer this need, the studios turned to a surprising source—young filmmakers recently graduated from university filmmaking programs. In the crisis of the late 1960s the industry had welcomed new talent to an extent not seen since the advent of sound. Among the many first-time directors of that period, the film school graduates were particularly prepared to make the big-budget, genre-oriented films the new marketing required. Though attuned to youth values, they were not primarily rebels or revisionists; their film studies had forged a link with the industry's past. Looking back a few years later, writers Michael Pye and Lynda Miles called them "movie brats, true children of Hollywood ... heirs to the great tradition of American cinema." Principal figures among them included Francis Ford Coppola (1939-), a graduate of the University of California at Los Angeles; George Lucas (1944-), a graduate of the University of Southern California; and Martin Scorsese (1942-), a graduate of New York University. An exception to the film school pattern among the "movie brats" was Steven Spielberg (1947-), a self-taught filmmaker who attended California State University at Long Beach.

1. 科波拉

弗朗西斯·福特·科波拉（Francis Ford Coppola）毕业于洛杉矶加州大学（UCLA）电影学院。意大利裔的科波拉以纽约西西里黑手党故事《教父》将家庭情感与冷血犯罪异态混搭，剖析美国社会的典型特质；《教父续集》创造性地运用非线性交叉叙事，展现黑手党教父命运的世代交替；而《现代启示录》则通过越战噩梦对战争的恐怖和人性的黑暗做出最深刻又最触目惊心的揭示。此外，科波拉还成功地执导过一系列个人化的小预算影片，如《谈话》就对人性孤独和现代技术作出精彩的探讨。

上述影片使科波拉这位"科班作者"成为20世纪70年代美国电影的执牛耳者，对同仁和后代产生过巨大的影响。他才华横溢、个性张扬，他对艺术的执著和对创作自由的追求，使他与好莱坞体制冲突不断、创作道路也尽显跌宕和坎坷（与前辈奥森·威尔斯相似）。但科波拉不屈不挠地追求商业与艺术艰难的平衡，并对电影艺术的进步和电影新技术的发展作出过极有创意的探索。

Francis Ford Coppola

If Robert Altman was a foe of movie myth and industry during the 1970s, Francis Ford Coppola virtually *was* the American film industry in this period. Coppola is less a film director than an all-around man of the movies. He began as an assistant to Roger *Corman*—where he learned to cut, dub, write, and direct films. He has written scripts for other directors (notably the Oscarwinning *Patton*, 1970, for Franklin Schaffner, co-written by Edmund H. North), and he has become a producer or co-producer of others' films. More than anything else, Coppola is committed to the cinema—to its past and its future, its genres and its possibilities.

For his personal projects, Coppola's films tend to be either big commercial epics (*Finian's Rainbow*, 1968; *The Godfather*, 1972; *The Godfather Part II*, 1974; *Apocalypse Now*, begun in 1976 and finally released in 1979; *The Cotton Club*, 1984; *The Godfather Part III*, 1990) or smaller, more offbeat style pieces (*The Rain People*, 1969; *The Conversation*, 1974; *The Outsiders*, 1983; *Rumble Fish*, 1983). *The Conversation*, with its clever use of sound as both the central subject and the dominant stylistic device of the film, with its furtive *cinéma vérité* sequences shot in Union Square that are an exact visual equivalent of the sound-recording process, with its effective settings, is the most profound and disturbing of his "smaller" films as well as the most highly respected. Like the two *Godfather* films that came just before and after it—the greatest of his "big" movies—*The*

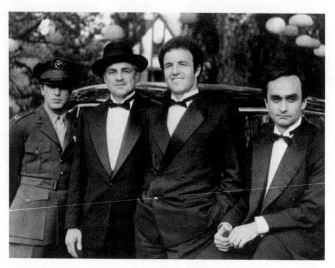

《教父》的父与子

Conversation is morally intense and intellectually solid. One might see the film's theme as the clash between a person's craft and conscience, the pure devotion to artisanship as opposed to the moral responsibilities of engaging in any business that affects the lives of other people.

The first two parts of *The Godfather*, adapted from Mario Puzo's bestselling novel, constitute a monumental American epic about the conflict between doing business and living according to meaningful values—a conflict built into the very familial and economic structure of American society. *The Godfather* opens with a wedding—a family celebration of fertility, union, and the future—and it ends just after the bride (Talia Shire) has become a widow. Vito Corleone (Marlon Brando) spends his time not outdoors, in the bright and open sunlight, but in his dark cave-like office, where he does business with his wedding guests. Although his may seem a special, unethical business (using his power and influence to do "favors" for his "friends"), he is no different from other American businessmen, who often discuss business at weddings.

The negotiations indoors represent the dark underside of the brightly visible activity outdoors; for Coppola, every American business has this dark underside. As an Italian American, Coppola is terribly conscious of the suspicion that all Italian and Sicilian immigrant families are branches of the illegitimate Mafia tree. Instead, Coppola argues that no American and no American business, of whatever ethnic extraction, can escape the conflict between business dealings and personal values. The Mafia is not a disease within American life; it is a symptom of American life itself.

The Godfather Part II extends the examination historically into both past and future—an epic chronicle of achievement and degradation, the dissolution of the American Dream that brought immigrants to the United States in the first place. The temporal leaps in Coppola's narrative—late-19th-century Sicily, the arrival of immigrants at Ellis Island, life in New York's Little Italy in the 1910s and 1920s, Batista's corrupt Cuba of the 1950s, Las Vegas of the 1960s—produce a political conversation between the simple hopes of the past and the complex corruption of the present, as the stories of Vito's and Michael's careers are cross-cut. Like the Ricos and Tony Camontes of Hollywood Past, Michael Corleone (Al Pacino) accumulates wealth and power at the expense of losing everyone close to him—associates, friends, wife, children, brother. Unlike those earlier gangsters, Michael himself does not lose his life but remains—a lonely, tragic, coldly powerful head of a corporation of crime.

The Godfather Part II, widely considered the best sequel ever made, is so different in style and structure that it and *The Godfather* form a genuine historical dialectic. Although no Marxist, Coppola's dialectical method within and between the two films suggests a historical analysis of the assumptions of Old and New World capitalism and is a vivid way to dramatize the rise and fall of the family and all that it stands for.

In *Part III*, Michael completes his project of shifting all the family's business interests to legitimate activities—but everywhere he turns, even the Vatican, he encounters corruption and more enemies. After confessing his sins to an insightful cardinal, Michael asks God for an opportunity to atone for killing his brother (Fredo, at the end of *Part II*—the most important of his sins, since it was against the family), and he gets it: Michael loses the person he loves the most—his daughter, who is shot to death right in front of him. His silent scream as he holds her body is the beginning of his penance. While not a complete betrayal of the first two parts, *The Godfather Part III* is nowhere near them in power and range. It has a few excellent scenes but no *necessary* ones.

Coppola's Vietnam epic, *Apocalypse Now*, had a stunning surround soundtrack, many unforgettable sequences, and a muddled ending. Coppola's foe is again the system itself, the military mentality that produces a Kurtz (Brando), insane with power; a Willard (Martin Sheen), who must search for Kurtz by becoming Kurtz; and a Kilgore (Robert Duvall), who can make litfie distinction between the fun of surfboarding and the fun of napalming. Coppola's metaphoric journey upriver—adapted from Joseph Conrad's *Heart of Darkness*—is dominated by powerful images: Playboy bunnies entertaining the troops, the psychedelic nighttime carnival in which Willard wanders through an eerie wasteland of stoned soldiers, the collection of severed human heads that decorates Kurtz's croup, and many more. Coppola and the great sound designer

and editor Walter Murch later recut and expanded it into *Apocalypse Now Redux* (2000, released 2001).

Coppola's musicals (*Finian's Rainbow*; *One from the heart*, 1982; *The Cotton Club*) are stylistic exercises that explore the central paradoxes of the musical as a genre—the relation of convention to credibility, stylization to reality, number to story, and entertainment to social commentary. Unfortunately, these musicals have at times (despite that title) very little heart—the ultimate element that gives a *musical* its artistic sense. *Brain Stoker's Dracula* (1992—and not a faithful adaptation of the novel, despite its title) has an analogous problem: It is a horror film that is not scary—drenched in romantic imagery, overwhelmed by style and getting nowhere, and sunk by a ridiculous ending. But when Coppola's romantic energy and grand imagination are focused by a compelling subject, as they were in his four great films of the 1970s—*The Godfather*, *The Conversation*, *The Godfather Part II*, and *Apocalypse Now*—his mastery of style is beyond challenge.

2. 斯科西斯

马丁·斯科西斯（Martin Scorsese）毕业于纽约大学（NYU）电影系并长期在母校兼任教职，拥有百科全书式的电影素养并痴迷于创新电影艺术手段。斯科西斯的电影执著于城市的紧张焦虑感、深层心理的黑暗、精神性的道德冲突和难以遏制的暴力倾向，《出租汽车司机》展现污秽纽约孤独局外人的生活，《愤怒的公牛》将拳击手狂暴的心理和力量的美感融为一体、《好家伙》则是对黑社会生活血淋淋的逼真描摹。

斯科西斯电影具有深刻冷峻、迅急狂暴和黑色沉郁的特色，他也对电影媒介的表现力进行过全方位的拓展，而对电影新人的鼎力提携和对独立电影的一贯支持又使斯科西斯获得了"独立电影教父"的美誉。

Martin Scorsese

Martin Scorsese brings a tense urban sensibility and a vision of spiritually charged moral conflict to the Italian-American film. He puts his characters through explosive scenes that have the flavor of improvisation and chaos but are profoundly determined. Scorsese seems to succeed most with carefully textured psychological portraits of people who are entangled in their detailed social environments—New York's Little Italy (*Mean Streets*, 1973), a diner in the American Southwest

《愤怒的公牛》

(*Alice Doesn't Live Here Anymore*, 1974), New York street life (*Taxi Driver*, 1976; *Bringing Out the Dead*, 1999), late-19th-century high society (*The Age of Innocence*, 1993), mid-19th-century slums (*Gangs of New York*, 2002). *Raging Bull* (1980) was an interpretive biography of boxer Jake La Motta, but it went much deeper. Combining Italian Neorealism and the visual style of 1950s New York films (set in that period, shot primarily in black and white), *Raging Bull* related the violence of boxing to sexual violence in general, as well as to the limits of theater and the beginnings of religion.

As fast and violent as Scorsese's films often are, they are also intensely meditative; many also have thoughtful voice-over narrators. He moves the camera with more zest and authority than any American now making movies. He is scrupulously attentive to technical quality and wildly excited about the work of classic directors like Michael Powell—or Lean, Rossellini, Welles, Bresson, Hawks, Hitchcock, Cassavetes—becanse this is one director who knows film history and loves watching movies as well as making them. The visceral editing (often by Thelma Schoonmaker), the evocative music, and beyond all that the ironies and depths of Scorsese's films have vaulted him to the first rank of American directors.

"I'm God's lonely man", says Travis Bickle (Robert De Nio), the psychopathic taxi driver who wants to cleanse the world of sin—and many of Scorsese's central characters are isolated (often within the limits of an obsession, whether it be an idea, a desire, or a view of the world) and do think about God. At the beginning of *Mean Streets*, Charlie (Harvey Keitel) observes, voice-over, "You

don't make up for your sins in church. You do it in the streets; you do it at home". Charlie would like to do penance for his sins on his own, in his own terms, with actions rather than words. For a character like Jake La Motta (De Nifo) in *Raging Bull*, punishing himself and impulsively, blindly seeking redemption might mean screaming at and fighting with everyone he loves or getting punched to a pulp in the ring and destroyed through all his mistakes.

After two diversions, *The King of Comedy* (1983) and *After Hours* (1985), Scorsese returned to the world of *Mean Streets* with *GoodFellas* (1990), the true story of a boy (Ray Liotta) who grew up to join the "wiseguys"—the friendly brotherhood of criminals who ran his neighborhood—and thought it was great until some of the crazy murderousness of his buddies (Joe Pesci, Robert De Niro) got out of hand. Highly charged, fast paced, full of sudden violence, and very funny, its tones and rhythms masterfully varied and controlled, *GoodFellas* presents the work and home life of its gangsters in a realistic, understated manner (unlike the romanticized *Godfather*)—at 100 miles an hour and changing direction without warning. *GoodFellas, The Age of Innocence* (faithfully adapted from the novel by Edith Wharton), and *The Departed* (2006, a cops-and-gangsters picture—based on a 2002 film from Hong Kong: Wai Keung Lau and Siu Fai Mak's *Infernal Affairs*—that reaches almost Jacobean levels of darkness and betrayal) reveal the absolute stylistic control and the emotional range of the films of his maturity.

3. 卢卡斯和斯皮尔伯格

与美国独立电影的大本营纽约不同，好莱坞基地洛杉矶的商业电影主导倾向不言而喻。1929 年美国电影艺术与科学学院与南加州大学联合创建电影专业，成为美国电影高等教育的起点，而与好莱坞业界的紧密联系和主流商业电影取向也成为南加大电影系的核心特色。

乔治·卢卡斯（George Lucas）是南加大电影系最著名的校友，他的科幻大片《星球大战》曾经风靡世界，并带来电影高科技和电影相关产品开发的革命，卢卡斯由此蜕变为成功的制片人、新技术开发商和电影产业大亨，直至 1999 年回归执导《星球大战前传：幽灵的威胁》。

斯蒂芬·斯皮尔伯格（Steven Spielberg）两次遭到南加大电影系拒绝，后来却成为最具影响力的"电影神童"，并被称为好莱坞电影的最佳代言人。斯皮尔伯格像卢卡斯一样迷恋神奇的科幻童话，《大白鲨》和《外星人》以其非凡的想象力和纯净的赤子心与《星球大战》一道掀起了 70、80 年代商业大片的狂潮。而反映纳粹大屠杀的《辛德勒的名单》则执著于犹太命运的心灵拷问，《拯救大兵瑞恩》也对战争的伦理和人性的价值展开深入的思考。

Lucas and Spielberg

By contrast, Lucas and Spielberg sought to recover their boyhood pleasure in movies. They tried to re-create the uncomplicated fun of space opera (*Star Wars*), action-packed serials (*Raiders of the Lost Ark*), and fantasy (*Close Encounters, E. T. :The Extraterrestrial*, 1982). In making *Star Wars,* Lucas pulled together the most exciting portions of several air battles from Hollywood combat pictures, storyboarded the compiled sequence, and then shot his space dogfights to match the older footage. As producers, Lucas and Spielberg revived the family film of adventure (*Willow*, 1988), fantasy (*Gremlins*, 1984), and cartoon comedy (*Who Framed Roger Rabbit?*, 1988). While the Disney studio was floundering, two baby boomers recaptured the old magic. Many critics noted that Walt himself would have loved to make *Star Wars* or *E.T.*

Spielberg divided his attention between what he called "fast-food movies" (*Jaws*, the *Indiana Jones* series) and more upscale directorial efforts (*The Color Purple*, 1985; *Empire of the Sun*, 1987). These dignified adaptations of best-selling novels had a nostalgic side, too, recalling the Hollywood prestige picture of the 1930s and 1940s. Looking back to the great tradition, Spielberg filled his films with reverent allusions to the studio program picture (*Always*, 1989, is a remake of Victor Fleming's *A Guy Named Joe*, 1943) and to Disney (*Close Encounters*; *Hook*,1991; and *A. I. : Artificial Intelligence*,2001).

In one respect, Spielberg proved himself heir to the studio directors. With the right material, he could make a story come grippingly alive for his audience. The cleverly constructed *Jaws* balanced its thrills with a skeptical attitude toward

《外星人》

political leadership. Against the money-grubbing businesspeople of Amity, the film offers three versions of male heroism: the grizzled man of action Quint, the scientific rationalist Hooper, and the reluctant pragmatist Sheriff Brody. Each sequence hits a high pitch of emotional tension, and scene by scene the audience's anxiety is ratcheted up through crisp editing, John Williams's ominous score, and inventive Panavision compositions. Likewise, in the *Indiana Jones* and *Jurassic Park* series, Spielberg revamped the traditions of Raoul Walsh and Ray Harryhausen for the blackbuster age.

Spielberg's New Age-tinted spirituality, often expressed as mute wonder at glittering technological marvels, proved no less popular. Over and over the young man from divorced suburban parents replayed the drama of a family's breakup and a child's yearning for happiness. He found emblematic images—spindly aliens communicating through music, a boy bicycling silhouetted against the moon—that verged on kitsch but also struck a chord in millions. Spielberg became New Hollywood's reliable showman, recalling Cecil B. DeMille, Alfred Hitchcock, and the director whom he claimed he most resembled, Victor Fleming, the contract professional who had a hand in both *Gone with the Wind* and *The Wizard of Oz*.

Less of a movie fan than Coppola and Spielberg, Lucas spent his youth watching television, reading comic books, and tinkering with cars. The world of cruising and rock'n'roll was lovingly depicted in *American Graffiti*, whose meticulously designed music track and interwoven coming-of-age crises presented the real teen picture that studios had been craving. *Star Wars* offered chivalric myth for 1970s teens, a quest romance in which young heroes could find adventure, pure love, and a sacred cause. Not surprisingly, *Star Wars* was published as a comic book before the film was released. Coppola loved working with actors, but Lucas avoided talking with them except for the occasional "Faster!" He looked forward to creating his scenes digitally, shooting isolated actors against blank screens, or creating characters wholly on computer. This dream, the ultimate film extension of the comic-book aesthetic, was realized first in *Star Wars Episode I: The Phantom Menace* (1999), in which Jar Jar Binks was the first wholly computer-generated character in a major live-action feature film.

Lucas often called himself an independent filmmaker, and in some sense he was. The triumph of *Star Wars* allowed him to dictate terms to any studio in town. After frequent clashes with Fox on *The Empire Strikes Back* (1980), which ran over schedule and budget, he vowed that he would never compromise again. Retreating to his own freedom, Skywalker Ranch, Lucas oversaw a high-tech wonderland based on a saga that gripped the imagination of millions around the world and spawned *Star Wars* novels, toys, games, action figures, and video games. Skywalker staff maintained a volume, "The Bible", that listed all the events occurring in the *Star Wars* universe.

《星球大战》

Yet Lucas continued to believe that he was spinning a simple tale grounded in basic human values. Like Spielberg, Lucas hit on a resonant New Age theme: the Force, representing God, the cosmos, or whatever the viewer was comfortable with. Beneath all the hardware, he claimed, *Star Wars* was about "redemption". Spielberg remarked, hyperbolically, that *Star Wars* marked the moment "when the world recognized the value of childhood".

All three directors (Coppola, Spielberg and Lucas) had colossal hits in the 1970s, but only Spielberg and Lucas continued to rule over the next twenty years. At one point in the early 1980s, the pair were responsible for the six top-grossing films of the postwar period. Coppola foresaw the multimedia future but believed that Zoetrope Studio could become a vertically integrated firm on its own. His two peers saw deeper, letting the studios remain distributors while they provided content. Lucasfilm and LucasArts created theatrical films, television series, commercials, interactive games, computer animation and special effects, as well as new editing and sound systems. Spielberg's Amblin Entertainment produced some of the era's most popular films (*Back to the Future*,1985; *Twister*, 1996). Later, DreamWorks SKG, which Spielberg founded with Jeffrey Katzenberg and David Geffen, churned out features and television shows, most distributed by Universal. By 1980, Lucas and Spielberg had become the most powerful director-producers in the industry, and they remained at the top for decades.

第五节　第三世界民族电影

第三世界民族电影（Third World Cinemas）主要是亚非拉国家探究发展中国家自身文化历史和当代后殖民社会问题、且将这些国家的立场和观点呈现给世界其他人的电影。第三世界民族电影受到马克思主义和苏俄意识形态的严重影响，倾向于抨击欧美殖民文化的主导控制、描述发展中国家农民贫困的生活、展示亚非拉国家传统生活与现代化发展之间的冲突、并暗示后殖民国家同病相怜和同仇敌忾的命运。

Third World Cinemas

The term *Third World film* does not so nmch describe a national tradition as provide a heading for many politically and economically related but geographically scattered national cinemas: those films from the underdeveloped emerging nations of Africa, Asia, and Latin America that explicitly examine the political, social, and cultural issues of those nations. Although Brazil is one of those countries that has produced Third World films, the popular romantic-erotic fantasy *Dona Flor and Her Two Husbands* (Bruno Barretto, 1978), with its escape from social realities, would probably not be considered one of them. Nor would the Kung Fus from Hong Kong. On the other hand, some European films (*The Battle of Algiers*, *State of Siege*) and some American black or Latino films (like Melvin Van Peebles's *Sweet Sweetback's Baad Asssss Song*, 1971, and Anna Thomas and Gregory Nava's *El Notre*, 1983) have been considered spiritual products of the Third World even though the films were produced or directed by Americans or Europeans. Michel

Khleifi's *Wedding in Galilee* (1987), officially an Israeli production, was made primarily with money from Belgium and France, has a distinctly Palestinian point of view, and is usually discussed as a Third World Palestinian picture (much like the films Khleifi did produce in Palestine, again with European money but without the participation of Israel), with a flavor of having been made under the nose of the enemy and a running theme of having to get Israeli approval for everything. *Yol* (1982), a realistic, socially critical Turkish film directed by Şerif Gören and written by Yilmaz Gűney—who wrote the script while in jail and had to smuggle it out—is certainly a Third World film. To keep an already muddy metaphor from becoming any more murky, it would make sense to define a Third World film by both its national origin and its cultural content.

These developing, often postcolonial countries produce films either to educate their own citizens about the cultural history and contemporary conditions of the nation or to present that nation's problems and positions to the citizens of the rest of the world—sometimes both. To make feature films up to the technical standards of the international market costs a lot of money, particularly for countries with limited economic resources. Those Third World films that have been widely screened outside local markets must pass a strict test of social utility—serving a country's national and international interests—or they must be artistically striking enough to do well at film festivals and find distribution, which brings prestige to the country and support for its film industry.

Whether or not they are films of revolt, almost all of them are films of national and cultural self-definition. Their clearest historical analogy is to the Soviet silent classics of the 1920s. Like the new Soviet Union, these nations are emerging from decades or even centuries of cultural exploitation. As in the new Soviet Union, films could be used to educate an audience unable to read and ignorant or dubious of the goals and methods of a new government. As in the Soviet Union, films could be projected in remote regions of these often topographically tortuous countries with the aid of portable power supplies. As in the Soviet Union, films could combine their political lessons with moving stories of human action, often mingling native symbols and folk elements with their didactic tales of social values.

No clearer parallels with the early Soviet movement can be found than in several specific devices of these Third World films. The ending of the Cuban films *The Last Supper* (1976), directed by Tomás Gutiérrez Alea, reflects the influence of Pudovkin: A montage of metaphoric crosscuts links the uprising of an oppressed people with the inevitable and irreversible processes of nature. The ending of Miguel Littin's Chilean film *The Promised Land* (1973; never released in Chile), like Pudovkin's *Mother,* shows a failed revolution of the past passing on its spirit to the future and, like Dovzhenko's *Arsenal*, develops the mystically unkillable power of the people. Finally, like the Soviet cinema, the cinema of the Third World includes

many works that are mere propaganda (telling the audience what to think) and many that present ideas for the audience to think about (comparable to a Brechtian theatre of ideas). Third World cinema is both an international phenomenon and a set of national cinemas, bursting with important movements (*Cinema Nôvo* in Brazil) and exciting director/theorists (Solanas and Getino in Argentina, Glauber Rocha in Brazil, Tomás Gutiérrez Alea in Cuba) and essential films (Rocha's 1969 *Antonio das Mortes*) whose international influence has been enormous.

The methods and goals of film production in these Third World countries can be divided into three very broad categories. First, one country, Cuba, with a well-developed, sophisticated, and nationalized film industry, can rival the industries of all but a few countries of the world in the quality of its output. Like Lenin, Fidel Castro declared the cinema the most important and socially useful of the arts; as a result, the Cuban government, like the Soviet Union, founded and funded a national film school and film production company (ICAIC—Instituto Cubano del Arte e Industria Cinematograficos). Although ICAIC produces mainly documentaries, it also makes several narrative feature films each year, for the Cubans discovered, as did the Soviets, that the populace preferred Hollywood-style stories to didactic documentaries. These feature films, too, help Cuba forcefully argue its case abroad—particularly in Paris, where there is less political resistance to them than in New York.

Second, several Third World countries make a small number of feature films for both national consumption and international distribution (for example, Senegal, Egypt, Ethiopia). Because the population of many of these countries is small, these films seek international distribution to expand their impact and justify their cost. And because the governments of some of these countries are still politically repressive, the political content of these films is often guarded and metaphoric—more ironic, less radical, less explicitly Marxist, less dominated by revolutionary rhetoric than the films of Cuba or those of the third group.

That third group of films comprises those from countries with such repressive totalitarian governments that the films become underground acts of rebellion and sedition in themselves—films from Argentina, Chile, Bolivia, Peru. Because these films are so dangerous to make, they could never be shown in the countries that produced them without a revolutionary change in their governments; two outstanding examples are *The Hour of the Furnaces: Notes and Testimonies on Neo-Colonialism, Violence and Liberation* (Fernando Solanas and Octavio Getino, 1968) and Parts I and II of *The Battle of Chile* (Patricio Guzmán, 1973-77). These films have been produced almost exclusively for international distribution, to rally international opinion against the ruling regimes.

It is not dangerous to make a nonpolitical film in a country like Argentina, especially when the international film market is hungry for good new work; in

2001 alone, Argentina released Lucrecia Martel's *La Ciénaga*, an independent film whose production funds were raised almost entirely through international grants, and Fabián Bielinsky's *Nine Queens*, a wonderfully twisted drama about con artists that was produced because its script won a national contest. Not every Argentinean film, let alone every Latin American or African film, is Third World; not every one is subversive, experimental, radical, and charged with an urgent message to its country and the world.

Despite these differences in the methods of their production and distribution, Third World films share several general themes. The first is an attack on the dominating cultural presence of the more affluent nations of Europe and America—the British presence in *The Night of Counting the Years* (Egypt, 1969), a film by Shadi AbdesSalam, the French presence in the films of Ousmane Sembene (Senegal), the American presence in South American films.

A second major theme is the crushing, unimaginable poverty of vast segments of the peasant population—whether of the Andes Indians of Jorge Sanginé's *Blood of the Condor* (Bolivia, 1969), the feudal farmers of Haile Gerima's *Harvest: 3000 Years* (Ethiopia, 1975), or the impoverished street children in the Rio de Janeiro slums of Hector Babenco's *Pixote* (Brazil, 1981).

A third theme, like the title of Eisenstein's 1929 film, might be called "Old and New", the contrast of the old backward ways of farming, living, thinking with newer, more progressive ones—the conflicts of ancient and modern customs in *Xala* (1974), and of the general patterns of historical evolution in the Cuban fictional classic, *Lucía* (1968). Some of these films celebrate the old ways, the founding rituals and unique look of their land and culture—as Souleymane Cissé treats Africa in *Brightness* (or *Yeelen*, Mali, 1987). Others say that it is about time for a change in customs: A powerful example is Ousmane Sembene's *Moolaadé* (2004), a study of female circumcision that is revolutionary, compelling, and easy to understand; the last point is important because Sembene went from writing novels to making movies so that he could reach more people in more direct, clear terms.

A final theme that unites many of these films is the implication that these scattered countries, continents, and peoples are indeed united by common cultural problems and goals—that the exploited peoples of tile Middle East, Africa, Cuba, and many other places share a common need and common enemy.

1. 巴西新电影

巴西新电影（Cinema Novo）是 20 世纪 60、70 年代最具影响力的第三世界民族电影运动，其领军人物格劳贝尔·罗查（Glauber Rocha）在宣言书中

《死神安东尼奥》

声称,巴西新电影"是悲惨、丑陋的电影,在这些哀号绝望的电影中理性并非总能获胜",但它"最终将让世人知晓它自身的苦难"。罗查更身体力行,拍摄出《黑色上帝与白色魔鬼》和《死神安东尼奥》等巴西新电影代表作。

巴西新电影的另一位代表人物纳尔逊·皮尔拉·多斯桑托斯(Nelson Pereira dos Santos)的《贫瘠的生活》是对"饥饿美学"的戏剧化直观呈现,而《我的小法国人多可口》则从土著人视角探讨欧洲文明与热带原始主义之间的冲突。

巴西新电影之后,巴西电影的左派倾向和商业诉求走向融合形成相对繁荣的局面,而阿根廷裔巴西著名导演赫克托·巴本科(Hector Babenco)的《蜘蛛女之吻》就以其戏中戏的套层结构、展现广泛的社会政治和历史人性内容而获得观众的肯定。

Cinema Novo in Brazil

The most prominent film movement to arise as part of a cinema of liberation was Cinema Novo (New Cinema) in Brazil, emerging in the early 1960s (though Solanas and Cetino in their essay "Towards a Third Cinema" included Cinema Novo in their second category, films of personal expression by individual *auteurs*). Cinema Novo was not the outgrowth of a revolutionary change in government, as in China or Algeria, but it was strongly affected by state policies, both liberal and reactionary. More than almost any other filmmaking practice, Cinema Novo embodied the multiple struggles and contradictions involved in the idea that

cinema could be a liberating force.

Cinema Novo developed in the aftermath of a failed effort to establish a commercial film industry in Brazil. A production company, Vera Cruz, had been set up in 1949 with a plan to import foreign directors and make expensive prestige productions a kind of instant Tradition of Quality that could compete in both the domestic and international markets. The effort collapsed on both counts, and closed down in 1954. In its wake, younger filmmakers turned to the Italian neorealist model of low-cost films concerned with social issues and were buoyed by the French New Wave's emphasis on *auteurs*. In a period of political liberalism, when the country's economic development was widely debated, filmmakers found bank financing for works dramatizing the nation's social ills.

The movement had barely been launched when a military coup took over in 1964 and tightened its grip with repressive measures in 1968. Filmmakers were able to continue their work, however, and their rhetoric became even more militant. They began to identify their efforts with Latin America as a whole and with a Third World struggle against European neocolonialism; they also proclaimed as a unique cultural expression an indigenous "tropicalism" a conjunction of the cultural forms of native Brazilian peoples with the popular arts that set their practice apart from the European aesthetics of neorealism and the French New Wave.

Glauber Rocha

The most widely known Cinema Novo filmmaker was Glauber Rocha (1938-1981), who also formulated one of the movement's manifestos in a brief 1965 essay, "*An Esthetic of Hunger*". There he speaks of Cinema Novo as "these sad, ugly films, these screaming, desperate films where reason does not always prevail", yet that "will ultimately make the public aware of its own misery". Rocha's reputation rests on four films he made in the 1960s before going into exile from Brazil in 1970: *Barravento* ("*The Turning Wind*", but known by its original title, 1962), *Deus eo diabo na terra do sol* (*Black God, White Devil*, 1964), Terra em transe (originally released in English as *Land of Anguish*, but more recently known by a more literal translation, *Earth Entranced*, 1967), and *Antônio das Mortes* (1969; known in English by its original title, the name of its lead character).

Barravento is often regarded as Rocha's best film, an understandable though problematic judgment, since the director claimed that he was working on the film only as a producer until the original writer-director left the project at midpoint and he stepped in to finish it. Formally the most traditional of Rocha's films, *Barravento* concerns the lives of black men and women in a fishing community in Bahia, in Brazil's impoverished northwest. It depicts the economic exploitation

of the fishermen in terms similar to Visconti's *La terra trema*, but gives greater attention to the music, myths, and folk religious practices of Afro-Brazilian culture. The film seems clearly Rocha's in inaugurating what was to become a pervasive rhetoric of his work the possibility of unexpected transformation, of a world turned upside down. The notion of "the turning wind" is defined in an opening epigraph: "Barravento is the moment of violence when sea and earth become changed, when life, love and social standing may be subjected to sudden change".

Black Cod, White Devil and *Antônio das Mortes* pursue this concept of reversal. They are linked texts-the first black-and-white, the second color, separated by five years and several sudden changes in Brazilian politics. They shift the location from the seacoast of *Barravento* to the northwest backlands, a region of legendary outlaws and millennial religious movements. Their styles expand the ritualism of *Barravento* toward greater theatricality and pageantry, with folk ballads on the soundtrack interpreting events and commenting directly to the spectator. Central to both works is the hired killer Antonio das Mortes, a massive, bearded figure wearing a scarf, a cape, and a leather hat. Refusing introspection ("I know nothing about myself", he says), in the first film he hunts down and slays Corisco, last of the backlands outlaws, the cangecieros.

In *Antônio das Mortes*, we learn (Brazilian audiences presumably would already have known this) that the events of *Black Cod, White Devil* were set in the 1930s. Three decades have gone by, and an older Antônio, haunted by his past, returns to the backlands. Industry and investment are beginning to make inroads, but a *cangeciero* and a religious movement have reappeared like ghosts. Antônio experiences a change of heart, seeks forgiveness for his killing, and says, "Now I understand who the real enemy is" the landowners and other powerful figures who have hired him to kill. He also proclaims his own obsolescence, saying to an intellectual fighting alongside him in a gun battle, "Fight with your ideas they're worth more than I am". Winner of a prize at the Cannes Film Festival, *Antônio das Mortes* evoked considerable debate over its "esthetics of violence" (which was an alternative title sometimes given to Rocha's essay "An Esthetic of Hunger").

Land of Anguish/Earth Entranced, made between the two backlands films, is concerned with Brazilian intellectual life, which Cinema Novo filmmakers began to examine after the 1964 military coup. It focuses on a poet who aspires to be active and influential as a journalist and advisor to politicians. In the opening sequence, after a coup has ousted his allies, the poet impulsively refuses to concede defeat. He drives through a police blockade and is mortally wounded. The film's central section is a flashback retrospective of his political life, leading up to the crisis with which it began. Exploring the relationship between art and power, it chronicles the failure of an intellectual who played the political game, rather than, as Antonio das Mortes advised, fighting with ideas.

Nelson Pereira dos Santos

The filmmaker whose work strikingly represents the shift from neorealism to "tropicalism" is Nelson Pereira dos Santos (1928). A decade older than Rocha, he had made documentaries and features in the 1950s and worked as an editor on *Barravento*. His *Vidas secas* (*Barren Lives*, 1963) dramatized the "esthetics of hunger" that Rocha had later proclaimed. Based on a classic 1930s novel of the northwest backlands, the film depicts a poor family's struggle to survive in the face of economic exploitation, police oppression, and a harsh environment. Though the novel was compared to John Steinbeck's *The Grapes of Wrath*, the film has closer affinities to Italian neorealism, which dos Santos acknowledged. Fabiano, the father of *Barren Lives*, is akin to Antonio, the father of *Bicycle Thieves*, as well-meaning men overwhelmed by circumstances, fading into oblivion in an inhospitable world.

By 1971, dos Santos was challenging European culture in *Como era gostoso o meu Frances* (*How Tasty Was My Little Frenchman*). Set in the sixteenth century, and shot in color largely with a hand-held camera, the film presents "tropicalism" in its native state, with its tribal men and women unclothed. A French man is captured by a tribe and made a slave, prior to the time when he will be killed and eaten. The film presents moments of brutality and of fellowship in the encounter between European "civilization" and tropical "primitivism," while emphasizing through periodic intertitles Europe's colonial discourse of racial superiority. Conditioned by familiar narrative conventions about the lone hero among strange peoples, the spectator awaits a "happy ending": his deliverance, perhaps accompanied by his native wife. But the wife blocks his escape, and the happy ending belongs to the tribe. Cannibalism is a social fact, rather than the grisly shock Godard made it in *Weekend*, and also a metaphor: Europe's presence in the new world has been "digested" and turned into something no longer recognizable as European.

2. 拉美电影：古巴、阿根廷、玻利维亚和智利

1959年卡斯特罗上台，并因"猪湾事件"和古巴导弹危机而遭到美国政府的全面封锁，也导致好莱坞电影完全退出古巴市场。但是，倒向苏俄阵营的古巴开始拍摄社会主义意识形态的影片，著名导演托马斯·古铁雷斯·阿莱亚（Tomás Gutiérrez Alea）的《低度开发的记忆》就展现新旧交替时期古巴中产知识分子左右为难的尴尬处境。而另一部获得国际影响的影片《露西娅》

《低度开发的记忆》

则是对 19 世纪末、20 世纪 30 年代、60 年代三代女性反殖民、反压迫和反歧视斗争的政治性叙述。

20 世纪 60 年代阿根廷产生了"自由电影"（Liberation Cinema）运动，其最著名的代表作品就是纪录长片《燃火的时刻》，集中呈现新殖民主义、解放运动和暴力等阿根廷社会问题。另一部反映 20 世纪 70、80 年代阿根廷军人政权时期三万人失踪真相的《官方说法》也是影响广泛的南美政治电影。

玻利维亚的《秃鹫之血》以半纪录的手法、充满激情地反映印第安土著反抗美国和平队所谓的"文明与卫生"、保护印第安文化传统和身份认同的不屈斗争。而著名的纪录电影《智利之战》则是对 20 世纪 70 年代智利民主与专制、殖民与独立、左派与右派等话题的严肃探讨。

Latin American Cinema

Cuba　Besides Brazil's Cinema Novo, the other major new component in Latin American filmmaking of the 1960s was the Cuban revolution. Other countries continued to struggle with the traditional difficulties of cinemas on the margin of the mainstream—foreign domination of exhibition, inadequate production funding, limited international recognition. But Cuba, soon after the Castro government gained power in 1959, initiated a radical break with its past, including these structures of cinematic subordination.

Rapidly escalating mutual antagonism with the United States led Cuba to align with the Communist bloc. Political tensions rose to new heights with the 1961 Bay of Pigs invasion by Cuban exiles supported by the United States, followed by the 1962 Cuban missile crisis in which nuclear war was threatened after the United States discovered that the Soviet Union was building missile bases in Cuba (the crisis ended when the Soviets agreed to dismantle the bases). As Castro's government transformed itself into a communist regime, it became clear that Cuba's new model of socialist filmmaking practiced some of the familiar constraints of other socialist cinemas, including ideological control and repression of dissidents. Nevertheless, for many in Latin America and elsewhere the Cuban experience encouraged renewed idealism and the possibility of utilizing cinema for social change.

In March 1959 the Castro government established the Instituto Cubano del Arte y Industria Cinematográficos (Cuban Institute of Cinematographic Art and Industry), known by its acronym, ICAIC. Among its tasks were the training of filmmakers, documenting the country's political transformation, finding films for theaters after Hollywood distributors withdrew from the courtry because of the U.S. government's prohibition of commerce with Cuba, and fostering filmmaking styles commensurate with political ideology. This latter question became acute after Cuba defeated the American-backed invaders at the Bay of Pigs. In that charged atmosphere, a short film was banned because it showed scenes of Havana low life considered offensive to the "Revolution" The debate that erupted among intellectuals and artists climaxed when Fidel Castro himself delivered a speech, "Words to the Intellectuals", which closed with the phrase: "Within the Revolution, everything, against it, nothing".

Nearly a decade passed before Cuba began to produce significant fiction feature films. In 1968 Cuban filmmaking made its mark with two works that received wide international attention, *Memorias del subdesarollo (Memories of Underdevelopment)*, directed by Tomás Gutiérrez Alea (1928-1996), and Lucía, a film by Humberto Solás (1942-2008).

Memories of Underdevelopment. From his studies at Rome's Centro Sperimentale di Cinematografia (along with fellow Cuban Julio García Espinosa, later the theorist of "Imperfect Cinema"), Gutiérrez Alea brought back a neorealist approach to filmmaking. But by the later 1960s, developments like the French New Wave and Cinema Novo, as well as his own analysis of Cuban circumstances, led him to a more eclectic, self-reflexive style. Combining actuality with fiction footage, material from television and other films, and scenes foregrounding the making of the text itself, Memories of Underdevelopment is an exploration of the politics of representation as much as a realist depiction of a social world. Based on a novel with the same original title (but translated in English as Inconsolable

Memories), the film is set in the crucial period between the Bay of Pigs and the following year's missile crisis. Its protagonist, Sergio, is a middle-class man who has refused to flee with his family to Miami but is also unable to commit to the new regime. Neither revolutionary nor counter-revolutionary, he is "nothing"—a figure formed by underdevelopment and living detached and alienated, without meaning. Memories of Underdevelopment is a subtle portrait of an old Cuba passing away and a new Cuba struggling to be born.

Lucía. Solás came from a different generation than Gutiérrez Alea. As a teenager he fought as an urban guerrilla against the Batista dictatorship, and he began making films at ICAIC before he was twenty. For *Lucía*, his breakthrough work, he developed a strongly melodramatic approach, while filming with an almost constantly moving hand-held camera. Committed to a postrevolu tionary revision—and revisioning—of Cuba's history, Solás frames that effort in *Lucía* through three episodes concerned with different women named Lucía. The first Lucía is an unworldly aristocrat, a fool for love who is tricked into betraying her country-men during the 1890s struggle against Spanish colonialism. The second Lucía is an idealistic middle-class woman of the early 1930s whose love for a revolutionary ends in tragedy after the violent overthrow of an earlier dictator fails to change business as usual. The third episode is set in "196-", and its Lucía is a revolutionary in her own right, but she struggles with her bridegroom against *machismo,* traditional male privilege and possessiveness which the Revolution has not (yet) reformed. For its scope, variety, and energy, *Lucía* remains a vivid achievement of political cinema.

Argentina Drawing inspiration from Cuba among other sources, a group in Argentina called Cine Liberación (Liberation Cinema) made a remarkable political film, *La hora de los hornos* (*The Hour of the Furnaces,* 1968), codirected by Fernando Solanas and Octavio Getino (who the following year published their manifesto "Towards a Third Cinema"). Though normally classified as a documentary, the film's purpose in part was to explode such categorizations in order to make spectators perceive and think freshly, about both politics and communications forms. It is a work of political advocacy cast in avant-garde style—a collage film utilizing a wide variety of image/sound juxtapositions and contrast editing, printed text, still images, borrowed scenes from fiction films, acted sequences, advertisements, voice-over, and sound effects. The full-length film, in three parts, ran to four hours and twenty minutes; only Part One, a ninety-minute segment dealing broadly with the subject of neocolonialism, generally circulates in the United States. The second and third sections, concerned more specifically with the Argentine situation, contained suggested break points for audience discussion.

Part One presents the view that violent rebellion is all appropriate response to the social disorders caused by existing forms of domination. Among its

most striking visual sequences is a montage of scenes from a slaughterhouse interspersed with shots of advertisements for foreign products, suggesting that a dependent culture and economy are linked to a life-destroying system. The film is dedicated to Ché Guevara, the Cuban revolutionary killed in 1967 while leading a guerrilla group in Bolivia, and other "patriots who have fallen in the struggle for the liberation of Latin America". In contrast to its fast-paced editing style, Part One ends with a shot of Guevara's face, filmed after his death, held on-screen for three minutes, while drums beat on the soundtrack.

Bolivia Another significant work of political advocacy, made as narrative fiction, was the Bolivian film *Yawar Mallku* (*Blood of the Condor,* 1969), directed by Jorge Sanjinés (1936-). It dramatized charges that members of the United States Peace Corps (called "Progress Corps" in the film) were sterilizing Indian women without their consent in an obstetrics clinic. Both the Bolivian and United States governments sought unsuccessfully to suppress the film, while experts supported its accusations. Peace Corps activities ended in Bolivia two years after the film's release.

3. 非洲和阿拉伯世界电影

20世纪60年代非洲国家独立运动催生了撒哈拉沙漠以南的黑非洲电影，而来自前法属殖民地塞内加尔的塞姆班·乌斯曼（Sembene Ousmane）则被公认为"非洲电影之父"。塞姆班曾参加过二战时期法国的抵抗运动、并到莫斯科学习电影，回国后用最直观的影像向文盲同胞传达独立与民主的现代思想。他的《黑女仆》呈现殖民化环境下黑人异化和隔绝的心理状态，而《阳痿》则对独立的民族政府仿效殖民宗主的种种丑行进行尖锐的抨击和辛辣的讽刺。

北非的阿拉伯国家埃及拥有全非洲最强大的电影工业，并从中成长出尤素福·夏因（Youssef Chahine）这位饮誉世界的埃及导演，他的新现实主义纪实风格的《大地》和缅怀青少年时代战乱和成长的《情迷亚历山大》等都是北非电影公认的杰作。

African Cinema

With nations throughout the continent achieving independence in the period around 1960, Africa might have appeared primed to play a central role in the emerging cinema of liberation. Substantial impediments existed, however, to the

《阳菱》

growth of filmmaking. Foremost was the lack of economic development of any sort in the former European colonies, leaving cinema as a low priority for scarce financial resources. Moreover, the colonial powers, especially France in the regions it had previously ruled, maintained control over film distribution. As had been the case since the early twentieth century in countries outside the large film-producing nations, local theaters played cheap foreign imports in preference to indigenous works. Filmmaking in the newly independent countries of Africa barely got under way in the 1960s, and did not become a significant practice for another decade or more.

The founder of feature filmmaking in black Africa, or Africa south of the Sahara desert, was Ousmane Sembene (b. 1923) of Senegal, a major figure both in literature and film. After fighting with Free French forces under Charles de Gaulle during World War II, Sembene spent the postwar years as a dockworker in France, where he began publishing fiction written in French. Around the time of Senegal's independence, he came to the view that in order to communicate with a substantially nonliterate population in his home country, he needed to make films. Sembene studied filmmaking in Moscow and returned to Africa in the early 1960s as a writer and film director.

Sembene made the first black African feature film with *La Noire de…* (*Black Girl*, 1966), followed by *Mandabi* ("*The Money Order*", but known by its original title, 1968), *Emitai* (1971), *Xala* (1974), and *Ceddo* (1977). Though surely his work belongs to a cinema of liberation, Sembene largely eschewed the technical innovations of the Latin Americans. His style has sometimes been called "classical," but it is more accurate to describe it as "realist" in the sense that André Bazin used the term. He utilized careful composition in the frame, medium

shots, and long takes with little camera movement. His mise-en-scène seems tailored for the audience he wished to reach, providing ample time and space for spectator interrogation of the image. Through subtle handling of décor, costume, language, performance, and narrative, he fashioned a critique of colonialism and neocolonialism quite as powerful as could be found in more modernist filmmaking styles.

Black Girl Sembene's first feature dealt with colonialism in its production as well as its narrative. Co-produced by a French company, it was shot largely in France, with a French cinematographer and editor, mostly French performers, and the French language almost exclusively on the soundtrack. These French contributions, as Senegalese filmmaker and critic Paulin Soumanou Vieyra has written, were thought to insure "high technical quality, as per the French brand image". Unmistakably, however, Sembene's viewpoint shaped the film. It was based on one of his novels, which in turn had been developed from a newspaper account of an African woman's suicide in France. A young black woman arrives in France as an employee of a French family for whom she had worked in Dakar, Senegal. The imperious wife inexplicably treats her as a prisoner and drudge, while the alcoholic husband is ineffectual. The despairing woman slits her wrists in a bathtub. The film is most intriguing as a sketch of colonial mentality, exemplified by a French family that exposes its racism and weakness outside the colonial setting.

Xala. By 1974, the time of *Xala*, Sembene had an international reputation as a filmmaker (he was already widely known as a novelist) and was able to finance the film entirely within Senegal. Nevertheless, his target was neocolonialism, in a masterly tragicomedy whose seriousness gradually emerges from what seems at first lighthearted satire. The opening sequence set the tone: declaring their independence from colonial influence, Senegalese businessmen kick out the Frenchmen who run their business association; then the French deliver briefcases filled with cash and return as "advisers".

One of the businessmen, El Hadj, uses his new wealth to take on a third wife. "Modernity must not make us lose our Africanity" says a colleague, referring to the male practice of polygamy. But El Hadj has received a curse—the Xala, pronounced ha-la—and cannot fulfill his sexual duties with his new young wife. His failures multiply, and he loses both his business and the new wife. The curse had been placed on him by one of the poor people he had previously cheated or ignored, and the film ends in a stark scene of El Hadj submitting to be spat on by beggars, as a means of lifting the Xala. As in other works, Sembene uses language as a key to power and consciousness in a neocolonial environment.El Hadj, who speaks French with his colleagues, grows angry when a daughter addresses him in the native language, Wolof; but when he is under attack he asks to defend himself in Wolof and is told that he is "racist, sectarian, reactionary".

Youssef Chahine

Youssef Chahine was born in Alexandria in 1926. the son of a lawyer and supporter of the nationalist Waft Party. He was brought up a Christian and studied at the English-language Victoria College in Alexandria, before spending two years studying drama at the Pasadena Playhouse, near Los Angeles. His beginnings were in the mainstream of Egyptian cinema and he began work as assistant director immediately after his return from the United States. Throughout his career he was a totally professional film-maker, concerned to remain in touch with his audience. But at the same time he has treated a consistent set of themes, central to which is a concern with the psychology of the individual which, from the first, he has been at pains to locate socially. His output shows an increasingly keen perception of the contradictory interactions of the individual and society. At the same time, his work has grown in stylistic assurance. from the routine narrative structures of his early years as a director, through the compelling realism of the 1950s and 1960s to the more complex allegories and personal introspections of the 1970s and 1980s. His mature work combines cosmopolitanism with a strong sense of Egyptian identity in story structures that are increasingly complex and open-ended.

Chahine's debut at the age of 24 with *Father Amin* (*Baba Amin*. 1950) came at a time of expansion for Egyptian cinema. and for a while he worked within its commercial confines. This was a period when serious writers were turning to the cinema, and Chahine worked with both Naguib Mahfouz and Abderrahmane Sharkawai on his film about the Algerian war, *Jamila* (*Jamila al-jazairiyya*, 1958), and his historical hymn to tolerance and Arab unity *Saladin* (*Al-nasir Salah ai-din*, 1963). Central to Chahine's early work is *Cairo Station* (*Bab el hadid*, 1958), which, in its study of the poor and dispossessed, has many affinities with Italian neo-realism, and, like *Bicycle Thieves*, was rejected by those whose problems it addressed. It is the portrayal of the psychological breakdown of a crippled and sexually frustrated newspaper vendor, played with remarkable force and intensity by Chahine himself.

The historical epic *Saladin*, with its portrait of a great and magnanimous Arab conqueror. marked the summit of Chahine's commitment to the national revolution instigated by President GamalAbdel Nasser. His later work, however, introduced a much more questioning note. *The Land* (*Al-ard*, 1969), Chahine's second realist masterpiece, was both a powerfully told story of peasant unity in defeat, and an implicit criticism of Nasser's policy towards the land. In total contrast, *The Choice* (*Al-ikhtiyar*, 1970) was a complex allegory which used elements of schizophrenia and the literary theme of the double to explore the uncertainties and confusions of the Egyptian intelligentsia after the defeat of 1967. *The Sparrow* (*Al-*

'*usfur*, 1973) was a directly critical examination of the Nasser era, attacking the corruption which Chahine sees as characteristic of the time, while celebrating the patriotism of the ordinary people, exemplified by the heroine, Baheya. The film's sharply critical tone was sufficient to get it banned for two years by the Sadat regime. Some twelve years after Saladin Chahine concluded a decade of social and political analysis with *The Return of the Prodigal Son* (*'Awdat ai-ibn al-dall*, 1976), which was openly derisive of the aspiration and pretensions of the Egyptian nouveaux riches.

As Chahine's technical command has increased. he has allowed more and more of his intimate emotions to emerge. In the late 1970s he began what was to be a three part autobiography: *Alexandria ... Why?* (*Iskandariya leeh?* 1978), *An Egyptian Story* (*Hadutha masriyy*, 1982). and *Alexandria: Again and Again* (*Iskandariya: kaman wa Kaman*, 1990). Starting in the wartime Alexandria of 1942 with the young Yehia's dreams of escape, the trilogy which mixes reconstructions, film clips, farce, and near tragedy, paints a rich portrait of Chahine's commitments and enthusiasms. The trilogy does not comprise the whole of his output in the 1980s-he also directed a Franco-Egyptian historical epic. *Farewell Bonaparte* (*Alwida'aBonaparte*, 1985), and an exuberant melodrama. *The Sixth Day* (*AI-yawm al-sadis*, 1987)-but it makes a fitting climax to one of the Arab cinema's most prestigious careers: perhaps the fullest self-portrait yet achieved by a Third World film-maker.

第六节　新中国电影与华语新浪潮

1. 新中国电影

　　1949 年毛泽东建立的中华人民共和国依照苏俄模式将电影业收归国有，加之对孙瑜导演、赵丹主演电影《武训传》的批判，电影基本成为服务于国家意识形态的政治宣传工具。1956—1966 年间尽管出现了《祝福》《新局长到来之前》《林则徐》《早春二月》《北国江南》和《舞台姐妹》等具备一定艺术追求的影片，但中国电影仍然在反右等一系列政治运动中备受摧残、举步维艰。电影为"极左"政治服务的状态在 1966—1976 年的"文化大革命"期间登峰造极，江青主导的八大"革命样板戏"（revolutionary model operas）几乎成为中国唯一的电影存在。

　　1976—1984 年邓小平主政的改革开放、为中国电影的现代化起飞进行着理论和实践的准备，《巴山夜雨》《天云山传奇》和《人生》等电影都产生过广泛的影响。

China: The Revolutionary Cinema

　　The history of cinema on the Chinese mainland after the Communist takeover in 1949 falls into four distinct periods. From 1949 to 1966, a national film base financed by the state produced Socialist Realist "worker-peasant-soldier" films, in an attempt to build an indigenous "revolutionary cinema". Feature film production virtually stopped during the early years of the Cultural Revolution

革命样板戏《红灯记》

from 1966 to 1972, except for ten filmed operas ("revolutionary model operas"). In the years following the Cultural Revolution innovative efforts and "exploratory films" dismantled the conventions of classical revolutionary realism and redefined the language of Chinese cinema. Then, in 1987 studios took up full financial accountability and started producing entertainment movies, prompting a gradual reversal to a market-driven commercial cinema.

Politics and Industry (1949-1956)

After 1949, production, distribution, exhibition, and censorship of films fell under the purview of the Ministry of Propaganda and, later, the Film Bureau of the Ministry of Culture. Beginning in 1951, movies from Shanghai made before 1949 were banned, as were those from Hollywood and Hong Kong. In their place, films for and about workers, peasants, and soldiers (*gongnongbing dianying*) were shown, to support a socialist reconstruction of the country. With Soviet assistance, the industry soon achieved technological self-sufficiency. By 1959, ten feature film studios and an animation studio had been built in the major cities, and in the

late 1950s small provincial studios also began producing newsreels and science education shorts.

National distribution of films was undertaken by the China Film Distribution and Exhibition Company which Operated through provincial, city, and county offices. The Film Bureau also set up more exhibition units for the masses: from 646 theatres in 1949, exhibition units increased up to 20,363 in 1965, with 13,997 projection teams which serviced peasants in the countryside with 16 mm projectors and slide projectors. Annual attendance grew from a total of 138,814,000 in 1949 to 4.6 billion in 1965. Beijing Film Academy, the country's only film school, was inaugurated in 1956 and offered formal training for prospective script-writers, directors, cinematographers, art designers, actors, and, later, for audio engineers and management personnel as well.

As early as July 1949, the First National Congress of film and literature professionals consecrated Mao Zedong's *Talks at the Yan'an Forum* (1942) as the guiding principle for works in art and literature. The creation of new worker-peasant-soldier types in what Mao called revolutionary realism became an official mandate. The film-makers, however, were far from uniform in background and outlook; key members of the 1930s underground left-wing film movement, previously non-aligned employees of private Shanghai studios, and members of the theatre troupes from Yan'an and the army. They borrowed from various traditions. Hence, narrative and formal strategies used in traditional drama and literature, and in Soviet and Hollywood films of the 1930s and 1940s, often appeared together in orthodox versions of revolutionary history and class struggles. The filmmakers' adherence to China's own theatrical and literary traditions was also revealed in their creation of 'opera film' and 'literary adaptations' (of modern Chinese literature) as new genres.

In October 1946, shortly after the Japanese retreat from Manchuria, Northeast Film Studio had begun production in Hegang, a coal-mining town north of Harbin. With equipment salvaged from the Japanese-owned Manchuria Cinema Association and assisted by sympathetic Japanese technicians, it produced newsreels, translated Soviet films, and completed two animation films. On 1 may 1949 it released its first feature film, *Bridge*, Witten by Yu Min and directed by Wang Bin, who had worked in Shanghai before they joined Yan'an. Yu and Wang set the precedent for film professionals to 'immerse in real life' by living among the factory workers they depicted in the film.

From 1949 to 1950 the Northeast Studio produced about eighteen low-budget black and white films which were early models of revolutionary realism. They portrayed heroic figures and memorable episodes of the revolution, several of which, such as *Daughters of China* (*Zhonghua nuer*, 1949), *The White-Haired Girl* (*Baimaonu*, 1950), and *Zhao Yiman* (1950), told moving stories of women as

fighters, victims, and martyrs. In these films, elements as diverse as documentary footage, folklore, traditional music and hagiography enhanced the popular appeal of female figures of liberation and struggle.

After the Communist take-over, the private studios that remained in Shanghai, including Kunlun, Wenhua, Guotai, and Datong, were encouraged to make films for the transitional period. Between 1949 and 1951 they produced approximately forty-seven films, but they soon ran into political difficulties, as a result of which they gradually disbanded and were incorporated into an expanded Shanghai Film Studio in 1953.

The political criticisms of the output of the private studios focused on the film The film *The Life of Wu Xun* (*Wn Xun zhuan*,1950), directed by Sun Yu. The film depicted a self-made educator who initially set up schools by literally begging on the streets. In a campaign which years later, in 1985, was officially denounced as 'partial, extreme and violent', it was accused of having misrepresented bourgeois reform as proletarian revolution and thus committed a grave political mistake. Following Mao Zedong's criticism of *The Life of Wu Xun*, the film circle underwent re-education and a Film Steering Committee was formed to censor scripts in a detailed manner. The harsh criticism launched against a single film not only ensured the Party's control over artists' interpretation of history and culture but also enabled the Yan'an faction to ride over veteran artists of Shanghai.

Standardization of administrative and censorship procedures took place in 1953. At the 2nd National Congress of All China Literature and Art Workers, Zhou Enlai declared that Scialist Realism in the Chinese context consisted of revolutionary realism and revolutionary romanticism. Though the formal and stylistic implications of these terms remained open for interpretation, their basic tenets remained the leadership of the proletariat in revolutionary struggles as guided by the CCP, and an idealistic rendering of the present and the future. Revolutionary realism, therefore, was grasped in its ideological rather than technical or formal sense. In formal terms, the films inclined towards classical realism as they took up traditional dramatic patterns and an organization of space and time according to the principle of verisimilitude. Nevertheless, motivation and behaviour as accounted for by the characters' class background and political attitude transformed the personal, psychological ground of "bourgeois realism" into the collective, public, and struggle-oriented basis of "revolutionary realism".

During the 1950s new genres gained stability; the village film, the revolutionary history or war film, the thriller (or spy film), the national minority film, films with industrial subjects, and literary adaptation of works from the May Fourth movement of the 1920s. Through repetition, the visual and aural conventions of these genres established iconic significance. For example, lively folksongs accompanied rural vistas and scenes depicting industrious and energetic

peasants in the village film ;brutal torture chamber scenes tested the Party member and a large red flag celebrated the triumphal ending in the revolutionary history film; exotic song-and-dance scenes underscored non-Han romances in the national minority film, and the presence of a male cadre as adviser and mediator represented the Party's position and policies in all genres. The European-style architecture and urbane life-styles which had symbolized China's modernity in films from the 1930s and 1940s were eliminated from the screens of the 1950s and replaced largely by Soviet-style buildings and the privileging of a rural and indigenous (i.e. non-westernized) orientation.

The "Hundred Flowers" and Anti-Rightist Periods (1956-1959)

In May 1956 Mao Zedong launched the policy to "Let a Hundred Flowers Bloom and a Hundred Schools of Thought Contend" "Baihua qifang, baijia zhengming". The film circle responded eagerly to the climate of openness by hinting at the negative impact of political pressures on film-making. Articles appeared, written by officials and film directors, which attributed the lack of interesting films to restrictions imposed on the creative process.

Connections with Europe were strengthened during this period as a five-member delegation attended the Cannes festival and visited Italy, England, and Yugoslavia to observe local productions. At home, Italian neo-realist films were shown in major cities, and studied by filmmakers. Urban movie-goers were also able to see progressive films from Italy, Japan, India, and Mexico.

The search for connections between film and traditional opera, folk music, and literature also began. Discourse on the nationalization of film (dianying minzuhua) underscored the cultural basis of revolutionary realism. Affirming the need to produce 'films with Chinese flavour' was a recognition of the tastes of Chinese artists and audiences and indicated a growing independence from Soviet models. Ways of merging the traditional arts and a Marxist-Leninist world-view were explored, exemplifed by two early colour films: *Liang Shanbo and Zhuyingtai* (1954), an opera film based on a traditional love story, and *New Year's Sacrifice* (*Zhufu*, 1956), adapted by Xia Yan from Lu Xun's novella of the same name.

In the spirit of innovation, a number of films were made with anti-bureaucratic content. The satirical comedies of Lu Ban were sharpest in their criticisms: *Before the New Director Arrives* (*Xinjuzhang daolai zhiqian*, 1956) exposed the hierarchical relationship existing among cadres, and the three episodes in *The Unfinished Comedy* (*Weiwancheng de xiju*, 1957) hinted at the longevity of bureaucrats and dogmatists. Ethnic and gender bias became the focus in Cheng Yin's *Young Women from Shanghai* (*Shanghai guniang*, 1956). These films were not afraid to adopt an urban-based outlook and even to identify the wrongdoings of Party members.

In early 1957, director-centred production units were introduced in the Beijing, Shanghai, and Changchun studios. While the censorship system remained intact, the importance of the director was recognized in these units, which had more autonomy in selecting scripts and personnel, in budgeting and ensuring box-office returns. The Shanghai Studio branched into three substudios: Jiangnan, Tianma, and Haiyen, each containing two or three director-centred production units.

Then, in August 1957, the Anti-Rightist movement hit the film circle. A large number of writers and film directors were designated as "rightists", and publicly attacked for spreading "bourgeois thinking". Lu's *Unfinished Comedy* was labeled a "poisonous weed", and Lu was never allowed to direct again. The Anti-Rightist movement moved to a new stage in April 1958, when Kang Sheng (later to become one of the Gang of Four) identified a number of films as "white flags" that were against the spirit of worker-peasant-soldier films. All in all twenty-four films made during 1957 and 1958 were to be declared "white flags" and banned from circulation.

In the two years following the Anti-Rightist movement, two major developments stimulated film output without lifting the repressive climate: in 1958, the national Great Leap Forward movement called for more films; in 1959, the occasion of the tenth anniversary of the PRC, better productions were demanded. In 1958, studios reduced budgets and shortened schedules. In response to Premier Zhou Enlai's call for more "record-oriented films with an artistic character" (yishuxing jilupian), docudramas were made which combined documentary footage with re-enacted scenes to illustrate the workers' accelerated pruction during the year. Xie Jin's *Huang Bao Mei* (1958), which began with the model textile mill worker learning opera singing and ended with a dance around the textile mill in fairy costume, was hailed as the exemplary collaboration between workers, cadres, and artists. Most of the films produced in this year, however, were made to fulfill studio quotas and to break efficiency records. As a result, they appeared crude and dated; by 1962, many of them had been officially withdrawn from circulation.

The tenth anniversary of the PRC encouraged better quality productions that celebrated the Party's achievements. While focusing on China's modern history, these films all shared an appealing human focus: Cui Wei and Chen Huaikai's *Song of Youth* (*Qjngchun zhige*) traced the trials and triumphs of a young woman who was suffocated by the genteel May Fourth culture and ultimately found real liberation through participating in the Communist movement. Zheng Junli's *Lin Zexu* portrayed Commissioner Lin Zexu's anti-imperialist efforts during the Opium War. The film was meticulous in the recreation of period details, and its broad historical background was complemented by scenes that captured Lin's private moments, Wang Yan's *Our Days in the Battlefield* (*Zhanhuozhong de quincun*) told

the story of a young woman disguised as a male soldier who had to withdraw from the army after her sexual identity was revealed. These films stood out as capable works that successfully merged politics and art. Although box-office records were routinely boosted by bulk-buying from work units using state money, the 1959 record high of 4.17 billion annual movie attendance indicated that, after a decade's efforts, revolutionary cinema had earned a national audience base.

Classical revolutionary cinema (1960-1966)

The early 1960s were a time of difficult social conditions, with widespread famine, Soviet withdrawal of financial and technological assistance, and the lingering effects of the Anti-Rightist movement. However, some of the best films of the classical revolutionary period were made in these years, with directors expanding the aesthetic possibilities of revolutionary realism/romanticism. Zheng Junli, director of *Lin Zexu*, made *A Withered Tree Meets Spring* (*Kumu fengchun*, 1962) to affirm the success of the combination of western and Chinese herbal medicine in healing peasants of schizotomaisis. The film, which extolled Chairman Mao's contribution to national healing, also beautifully incorporated codes of Chinese drama, scroll painting, and poetry in a heart-rending story of separation and reunion, death and survival. Xie Jin, who emerged as a new talent in the late 1950s, demonstrated exemplary skills in adapting traditional and Hollywood type narrative and characterization strategies to revolutionary contexts. His military film *Red Detachment of Women* (*Hongse niangzijun*, 1960) incorporated thriller-type elements and exploited the 'exotic' details of southern China; while *Stage Sisters* (*Wutai jiemei*, 1964) was a finely crafted, melodramatic character study of two female opera singers.

Successful films of various genres appeared in the early 1960s. Two animated ink and wash films (shuimo donghuapian), *Where is Mama?* (*Xiaokedou zhao mama*, 1960) and *The Flute of the Cowherd* (1963), captured the art and poetry of Chinese brush painting. Xie Tieli's *Early Spring in February* (*Zaochun eryue*, 1963), adapted from a novella written by the May Fourth writer Rou Shi, dealt with emotional entanglements with an open story ending unusual for Chinese films of the time. Shui Hue's *A Revolutionary Family* (*Gaming jiating*, 1960) and Ling Zifeng's *Red Flag Chronicle* (*Hong qipu*, 1960) traced the harsh trials faced by those committed to the revolution. National minority films, such as Su Li's *Third Sister Liu* (*Liu sanjie*, 1960), Wang Jia-yue's *Five Golden Flowers* (*Wuduo Jinhua*, 1959) and Liu Qiong's *Ashma* (*A Shi Ma*, 1964), were popular for their folk tunes and vivid stories of romance which were acceptable in the non-Han contexts. Wang Ping and Dong Kena, the only women feature film directors of the period, completed *Lotus Tree Manor* (*Huaishu Zhuang*, 1962) and *A Blade of Glass on the Kunlun Mountains* (*Kunlunshanshang yikecao*, 1962) respectively. These films

featured women protagonists whose strength and determination enabled them to overcome their own losses and complete demanding revolutionary tasks.

The Cultural Revolution (1966-1976)

Attacks on drama and films served as the prelude to the Cultural Revolution. In June 1964 Mao Zedong indicated that many officials were verging on reformism, and a number of films, notably Shen Fu's *Jiangnan in the North* (*Beiguo Jiangnan*, 1963) and Xie Tieli's *Early Spring in February*, were shown in fifty-seven cities to generate a public critique of their "bourgeois" ideology. By December 1964, another ten films were labelld "poisonous weeds", including *A Revolutionary Family, Ashma*, and *Stage Sisters*. In the two years that followed, under the influence of Kang Sheng who had attacked the "white flags" in 1957, a large batch of films made in the 1950s and early 1960s that were orthodox versions of the class struggle were labeled "poisonous weeds", and many were either withdrawn from circulation or shown merely to generate public condemnation.

The political upheaval of the Cultural Revolution caused massive disruption to public and private life in China. The film industry suffered a major blow: several directors, writers, actors, and actresses were imprisoned and some died during the period, and most film professionals were dispatched to cadre schools and countryside work-camps. Almost all the films produced since 1949 were labeled "anti-Party, anti-socialist poisonous weeds" and withdrawn from circulation. Many published materials and documents on film were permanently destroyed.

From 1967 to 1972, feature film production virtually stopped; later, it was partly resumed when a few specially selected directors were assigned by the "Gang of Four" to film stage operas. The subsequent productions, *Geming yangbanxi* or "revolutionary model operas", were subjected to close supervision by Jiang Qing (Madame Mao). They took an uncompromising stance in their condemnation of class enemies and celebration of poor peasant-worker-soldier types. Each energetic and stylized stage performance meticulously combined Beijing opera modes and western ballet dance steps, accompanied by choruses and symphonic music involving western and Chinese instruments. In the filmed versions, the placement of characters, the length, type, and angle of each shot, as well as the editing, carefully realized Jiang's principle of 'three prominences' (the prominence of positive figures, the prominence of heroic figures, and the prominence of a major heroic figure). Close-ups, frontal and low-angle shots, as well as a reddish lighting scheme (in colour films), were reserved for the major hero(ine), while long shots, more or less oblique and high-angle perspectives, and a greenish lighting scheme identified class enemies. The most famous operas were: *Taking Tiger Mountain by Strategy* (*Zhiqu Weihushan*, 1970) directed by Xie Tieli; *The Red Lantern* (*Hong Dengji*, 1970) by Cheng Yin; *The White Haired Girl* (*Baimaonu*, 1970) by

Sang Hu; and *The Red Detachment of Women* (*Hongse niangzijun*, 1971) by Pan Wanzhan and Fu Jie. The latter two were based on feature films of the same names made in 1950 and 1960, but in these new versions, the growth processes of the protagonists were eliminated to indicate that they were perfect class heroines from the very beginning. These productions formed a genre of their own; a unique stage hybrid, characterized by dense colours, long takes, and a binary approach in the visual presentation of class heroes and their enemies.

After 1973 feature film production slowly resumed, as film professionals returned from work-camps. Between 1973 and 1976 about eighty films were made, with the Changchun, Beijing, and Shanghai studios bearing most of the production load. Several classical opera films were adapted from folklore for their safe and presumably apolitical character, but many of them remained unreleased. Inevitably, stylistic inflections of "revolutionary model operas" appeared in most films, and those which did not strictly follow Jiang Qing's "three prominences" principle were immediately condemned. In 1975 and 1976 the Gang of Four commissioned several films including Xie Jin's *Chun Miao* and Li Wenhua's *Breaking with Old Ideas* (*Jule*) which allegorized the Gang's political opponents within the Party as "bourgeois" characters.

"Wound" or "Scar" Films (1977-1984)

In 1977 the Gang of Four's accusations were officially refuted and the rehabilitation of film-makers was accompanied by the exhibition of the once-condemned films made between 1949 and 1965. About fifty feature films, mostly anti-Gang of Four in content, appeared in 1977 and 1978, to the audiences' delight. Zhang Yi's *Upheaval in October* (*Shiyue fengyun*, 1977), which dramatized cadres and workers struggling together against the Gang's allies in an arms factory, was in circulation for fifteen months with attendances reaching 67 million. These anti-Gang films were, however, as schematic and clichéd in their approach as the pro-Gang ones, and soon they lost their audience.

Most of the films that were adapted from "wound" or "scar" literature were produced before 1983. They focused mainly on the disruption of relationships and careers by unjustified persecution before and during the Cultural Revolution. They used flashbacks and voice-over as narrative devices, and, overall, melodramatic and poetic approaches replaced didactic ones. These films were quite outspoken about political injustice, and "re-humanization" was their goal. For example, Yang Yanjin and Deng Yimin's *Troubled Laughter* (*Kunaoren de xiao*, 1979) centred on a journalist's frustration with bureaucratic pressure, Wu Yigong's *Evening Rain* (*Bashan yeyu*, 1980) contrasted the unsympathetic Red Guard with the human warmth of the common people, and Xie Jin's melodramatic *Legend of the Tianyun Mountain* (*Tianyunshan chuanqi*, 1980) presented a relentless picture of

an intellectual's sufferings during the Anti-Rightist movement, recalled by a young woman who was pressured to jilt him for political reasons. The Party sanctioned these stark revelations of political persecutions; *Evening Rain* and *Legend of the Tianyun Mountain* won the first official Golden Rooster award in 1981, decided upon by a panel of officials and critics. The films of this period also saw a conscious redefinition of character types, in that they no longer eulogized peasants at the expense of intellectuals. For example, Wang Qimin and Sun Yu's *At Middle Age* (*Rendao zhongnian*, 1982) bemoaned the physical and mental exhaustion of a dedicated woman doctor, and Wu Tianming's *River without Buoys* (*Meiyou hangbiao de heliu*, 1983) dramatized workers' indifference to the "model operas". Overall, however, the genre of "wound" or "scar" films had run its course by 1984, as the imagination of writers and directors was captured by China's modernization.

The Process of Modernization (1984-)

Wu Tianming's 1984 film *Life* (*Ren Sheng*) was the first in a series of films that depicted an individual's struggle against his/her destiny in a conformist environment. In *Life*, a young peasant who has obtained a high-school education bitterly rejects his family background. A claustrophobic setting visually reinforces his frustrations, and reverses the idyllic views of the countryside of the village genre film. The question of whether he is a sympathetic rebel or a ruthless opportunist remains open, as a triangular love relationship shows him ready to abandon his attachments in the countryside and leave the village through a romantic connection. In a similar spirit of youthful rebelliousness, the inquisitive high-school student in Lu Xiaoya's *Girl in Red* (*Hongyi shaonu*) refuses to accept her teacher's unreasonable chastisement. The delightful interplay of colours in this film invoked a new generation's innocence and vitality. In the early years of economic reform, engaging in private enterprise became a legitimate means of changing one's destiny, and this became the subject of many films of the period. Young entrepreneurs often felt isolated, as the sewing woman experienced in Chen Beichen's *Under the Bridge* (*Daqiao xiamian*); small businesses could rise and fall quickly, as the unemployed youths in southern China find out in Zhang Liang's *Yamaha Fish-Stall* (*Yamaha yudang*). Zhang's subsequent film, *Juvenile Delinquents* (*Shaonian fan*, 1985), caused a sensation by recruiting teenagers serving in juvenile disciplinary centres as actors to depict an aspect of Chinese society that had never appeared on film before. In many of the popular films of 1984, the thematic affirmation of individual desires was reinforced by a formal independence from generic conventions, and the pursuit of a more "natural" style.

Two developments helped pave the way for the appearance of groundbreaking works in the 1980s. In December 1978 the historic 11th Plenary Session of the 3rd Central Committee of the CCP upheld an open-door policy as an integral

part of economic reform, and inaugurated the second "Hundred Flowers" period for art and literature. In 1979 a seminal article, "*On the Modernization of Film Language*" ("*Dianying yuyan de xiandaihua*"), was published, written by woman director Zhang Nuanxin and writer Li Tuo. For the first time in three decades, narration, *mise-en-scène*, cinematography, sound, and rhythm were emphasized independently of their role in political edification. The essay sparked eager discussion on the nature of film(particularly the possibility of divorcing film from theatre), questions of aesthetics, authorship, and audience. In the early 1980s, production eagerly sought inspiration from translations of western film theory as directors steered away from revolutionary realism.

A new relationship between the Party/State, the film industry, and the audience also began to take shape in the early 1980s, caused by the policy of incorporating the market economy into the planned economy. The state withdrew financial backing for all but a few productions, and each studio was required to balance its own annual budget. Audiences' tastes gained a new status. Until 1993, however, box-office receipts were still only indirectly connected to studio profit, since distribution of films was monopolized by the China Film Distribution and Exhibition Company (CFDEC), whose local representatives would order a certain number of exhibition prints based on an estimation of a film's popularity and sometimes on decisions from another district. This practice had provided a financial buffer for studios in the years when prints were bought mostly on the basis of edifying needs. However, as both CFDEC's branch offices and local theatres had to balance their own budgets while annual movie attendance fell steadily from 1984, many films did not recoup their production costs as the selling of prints was no longer guaranteed. The conversion to an audience-based film market stimulated the massive production of entertainment movies, which hastened the demise of politically didactic films. However, the increasingly competitive entertainment market also proved to be detrimental to the formal experiments begun in the early 1980s.

The Fourth Generation

The so-called "Fourth Generation" directors were more humanist in outlook than their younger counterparts, and thus were more accepted, even though they were as ambitious as the Fifth Generation in redefining China's fllmic conventions. Given the label soon after the term "Fifth Generation" appeared, the "Fourth Generation" refers to those directors who completed their professional training before 1966, and whose careers were suspended by the Cultural Revolution. While diverse in subject and style, several of their films of the mid-1980s shared a thematic concern with the conflicts and frustrations arising from an individual's attempts to break with the established system. Huang Jianzhong's *A Good Woman*

(*Liangjia funu*, 1985) incorporated Freudian imagery in its depiction of the desires of a young woman who is married to a child husband, and has an affair with a farm labourer. Xie Fei and Wu Lan's *Girl from Hunan* (*Xiangnu xiaoxiao*, 1986) had a similar story but focused on the repression and internalization of feudal ideologies, which enabled such unreasonable arrangements to perpetuate. Yan Xueshu's In the *Wild Mountains* (Ye shan, 1985), winner of the year's Golden Rooster award, traced the changes between two peasant couples as one of them responds to the opportunities brought about by economic reform. Concerns with peasants encountering a different economic climate was also broached by Hu Binliu's *Country Folk* (*Xiang min*, 1986), whose village trilogies (which included *Call of the Home Village* and *Country Couple*) thematized the clash of traditional rural values with modern ones. Wu Tianming's *Old Well* (*Lao ting*, 1987) dramatized a village's desperate search for water and the sacrifices made by a young peasant who returned from the city to help the village and his own family. In many of these films, sexual love has a redemptive value, as it is expressive of individuality and desire to change.

The rise of Xi'an Film Studio to national prominence from the mid-1980s helped to develop the "exploratory film" movement. Under the leadership of director Wu Tianming, Xi'an balanced its annual budgets with commercial hits like *Magic Braid* (*Shen bian*, 1986), and sponsored experimental works by the Fifth Generation directors. Wu undertook political and financial risks by producing *The Black Cannon Incident*, *Horse Thief*, *In their Prime*, and *King of Children*. Xi'an's goal, to 'make profit with one hand and take awards with another', was wonderfully realized when Zhang Yimou's *Red Sorghum* (*Hong gaoliang*, 1987) won the Golden Bear in the 1988 Berlin Film Festival and drew a large local audience as the result of its international reputation. Arguably, Wu's prolonged stay in the United States after 1989 also contributed to the demise of the "exploratory film" movement.

2. 第五代：张艺谋、陈凯歌和田壮壮

"第五代导演"（the Fifth Generation）是指 1982 年毕业于北京电影学院（Beijing Film Institute）的年轻电影人，1984 年张军钊导演的《一个和八个》和陈凯歌导演《黄土地》（均由张艺谋担任摄影）两部在声画造型和人文内涵方面具有里程碑意义的影片，成为现代化中国新电影的开山之作。第五代导演张艺谋的《红高粱》和《活着》、陈凯歌的《霸王别姬》和田壮壮的《蓝风筝》以其锐意创新的探索精神、深沉凝重的文化反思和张扬灵动的视听表达

《黄土地》导演、摄影和美术

《小武》

赢得世界影坛的盛誉，使中国电影一举成为全球电影不可或缺的重要力量。

张艺谋（Zhang Yimou）是具有典型意义的"第五代导演"标志性人物，他来自备受压制的社会下层，依靠自己的天赋和执着，从摄影师到导演、从艺术电影到商业类型片，执导了20世纪90年代中国电影最重要的代表作品（《菊豆》《大红灯笼高高挂》和《秋菊打官司》），其视觉造型能力和电影艺术风格获得过戛纳、威尼斯、柏林电影节和奥斯卡奖等最高肯定。2000年后张艺谋转型商业大片，又在饱受争议中也赢得了很高的票房。

1989年后，关注现实城镇生活和执着个人表达的"第六代导演"以非官方独立电影（也称地下电影）的姿态、在90年代出现在中国影坛，并继续引

发世界影坛的瞩目。张元的《妈妈》和《北京杂种》、王小帅的《冬春的日子》、何建军的《邮差》、贾樟柯的《小武》和《站台》等都是这类电影的代表作品。与此同时，商业电影的大潮也在中国迅猛兴起，冯小刚以《甲方乙方》等喜剧片和最近的《唐山大地震》等高概念大片成为中国商业电影的弄潮儿。

The Fifth Generation

Until *One and Eight* (*Yige he bage*) appeared in 1984, attempts to modernize film language did not go beyond that of humanist realism. Director Zhang Junzhao and cinematographer Zhang Yimou, both 1982 graduates of the Beijing Film Academy, shocked everyone with the unprecedented handling of filmic space (specifically, close-ups and off-screen space to create tension between characters), a sparse and highly elliptical dialogue, as well as the creation of a masculinity so far absent from China's screens. The film has an unusual story, involving a chain-gang of prisoners held by Communists during the anti-Japanese war. Many changes had to be made before the film passed the censors, and it remained unreleased for quite some time.

In the same year, Chen Kaige, also a 1982 graduate of the Academy, made *Yellow Earth* (*Huang tudi*), again with Zhang Yimou as the cinematographer. The film impressed local critics but was considered too obscure by officials. It was not until *Yellow Earth* was shown at the Hong Kong International Film Festival and received praise from enthusiastic critics and audiences that its exceptional quality was properly acknowledged. *Yellow Earth* remained a seminal film with its critical insight into China's contemporary political culture through a deceptively simple story with sparse dialogue, involving four symbolic characters. Epic shots of the loess (silt) plateau of the Yellow River were created with a cinematographic style which, like that of a traditional Chinese painting, was austere yet rich in meaning; while local tunes underscored the film's ethnographic aspects.

Chen's next film, *The Big Parade* (*Dayuebing*, 1985), used military training as a metaphor for the society's repression of difference, and his obscure *King of Children* (*Haizi wang*, 1987) was a profound critique of the oppressive nature of China's symbolic order. Tian Zhuangzhuang (1952-), a classmate of Zhang and Chen, made *On the Hunting Ground* (*Liechang zhasa*, 1985) and *Horse Thief* (*Daoma zei*, 1986), situating his stories among the dignified Mongolians, and obliquely expressing a disdain for the dominant Han nationality and their ethnocentrism. His films caused noted documentarist Joris Ivens to declare that 'Chinese film has great hope'; but since they were thought to be too obscure for the Chinese audience, very few exhibition prints were bought by the distribution

agents.

Though similar neither in theme or style, the experimental works by these young directors were identified by critics as "exploratory films" and their makers as "Fifth Generation directors". The term "exploratory" (*tansuo*) refers to an unprecedented use of modern film language, as well as an uncompromisingly critical outlook that later was regarded as too élitist, especially since many of these films failed in their home box-offices while winning awards at international festivals. The Fifth Generation label acknowledged the previous generations' contribution to the development of Chinese film.

The young Academy graduates shared the experience of marginalization, exile from urban centres, and hardship during their adolescent years because of the Cultural Revolution, and they had no reservations in publicly expressing their disillusionment with their country. More importantly, the Fifth Generation movement enforced a rupture between itself and the types of realism so far established. In relentlessly dismantling the language and ideology of an established political culture, the Fifth Generation films renounced the dramatic patterns of both revolutionary and humanist realism; instead, their narrative and formal strategies were critique-oriented. In short, the Fifth Generation films refused to be appeased with the official announcement of the coming of a "new" era.

As mavericks, the Fifth Generation directors were far from being homogeneous in their output: Wu Ziniu's *The Last Day of Winter* (*Zuihou yige dongri*, 1986) centred on a prison labour-camp in the north-western desert; Hu Mei's *Army Nurse* (*Nuer lou*, 1985) focused on a young woman's feelings in a story of repressed love; Huang Jianxin's *Black Cannon Incident* (*Heipao shijian*, 1985) was a black comedy which exposed the debilitating aspects of China's political culture, and his *Dislocation* (*Cuo wei*, 1987) was a science-fiction fantasy; Zhou Xiaowen's *In their Prime* (*Tamen zheng nianqing*, 1986) staged scenes of the Sino-Vietnamese war to expose its bleak and tragic aspects; and Zhang Zeming's *Swan Song* (*Jue xiang*, 1985) traced the disappointments and betrayals in the life of a Cantonese musician. Though not considered a Fifth Generation director, Huang Jianzhong contributed towards the movement with his surrealistic experiment *Questions for the Living (Yige shizhe dui shengzhe de fangwen*, 1986).

While tragedy and satire had been largely absent from the didactic films of the classical revolutionary period, tragedy, absurdity, and ambiguity made their return in the Fifth Generation films, which consciously steered away from the established generic conventions. Though embraced by young critics in Shanghai and Beijing who admired their "exploratory" path, from 1987 the Fifth Generation film-makers were subjected to increasing commercial pressure and criticism.

The mid-1980s saw the emergence of Zhang Yimou, from cinematographer to award-winning actor and director. Though a Fifth Generation member, Zhang

cultivated a more sensuous and popular style than many of his classmates, and his stories of desire were captivating for their legendary and mythic dimensions. His art films' accessibility both internationally and locally marked the beginning of the end of the more austere and difficult "exploratory films".

Zhang Yimou

Of the many talents to emerge among the "Fifth Generation" of Chinese film-makers, Zhang Yimou is certainly the most versatile and arguably the most significant. With international awards for acting, cinematography, and direction, he is best known for five films he has made with Gong Li in the female lead: *Red Sorghum* (1988), *Judou* (1990), *Raise the Red Lantern* (1991), *The Story of Qiu Ju* (1992), and *Shanghai Triad* (1995).

Unlike contemporaries such as Chen Kaige who came from privileged backgrounds in the Communist Party intelligentsia, Zhang was an outsider. He was born in 1950 near Xi'an in the Shaanxi district featured in films such as *Yellow Earth* (1984) and *Red Sorghum*. His father's prerevolutionary involvement with the Nationalist KMT that now runs Taiwan meant he could not find regular work and that his son was largely educated at home.

During the Cultural Revolution Zhang was sent to the countryside and later transferred to a cotton mill, where he took up still photography as a hobby. The legend of a career that almost never happened is well known; when the beijing Film Academy reopened in 1978, Zhang's application was blocked because he was over the age limit, and he was only admitted after many special pleas. Even then, he was denied entry to his chosen department, direction, and was required to study cinematography.

However, Zhang's lack of political connections ultimately proved an advantage. Upon graduation in 1982, he was assigned to the fledgeling Guangxi Film Studio in Nanning, a remote south-western city whose location Zhang had to determine with the help of a map. However, such was the shortage of talent there that the new graduates were set to work straight away.

Determined to mark their films out from the existing Socialist Realist cinema, the young film-makers chose to question what was supposedly the most glorious period of Communist revolutionary history in *One and Eight* (1984) and *Yellow Earth*; the 1930s and 1940s. As cinematographer, Zhang complemented these challenging themes with an equally challenging look. The old Chinese cinema featured well-lit and centred, glossy compositions. Zhang designed dark, asymmetrical compositions in which humans were often small dots in enormous landscapes with a high horizon line. The result took the Chinese film world by

surprise and was an enormous international success.

Zhang refined his cinematographic style in *Big Parade* (1985) and *Old Well* (1987), in which he also took the lead, and won the award for Best Actor at the ToKyo International Film Festival. In 1988, he made his directing début with *Red Sorghum*. This boisterous and lusty film, for which he discovered Gong Li, was an instant success with young people all over China; they identified with the unfettered sensuality of the lead characters, and whistled the folk-songs from the sound-track for months after the film's release. *Red Sorghum* also won Zhang the Golden Bear at the Berlin Film Festival, the first Chinese film to win such an honour.

Judou (1990)—another period piece, centred on a woman rebelling against feudal patriarchy, which won awards at Cannes and in Chicago—differed from *Red Sorghum* in two major respects. First, The high spirits of *Red Sorghum* turned to apocalyptic rage and anger at old patriarchs in *Judou*. Second, facing political censorship and reduced funds, Zhang turned to co-production financing from overseas. This pattern was repeated with the powerful but bleak and despairing *Raise the Red Lantern*.

The release of *Judou* and *Raise the Red Lantern* was blocked in mainland China for some time. Zhang's most recent film has run into no such difficulties. *The Story of Qiu Ju* indicates a shift in Zhang's spirits, and a shift in his directing style that marks his versatility and command of the medium. A wry, ironic film with none of the grandeur and flamboyance of his previous works. *The Story of Qiu Ju* depicts a peasant woman's efforts to get justice out of China's complex legal bureaucracy. The camera is static, often in long shot, reminiscent of *cinéma vérité* documentary, as in the actors' improvised dialogue. For this new departure Zhang received the Golden Lion at Venice, and his partner Gong Li, who forsook her usual glamour to play Qiu Ju, won Best Actress.

The Sixth Generation and Illegal Films

The fame of the Fifth Generation brought in funding from foreign production companies, just when domestic financing swung toward more commercial projects. Well-known directors could turn to the international arthouse market. Chen Kaige made several international coproductions, notably *Farewell My Concubine* (1993) and *The Emperor and the Assassin* (1999). Under Shaw Brothers of Hong Kong, Wu Tianming, godfather to the Fifth Generation, directed the poignant *King of Masks* (1996), from a Taiwanese script. Tian Zhuangzhuang found European and Hong Kong financing for *The Blue Kite* (1994), a chronicle of a mother's search for her husband across the years 1953-1967, from the Great Leap Forward to

the Cultural Revolution. In bold pictorial juxtapositions, Tian questions Maoist ideology and the sacrifices it demanded of the Chinese people.

While some Fifth Generation directors remained prominent, a younger generation came to the fore in the early 1990s. Most of these directors were not Film Academy graduates. They often became entranced with cinema by watching foreign films on pirated videos and reading translations of Western film theory. The Sixth Generation directors pursued their own visions, and overseas financing allowed them to skirt governmental control. The government did not forbid the making of independent films, but if a project was not submitted for censorship in the script stage or was not distributed by a studio, it became "unofficial" or "illegal". It would likely never be shown in China, and if it offended official sensibilities the maker might be punished.

One of the Sixth Generation pioneers of illegal cinema was Zhang Yuan, who began his first film, *Mama* (1990), under studio auspices. After 1989, he raised completion money from businesses, edited the movie in a hotel room, and persuaded the Xi'an Studio to release it. His second feature, *Beijing Bastards* (1993) traveled to festivals without any studio imprimatur. Similarly, Wang Xiaoshuai's *The Days* (1993), made underground for $14,000, was distributed abroad but not in China.

Centered on young people and social problems, Sixth Generation films lacked the regional flavor, exotic customs, and breathtaking landscapes on display in *Yellow Earth* or *Red Sorghum*. This was a cinema of contemporary urban life, moody and modern, set among young people who had to adjust to the new China. Marital difficulties were at the center of *The Days*, while Chinese rock music was on display in *Beijing Bastards*. In *Postman* (1995), He Jianjun created a sparse, unsettling drama based on the premise shocking to official ideology—that a postman might interfere with people's lives by reading their letters. Zhang Yuan's controversial *East Palace West Palace* (1996) portrayed Beijing's gay cruising scene.

As illegal films triumphed at festivals, the government took sterner measures, raising obstacles to coproductions and foreign investment. After Zhang Yimou's *To Live* (1994) competed at Cannes without permission, authorities demanded that any film made in China, official or not, had to pass censorship in order to be shown abroad. Zhang had to offer a "self-criticism" in order to finish the French-financed *Shanghai Triad* (1994). After *The Blue Kite*, Tian Zhuangzhuang was blacklisted from studio-based production for ten years. Directors were denied permission to leave the country, and the negatives of films shot in China were required to be deposited there until censors approved them. *Postman's* negative was smuggled out for completion in the Netherlands. The government also began to withhold approved films from any festivals which showed illegal films.

In a few years, these strictures were relaxed somewhat, but filmmakers remained at risk. Jiang Wen, one of China's most popular comedians, ran afoul of officialdom with his *Devils on the Doorstep* (2000). It begins as a humorous portrayal of culture clash during World War II, when a villager must hide a pair of Japanese soldiers. After the Japanese retake the village, the tone switches abruptly and an evening feast turns into a massacre. *Devils on the Doorstep* won the Jury prize at Cannes, but that seemed only to deepen Jiang's plight. As punishment for not submitting his work to censors, the film was forbidden to be shown at home or abroad, and Jiang was banned from Chinese cinema for seven years. He would eventually return with *The Sun Also Rises* (2007), a zestful fable set during the Cultural Revolution.

The Cinema and "Market Socialism"

For a few years, distribution was passed to the studios, but they proved unable to handle the business. By the late 1990s, the studio system of production was finished, supplying only facilities to independent films and foreign productions. An agency known as China Film Group now had a monopoly on distribution, as well as on the import of foreign titles. The government continued to finance big—budget "major theme" films, propaganda vehicles celebrating key moments in Chinese communism. These, however, drew small audiences. Directors were encouraged to create more commercial products, preferably funded by entrepreneurs. Feng Xiaogang became China's most popular filmmaker of the 1990s by concentrating on amusing fare showcasing the comedian Ge You. His *Be There or Be Square* (1998) centered on two Mainland con men who move to a crime-ridden Los Angeles in search of the good life. Funded by private investors, the film became the second-best grossing film to date. Feng baited critics by declaring that he loved making money and scorned art house movies.

The shift to entertainment-based, privately funded cinema reflected China's rapid development toward a market economy. The country was generating nearly a third of the world's economic growth. China took steps in the 1990s to join the World Trade Organization (WTO), which included concessions to Western governments. Hollywood wanted access to the one billion Chinese consumers, but it was worried about the explosion in piracy. With videotape the black market had been an irritation, but the arrival of digital technology enabled the rapid copying of millions of DVDs. Soon 95 percent of all DVDs sold on the mainland were pirate copies, with Hollywood films priced at less than a dollar. China's leisurely enforcement of copyright would be a source of conflict with Hollywood for years.

Viewers were growing more affluent and gobbling up films on video, but

exhibitors wondered how to lure them into theatres. The stunning success of *Titanic* (1997) had shown that Hollywood could help. In 1999, the government expanded the quota limit from ten to twenty and made that part of the 2001 WTO agreement. Then a revenue-sharing scheme was worked out, with the foreign company getting around 15 percent of the box-office take. The income was small by Western standards, given China's low ticket prices, but American companies wanted to enter this growing market by any means necessary. At the same time, exhibitors needed to upgrade the decrepit movie houses, and so foreign capital was welcomed. Warner Bros. was the first Hollywood studio to partner with a local company to build theaters, and the joint venture's Beijing multiplex quickly became the most popular venue in China. In all, foreign money helped support production and upgrade exhibition in line with the new market policy.

Then came *Hero* (2002). The timing was ideal. *Crouching Tiger, Hidden Dragon* (2000) had proven that an expensive-looking martial-arts film could make millions worldwide. Backed by the Hollywood firm Miramax, Zhang Yimou tried to outdo *Crouching Tiger* in grandiose spectacle. A boldly unrealistic color scheme differentiates flashbacks, and CGI creates vast crowds and turns swordfights into painterly abstractions. Using a quartet of stars, Zhang created the biggest-earning Mainland film yet made. So eager was the government to support the project that it removed competing films from theaters and even managed to suppress bootleg copies for a time.

Hero set the mold for a cycle of lush costume epics, both by Zhang (*House of Flying Daggers*, 2004; *Curse of the Golden Flower*, 2006) and by fellow Fifth Generation veteran Chen Kaige (*The Promise*, 2005). Feng Xiaogeng, never reluctant to follow a trend, provided *The Banquet* (2006), and Hong Kong producers got into the act with Tsui Hark's *Seven Swords* (200,5), Jackie Chan's *The Myth* (2005), and Peter Chan's *The Warlords* (2007). John Woo returned from Hollywood to make the most expensive Chinese film to date, *Red Cliff* (2008). Censors approved of these safely distant imperial spectacles, and audiences were drawn to the pageantry, mild sexuality, and spectacular battle scenes. *Hero* also showed that release tactics could massage the market. The government began imposing "blackout periods", weeks or months in which only local pictures could be shown. It also restricted the number of copies of imported films. Thanks to such maneuvers, Mainland films were assured a substantial market share.

The new megapictures attracted production investment, which grew to over $100 million in 2007. A large part of the growth was due to 2003's Closer Economic Partnership Arrangement (CEPA), which gave Hong Kong investors preferred access to the Mainland market. Mainland-Hong Kong coproductions increased, usually coordinated by the state-owned China Film Group Corporation. The CFG controlled production facilities, a distribution company, and several

theater circuits, while also having power to set release dates.

CEPA also enabled China to push back U.S. encroachment. In 2005, Warner Bros. abandoned its theater investments, and Hong Kong companies such as Golden Harvest rushed to fill the gap. American funding had helped China upgrade its exhibition sector until the industry was mature enough to attract Asian capital.

Thanks to *Hero* and its successors, Chen Kaige and Zhang Yimou, the nonconformist talents of the Fifth Generation, were now the establishment. Zhang became the official filmmaker of the New China and perhaps its most famous figure in all the arts. Had he sold out? "You can say all I care about is kissing up to foreign audiences or the Chinese government. Fine, I don't care.... You can hate my films, but no one can accuse me of not loving the art of film".

At the other extreme, Jia Zhang-ke (1970-)became the most visible member of the Sixth Generation. Jia first attracted attention with a realistic drama about a pickpocket, *Xiao Wu* (1997), and a year later he called for a new "amateur" cinema to counter bland commercial imitations of Hollywood. "Independent filmmakers don't care about professional conventions because this is the only way they can give themselves the freedom to work creatively".

Jia's breakthrough film was *Platform* (2000). Like *The Blue Kite*, *Platform* undertakes an ambitious survey of recent Chinese history. Jia follows a provincial acting troupe across the post-Mao period, tracing how traditions erode and young people start to question their elders' authority. *Platform's* long-take style suggested that Chinese cinema was being influenced by Taiwanese masters Edward Yang and Hou Hsiao-hsien.

Although most of his films were banned, Jia established himself as China's outstanding new voice. He portrayed unprepared youths drifting through the confusions of globalizing China. *The World* (2004) took place in an actual theme park that replicates the Eiffel Tower, the Leaning Tower of Pisa, the Pyramids, and other wonders. The tangled passions and misunderstandings of the provincial young people who work there are filmed in Jia's characteristically dry, distant takes. *Still Life* (2006) located a private drama in h village about to be flooded by a dam project. It is the sort of topic that might have attracted the Fifth Generation in the 1980s, but Jia blends documentary realism with abstract compositions and computer effects that inject doses of fantasy.

Jia and his fellow filmmakers pleaded for specialized theaters and a rating system that would protect their challenging films, to no avail. Films were routinely recut and suppressed. *Peacock* (2005), another survey of a family's journey through recent history, went through several versions, with scenes of homosexuality deleted. Directors, some of them living-overseas, found foreign money to make films about Mainland life. Lou Ye's dreamlike *Vertigo* homage *Suzhou River* (2000) and Li Yang's harsh, suspenseful *Blind Shaft* (2003) represented China to the West

but were denied screenings in the country they depicted. Lou, banned from filming for two years after *Suzhou River*, screened *Summer Palace* (2006) at Cannes without government approval; its explicit sex scenes and footage earned him another five-year penalty.

Films in lower-line genres could get away with more. *Baober in Love* (2003) was a zany, *Amélie*-like exercise in style. Another romantic comedy, *Waiting Alone* (2004), satirized clubgoing and youth fads. In 2006, *Crazy Stone*, a modestly budgeted farce about a jewel robbery gone wrong, became a box-office sensation. With its scatological humor, satire on wealth and pretension, and comic-book HD look, *Crazy Stone* confirmed that Chinese popular cinema could succeed without appeal to pageantry.

By 2007, China was turning out films for local consumption, some regional hits, and fare for western festivals and arthouses. It was also starting to export its local blockbusters to Europe and North America. But for some time it could thrive on its domestic audience, which now constituted one-fifth of the world's population and which was becoming affluent at a breathtaking rate. The boxoffice revenue was increasing by 25 percent each year. There was much money to be made, by people on the scene and by eager foreigners, and the government was controlling the operation with a strong hand.

3. 香港电影新浪潮

最初的香港电影分为国语片和粤语片两大类，基本沿用 1949 年前上海电影的商业剧情片和类型片的套路。20 世纪 60 年代主导香港电影的邵氏公司涌现出胡金铨的《大醉侠》《侠女》和张彻的《独臂刀》等新武侠片（the New Wuxia Pian）。而 70 年代异军突起的嘉禾公司则使李小龙的功夫片（the Kung-Fu Film）风靡全球。

香港电影新浪潮（the Hong Kong New Wave）出现在 20 世纪 70 年代末和 80 年代初，是一批留学欧美、电视起家的年轻导演掀起的一场香港电影创新运动，他（她）们关注人际家庭关系、社会现实问题和本土文化困境等主题内涵，并追求实验性的视听语言表达。香港电影新浪潮的重要作品包括许鞍华的《疯劫》、徐克的《蝶变》、方育平（Allen Fong）的《父子情》和严浩的《茄喱啡》等。

20 世纪 80、90 年代香港电影继续在商业和艺术两个侧面继续引发本土和国际影坛的瞩目，而吴宇森的《英雄本色》和《喋血双雄》、王家卫的《阿飞正传》和《花样年华》就是这一时期深受欢迎的香港电影。

李小龙

《英雄本色》

Hong Kong

The most prominent Asian cinema outside Japan was located in the British Crown Colony of Hong Kong. During the 1930s, Hong Kong had been a refuge for Chinese filmmakers fleeing the war-torn Mainland, and by the 1950s several studios were operating there. Hong Kong firms provided comedies, family melodramas, Cantonese opera films, and swordfight movies to South China and Chinese populations throughout East and Southeast Asia.

Shaw Brothers and the New Wuxia Pian One company came to rule the market. The Shaw Brothers firm had established all entertainment empire in Singapore. The indefatigable entrepreneur Run Run Shaw decided to use Hong Kong as his production base and in 1958 built a studio there. Shaw's Movietown complex held ten shooting stages, numerous backlots (including an artificial lake), an actor's training school, laboratory and sound facilities, and even dormitories and apartments for the employees. Shaw Brothers was vertically integrated, owning distribution agencies and theater chains throughout East Asia, and the company emphasized production in Mandarin, the most common regional Chinese dialect.

During the 1960s, Shaw pioneered the revision of the martial-arts film (the *wuxia pian*, or film of "martial chivalry"). Borrowing from Peking-opera acrobatics, Japanese samurai films, spaghetti Westerns, and even James Bond films, the Shaw swordplay movies were vehicles for dazzling action. Chang Cheh, the most successful practitioner of the genre, turned *The One-Armed Swordsman* (1966) and *Golden Swallow* (1968) into violent spectacles. Chang's assistant directors and choreographers went on to become important directors in the 1970s.

Shaw's other wuxia pian master was King Hu, whose *Come Drink with Me* (1965) marked the emergence of the new swordplay film. *Come Drink with Me* builds its action out of intrigues and masquerades among the guests at an inn. Hu's

rapid editing, sweeping widescreen compositions, and Peking-opera acrobatics gave the genre a fresh panache. Hu left Shaw Brothers for Taiwan, where he made several films. The most influential, *A Touch of Zen* (1970), was mounted on a scale unprecedented in the wuxia pian. Based upon the intricacies of Buddhist philosophy, the original version ran three hours and pushed Hu's stylization to new extremes. Warriors hurl themselves over rocks, ricochet off walls and tree trunks, and swoop down from the sky. A fierce combat in a bamboo grove has become a classic sequence, reworked in Ang Lee's *Crouching Tiger, Hidden Dragon* (2000). In Hu's work, the swordplay film achieved a new kinetic grace, and his productions had an enduring influence on Asian cinema.

Bruce Lee and the Kung-Fu Film A fresh martial-arts cycle came to popularity under the auspices of Raymond Chow. Chow had been head of production for Run Run Shaw, but in 1970 he broke away to found his own company, Golden Harvest, and to make films starring the martial artist Bruce Lee.

Born in California, Lee had been a popular juvenile actor in Hong Kong, but he found only minor roles in U.S. films and television. Then Golden Harvest's *The Big Boss* (aka *Fists of Fury*, 1971) burst onto screens. It propelled Lee to stardom and made kung fu known worldwide. Chow built on Lee's success with *Fist of Fury* (aka *The Chinese Connection*, 1972) and *The Way of the Dragon* (1972), each of which broke box-office records. Lee appeared with minor Hollywood actors in the bigger-budget *Enter the Dragon* (1973), a coproduction with Warner Bros.

The most famous Chinese star in history, Lee opened foreign markets to Hong Kong films. He saw himself as an emblem of the excellence of Chinese martial arts, a point made explicit in *Fist of Fury*, which celebrates Shanghai's resistance to Japanese occupation during World War II. Lee's films, enjoyed throughout the Third World, were often taken as symbolizing the rebellious pride of insurgent Asia. His death under mysterious circumstances in 1973 secured his status as a cult hero.

Although Lee directed only one film, *The Way of the Dragon*, he shaped the productions to project his star image. Typically he played a superman, unquestionably the best fighter around but keeping his full force in reserve until the explosive climax. Lee insisted on more realistic combat scenes than were the norm in Hong Kong films, displaying his skill in longish takes and long shots.

After Lee's death, producers cast about for substitutes, but none had Lee's fierce charisma. Nevertheless, foreign audiences had embraced the genre, and Raymond Chow's enterprise grew. By the mid-1970s, Golden Harvest and Shaw Brothers produced around one-third of Hong Kong films. Chow controlled the largest theater circuit in the colony and 500 other screens across Asia. The martial-arts film, as developed under Shaw and Chow, contributed conventions to action movies around the world and won Hong Kong films a place in international

markets.

Breakthroughs in the 1980s From the 1960s through the early 1990s, Hong Kong cinema was a vital force. In the colony itself, it dominated the box office. The genres and stars were hugely popular throughout Asia, as well as in Africa, Latin America, and Asian communities in Europe and North America. Vertically integrated companies like Shaw Brothers and Raymond Chow's Golden Harvest supplied their own theaters with a staple product, while smaller production companies, funded by stars, businessmen, and triads, found a responsive audience as well.

Some directors, such as Shaw's Lau Kar-leung, sustained the martial-arts genre in *Spiritual Boxer* (1975) and *The Eight-Diagram Pole Fighter* (1984), but on the whole swordplay and kung-fu films declined. Police thrillers, contemporary comedies, and underworld action films became the major genres of the 1980s. For many critics and audiences, the new genres reflected the city's modernizing, Westernizing culture. New stars also emerged. The television comedian Michael Hui formed his own company and provided Golden Harvest with a string of slapstick films (*Games Gamblers Play*, 1974; *Security Unlimited*, 1981; *Chicken and Duck Talk*, 1988). Hui played grasping merchants and boorish professionals, types readily associated with the new mercantile Hong Kong.

The success of Hui's comedies boosted another performer, Jackie Chan. Chan began his career as a Bruce Lee imitator before mixing acrobatic kung fu with breakneck comedy in *Snake in the Eagle's Shadow* (1978) and *Young Master* (1980). Chan soon became the biggest star in Asia. Refusing to use a double, he executed astonishingly risky stunts while giving himself a screen persona reminiscent of Keaton and Harold Lloyd—the diminutive, resourceful, never-say-die average man. Chan also shifted genres rapidly. Sensing that kung fu was waning in popularity, he blended action and his physical comedy with historical intrigue (*Project A,* 1983), the cop thriller (*Police Story*, 1985), and swashbuckling adventure modeled on *Raiders of the Lost Ark* (*Armour of God,* 1986). Chan remained a popular star well into the 2000s, when he became widely known to Western audiences in Hollywood's *Rush Hour* franchise.

The Hong Kong New Wave

The sense of a cosmopolitan Hong Kong identity was an important ingredient in the "new wave" of the late 1970s. A new film culture emerged with the establishment of the Hong Kong Film Festival (1977), serious magazines, and college courses. Several directors, often trained abroad and starting out in local television production, won international recognition. Some remained independent

filmmakers, while others quickly became central forces in the industry—the Hong Kong equivalents of the Hollywood "movie brats" of the 1970s.

After directing in television, Ann Hui (1947-) entered feature production with *The Secret* (1979), a murder mystery using an unprecedented number of women in production roles. *The Spooky Bunch* (1980) helped revive the ghost-story genre, and *The Story of Woo Viet* (1981) looked forward to the "hero" crime films. Hui's international reputation rested on more somber dramas reflecting on postwar Asian history. *Boat People* (1982) explains the political oppression that drives Vietnamese to emigrate to Hong Kong. *Song of the Exile* (1990) traces how a young woman comes to understand the complex past of her mother, a Japanese woman sent to become a prostitute in China during the war.

Other filmmakers contributed to the New Wave. Shu Kei's *Sealed with a Kiss* (1981) detailed a love affair between two handicapped adolescents. Allen Fong (1947-), who studied filmmaking at the University of Southern California, also specialized in intimate human dramas. Rejecting the hectic pace of commercial cinema, often obliged to shoot in 16mm, Fong worked in a bittersweet vein reminiscent of Truffaut in *Father and Son* (1981) and *Ah Ying* (1983).

The sobriety of such films identified the Hong Kong New Wave with social commentary and psychological nuance. But this side of the trend was quickly overwhelmed by a rapid-fire revamping of popular genres. Central to this development was Tsui Hark (1950-). Tsui studied film in the United States before directing TV movies. He entered theatrical features with a futuristic wuxia plan, The *Butterfly Murders* (1979). After some violent satires, Tsui turned abruptly toward more affirmative entertainment. He launched a cycle of fantasy wuxia films with *Zu: Warriors of the Magic Mountain* (1982), and he gained more recognition with the period adventures *Shanghai Blues* (1984) and *Peking Opera Blues* (1986).

These dazzling, hyperactive mixtures of action, comedy, and sentimental romance borrow openly from the New Hollywood. Tsui's scenes are busy to the point of exhaustion: the camera rushes up to the actors and wide-angle setups multiply rapidly. A characteristic scene of *Shanghai Blues* shows several characters dodging one another, popping up in unexpected crannies of the frame.

Like Spielberg and Lucas, Tsui became a powerful producer. His company, Film Workshop, produced many of the all-time successes of the Hong Kong cinema. John Woo's gory *A Better Tomorrow* (1986) made television star Chow Yun-fat sensationally popular and launched a cycle of "hero" films featuring sensitive, romanticized gangsters. Tsui also produced Ching Siu-tung's *A Chinese Ghost Story* (1987), an extravaganza of supernatural martial arts, and the key Jet Li vehicle *Once upon a Time in China* (1991)—both of which spawned numerous sequels and clones. Tsui's success with flamboyant entertainment signaled the end of the New Wave and created a vogue for flashy, fast-paced movies.

The films of Tsui and his colleagues, showcasing visceral style and open appeal to emotion, began to be recognized in Western circles. European and North American distributors circulated Woo's *The Killer* (1989), in which the gangster-hero cycle reaches delirious heights. In the middle of almost unremitting carnage and sentimental scenes of manly devotion, genial conversations are conducted at gunpoint. U.S. companies began hiring Woo, Tsui, and other Hong Kong directors for lowbudget action pictures, and Woo became an A-list presence, earning assignments like *Face/Off* (1997), and *Mission: impossible II* (2000). Ironically, however, the worldwide appreciation of Hong Kong cinema coincided with a downturn in the local industry's fortunes.

4. 台湾新电影：侯孝贤和杨德昌

台湾电影肇始于日据时代，1949年蒋介石政权退居台湾后，《薛平贵与王宝钏》之类的台语歌仔片长久风靡，与此并行的是20世纪60年代李行《蚵女》和《养鸭人家》等写实主义电影，而20世纪70年代流行的关注青年学生的琼瑶电影则为台湾新电影作出铺垫。

台湾新电影开始于两部集锦片《光阴的故事》和《儿子的大玩偶》，旨在追寻自己的本土身份认同、传统血脉与现代变迁的纠缠、争取创作的自由表达并反抗保守的电影体制。作为台湾新电影的两大主力，侯孝贤以《风柜来的人》《冬冬的假期》《童年往事》和《悲情城市》等个性化的沉思、简约性的风格和东方式的气韵，展示个人的郁结和本土的宿命。而杨德昌则以其《海滩的一天》《恐怖分子》和《枯岭街少年杀人事件》等，冷峻而悲悯地关注城市青少年生存的焦虑和道德价值的失范。

20世纪90年代，留学美国的台湾导演李安凭借反映中外新旧文化冲突的《喜宴》和《饮食男女》成功进军好莱坞，并通过《卧虎藏龙》成就叫好又叫座的全球新武侠片热潮。另外，蔡明亮执著于拍摄《爱情万岁》等艺术片，也为台湾电影赢得了很大的国际声誉。

Taiwan

In 1982, Taiwan was an unlikely source of innovative filmmaking. Its products were notorious for being either stultifyingly propagandistic or rudimentary, lowbudget entertainment. Yet by 1986, Taiwanese cinema had become one of the most exciting areas of international film culture.

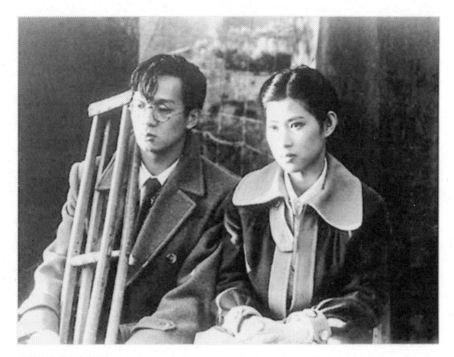

侯孝贤的《悲情城市》

Taiwan was colonized by the Japanese in 1895, and not until World War II were they driven out. But native Taiwanese were not to enjoy independence long. In 1949, Chiang' Kai-shek's Guomindong troops fled Mao's revolution, bringing 2 million mainland Chinese to the island. The emigrants took control and created an authoritarian state, on the grounds that Chiang, China's rightful leader, would someday retake the mainland. Martial law was declared for the indefinite future.

Initially, filmmaking was under the control of the government, principally through the Central Motion Picture Corporation (CMPC). The CMPC and other agencies concentrated on making anti-Communist documentaries. Commercial firms copied the costume operas, comedies, love stories, and martial arts movies brought in from Hong Kong. Some Hong Kong directors and companies set up studios in Taiwan. The CMPC moved toward fictional films no less didactic than its documentaries had been. Production soared, reaching over 200 features per year, and movie attendance increased dramatically.

Yet in the early 1980s, a decline set in. Star-laden Hong Kong films pulled viewers away from domestic productions. At the same time, Taiwan was shifting from a rural economy to one based on manufacturing and modern technology. For many young people, Chiang Kai-shek's promise to recapture the mainland

was dead; like Hong Kong youth, they sought a distinct cultural identity. College-educated and urban white-collar workers disdained the action pictures and romances that were the staples of Taiwanese production.

The Taiwanese New Wave

During this period, a new film culture emerged. The government created a national archive in 1979, and three years later an annual film festival began showcasing new works. Film magazines appeared, and European classics were screened in universities and small theatres. As with many new waves—in 1950s France, in 1960s Eastern Europe, in 1970s Germany—an educated, affluent audience was ready for a national art cinema.

So too was the industry. By 1982, the box-office decline pressed the CMPC and commercial producers to recruit young, largely Western-trained directors. The success of the anthology-films *In Our Times* (1982) and *The Sandwich Man* (1983) and a host of new features proved that low-budget films could attract audiences and win prestige at festivals. In effect, the government conjured up a new cinema. Like many other "young cinemas", the Taiwanese New Wave benefited from a financial crisis, and the industry welcomed cheap, quickly made fihns by newcomers.

Most of the New Wave films reacted against the studio-bound spectacle characteristic of Taiwanese cinema. Like the Neorealists and the directors of France's *Nouvelle Vague*, the directors took their cameras on location to film loose, episodic narratives, often enacted by nonprofessional performers. Many of the films were autobiographical stories or psychological studies. Since government policy banned overt political comment, social criticism was left implicit. Directors cultivated an elliptical approach to storytelling, using flashbacks and fantasy sequences, and dedramatized situations—all owing something to European art cinema of the 1960s. Two very different directors stood out: Edward Yang and Hou Hsiao-Hsien.

Edward Yang and Hou Hsiao-Hsien

Born in China in 1947 to families who then emigrated to Taiwan, the island's two major filmmakers pursued paths that often split off and occasionally converged. Both were given a key opportunity through the government's New Cinema initiative, but their films became significantly different.

Yang went to college in the U.S., studying computer science before returning to Taiwan in the 1980s. After doing some scriptwriting and television directing, he won a chance to direct an episode of *In Our Times*, which led to his first feature, *That Day, on the Beach* (1983). The success of the film led him to make *Taipei*

Story (1985) and *The Terrorizers* (1986).

Yang focused on the anomie and frustration of young urban professionals. Wearing chic fashions and living in modern apartments, his characters fall prey to mysterious forces rippling through the metropolis. *The Terrorizers*, for instance, intercuts two stories: that of a Eurasian woman involved with terrorists and that of a young novelist who eventually separates from her husband. A fan of comic books, Yang relies on striking imagery, staccato cutting, and a minimum of dialogue. He uses urban architecture to frame his yuppies in static, foreboding shots.

The Terrorizers won acclaim overseas, but with the decline of the New Wave, it took Yang several years to win support for the film many regard as his masterpiece. *A Brighter Summer Day* (1991) took its title from an Elvis Presley song and told the story of a 1960s teenage gang. Nearly four hours long, with dozens of speaking parts, the film pivots on what one boy saw—or didn't see— one evening in a schoolroom; that glimpse leads eventually to murder. Yang's technique is at its most refined in his gang confrontations, staged in long takes and rich depth.

Hou Hsiao-hsien started in the film industry by another route, becoming an assistant director after studying at the Taipei Academy of Dramatic Art. His first solo efforts were ingratiating teenage musicals. His episode in *The Sandwich Man*, however, turned him toward a more personal and contemplative cinema. His major New Wave films—*A Summer at Grandpa's* (1984), *The Time to Live and the Time to Die* (1985), and *Dust in the Wind* (1986)—dedramatize the narrative. Coming-of-age stories, usually taking place in a rural milieu, the films recall Satayajit Ray's Apu trilogy in building up a rich texture of daily life through dwelling on mundane routines. The story emerges not out of dramatic climaxes but out of details, observed in a painstaking rhythm. Hou also obliquely evokes the history of Taiwan through the interplay among generations.

Hou applied this dedramatizing strategy to film technique through extreme long shots, long takes, static framing, and almost no shot/reverse-shot cutting. Like Kenji Mizoguchi and Jacques Tati, he subordinates character action to a large-scale visual field. The viewer's eye roams around the frame, led into depth and often to the very limits of visibility. Hou sometimes punctuates these long-take scenes with Ozu-like shots of landscapes or objects.

With *City of Sadness*, Hou launched a trilogy on Taiwanese history, which included *The Puppetmaster* (1993) and *Good Men, Good Women* (1995). In these films past and present mingle unpredictably, sometimes in the same shot, and Hou meditates on the mixture of languages and cultures that constitute modern Taiwan. One of his most striking accomplishments was *Flowers of Shanghai* (1998), a sumptuous re-creation of nineteenth-century Chinese brothel society. Lit by

lanterns, observed in long takes by a gently arcing camera, the sexual intrigues and drinking games become mesmeric.

During the heyday of the New Wave, Hou and Yang tried to form a cooperative production company and an alternative distribution network. The decline of the domestic industry, however, blocked their efforts. Their films had virtually no audience in Taiwan, but overseas financing and the film festival circuit gave them vigorous international careers. Hou's 1990s films were widely considered among the world's best, and Yang won a Cannes prize for his family drama *Yi Yi* (2000), Hou began to make films in Japan (*Café Lumiere*, 2003) and France (*Flight of the Red Balloon*, 2007), and Yang died in 2007, but their accomplishments continued to influence young filmmakers across Asia.

A New Cohort of Filmmakers

By 1987, the New Cinema had ended. The success of video entertainment in Taiwan (a center of videocassette piracy) drove production to abysmal laws, and Hong Kong imports still ruled the market. At the same moment, however, martial law was lifted, censorship relaxed, and those filmmakers still practicing could broach sensitive issues of Taiwanese history and identity. Hou's *City of Sadness* (1990), which won the main prize at the Venice Film Festival, portrays in muted form how the events of 1945-1949 tear a family apart—a topic filmmakers could not have treated a few years earlier.

Now that Taiwan had no seat at the United Nations, there was a need to remind the world that this island was a home to progress and a unique vessel of Chinese culture. Film became a major vehicle for presenting Taiwanese life to overseas audiences. Gratified by the success of the New Wave at festivals, government agencies continued to fund filmmaking. The result, in the eyes of many observers, was a cinema of personal expression that ignored the mass audience. The government, eager to win a place in international trade, took down quotas, and American films poured in, making films in the New Wave mold seem rustic and introverted. Taiwanese filmmaking nonetheless continued to win prizes at overseas festivals. Hou and Yang became reluctant to release their films in Taiwan, knowing that they had no appeal on home ground. Ironically, a cinema aiming to capture local life had lost its own public.

Younger filmmakers benefited from the New Wave, particularly in its focus on young people's search for identity. *Murmur of Youth* (1997) focused on the growing affection between two girls working as movie ticketsellers. Chang Tso-chi, Hou's assistant on *City of Sadness*, built *Darkness and Light* (1999) around a girl who spends her summer caring for her blind father and becoming involved with two young men. Chen Kuo-fu, another associate of Hou, created in *Treasure Island* (1993) a powerful tale of a boy caught up in organized crime, and his *The*

Personals (1998) wrung social satire from an executive's search for a husband through a newspaper advertisement.

One member of this cohort achieved worldwide popular success. Ang Lee (1954-) was born in Taiwan but studied film at New York University, He returned to his homeland and with government aid made *Pushing Hands* (1991). He followed with *The Wedding Banquet* (1993), a comedy about a gay bridegroom, and *Eat Drink Man Woman* (1994), centering on a father's tense relations with his daughters. These became international hits, and Lee moved into English-language filmmaking with a string of varied projects, from blockbusters (*Hulk*, 2003) to psychological dramas (*Brokeback Mountain*, 2005). He did not forsake Chinese cinema, however, returning to the region for his swordplay saga *Crouching Tiger, Hidden Dragon* (2000) and the spy romance *Lust, Caution* (2007), Although Lee was often considered an American or Asian—American director, Taiwanese pointed to him proudly. His early 1990s "father trilogy" gave Taiwan an international visibility it received in no other media.

On the festival front, the most prominent and prolific of the newcomers was Tsai Ming-liang (1957-). Like Hou and Yang, he favored long takes and tangled storylines, but he brought to his films of dysfunctional families an anxious, somewhat comic eroticism alien to the older generation. In *Vive l'amour* (1994) a boy hiding under a bed becomes embarrassingly aroused when a couple make love above him. In *The River* (1997) a gay father searching for lovers in a darkened bathhouse inadvertently makes overtures to his son. *The Hole* (1998) shows an apartment house crumbling and flooding during a rainstorm; casual contacts among the tenants are interrupted by musical production numbers.

Although influenced by the New Wave, Tsai's films reach back to the music and films of his childhood in Malaysia. *Goodbye Dragon Inn* (2003) depicts the last night of a decrepit movie house, which is showing a King Hu classic that Tsai saw when he was eleven. Youthful nostalgia, however, doesn't exclude brash humor; during the screening of *Dragon Inn*, gay men cruising the theatre are caught in impish sight gags. Tsai's film proved a top local attraction—as did the far more outrageous *Wayward Cloud* (2005), which traced the offscreen romance of two porn actors through song-and-dance sequences and boldly filmed sex scenes (one starring a watermelon).

Tsai became an influential force in local film culture. His daring themes encouraged 'directors to make gay comedies and romances with broader appeal, such as *Formula* 17 (2004) and *Spider Lilies* (2007). His protégé, actor Lee Kang-sheng, embarked on his own directing career. Yet such gains seemed minor in the face of huge problems. Hollywood films dominated screens. The twelve to twenty Taiwanese films released each year took in less than 3 percent of the box office. High-grossing films such as the thrillers *Double Vision* (2002) and *Silk* (2006)

were rare.

Attendance dropped as young people took to the Internet, videogames, and pirated DVDs. Throughout the 2000s, the government experimented with generous credit schemes to lure foreign projects to the island and to invest in local production, but these attempts bore little fruit. New companies, hoping to replicate the success of *Crouching Tiger*, aimed for pan-Asian coproductions featuring bankable Hong Kong and Japanese stars. When Ang Lee won the top prize at Venice with *Lust, Caution*, the government awarded him $600,000. He converted it into a fund to help young filmmakers, because "so few Taiwanese directors are able to make a living by pursuing their art." As the New Cinema and Tsai's generation had shown, the best prospects for Taiwanese filmmaking continued to lie in the arthouse realm.

第七节 美国先锋派电影

1. 美国地下电影

第二次世界大战导致大量欧洲电影人才的流落北美新大陆,包括雷内·克莱尔、路易斯·布纽埃尔和汉斯·里希特等在内的欧洲先锋电影大师,为美国带来新奇、另类和实验性的电影艺术观念,成为培育美国先锋派电影(又称美国地下电影或另类电影)的重要前提。

The Cinematic Avant-Garde

The French term *avant-garde* signifies a vanguard—those who march in front, keep ahead of the pack. In the arts, it defines creators who break with standard conventions and push beyond accepted limits of form. In cinema, vanguard filmmakers have been designated by such terms as "experimental" or "underground". Earlier chapters gave attention to avant-garde filmmaking from the era prior to World War II. Here further manifestations of noncommercial or anti-mainstream cinema will be traced through the postwar decades. It has been a period of diverse and sometimes contradictory trends for avant-garde filmmaking, containing extreme forms of film experiment along with greater opportunities for vanguard film-makers to move closer to the mainstream.

In the World War II era, fascism and war drove many of Europe's avant-garde filmmakers into exile. Hollywood companies played an important role in their support, as the studios also had done with other film workers. Among

pioneer vanguard figures, for example, René Clair, maker of *Paris qui dort* and *Entr'acte*, spent the war years in the United States directing fiction features. Luis Buñuel, maker of *Un Chien andalou*, worked in New York and later in Hollywood, where he was hired to dub features into Spanish. While these circumstances were shaped by war's disruptions—Clair returned to France after the war and Buñuel (as we have seen) went on to Mexico and eventually to Europe—they suggest a more complex relationship between Hollywood and the avant-garde than one might assume. Mainstream cinema served not only as an aesthetic antagonist for vanguard filmmakers but also as a source for imagery, an occasion for commentary or parody, and sometimes a goal. As it happened, not entirely by coincidence, the film that launched the postwar avant-garde movement was made privately in Hollywood during the war, not far from the studios' doors.

2. 梅雅·德伦

出生于俄国的梅雅·德伦（Maya Deren）被称为美国最著名的先锋派"电影诗人"（film poet），她的《午后的网罗》是对潜意识心理和偏执迫害妄想最精妙的呈现，而《摄影机对舞蹈的研究：双人舞》则对电影的运动性时空关系作出有益的探索。

Maya Deren

The film was *Meshes of the Afternoon* (1943), a fourteen-minute work by Maya Deren (1917-1961) with Alexander Hammid. It has become one of the most famous avant-garde film in cinema history and perhaps the best documented, thanks to a remarkable publishing project, *The Legend of Maya Deren*, by VèVè A. Clark, Millicent Hodson, and Catrina Neiman, which has compiled in two volumes more than a thousand pages of documents, interviews, and film criticism covering the first thirty years of Deren's life (with more books to come on her later years).

Born in Russia and brought to the United States with her family as a child, Deren was preparing a book on dance and traveling with a dance company when she arrived in Los Angeles, where she met and married Hammid, a filmmaker in exile from Czechoslovakia. Deren took up photography and poetry. In late spring 1943, just before moving to New York, the couple decided to make a film. They shot it with a 16mm camera without sound (a music soundtrack was added years later) and without a scenario, planning shots as they went along and performing the

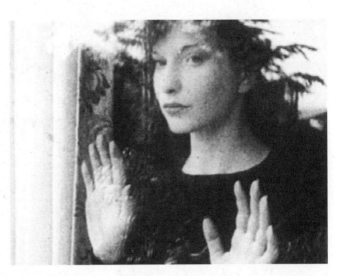

《午后的网罗》

roles themselves.

 Meshes of the Afternoon has been described in many ways-as a film poem, a dream film, a trance film, as a work that forms a bridge between the prewar European Surrealist avant-garde and the postwar self-exploratory "New American Cinema". Deren portrays a woman who enters an apartment, sits down in an armchair, and falls asleep. The film's images then become her increasingly disorienting and violent dreams, shot at odd angles and in slow motion. Household objects take on ominous character in the dream sequences, and her "self" splits into three identical figures, two of whom appear together in double-expo sure shots. Just as one of the dream women appears to stab the sleeping woman with a kitchen knife, a man (Hammid) intervenes and waking life seems to return. But at the end the man finds the woman dead in the armchair. Nearly every shot of *Meshes of the Afternoon* conveys a distinct beauty and mystery, and repeated viewings suggest few pat psychological or symbolic explanations.

 In New York, working on her own, Deren continued to make short dreamlike films and to promote her film aesthetics through screenings and writings. After the war, communities of filmmakers, critics, and audiences formed in the United States on both east and west coasts. New York's Cinema 16 was established as a film society on the model of prewar European "ciné-clubs". In San Francisco, the Museum of Art inaugurated a historic series, Art in Cinema, that screened European avant-garde classics and the works of Deren and her contemporaries, such as *The Potted Psalm* (1946) by Sidney Peterson and James Broughton, who collaborated on this debut film and then went on separately to careers as

independent filmmakers. Another significant first appearance was *Fireworks* (1947), a symbolically homoerotic work by a seventeen-year-old filmmaker, Kenneth Anger, who had been making short films since he was eleven. An "underground" film culture gradually developed in the United States in the first decade after the war. But it was not until the late 1950s-early 1960s, when the country entered a period of political and cultural transformations and a crisis in mainstream filmmaking also became apparent, that independent and avant-garde films began to make wider impact.

3. 60 年代美国另类电影

60 年代是美国另类电影蓬勃发展的时期，其中雪莉·克拉克（Shirley Clarke）的《毒贩》、斯坦·布鲁克奇（Stan Brakhage）《天狼星人》、肯尼斯·安格尔（Kenneth Anger）的《天蝎座升起》、乔纳斯·麦卡斯（Jonas Mekas）的《禁闭室》和迈克尔·斯诺（Michael Snow）的《波长》等都对极端的电影语言作出大胆的尝试、对社会禁忌的底线作出偏激的挑战。

Alternative Films of the 1960s

Among all the possible designations for the vanguard film movements of the 1960s, "alternative" works best because it is most broad—it encompasses the experimental and the underground, the filmmakers who called themselves New American Cinema, the emergence of gay-related films, and any other subcategories identifiable in the world of noncommercial cinema. What held them together was expressed in *The Connection* (1961), a film by Shirley Clarke (1919-1997), when a character who is making a documentary film explains his aesthetic approach: "I'm not interested", he says, "in making a Hollywood picture".

Shirley Clarke Clarke's *The Connection* brought to the surface of its narrative a question that was central to nearly all aspects of alternative filmmaking: what it means to shoot a film, and to be filmed—to look and to be looked at. In adapting Jack Gelber's drama about heroin addiction, performed on stage and for the film by the Living Theatre, the director and the playwright (who wrote the script) added the framing device of a filmmaker and his camera man making a film in a drug addicts' pad. In the course of Clarke's film the fictional filmmaker becomes hooked on the drug himself, and his final words are addressed to the cameraman and, through the lens, to the spectator: "It's all yours now". Besides the

implied appeal here both for artistic and for social action, *The Connection* amply conveys the potential for danger and destructiveness in filmmaking, as well as in drug taking.

Stan Brakhage Another name for alternative filmmaking was "personal" film, to distinguish it from the films of an industry and to suggest that an alternative mode of production could be one person with a camera, or even one person splicing together or scratching on found footage. Stan Brakhage (1933-2003) once made a film by sticking flower petals and moth wings between strips of splicing tape (*Mothlight*, 1963). Brakhage was perhaps the most direct successor to Maya Deren as a "film poet," and indeed his film aesthetics were more closely aligned with contemporary poetry than the vague notion of "film poet" would suggest.

Prolific as a writer, lecturer, and filmmaker, Brakhage made more than one hundred films since beginning his career in the 1950s. A centerpiece was *Dog Star Man* (1964), a multipart film that links consciousness, nature, and myth through superimposed images and manual manipulation of the film surface with paint and scratches. After finishing *Dog Star Man*, he took the work apart and made an even longer film, *The Art of Vision* (1965), which played the superimposed images separately and then together in different combinations. Brakhage's concern with seeing and being seen was carried forward in a radically different style in *The Act of Seeing with One's Own Eyes* (1971), a meditation on autopsies conducted in the Pittsburgh morgue.

Kenneth Anger The precocious filmmaker of *Fireworks* took the personal film in a different direction from Brakhage, toward magic, ritual, and a critical engagement with popular culture through image and sound. His most widely known film, *Scorpio Rising* (1963), counter-pointed its images with commercial rock-and-roll songs of the 1950s and early 1960s, and the music and his own photographed scenes of a motorcycle gang initiation were in turn juxtaposed with still photographs and clips from Hollywood films and television programs. Both comic and portentous, *Scorpio Rising*'s aesthetic is linked, as several critics have suggested, to Sergei Eisenstein's "Montage of Attractions", in which the shock of perception from the clash of linked images is more important than the underlying narrative.

Jonas Mekas Born in Lithuania, Jonas Mekas (1922-) came to the United States in 1950 after years in European displaced persons' camps and became the key organizing figure of New American Cinema, as well as a filmmaker. He was the founder in 1955 and longtime chief editor of *Film Culture* magazine, which chronicled the underground and avant-garde; an influential columnist on independent film for the New York weekly newspaper *The Village Voice* (the columns were collected in his book Movie, Journal: *The Rise of a New American Cinema*, 1959-1971); an organizer of the Film-makers Cooperative in 1961, which

distributed independent films, and the Film-makers Cinematheque in New York in 1963, which exhibited them; and a founder in 1970 of Anthology Film Archives in New York, which screens films and houses an archive and library of printed materials pertaining to independent films.

In 1964 Mekas made *The Brig*, one of the remarkable films of the period. Like *The Connection*, it derives from a stage production by the Living Theatre, of a play by Kenneth Brown set in a U.S. Marine Corps brig, or base prison. After the play closed, Mekas restaged it during a marathon all-night session and shot his film as he walked among the performers carrying a camera and sound recording equipment. The result is a harrowing, claustrophobic rendering of dehumanization and oppression.

Michael Snow Canadian filmmaker Michael Snow (1929-), who worked in New York during the 1960s, was a leading figure in a late 1960s movement that became known as "structural film". If, as we have seen, a central project of alternative filmmaking was to foreground the act of making a film, the experiences of seeing and being seen on film, structural films gave primacy not to the filmmaker's consciousness but to the technological workings of the apparatus. In structural film, critic P. Adams Sitney has written, "the shape of the whole film is predetermined and simplified, and it is that shape which is the primal impression of the film". Snow's *Wavelength* (1967) is a forty-five-minute fixed-camera zoom (it consists of several shots spliced together, because of the length limits of film rolls) going from the widest to the smallest field of vision. His ,↔, (also known as *Back and Forth*, 1969) shows a continual series of panning—movements from left to right, right to left. In both films events occur, sounds are heard, people are glimpsed; but human activities are decentered, peripheral to the inexorable movement of the machine for seeing, which takes on seemingly a life and a story of its own.

4. 安迪·沃尔霍和"波普电影"

美国著名的波普艺术家安迪·沃尔霍（Andy Warhol）也热衷于拍摄所谓"波普电影"（Pop Cinema），长达六小时的《睡眠》和八小时的《帝国大厦》挑战人类耐力的极限，《我的小白脸》最早触及同性恋话题，而《切尔西女郎》则创造性的运用了分割画面和声画对位，并成为极少数在商业上获得成功的先锋电影。

《帝国大厦》

Andy Warhol

The most significant alternative filmmaker of the 1960s may turn out to be the famed Pop artist Andy Warhol (1928-1987). Warhol encompassed many of the categories of alternative filmmaking—he made both structural films and narrative fiction works—and at the same time exploded the most cherished category, that of the individual artist. He exemplified contemporary theories about "the death of the author".¹ Warhol operated what was in effect the alternative cinema's version of a motion picture studio at the Factory, his loft space in New York. While standard filmographies list him as producer and director of "Warhol" films from 1963 until 1968 (when he was shot and wounded by a woman at the Factory), and as producer, with Paul Morrissey as director, thereafter, the question of who wrote, shot, or directed which "Warhol" films is far from settled, and perhaps irrelevant. They were as much products of a worldview and a mode of production as the films of M-G-M—though quite different in nearly every respect.

Most of Warhol's films were not widely seen when they were made and for several decades were almost entirely out of circulation. When many became available again after Warhol's death, they generated considerable interest, and Warhol's work seems certain to become more familiar. His first films were of

stationary objects, shot without sound and in black-and-white, with no camera movement and little movement in the screen image. *Sleep* (1963) was a six-hour film of a man sleeping, and *Empire* (1964) an eight-hour film of the Empire State Building, whose aesthetic interest derives from the changing gradations of light and darkness in the black-and-white image. Nearly everyone who came into the Factory was filmed in static close-up for the length of a film roll, three and one-half minutes; selections from these moving image photographs were assembled in *The Thirteen Most Beautiful Women* (1964) and *The Thirteen Most Beautiful Boys* (1965). "You could do more things watching my movies than with other kinds of movies", Warhol told an interviewer in 1967. "You could eat and drink and smoke and cough and look away and then look back and they'd still be there. It's not the ideal movie, it's just my kind of movie".

Warhol began making sound films, with scripts and performers, in 1965. *Chelsea Girls* (1966) was his most circulated film, and indeed it marked a breakthrough of alternative cinema into commercial exhibition. The film consisted of twelve reels each thirty-five minutes in duration, but two reels were projected side-by-side, so the viewing time was about three and one-half hours. Though a narrative order was later suggested for the reels, Warhol's original idea was to let the projectionist decide which reels to show in whatever order and juxtaposition. Each reel was set in a separate room of New York's Chelsea Hotel, where figures from the 1960s "underground" acted out their personas. Among Warhol's dozens of other films, *My Hustler* (1965) has attracted attention as an important early work exploring issues of gay culture and style through the alternative cinema's inevitable concerns, looking and being looked at, in lengthy, single-take scenes.

第五章

多元时期
1989—2010

第一节　好莱坞大片和全球化战略

1. 好莱坞大片与卡梅隆

"大片"（blockbuster）观念从20世纪70年代后期开始主导好莱坞，制片业对集合大明星、高预算、奇观特技和熟识叙事套路的超级电影制作趋之若鹜。20世纪90年代之后，《侏罗纪公园》《阿甘正传》、"骇客帝国"三部曲、"星球大战前传"三部曲和"指环王"三部曲相继掀起数以亿元计的全球票房狂潮，"好莱坞大片"由此成为电影业和观众顶礼膜拜的商业图腾。

詹姆斯·卡梅隆（James Cameron）被称为好莱坞大片的世界之王，他的《魔鬼终结者2：审判日》《泰坦尼克号》和《阿凡达》三部影片创造出全球50亿美元前无古人的票房纪录，而《泰坦尼克号》还追平了奥斯卡获奖11项的最高纪录。学物理出身的卡梅隆深谙电影技术和电脑特技、偏爱视觉奇观和运动画面，更为重要的是他超凡脱俗的想象力、游刃有余的叙事手法、贴近观众的普世价值观和严谨执著的创作态度，将《魔鬼终结者2》的未来机器人英雄、《泰坦尼克号》的灾难性悲剧爱情和《阿凡达》的星际殖民与异类爱情都演绎得惊心动魄又感天动地。

The Return of the Myths: 1977-

At some point in the late 1970s, the American cinema abandoned its attack on the genres of American movies and the myths of American life to embrace

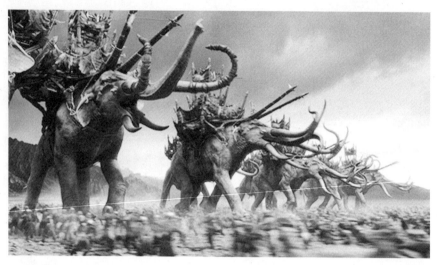

《指环王》

them both again. Though some critics sneeringly compared the new films to computerized video games, American movies were born as close cousins to the electrical and mechanical novelties in amusement arcades. The new films self-consciously defined movies as both the repository for cultural myths and the contemporary medium for their dissemination. They saw the movies as myth machines. The new films viewed these myths and mysteries not with the jaded eye of adulthood but with the hope and wonder of childhood; they set out to recapture or invent a kind of innocence.

In this period, muscular heroes in T-shirts, robots with hearts of gold, tough cops, resourceful teens, and benevolent masters rose up to vanquish purely evil villains. Instead of the intellectual and emotional complexity of such previous big films as *Lawrence of Arabia* and *The Godfather*, the typical blockbuster became a wide screen, color, stereophonic ride, full of action and special effects, constructed for speed and thrills rather than contemplation, and with a simple, forceful, unthreatening message (for example, cheaters never prosper); examples range from Steven Spielberg's *Indiana Jones and the Temple of Doom* (1984) to Jan De Bont's *Speed* (1994). Many audiences and most producers preferred what were called "feel-good" movies to "downers" and "bummers;" by far the majority of films had heroes to root for, villains to hate, and happy endings. Movies fit once more into recognizable genres and embraced their conventions, even while harmlessly making fun of them.

Films that tackled difficult political or psychological material (or were

considered too negative, like Ridley Scott's *Blade Runner*, 1982) sometimes had their endings changed by executives-although a few subversive, questioning films did sneak by. It was the period of the blockbuster, the sequel, the Dolby soundtrack, the videocassette and laserdisc and DVD, the direct-to-video release, the camcorder, the computer, and the all-powerful talent agent—a time that began with the science-fiction spectacles of George Lucas and Steven Spielberg and grew to include the creepy ironies of David Lynch and the political fables of Spike Lee. This period of American film history has continued into the 2000s, so its end remains unknown, but its aesthetic, technical, and economic elements are already clear enough. It is not an extension of the Hollywood Renaissance but an entirely new period: technically advanced and politically in retreat, devoted utterly to entertainment, with films that are innovative but rarely new. For a capsule version of the difference, compare the spiritual scenes in *Mean Streets* and in *Field of Dreams* (Phil Alden Robinson, 1989).

The late 1970s saw major changes in the film industry, film technology, and film content. The film business adopted a "blockbuster mentality," preferring to finance and distribute a few big films with the potential for enormous profits rather than a larger slate of modest films with modest profits. One "monster hit" a year could keep a studio in business and help to pay for the flops and the less expensive movies it also produced. *The Godfather, Jaws, Star Wars, Close Encounters of the Third Kind, Grease,* and *Superman,* all from the 1970s, were among the top-grossing films of all time—as were their 1980s cousins *The Empire Strikes Back, E. T., Raiders of the Lost Ark, Return of the Jedi,* and *Batman.* The 1990s added *Titanic* and others to that list. *The Birth of a Nation, Snow White,* and *Gone With the Wind* may still be considered more commercially successful than most of these blockbusters, however—they made more profit in relation to their cost, and in more valuable dollars; in fact, when the figures are adjusted for inflation and the picture's many re-releases are added in, *Gone With the Wind* is ahead of *Titanic* (James Cameron, 1997). Inflation aside, *Titanic* is ahead of them all. In the hope of repeating the kind of success introduced by *Jaws* in 1975, the studio attitude became to spend a lot of money to make a lot of money. *Titanic* cost and made so much that it confirmed this attitude all over again. At $200 million, it was the most expensive movie yet made, and it was the first to earn over $1 billion at the worldwide box office ($600 million domestic). A blockbuster is a picture that takes in over $100 million at the U.S. box office. "Small" films with relatively low budgets—many of which were "picked up" from independent producers and simply released by the studio—were given smaller openings and often had to make their profits overseas or on video. (Video itself made a difference, to be discussed later.) Given the cost of these spectacles—as high as $100 million or more, when to produce the average feature cost $11 million in 1981, $34 million in 1994,

$55 million in 1997, and $64 million in 2003—the films required tremendous advertising campaigns, which cost even more, and the theatre owner had to send a higher percentage of ticket earnings back to the distributor. Blockbuster or not, a movie that cost $90 million to make and $110 million to distribute but that grossed only $120 million would be in the red until the foreign box office, and perhaps even video, raised its earnings. Theatres learned to make their profits at the concession stand, not at the box office. Theatres also were remodeled, or built, to house 2 or 4—or 16—screens; the multiplex cinema marked the eras biggest change in the practice of theatrical exhibition.

Coming to Terms with Blockbusters

Steven Spielberg and George Lucas were the only directors to make top-ten films in each decade from the 1970s to the 2000s. Nearly all the major 1970s directors, from Woody Allen and Robert Altman to Brian De Palma and Clint Eastwood, were outstripped at the box office by newer names willing to turn out megapics. Leaving risk-taking to the independent sector, Hollywood wanted movies to be dominated by stars, special effects, and recognizable narrative conventions. Ambitious filmmakers were obliged to find inspiration in genre exercises, sequels, or remakes. Still, some directors blended distractive personal styles with the demands of event films.

James Cameron (1954-) was perfectly suited to the new demand for megapics. Beginning in special-effects jobs, he became adept at every phase of the filmmaking process, from scriptwriting to editing and sound. Science fiction and fantasy came naturally to him, as did the sort of striking, powerful ideas that succeeded in the high-concept 1980s. Above all, Cameron realized that a successful film could be built around nonstop physical action. His breakthrough, *The Terminator* (1984), displayed ingenious chases and gunplay, sketching in its time-travel premise without halting the breathless pace. *The Terminator* proved that Cameron could squeeze high quality out of a small budget while yielding catchphrase dialogue ("I'll be back", "Come with me if you want to live") and a career-making performance from robotic Arnold Schwarzenegger. *Terminator 2: Judgment Day* (1991), with even more grandiose action set-pieces, pushed computer-generated visual effects to new levels in the presentation of a liquefying Terminator. Cameron was comfortable with sequels and spinoffs, injecting adrenaline into every plot. *Aliens* (1986) gave *Alien* (1979) a military twist, emphasizing firepower and squad camaraderie. *The Abyss* (1989) inserted into a *Close Encounters* premise more thrills than Spielberg bad felt necessary, and *True Lies* (1994), a tongue-in-cheek spy piece, sought to out-Bond the Bonds.

With *Titanic*, Cameron produced the ideal date movie: doomed love between a spunky heroine and a boyish hero, a long prologue featuring high-tech gadgetry, and a climax packed with action, suspense, and spectacular visual effects. *Titanic* was scheduled as a summer blockbuster, but production delays pushed it to December, where it gained an aura of Oscar-level prestige. Opening on nearly 2,700 screens, it played for months, sometimes increasing its audience from week to week. Although the production had cost $200 million, one of the studios backing it profited by at least $500 million. Titanic won audiences in all demographics, including older viewers who had given up on modern movies. It reconfirmed Hollywood's faith in megapictures.

Over the next dozen years, Cameron pursued further cutting-edge technology, making a 3-D documentary for IMAX as preparation for a feature, *Avatar* (2009). Cameron's faith in high-tech filmmaking was paralleled in the career of Robert Zemeckis, who mounted blockbusters that blended live action with animation (*Who Framed Roger Rabbit*, 1988), inserted contemporary actors into historical footage (*Forrest Gump*), and created 3-D warriors (*Beowulf*, 2007). Peter Jackson (*the Lord of the Rings trilogy*; *King Kong*, 2006), Andy and Larry Wachowski (*the Matrix* trilogy; *Speed Racer*), Zack Snyder (*300*), and other younger directors utilized digital technology to give action-adventure pictures a new scale and impact.

2. 全球化战略和媒体帝国迪斯尼公司

随着世界全球化进程的发展，美国电影对全世界的主导和渗透更加明显；外国公司对于好莱坞制片企业的收购（1985年澳大利亚新闻集团收购20世纪福克斯、1989年日本索尼公司并购哥伦比亚和2000年法国维旺迪公司买下环球），又将全世界的资金吸引到好莱坞。与此同时，美国国内的电影市场几近饱和，越来越多的票房收入来自于海外的欧洲、拉美和亚洲，好莱坞电影占据着全球75%的票房和更大比例的相关收入。

迪斯尼、时代华纳（Time Warner）和新闻集团（News Corporation）等通过不断并购形成的媒体集团（media conglomerates）不但可以整合各种媒体资源，而且能够动员强大的资金和制作力量，更重要的是它们时刻将全球市场牢记心间，并引进香港的吴宇森（《变脸》和《职业特工队2》）、德国的罗兰·艾默瑞奇（《独立日》和《2012》）和墨西哥的阿方索·卡隆（《哈利波特》和《地心引力》）等电影人制作融合多种文化元素的世界电影。

好莱坞电影依靠美国电影协会（MPAA）的强力支持和世界贸易组织（WTO）的规则，反对文化贸易保护和电影审查、全力拓展全球电影市场。

迪斯尼帝国的图腾

同时，美国式的多厅影院（multiplexes）在 2000 年征服西欧后，正在逐步覆盖欧洲、亚洲、拉美乃至整个世界。这意味着美国不但输出好莱坞电影，更在将美国的观影体验甚至生活方式推展到地球的每一个角落。

Toward A Global Film Culture

The Media Conglomerates How did Hollywood cinema strengthen its hold on world culture? We have already seen that many European and Asian film industries declined in the 1970s and 1980s, often because of competition from television and other leisure activities. Hollywood films, particularly megapictures, could benefit from weakened local production. Moreover, U.S. companies had often stayed out of markets where admission prices were very low, since they could not recoup much of their investment there. But as more people joined the middle class in Asia, Russia, and other regions, they could afford higher ticket prices, and the U.S. firms moved in.

The U.S. studios also benefited from the vast power of the multinationals to which they now belonged. The entertainment conglomerates that had acquired most of the Hollywood firms in the 1980s and 1990s were among the world's top-ten media companies. In 2001, the combined revenue of the six giants came to $130 billion. Each conglomerate, linked to international funding and audiences, could act globally. Viacom, parent to Paramount, owned MTV, which broadcast in eight languages throughout the world, and the company programmed over 2,600 movies and series per year for international television. Viacom also owned the Blockbuster video rental chain. Similarly, News Corporation owned not only 20th Century Fox

but also newspapers, book publishers, and the rights to broadcast major sports events, such as NFL football and Manchester United soccer. News Corporation's television holdings, particularly its satellite outlets BskyB and Asian Star TV, reached three quarters of the world's population.

By owning media outlets in many countries, a conglomerate gained access to new markets, competing with smaller-scale local companies. The conglomerate could also reap economies of scale. The modern media empire, dependent on "content providers", sought synergy between a novel, a movie, a videogame, or a television series and other divisions, such as record companies.

Cooperation and Cooptation The Disney company taught Hollywood to keep the world market in mind at all times. Studios imported directors—for example, Hong Kong's John Woo, Germany's Roland Emmerich, and Mexico's Alfonso Cuarón—who supposedly knew how to please foreign audiences. Stars had to tour the world with their movies. Above all, producers sought a "global film". *Batman* (1989), *The Lion King* (1994), *Independence Day* (1996), *Men in Black* (1997), *Titanic* (1997), *The Lord of the Rings* (2001-2003), *the Pirates of the Caribbean franchise* (2003-)—these were mega-events that aimed to attract every viewer, everywhere. *Jurassic Park* (1993) is a compelling early model of the global film.

Hollywood's success in mounting event pictures is shown by the fact that they began to earn more overseas than in the U.S. Throughout the 2000s, the ten top-grossing films earned between 50 percent and 70 percent of their revenues outside North America. *The Da Vinci Code* (2006), for instance, garnered $218 million in America but $541 million elsewhere. As a result, Hollywood based its big projects on internationally best-selling books such as the Harry Potter series and on well-tested offerings such as the *Terminator* and *Die Hard* franchises. The overseas audience also reinforced the studios' dependence on stars. Thanks to the popularity of Tom Cruise, *The Last Samurai* (2003) earned more in Japan than it did in the U.S. To maximize the global audience, and to undercut piracy, studios increasingly aimed at day-and-date release, putting the film on offshore screens at the same time as it appeared in North America. *Spider-Man 3* (2007) became the first film to launch day and date in 75 territories and on nearly 17,000 screens, generating $230 million in six days.

It was not only home-grown movies that allowed Hollywood to penetrate other countries. For decades the Majors had invested in the overseas film trade, a process that began to intensify in the 1980s. The studios sank money into cable and satellite television, theater chains, and theme parks. Because of the power of the Majors' distribution network, many local films were marketed, either nationally or internationally, by a Hollywood company. The most noted instance was *The Full Monty*, (1997), a British-made film funded and distributed worldwide by Fox. U.S.

studios also stepped up the number of coproductions they mounted with overseas firms. With the 1990s boom in international movie receipts, studios wanted bigger pieces of regional markets. They set up production units or funded local projects in Mexico, Spain, France, Germany, Brazil, Russia, and even India and China.

One advantage in going global was that certain activities were less strictly regulated outside the United States. When vertical integration had been ended at home, the studios had owned foreign theaters and local distribution companies. Block booking and blind bidding, outlawed in the United States, were routine in foreign markets, and they continued into the 2000s. These practices carried even more clout when multinational media empires were backing them up.

Battles over GATT The U.S. majors had long protected their international interests through their trade association, the Motion Picture Export Association of America. In the 1990s, the MPEAA had branches in sixty nations, where 300 employees worked to increase the local market for the Majors. MPEAA employees monitored legislation that might create barriers to American media, and they lobbied politicians and government decision-makers. Since the mid-1960s, Jack Valenti, the head of the MPEAA's parent organization, the Motion Picture Association of America, had fought fiercely to limit censorship, to persuade U.S. politicians to look kindly on the media industry, and to keep Hollywood films supreme throughout the world.

Just as Hollywood's grip on the market tightened in the early 1990s, Valenti faced rebellion. Film and television became flashpoints in the long-running negotiations on the General Agreement on Tariffs and Trade (GATT, later to become the basis of the World Trade Organization). Nations signing on to GATT pledged to eliminate subsidies and tariffs, allowing other nations' products to compete equally with domestic ones. The Majors fought to have films defined as services, which would have required European countries to cut their subsidies to local filmmaking and eliminate levies and taxes on U.S. movies.

In 1992, the French led a counterattack against any effort to include "audiovisual industries" in GATT. They pointed out that Hollywood already dominated the region; to dissolve the protectionist measures in place would virtually eliminate European film production. The announcement that *Jurassic Park* would play on one-quarter of France's top screens strengthened the case against the Majors. The MPEAA fought hard, but when GATT was signed in December 1993, film and television were not included. The Europeans were jubilant.

The Majors tried to make amends by muffling free-trade rhetoric and donating money for European film education. Still, the next year proved how well founded the Europeans' fears had been. In 1994, the Majors earned more income from overseas than from domestic exhibitors. Meanwhile, films from all other countries

received a still thinner slice of the world market. *Variety*'s headline ran "Earth to H'wood: You Win".

A sequel to the GATT debates ensued in 2005. At meetings of UNESCO, the United Nations' cultural wing, Canada and France introduced a treaty that would authorize countries to identify "special situations where cultural expressions... are at risk of extinction" and take "all appropriate measures" to preserve them. The treaty was passed by 148 countries; only Israel and the United States opposed it. To the American film industry, it signaled that France's insistence on protection of national media was now widely shared. In 2006, the treaty was ratified, over American objections. The treaty might have had long-term impact on future trade negotiations, but in the short run it was not likely to alter the way Hollywood behaved. Throughout the 2000s, revenues for the Majors rose, with nearly every year notching record returns. Overseas theatrical grosses and home video income were increasing faster than domestic ones, which seemed to confirm Hollywood's belief that its global market still had room to grow.

Multiplexing the Planet At the start of the 1990s, the United States contained 30 percent of the world's movie screens, about one screen for every 10,000 people. Most of Western Europe had far fewer screens per capita, and densely populated Japan had only one for every 60,000 people. The Majors came to believe that U.S. attendance was high because viewers had access to many screens. By that standard, most regions were "underscreened" and failed to tap the potential market. In addition, the studios and the U.S. independents were pumping out many films, but most countries had comparatively few places to show them.

Multiplexing seemed the natural solution. Multiscreen cinemas had increased attendance in North America by reinforcing the moviegoing habit, so why wouldn't they spur demand in other markets? The advantages of many screens under one roof, a single box office, centralized concession sales, and other economies of scale would apply abroad. By increasing the number of screens, multiplexes would also allow more films to open, and open sooner. As in the United States, where films opened wide and played off quickly, the distributors would benefit by getting a large share of the firstweek receipts. If the new theaters were more luxurious than the older movie houses, ticket prices could be boosted. And, if the Majors operated multiplexes, then they could compete with local exhibitors, monitor boxoffice receipts accurately, and control access to prints, thus limiting piracy.

The idea was too tempting to resist, especially since European exhibitors had already started building multiplexes on their own. Soon American firms launched multiplexes in the United Kingdom, Germany, Portugal, Denmark, and the Netherlands. Warner Bros. was a leader in the effort, often in alliance with Australia's Village Roadshow circuit. Paramount and Universal launched a joint venture, United Cinemas International. Because European exhibition firms were

well-entrenched, the U.S. companies usually partnered with regional chains. By 2000, Western Europe was blanketed with multiplexes. The fever spread to Asia. Warners joined with Village Roadshow to erect a complex in Taiwan and parmered with a department-store chain to build thirty multiplexes in Japan.

Now Hollywood was exporting not just American movies but the American moviegoing experience. Snacks were tailored to local tastes, but popcorn, previously a U.S. specialty, proved surprisingly popular. European multiplexes were usually on the edge of town, providing ample parking and adjacent malls with restaurants, bars, and shops. Some cineplexes went beyond the American standard, offering VIP auditoriums with champagne, hot meals, and waiter service. The Village Cinemas circuit in Australia provided reclining chairs with built-in wine chillers.

Wherever multiplexes were introduced, attendance rose dramatically. In the early 1990s, European box-office returns jumped after a decade of decline. Germany, which began building 'plexes in the early 1990s, had its biggest surge in attendance since World War II. Customers proved willing to pay more for a bright, comfortable, modernized venue. In Bangkok, the Golden Village complex, with only ten screens, grossed nearly as much as all other screens in Thailand combined. In some markets, as in the United States, multiplex saturation set in. Still, in emerging markets such as China, Russia, Eastern Europe, and Latin America, as well as in "underscreened" Japan, the multiplex boom continued. Single-screen cinemas virtually vanished. The major players believed that the future lay with the multiplex, an entertainment center for the public and a profit center for big companies—many of them affiliated with Hollywood.

The Disney Empire

For many studios, the model was the Walt Disney Company. Although it floundered in the 1960s and 1970s, it took off again when Michael Eisner became president in 1984. Eisner, largely uninterested in animated cartoons, started his job by seeking "to formalize the role of synergy and brand management". He understood that the Disney name, like famous brands of soap or automobiles, guaranteed quality and consistency. Trademarked characters Mickey Mouse and Simba the Lion could be poured into many media molds—a film, a TV show, a comic book, a song, a Broadway play, or merchandise. The Disney company had practiced synergy long before the term became fashionable, and Eisner realized that the key to the Magic Kingdom's success would be branded content.

Disney invested in cable and satellite television companies, licensed

merchandising to an estimated 3,000 firms worldwide, and dubbed its entire film and television library into thirty-five languages. At the end of the 1990s, nine of the world's ten top-selling home videos were Disney animated features. By buying Capital Cities/ABC in 1995, Disney gained not only a venue for its cartoon and live-action programs but also access to the audiences who watched sports programs on ESPN. The company entered the adult market in the 1980s, with the Touchstone and Hollywood labels signaling that these were not traditional family entertainment. Later Disney bought Miramax, so that films as varied as *Pulp Fiction* (1994), *Shakespeare in Love* (1998), and *Scary Movie* (2000) contributed their share to the Magic Kingdom.

 Eisner placed special emphasis on activities and services that went beyond moviegoing or TV viewing. He established cruise lines, launched Disneyland parks in Japan, France, and Hong Kong, and planted stores in European and Asian capitals. Disney employed people from eighty-five different countries in all its divisions. Rancorous disagreement in the board of directors led Eisner to leave in 2005, but his makeover had succeeded in putting Disney in the top tier of global entertainment companies, second only to AOL Time Warner. The overseas market routinely brought in 20 to 25 percent of all Disney's revenues.

第二节　美国独立电影

1. 美国电影的独立传统

1948年的"派拉蒙裁决"和其后大制片厂体制的没落,直接导致了20世纪60年代美国独立电影（Independents）的兴起,著名独立电影制片人罗杰·科尔曼（Roger Corman）曾经栽培和提携过科波拉、斯科西斯和卡梅隆等人。20世纪60、70年代也曾涌现过《活死人之夜》《黑人战警》《德州链锯杀人事件》和《洛基恐怖秀》等颇有影响的独立电影。

演员出身的约翰·卡萨维茨（John Cassavetes）执导《影子》《面孔》和《权势下的女人》等,利用自筹资金、即兴表演和真实场景反映复杂微妙的都市情感关系,赢得好评并成为当时公认的独立电影之父。

Opportunities for Independents

The difficulties and recovery of the Majors were bound up with the fate of independent production in the United States during this period. The 1948 Paramount decision and the rise of the teenage market gave independent companies like Allied Artists and American International Pictures (AIP) an entry into the low-budget market.

During the late 1960s, the low-budget independents grew stronger, partly through the relaxing of the Production Code and partly through the decline of the Majors. With the slackening of censorship controls, the 1960s saw growth in

《影子》

erotic exploitation. "*Nudies*" surfaced from the 16 mm *stag film* world and could be seen in decaying picture palaces in America's downtown neighborhoods. Eroticism became mixed with gore in Herschell Gordon Lewis's *Blood Feast* (1963) and *2000 Maniacs* (1964). Russ Meyer began in nudies before discovering his idiosyncratic blend of hammering editing, gruesome violence, and parodically overblown sex scenes (*Motorpsycho*, 1965; *Faster Pussycat, Kill! Kill!*, 1966). Meyer blazed the trail for "mainstream"1970s pornography with films such as *Vixen* (1968).

The youthpics craze was fed by AIP's cycle of motorcycle-gang movies and *Wild in the Streets* (1968). The films of AIP's main director, Roger Corman (1926-), had a strong influence on young directors of the late 1960s, and AIP gave opportunities to Coppola, Scorsese, Bogdanovich, John Milius, De Palma, Robert De Niro, and Jack Nicholson. The low-budget independent film *Night of the Living Dead* (1968), rejected by AIP as too gory, went on to become a colossal cult hit and launched the career of director George Romero.

During most of the 1970s as well, independent production proved a robust alternative to the Majors. As the studios cut back production, low-budget films helped fill the market. Firms began to specialize in certain genres—martial-arts films, action pictures, erotic pictures (*sexploitation*). Films aimed at African Americans (*blaxploitation*) showcased young black performers and, sometimes,

black creative personnel like directors Gordon Parks, Sr. (*Shaft*, 1971) and Michael Schultz (*Cooley High*, 1975; *Car Wash*, 1976). In the wake of *Night of the living Dead* and *The Exorcist*, the teenage horror market was tapped with films like Tobe Hooper's grotesque *Texas Chair-saw Massacre* (1974) and John Carpenter's more sober and expensive *Halloween*. Corman's new company, New World Pictures, created cycles and trained new directors (Jonathan Demme, John Sayles, James Cameron).

In some venues, the cheaper films could find an audience denied to the glossier studio product. Sunn International discovered, to the Majors' surprise, that there was still a family audience who could be lured from the television set with wildlife adventures and quasi-religious documentaries. Tom Laughlin, the enterprising director-producer-star of *Billy Jack* (1971), showed that small-town viewers would still come to films that mixed sentiment, action, and populist themes. Meanwhile, teenagers and college students began flocking to outrageous movies like John Water's *Pink Flamingos* (1974). Theaters found that midnight movies would attract a young crowd; *The Rocky Horror Picture Show* (1975) and *Eraserhead* (1978) became profitable almost solely through such shows.

The Majors responded by absorbing the sensational elements that had given independent films their edge. Big-budget films became more sexually explicit, and for a time Russ Meyer, exploiter of erotica, found himself working for a studio (*Beyond the Valley of the Dolls*, 1970). *The Exorcist* traded on blasphemy and visceral disgust to a new degree. *Star Wars* and *Close Encounters* incorporated elements of low-budget science fiction (*Silent Running*, 1971; *Dark Star*,1974), while *Alien* (1979) and other films reflected the new standards of gory violence established by independent directors such as Carpenter and David Cronenberg (*Shivers*, 1975; *Rabid*, 1977; *The Brood*, 1979). "'Exploitation' films were so named because you made a film about something wild with a great deal of action, a little sex, and possibly some sort of strange gimmick", wrote Corman. "[Later] the majors saw they could have enormous commercial success with big-budget exploitation films".

Apart from the mass-market independents, there emerged a more artistically ambitious independent sector. New York sustained an "off-Hollywood" tendency. Shirley Clarke, known for her dance and experimental shorts, adapted the play *The Connection* (1962) and made the semidocumentary *The Cool World* (1963). Jonas and Adolfas Mekas modeled *Guns of the Trees* (1961) and *Hallelujah the Hills* (1963) on the experiments of European new waves.

John Cassavetes (1929-1989) was the most famous member of this off-Hollywood group. A New York actor, Cassavetes made a career on the stage and in films and television. He scraped up donations to direct *Shadows* (1961). "The film you have just seen was an improvisation": this curt closing title announced

Cassavetes's key aesthetic decision. The story, about two black brothers and their sister in the New York jazz and party scene, was outlined in advance and the dramatic development of each scene was planned. During filming, however, the actors were free to create their own dialogue. Although shooting in a semidocumentary style, with a grimy, grainy look, Cssare also relied on deep-focus compsitions and poetic interludes familiak from contem porary Hollywood cinema. Shadows won festival prizes and led Cassavetes to undertake a pair of ill-fated Hollywood projects. He returned to independent cinema, financing his films by acting in mainstream pictures, and became an emblematic figure for younger filmmakers.

Basing his aesthetic on a conception of raw realism, Cassavetes created a string of films featuring quasi-improvised performances and casual camerawork. *Faces* (1968) and *Husbands* (1970), with their sudden zooms to close-up and their search for revelatory detail, use Direct Cinema techniques to comment on the bleak disappointments and deceptions of middle-class American couples. Characteristically, his counterculture comedy *Minnie and Moskowitz* (1971) centers on the love affair of a middle-aged hippie and a lonely museum curator. In *A Woman under the Influence* (1974), *Opening Night* (1979), and *Love Streams* (1984), the drama alternates between mundane routines and painful outbursts that push each actor to near-hysterical limits. This spasmodic rhythm, and his focus on the anxieties underlying adult love and work, made Cassavetes's midlife melodramas seem experimental by 1970s and 1980s Hollywood standards.

The New York scene received a further burst of energy from Joan Micklin Silver's *Hester Street* (1975), a drama of Jewish life in late-nineteenth-century New York. Filmed for less tnan $500,000, it was released nationwide and earned more than $5 million. When it received an Academy Award nomination, the film sparked a new awareness of off-Hollywood filmmaking.

The independent impulse spread to regional filmmakers, who managed to make low-budget features centered on cultures seldom brought to the screen. John Waters revealed Baltimore as a campy Peyton Place (*Female Trouble*, 1975), while Victor Nuñez's *Gal Young 'Un* (1979) took place in Florida during the Depression. Another historical drama was John Hanson and Rob Nilsson's *Northern Lights* (1979), set in 1915 North Dakota during labor unrest. It won the best firstfilm award at the Cannes Film Festival.

Slowly, alternative venues were emerging for independent film. In addition to New York's Anthology Film Archive (founded in 1970), several festivals were established in Los Angeles (known as Filmex, 1971), Telluride, Colorado (1973), and Toronto and Seattle (1975), as well as the U.S. Film Festival (1978), later known as Sundance. At the same time, enterprising filmmakers organized the Independent Feature Project (IFP) as an association of independent film artists, and

the IFP established, in 1979, the Independent Feature Film Market as a showcase for finished films and works in progress. The American independent cinema was poised for takeoff.

During the 1960s, the failing studios searched for new corporate identities and business models. After some winnowing, the 1970s set in place patterns that would dominate American film for the rest of the century. A new generation of moguls would partner with a new generation of producer-directors, typified by Lucas and Spielberg, under the auspices of a conglomerate. The studios would concentrate on funding and making must-see movies. Alongside the expanding industry was an independent sector whose fortunes fluctuated but whose commitment to alternative stories and styles increased the diversity of U.S. film culture.

2. 美国独立电影的繁荣

1978 年圣丹斯电影节（Sundance Film Festival，主导该电影节和支持独立电影的著名演员兼导演罗伯特·雷德福也成为美国独立电影教父）的前身美国电影节诞生。次年，独立电影项目（Independent Feature Project）创建并在五年后开始颁发"独立精神奖"（the Spirit awards）。同时，《天堂陌影》《血迷宫》和《蓝丝绒》等掀起 20 世纪 80 年代独立电影的浪潮。

90 年代，美国独立电影的繁荣景象如日中天，《性、谎言和录像带》《我心狂野》《巴顿·芬克》和《低俗小说》相继荣获戛纳电影节"金棕榈奖"。米拉麦克斯公司（Miramax）依靠《性、谎言和录像带》《低俗小说》《英国病人》《心灵捕手》和《莎翁情史》大放异彩，而《女巫布莱尔》更以三万五千美元的超低成本收获约两亿五千万美元的全球票房，创造出电影投入产出比的空前奇迹。

一时间，独立电影成为叫好又叫座的时尚话题和金字招牌，就连好莱坞大公司也纷纷收购和创立独立电影公司，将独立电影作为招徕观众的广告牌。迪斯尼收购米拉麦克斯（1993 年联姻、2005 年分手）、华纳并购新线、环球收购十月，而福克斯和索尼则分别创立探照灯和索尼经典，独立电影的精神实质遭到商业金钱的侵蚀和消解，独立电影浪潮也逐渐趋于平息。

A New Age of Independent Cinema

Video income allowed low-budget companies such as Troma to continue turning out the sort of gross comedies and exploitation horror (*The Toxic Avenger*,

《天堂陌影》

1985) that had surfaced in the 1970s. More and more, however, there emerged independent productions that behaved like upscale Hollywood films. How many people who saw *Platoon* (1986), *Dirty Dancing* (1987), *Mystic Pizza* (1988), *The Player* (1992), *Leaving Las Vegas* (1995), *Pleasantuille* (1998), and *The Passion of the Christ* (2004) realized that these were, in financing and distribution, independent movies? To fill all those multiplex screens, exhibitors were willing to show unusual films from distributors outside the Majors.

At the same time, some independent films pushed the boundaries of style and subject matter. *Stranger than Paradise* (1984) and *Blue Velvet* (1986) presented off-center, avant-garde visions. By the mid-1990s, "independent film" took on an outlaw aura, with *Pulp Fiction* marketed as the last word in hipness. Part of the buzz around *The Brothers McMullen* (1995), *Big Night* (1996), *The Tao of Steve* (2000), and other fairly conventional work came from the sense that they were indie movies. The Hollywood conglomerates realized that they could diversify their output and reach young audiences by teaming up with independent filmmakers in one way or another. The Majors bought independent distribution companies or created their own; they hired successful indie producers, writers, directors, and stars, sometimes for blockbusters. The twists and turns of independent U.S. cinema of the last three decades involve not only films but also institutions—notably, film festivals, professional associations, and companies involved in production and distribution.

Building the base By the late 1980s, there were between 200 and 250 independent releases per year, many more films than the studios were putting

out. What enabled the independents to become so active? For one thing, new labor policies. In the early 1980s, a new contract arrangement permitted union technicians to work on independent productions without losing their union membership. The Screen Actors Guild wrote special agreements to allow performers to work for lower pay scales on small-budget and nontheatrical projects. There also emerged new venues for independent work, such as the Independent Feature Film Market, an annual round of screenings for press and distributors. IFC also sponsored awards and eventually launched its own cable channel. In 1980, Robert Redford established the Sundance Film Institute in Utah, where aspiring filmmakers could meet to develop scripts and get coaching from industry professionals.

Fresh funding sources also appeared. The Public Broadcasting System's American Playhouse series financed theatrical features ill exchange for first television rights. Independents could also draw production money from the new ancillary markets. Specialized U.S. cable companies had an appetite for niche fare, and European broadcasting companies were eager to acquire low-cost American films. The German firm ZDF was the most prominent, funding such films as *Stranger Than Paradise* and Bette Gordon's *Variety* (1984). Above all, in the early years of the home video market, cassette presales could cover a large part of an independent film's budget.

While the Majors had enormous publicity machinery, independent releases relied on press reviews and film festivals. Overseas festivals were important showcases, but the prime venue turned out to be in Utah. In1978, the U.S. Film Festival began in Salt Lake City, featuring some independent work alongside retrospectives of classic cinema. Redford's Sundance Institute took over the event and moved it to Park City, renaming it the Sundance Film Festival in 1990. In the early years, Sundance programming leaned toward humanistic rural pictures ("granola movies"), but the screening of Steven Soderbergh's *Sex, Lies, and Videotape* (1989) changed the festival's image drastically. This polished tale of yuppie angst won the top prize and went on to gross nearly $100 million in worldwide theatrical release, a staggering amount for a low-budget drama.

The Sundance Film Festival became the preeminent indie brand name. It attracted thousands of submissions for its 100 or so screening slots, was covered extensively in the press, and established its own cable television channel. Park City swarmed with Hollywood agents and distributors looking for the next big hit. Soon many U.S. communities launched festivals showcasing independent film. Sundance was thus central to the mainstreaming of independent cinema. Redford explained that Sundance's concentration on personal films did not constitute a criticism of Hollywood. "What we have tried to do is to eliminate the tension that can exist between the independents and the studios Many industry people participate, and

it's a great place for independent filmmakers to make contacts".

Mini-Majors such as Orion sometimes underwrote independent productions, but the biggest players on the emerging independent scene were New Line Cinema and Miramax. Both these "art house indies" began as small companies acquiring finished films and distributing them with flair. By the early 1990s, they were themselves Mini-Majors, financing and producing films.

New Line, established in 1967, became a premiere distributor of European films and low-budget horror (*The Texas Chainsaw Massacre*, 1974), as well as John Waters's outrageous oeuvre, from *Pink Flamingos* (1972) to *Hairspray* (1988). New Line eventually became an important conduit for more highbrow independent films (*The Rapture*, 1991; *My Own Priv, ate Idaho*, 1991; *My Family*, 1995; *Wag the Dog*, 1997). The company started its Fine Line division to deal in edgier fare such as *The Unbelievable Truth* (1990) and *Gummo* (1997). At the same time, New Line found wide success with *Teenage Mutant Ninja Turtles* (1990) and the *Nightmare on Elm Street* and *House Party* franchises, Jim Carrey comedies, and other lucrative genre items. Said Mike De Luca, then production head: "I always thought of us as a Hollywood studio". 14

Miramax was founded in 1979 by two brothers, the rock-concert promoters Bob and Harvey Weinstein. Buoyed by the Oscar-crowned U.S. release of *Cinema Paradiso* (1988), the Weinsteins discovered their first indie blockbuster in *sex, lies, and videotape*. Miramax went on to triumph with *Reservoir Dogs* (1992), *Clerks* (1994), *Pulp Fiction*, *The English Patient* (1997), *Shakespeare in Love* (1998), and *Chicago* (2002). Directors complained that "Harvey Scissorhands" was too quick to trim their movies, but no one doubted the advantages of doing business with a company that could offer $10 million at Sundance for the rights to an unknown movie (*Happy, Texas*, 1999). The company became an indie empire, setting up long-term relations with preferred actors and expanding into television, music, and publishing. Miramax also started its own downscale line with Dimension, which found wide success with the perennial low-budget genre, teen horror, in the *Scream and Scary Movie* franchises.

Alongside the two big players were several smaller production and distribution companies. A few, like Good Machine, flourished. Others struggled on, and many fell by the wayside. Most got into the business out of a sincere hope that alternatives to mainstream entertainment had a place in the market. Juggling many funding sources, releasing films on few prints and little advertising, the indie infrastructure was driven largely by a faith in good cinema, not conglomerate strategy. That was to change.

The Majors Get into the Game By any measure, the indie market involved a big financial gamble. The extravagant revenues earned by *sex, lies, and videotape* and *Pulp Fiction* were exceptional. In 1995, independent films represented only

about 5 percent of U.S. boxoffice income. Yet the studios came shopping. In 1993, the Disney corporation purchased Miramax. A year later Ted Turner acquired New Line and Castle Rock. In 1996, Time Warner bought out Turner's media holdings. The Majors also relaunched classics divisions (Fox Searchlight, Sony Pictures Classics) and created new labels (Paramount Vantage, Warner Independent) to create and market offbeat product. Because these companies were subsidiaries of the Majors, they were sometimes sarcastically called the "Dependents".

Why this embrace of independent cinema? For one thing, although indie blockbusters were rare, even a moderate success could return a handsome profit. In 1998, *Pi* yielded $4 million in rentals, thirteen times its $300,000 budget. The dream success story was *The Blair Witch Project* (1999), which was made for $35,000, sold to the mini-distributor Artisan for $1 million, and earned over $241 million worldwide. Moreover, the studios were always on the lookout for new blood and culture's cutting edge. By acquiring independent companies and setting up specialty divisions, the Majors could scout for young directors who might bring fresh talent to the synergy mix. Several independent directors were recruited for big-budget projects where pushing the envelope could be seen as novelty. From two indie comedy-dramas, David O. Russell moved to Warners for the unconventional war movie *Three Kings* (1999). In the 1990s, Kevin Smith and Robert Rodriguez were snapped up by the Majors, and the latter had a mainstream hit with *Spy Kids* (2000). Sometimes directors were hired to work on action blockbusters. Bryan Singer moved from *The Usual Suspects* to *X-Men* (2000), while Christopher Nolan, following his success with *Memento* (2000), was hired to reinvigorate a comic-book franchise with *Batman Begins* (2005). Karen Kusama went from the indie hit *Girlfight* (2000) to the live-action cartoon *Aeon Flux* (2005).

In absorbing the indies the studios were also diversifying their product. While the studios' core business consisted of blockbusters and program fillers, they were assigning their prestige pictures and more unusual titles to their boutique divisions, labeling them "independent," and hoping some would attract big box office. More and more independent films were winning Academy Awards, which gave studios bragging rights and sometimes boosted the bottom line.

Independent filmmakers benefited from the new visibility and financial opportunities, but sometimes the effect was to dilute the originality of what had offered an alternative to Hollywood. From the early 1990s onward, although the films' themes might differ from mainstream entertainment, directors were pressured to use recognizable stars, genres, and storytelling techniques. Many, critics argued that *Garden State* (2004), *Napoleon Dynamite* (2004), *Little Miss Sunshine* (2006), and *Juno* (2007) were simply studio pictures with a dash of quirk.

Yet the mainstreaming of the independent film diversified the studio output. Before the rise of independent film, few studios would have taken a risk on *The*

Truman Show (1998), *Eternal Sunshine Of the Spotless Mind* (2004), and *Stranger than Fiction* (2006). David Fincher made *Se7en* and *The Game* (1997) for New Line, but his most daring film, *Fight Club*, was released through 20th Century Fox. The career of M. Night Shyamalan, from *The Sixth Sense* to *The Happening* (2008), is testimony to independent cinema's ability to alter what studios would accept. Independent films' storytelling strategies—complex flashbacks, network narratives, plays with point of view and parallel universes—found their way into mainstream crime films, romantic comedies, and psychological dramas. "One thing that independent film has helped affect", noted Geoff Gilmore of the Sundance festival, "is the reinvention of genre films.... Now you have work that has a place in the mainstream that ten years ago would have been seen as something that was quite marginal". If the Majors changed the indies, to some extent the indies changed the Majors.

Just as it seemed that the conglomerates had overwhelmed the indie market, new sources of funding appeared. The spectacular growth of private wealth during the 1990s and 2000s led several entrepreneurs to finance films that they found worthwhile. Jeff Skoll, an early executive at eBay, founded Participant Productions to support liberal films like *Syriana*, *An Inconvenient Truth* (2006), and *Darfur Now* (2007). Vulcan Productions, underwritten by Microsoft billionaire and philanthropist Paul G. Allen, funded films from a liberal-progressive perspective. Mark Cuban, another Internet billionaire, created a vertically integrated motion picture company, 2929 Pictures. It produced mid- or low-budget films, distributed them through its subsidiary Magnolia Pictures, and held a theater chain, the arthouse circuit Landmark Theaters. Cuban also owned the HDNet cable channel. Some films produced or financed by 2929 reflected Cuban's liberal/libertarian outlook, including *Control Room* (2004) and *Enron: The Smartest Guys in the Room* (2005).

By the late 2000s, more money was sloshing through the independent film community than ever before. In 2007, Summit Entertainment announced that it had access to over $1 billion for creating, distibuting, and marketing new films. Foreign video and cable rights, private investment capital, studio allocations, and equity funding created a surprisingly flush situation—for certain players. Penniless filmmakers at the other end of the scale were obliged to reinvent microbudgeted films, often with the aid of new technology.

3. 独立精神

独立电影首先是指影片独立思考的精神气质和个人体验的自由表达，其次是独立于好莱坞体制的小成本制作和个性化推展，再次是追求非传统叙事

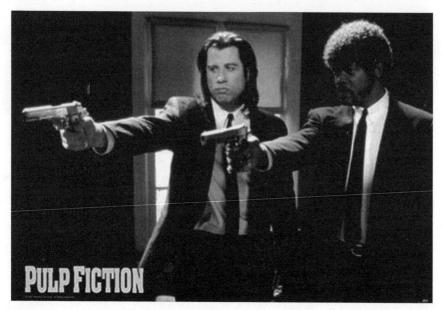

《低俗小说》

和创新电影语言，最后则是独特的社会、政治和美学观以及挑战情色、暴力、族裔、性向和心理变态的底线。

作为美国独立电影的大本营，纽约（主要是纽约大学电影系）孕育出一大批成绩斐然的独立电影人。吉姆·贾木什（Jim Jarmusch）的《天堂陌影》用布列松和小津安二郎式的简约风格白描冷漠疏离的都市人际关系，科恩兄弟（Joel and Ethan Coen）的《血迷宫》将凌厉的惊悚血腥和放肆的讽刺嘲笑融为一体，奥利弗·斯通（Oliver Stone）《野战排》提供极端残酷逼真的越战体验，而黑人导演斯派克·李（Spike Lee）则以《循规蹈矩》表达非洲裔美国人的自我反省和对种族歧视的严正立场，并成为美国黑人电影的旗帜。

以《蓝丝绒》《我心狂野》和《穆赫兰大道》闻名的大卫·林奇（David Lynch）执著于诡异的想象、晦暗的内心和愤懑的嘲讽，自学成才的昆廷·塔伦蒂诺（Quentin Tarantino）在《落水狗》和《低俗小说》中淋漓尽致地展现其玩世不恭的恶搞和后现代的混搭解构，格斯·范·桑特（Gus Van Sant）执著于《我私人的爱达荷》和《大象》中的同性恋弱势群体表达，而斯蒂芬·索德伯格（Steven Soderbergh）则依仗《性、谎言和录像带》和《毒品网络》在独立电影和好莱坞体制之间左右逢源。

此外，这一时期影响较大的独立电影，还包括大卫·芬奇（David Fincher）的《七宗罪》、布赖恩·辛格（Bryan Singer）的《普通嫌疑犯》、保

罗·托马斯·安德森（Paul Thomas Anderson）的《不羁夜》、麦克·菲吉斯（Mike Figgis）的《时间密码》、克利斯托弗·诺兰（Christopher Nolan）的《失忆》和达伦·阿罗诺夫斯基（Darren Aronofsky）的《梦之安魂曲》等。

Four Trends

The diversity of independent work makes it hard to categorize, but four main trends can be identified from the 1980s through the 2000s: arty indies, off-Hollywood films, retro-Hollywood independents, and DIY (do-it-yourself) indies.

The Arty Indies In 1984, a grainy, bleached-out black-and-white film made for $110,000 became the emblem of a new trend in independent filmmaking. It seemed to reject just about everything that Spielberg-Lucas Hollywood stood for. Its tempo was slow, and every scene consisted of a single shot, usually a static one. In place of a sumptuous score, the sound track mixed discordant string music with the wailing beat of Screamin' Jay Hawkins. There were no stars, and the actors' performances were dry and deadpan. The plot, broken into three long parts, seemed utterly undramatic. Two men in Sinatra fedoras meet a young woman who has just arrived from Hungary. They float and drift, mostly quarrelling or playing cards. It was the ultimate hanging-out movie: the three losers hang out in Manhattan, then in Cleveland, and finally in a Florida motel, where they get caught up in a drug deal.

Yet this understated chamber drama/road movie proved strangely compelling. The director, Jim Jarmusch (1953-), finished the first section as a short film (using film stock loaned by Wim Wenders), but after strong festival screenings in Europe, he found enough funding to spin the tale out to two more parts. As a full-length feature, *Stranger Than Paradise* won the prize for best first film at the Cannes film festival and became a highlight of Sundance. The National Society of Fihn Critics named it the best film of the year, and it grossed over $2 million in U.S. art theaters.

In its static visuals and dedramatized approach to its characters, *Stranger Than Paradise* recalled the European art cinema of the 1960s and 1970s, a tradition that Jarmusch (who studied filmmaking at NYU) knew well. His portrayal of cool bohemians also recalled Beat cinema of the 1950s. Yet in its respectful treatment of people struggling to hide their emotions, his film had an affinity with Robert Bresson, Yasujiro Ozu, and other minimalist masters whom Jarmusch admired. Still, *Stranger Than Paradise* was more than the sum of its influences, bringing a tone of ironic affection to the post-Punk New York scene.

The success of *Stranger* launched an indie trend toward artifice and stylization. Hal Hartley (1959-) brought a Jarmusch-like detachment to his

tales of Long Island anomie, such as *Trust* (1991) and *Simple Men* (1992), but Hartley tended to be more philosophical and literary. His characters deliver hyperarticulate dialogue in flat tones, the scenes captured in ingeniously staged long takes. *Stranger's* loose structure, opposed to Hollywood's strongly plotted script, also encouraged filmmakers to explore fractured storytelling, as in the daisy-chain monologues of Richard Linklater's *Slacker* (1991). In the same spirit, Todd Haynes's first feature, *Poison* (1991), presents three distinct AIDS-related stories, each in a different cinematic or televisual style. Like many films in this trend, Haynes's projects have a European art-cinema sensibility. *Safe* (1995) traces the plight of a mysteriously ailing housewife in static long shots reminiscent of Michelangelo Antonioni. Both Hartley and Haynes continued to explore self-conscious artifice in their later films. In *Henry Fool* (1997) Hartley satirized literary culture, and his *Flirt* (1995) presents three separate stories using the same dialogue. Haynes offered the 1950s-tinted melodrama pastiche *Far from Heaven* (2002) and *I'm Not There* (2007), a multileveled collage of Bob Dylan's career.

Stranger Than Paradise showed that offbeat films made on a minuscule budget could play theaters. The minimal means available to Jarmusch, Hartley, Linklater, and Haynes prodded their imaginations and allowed them to take chances with both subject and style. The films, to use Jarmusch's term, were "hand-made". Later experimental features such as Harmony Korine's *julien donkey-boy* (1999) and Gus Van Sant's *Gerry* (2002) would also tailor their offputting approach to the constraints of small budgets.

Off-Hollywood Indies *Stranger Than Paradise*, *Poison, Slacker*, and *Safe* could never have been released by Hollywood companies, but other independent films were less avant-garde. They used recognizable genres and sometimes featured stars. What pushed them off-Hollywood were their comparatively low budgets and risky subjects or storytelling strategies. The careers of Woody Allen and Robert Altman exemplify this trend. Highly praised studio filmmakers in their early careers, both were forced to work as independents in the 1980s and 1990s.

A key example of the off-Hollywood trend is *Blue Velvet* (1986). After the avant-garde midnight movie *Eraserhead* (1978), the historical piece *The Elephant Man* (1980), and the big-budget science-fiction epic *Dune* (1984), David Lynch (1946-) made one of the most disquieting films of the decade, a small-town murder mystery wrapped around a young man's sexual curiosity. Nighttime scenes of erotic obsession alternate with sunny picket-fence normality. At the center of it all stands a voyeuristic college boy, a femme fatale nightclub singer, and a terrifying bully who inhales a mysterious drug through a mask. In the dreamy prologue, a man collapses over his garden hose and the camera plunges into the grass, where beetles and ants swarm. At the end, with a perky robin on a windowsill, the narration suggests that perhaps everything we have seen has been the repressed

hero's fantasy. *Blue Velvet* revived Lynch's career and opened up the anxious, dread-filled landscape he explored in the television series *Twin Peaks* (1990-1991). He would, however, gradually return to his more esoteric roots; *Wild at Heart* (1990), *Lost Highway* (1997), *Mulholland Drive* (2001), and *Inland Empire* (2006) all seem steps back to the hallucinatory experimentalism of *Eraserhead*.

Steven Soderbergh (1963-) likewise skewed genre conventions in *sex, lies, and videotape* (1989). A husband is having an affair with the sister of his slightly neurotic wife; so far, a standard domestic melodrama. But into the triangle comes the husband's old friend, who confesses that he records women's sexual fantasies on video and masturbates while replaying them. Gradually the sisters are drawn toward him, and his boyish passivity becomes a challenge to the swaggering husband. In technique, the film displayed a Hollywood polish. Soderbergh engineered a clever psychodrama while pushing sexual frankness beyond what the Majors would have allowed.

For the 1990s, the milestone off-Hollywood movie was *Pulp Fiction*. In *Reservoir Dogs*, Quentin Tarantino had given the caper film a zestful viciousness and vulgarity. His follow-up was a stew of old genres—gangster film, prizefight film, outlaw movie. Tarantino, a self-admitted movie geek, gave several stars showcase roles. Bathing nearly every character in world-weary cool, he shuffled chronology and interwove storylines. He wrote scenes of arch wit and visceral violence (a hypodermic to the heart, the interior of a car spattered with blood and brains), sprinkling in references to movies and television shows. His chatty hitman duo quickly entered popular culture, as did such taglines as "Royale with cheese" and "Did I break your concentration?" At a cost of $12 million, *Pulp Fiction* grossed $200 million worldwide, becoming the most financially successful off-Hollywood independent film of the decade.

On a lesser scale, many 1980s and 1990s independent directors took Hollywood traditions ill daring directions. Lizzie Borden, *Working Girls* (1986) offered a spare but sympathetic portrayal of women in the sex industry. Gus Van Sant mixed seedy realism and filmnoir stylization in *Drugstore Cowboy* (1989) and *My Own Private Idaho* (1991), a gay/grunge road movie based on Shakespeare. Under the same conditions, Altman protégé Alan Rudolph continued the quest for an Americanized art cinema in the ambiguous fantasy/flashback sequences of *Choose Me* (1984) and the enigmatic motivations of *Trouble in Mind* (1985).

Joel and Ethan Coen offered hyperbolic versions of film noir (*Blood Simple*, 1984), Preston Sturges comedy (*Raising Arizona*, 1987), the Warners gangster film (*Miller's Crossing*, 1989), and the Capraesque success story (*The Hudsucker Proxy*, 1994). While the Coens delighted in pushing genres to the brink of absurdity, playwright David Mamet's tense psychodramas of swindling and misdirection, such as *House of Games* (1987) and *Homicide* (1991), stripped noir conventions

down to bare plot mechanics and laconic, repetitive dialogue. The Coens cultivated comic-book visuals and extroverted sound tracks, but Mamet's images and sound effects were Bressonian in their austerity.

Soderbergh, Van Sant, the Coens, and other offHollywood directors also worked, regularly or sporadically, for the studios. The fastest move to the Majors was made by Jarmusch's NYU contemporary Spike Lee. In outline, *She's Gotta Have It* (1986) resembles a classic romantic comedy, with three men pursuing a selfreliant woman. But the men are black, and the woman makes no secret of her sexual appetites. In the long run, Nola Darling is revealed as more liberated than her lovers. Lee revels in African American slang and courtship rituals, as well as his own frenetic performance as the unstoppable jive artist Mars glackmon. To-camera monologues show a domesticated Godard influence, particularly in the hilarious montage of strutting men trying our seduction lines. *She's Gotta Have It* proved a perfect indie crossover, earning $7 million in domestic theatrical grosses. Lee was immediately taken into the studios, for which he made many provocative films.

Another politically committed independent was John Sayles (1950-), whose low-key but nuanced scrutiny of the political dimensions of everyday life brought a 1970s concern with community into the next three decades (*The Return of the Secaucus Seven*, 1980; *Matewan*, 1987; *City of Hope*, 1991; *Lone Star*, 1996; *Sunshine State*, 2002; *Honeydripper*, 2008). Oliver Stone (1946-) offered a more strident critique, expressing his sense that 1960s liberal idealism lost its way after the death of Kennedy. *In Salvador* (1986) and *Platoon* (1986), he consciously sought to meld political messages with entertainment values. After *Platoon* won three Academy Awards and grossed $160 million, Stone became a high-profile Warner Bros. director.

Off-Hollywood filmmakers also designed their fare for overlooked audiences. On the whole, the Majors neglected the tastes of minority viewers. The gay and lesbian films of the 1980s and 1990s were nonstudio productions, adapting traditions of melodrama and comedy to alternative lifestyles (*Parting Glances*, 1986; *Desert Hearts*, 1986; *Longtime Companion*, 1990; *Go Fish*, 1994), Similarly, most of the African American, Asian American, and Hispanic directors eventually cultivated by the studios started as independents. Reginald Hudlin moved from *House Party* (1990) to *Boomerang* (1992), while Wayne Wang's microbudgeted *Chan Is Missing* (1982) led him eventually to *The Joy Luck Club* (1993).

Throughout the 1990s and 2000s, off-Hollywood filmmakers earned critical acclaim. Billy Bob Thornton's *Sling Blade* (Miramax, 1998) won praise despite its slow pace, thanks largely to Thornton's performance as a feeble-minded innocent. Darren Aronofsky's hectic *Pi* proved only a prelude to the frenzied drug trip *Requiem for a Dream* (2000). In *Happiness* (1998), Todd Solondz offered a cross

section of middle-class misery, from phone sex to pedophilia. Multimedia artist Miranda July's first feature, *Me and You and Everyone We Know* (2004), handled similar subjects, but with a wide-eyed insouciance that was nearly comic. The experiments with narrative structure in *Thirteen Conversations about One Thing* (2001), *Elephant* (2003), and *Palindromes* (2005) showed that the indie film had not lost its exploratory ambitions.

The off-Hollywood film, often lacking stars, could make a selling point out of novel storytelling tactics. The most striking instance was probably Christopher Nolan's "puzzle film" *Memento* (2000). The main plot of the film presents the action in reverse order, with the last scene first and the initial scene last. At the same time, a forward-moving line of action is presented in brief scenes of the protagonist Leonard in a motel room receiving a string of mysterious phone calls. If the plot were this abstract, we might have an "arty indie", but other factors make the film a complex riff on tradition. Leonard is determined to find the man who killed his wife. The reverse-order plotting is motivated, approximately, by his traumatic lack of short-term memory. In classic film noir fashion, Leonard meets informants, thugs, and a femme fatale. Mystery surrounds everything, including the possibility that the man whom Leonard kills at the outset is not guilty. In a feat of screenwriting virtuosity, the reverse-order plot obeys the Hollywood three-act structure, and local connections between scenes help the audience reconstruct the chronology. *Memento* became a model off-Hollywood film, borrowing art-cinema strategies of scrambled time schemes and ambiguous endings but balancing them with familiar storytelling conventions.

Arguably the most gifted and unpredictable of the off-Hollywood filmmakers debuting in the 1990s was Paul Thomas Anderson. A grant from the Sundance Institute allowed him to transform a short film into his first feature, *Hard Eight* (1997). *Boogie Nights* (1997), a jolting New Line vehicle, offers an Altmanesque portrait of the 1970s porn-movie industry, treating scandalous scenes (explicit couplings, a final revelation of the hero's penis) with delicate framing and sweeping camera movements. Like Altman, Anderson became known as an actor's director, showcasing performances by his recurring players Philip Baker Hall, Philip Seymour Hoffman, John C. Reilly, and Julianne Moore (some of whom would become stars in their own right). *Magnolia* (1999) was even more ambitious than *Boogie Nights*, charting a day in the San Fernando Valley that is interrupted by a meteorological miracle. Few American melodramas have put angry suffering so centrally on display, portraying men cracking under physical and emotional strain, endlessly wounding themselves and their loved ones. Instead of making more films in the same vein, Anderson shifted to, of all things, an Adam Sandler comedy. But *Punch-Drunk Love* (2002) was far from what the comedian's fans could have expected: a melancholy romance wringing poignancy out of Sandler's

awkward performance style. *There Will Be Blood* (2007) was a brooding study of a flinty 1900s oilman, and its analysis of ruthless business ventures marked another departure for Anderson.

The independent companies marketed their films through a new auteurism. One producer claimed, "I'm in the business of selling directors". This was an echo of the 1970s, when directors purportedly could make personal films for mainstream companies. Paul Thomas Anderson grew up admiring Altman, Scorsese, and films like *Network* (1976). David O. Russell likewise recalled "all those great 1970s Hollywood movies that had stars and were commercial; yet they were original and subversive". For some, the return of Terrence Malick (*Badlands*, 1973; *Days of Heaven*, 1978) with his lyrically spiritual war film *The Thin Red Line* (1998) signaled a revival of ambitious American filmmaking at the end of the century. The aspirations of 1970s auteurs had been taken up by the off-Hollywood independents. Yet by the mid-2000s, with the creation of the Majors' niche divisions, many of those independents found themselves "dependents", boutique Hollywood brands that diversified the studios' access to audiences.

Retro-Hollywood Independents Hollywood had not only purged the controversial trends of the 1970s; it had also narrowed its genre base. Studios focused on special-effects extravaganzas, action pictures, star-driven melodramas and romances, and gross-out comedy. This left several traditional genres unexplored, and independent filmmakers were prepared to take up the slack.

For example, most Majors failed to capitalize on the low-budget horror trend, and so the Mini-Majors and smaller players could develop profitable franchises around *The Evil Dead* (1983), *Nightmare on Elm Street*, *Scream* (1996), and *I Know What You Did Last Summer* (1997). Indie neo-noir could be edgier than studio fare, as seen in John Dahl's *Red Rock West* (1993) and *The Last Seduction* (1994), Bryan Singer's duplicitous *The Usual Suspects*, and Larry and Andy Wachowski's lesbian heist film *Bound* (1996). There also remained the unpretentious, intimate drama. Hollywood had largely left it to television, but it offered opportunities for independents: Victor Nuñez's lyrical Florida tales (*Ruby in Paradise*, 1993; *Ulee's Gold*, 1997), Kimberly Peirce's thematically daring *Boys Don't Cry* (1999), and Kenneth Lonergan's *You Can Count on Me* (2000). James Mangold's debut *Heavy* (1995) established his credentials in psychological drama, allowing him to go on to *Girl, Interrupted* (1999) and *Walk the Line* (2005), films that sustain the classical studio tradition of smooth storytelling and subtly inflected technique.

After the 1960s crisis, Hollywood had abandoned most historical drama and literary adaptations—those prestige pictures like *Lawrence of Arabia* (1962) and *Who's Afraid of Virginia Woolf?* (1966), which garnered not only profits but awards. As the Majors moved away from middle-budget projects, there opened

a market that independents could fill. Costume pictures, for example, did well on video and suited the independents' mid-range budgets. Director James Ivory (1928-) and his producer Ismail Merchant had made small, urbane films since the 1960s, but the new market enabled them to create prestigious adaptations of novels (*The Bostonians*, 1984; *Howards End*, 1992; *The Remains of the Day*, 1993). The independents pursued this path even more aggressively after Miramax triumphed with *The English Patient*. Likewise, several modestly budgeted films were based on theatrical works by David Mamet, Sam Shepard, and other contemporary playwrights. Top stars (Alec Baldwin and Al Pacino for *Glengarry Glen Ross*, 1992; Dustin Hoffman for *American Buffalo*, 1996) sacrificed pay to be in high-quality adaptations. If the Majors fed off the Indies, independent companies benefited from niches left vacant by the rush to megapictures.

DIY Indies All three of these trends can be plotted along a spectrum, from the most avant-garde (arty indies) to the most traditional (retro-Hollywood). Occasionally, however, there came along a film whose main selling points were its unprofessional look and its lack of budget.

At a time when the studios were starting to notice the independent wing of the industry, two films seemed resolutely committed to grit and grunge: Robert Rodriguez's gunfest *El Mariachi* (1993) and Kevin Smith's day-in-the-slacker-life comedy *Clerks*. *El Mariachi* is a showcase for resourceful camerawork and dynamic cutting, while *Clerks*, as grainy as a surveillance video, features casually scabrous humor. Neither was as experimental as an arty indie, nor as plush as a retro-Hollywood exercise. Both drew on classic genres (the comic crime movie, the romantic comedy), but their resolutely cheap look also put both outside the off-Hollywood tradition. These were the cinematic equivalents of garage-band CDs.

Similarly, although it offers only a minor twist on the teen-horror genre, *The Blair Witch Project* (1999) made a virtue of its defiantly amateurish style by pretending to be an unfinished student film. Brilliantly marketed on the Internet, it proved a spectacular hit, possibly the most profitable film ever made. If films this low-tech could be released theatrically, one might conclude that the "age of independents" had indeed arrived. Kevin Smith remarked of Jarmusch's breakthrough film, "You watch *Stranger [Than Paradise]*, you think 'I could really make a movie", Thousands of young people watching *Clerks*, *El Mariachi*, and *The Blair Witch Project* thought exactly the same thing.

As if in response to the mainstreaming of the independent cinema, a new do-it-yourself filmmaking emerged in the new century. For *Tarnation* (2003) Jonathan Caouette compiled years of super-8 and VHS home-movie footage and, using computer programs, created a memoir of his unhappy family life. Transferred to film, it won a prize at Cannes and earned a theatrical release. *Primer* (2004), a somewhat nerdy, enigmatic time-travel story made for $7,000, also won prizes

and theatrical distribution. The director had never made a movie before, but his film, with the air of a science-club experiment gone wrong, attracted a cult, and byzantine websites plotted *Primer's* convoluted time scheme. It seemed that young audiences would embrace an independent film that lacked flashy production values.

A broader manifestation of the DIY aesthetic was the movement dubbed Mumblecore by a sound recordist for one of the films. In various cities young filmmakers were converging on a similar approach. Centering on college-educated twentysomethings trying to sort out their lives, their film consisted of long, often fumbling conversations about love, sex, work, and everyday incidents. Most were shot on video fairly quickly and, though scripted, counted on the actors to improvise. Like Neorealism of the 1940s and the New American Cinema of the 1950s, the low-tech aesthetic of Mumblecore tried to appear more faithful to reality than studio gloss. Andrew Bujalski's *Funny Ha Ha* (2002) and *Mutual Appreciation* (2005), though shot on 16mm rather than video, typify the movement's use of lengthy dialogues. Bujalski shoots using classic Hollywood continuity and puts the emphasis on the performers.

Some critics saw Mumblecore as sustaining the tradition of John Cassavetes and returning to the roots of American independent cinema. "The films feel more like dialogues between filmmakers and their audience and less like calling cards to the studios", remarked producer Scott Macauley. The Mumblecore group had largely been ignored by Sundance, but they met at other festivals, encouraging each other and sometimes collaborating. Because virtually no distributors would touch their films, they pioneered direct Internet marketing. They created websites and posted video Nogs, podcasts, trailers, and promos on YouTube. Some of the features sold thousands of copies on DVD.

On the demand curve for movies, Hollywood was going for the peak, while Mumblecore was serving what was coming to be known as the long tail. That included the niches created by Web 2.0 for self-published books and indie bands. But just as the conglomerates used the web to scout for breakout bloggers and musicians, they could woo Mumblecore filmmakers with the lure of theatrical distribution and wider exposure. "If I have kids that need to go to college", remarked Bujalski, "maybe I'll say yes to a studio movie. It would be good to turn naturalism into a crowd-pleaser". Soon afterward, Hollywood producer Scott Rudin hired Bujalski to adapt a novel, and Jay and Mark Duplass's *Baghead* (2008), a Mumblecore take on teen-slasher films, premiered at Sundance and was picked up by Sony Pictures Classics.

By the end of the 2000s, the American film industry faced several problems. Attendance was not growing, piracy was rampant, audiences fled to videogames and the Internet, and a practical way of distributing films online had yet to be

found. Too many films were being released, and blockbusters were starting to cost well over $100 million. Nonetheless, the industry had adapted comtortably to the new media that had emerged since the 1970s. In 2007, worldwide video in all its forms—DVD, broadcast television, and cable television-yielded the Majors over $38 billion, nine times their share of ticket sales.

Despite their slim slice of the studios' total income, movies in theatres remained crucial ingredients in the media mix. Theatrical release was in effect the advertisement for the DVD and cable transmission. Films spawned television programs, videogames, comic books, and straight-to-video sequels. The press tracked top-grossing films as if they were sports teams, and the Academy Awards ceremony remained all international ritual. Film festivals relied on Hollywood stars to assure press coverage. Fan magazines, infotainment television, websites, and bloggers catered to an insatiable appetite for gossip and insider opinion. In addition, independent cinema, constantly in dialogue with whatever the mainstream was doing, remained prominent far out of proportion to its financial clout.

Well after the start of the new century, Hollywood filmmakers remained among the world's most important and influential. Spielberg, Scorsese, Spike Lee, Quentin Tarantino, Paul Thomas Anderson, and many others took the traditions of American popular cinema in fresh directions. And while some Independents became Dependents, there were still daring and unclassifiable films churning on the periphery. Economically and artistically, film sat securely at the center of America's popular Culture, and the world's.

第三节　英语世界电影

1. 英国电影

面对强大的好莱坞电影，英国电影一直在寻求自己的身份定位。20 世纪 80 年代之后，通过《烈火战车》《甘地传》《看得见风景的房间》等杰作，英国电影再次为自己赢得声誉。与好莱坞梦幻工场不同，英国电影拥有坚定的写实主义传统和强烈的社会责任感。肯·洛奇（Ken Loach）的《鹰与男孩》《雨石》和《风吹稻浪》、麦克·李（Mike Leigh）的《秘密与谎言》和《维拉·德雷克》、尼尔·乔丹（Neil Jordan）的《哭泣游戏》等都展现出惊人的现实生活逼真性和毫不妥协的社会正义感。

与此同时，英国电影也体现出多彩的个性风格，彼得·格林纳威（Peter Greenaway）的《画师的合同》和《情欲色香味》独创一种浓烈繁复的绘画风格和萨德侯爵式纵欲体验。而丹尼·博伊尔（Danny Boyle）和盖·李奇（Guy Ritchie）则分别以《猜火车》和《两杆大烟枪》成就英国式后现代电影放纵和颠覆的解构狂欢。

Britain at Home

In the early 1980s there was talk of a British film renaissance. *Chariots of Fire*, directed by Hugh Hudson, had become the most successful British film ever released in the U.S. and won the Oscar for best picture of 1981. In the exhilaration of the moment the cry "The British are coming!" was uttered (by a

《画师的合同》

Brit, admittedly). *Gregory's Girl* (1981), *Gandhi* (1982), *Educating Rita* (1983), and other films well received by critics and public at home and abroad, followed.

Amidst this bustle of profitable activity two contemporary filmmakers, who have worked together on occasion, established trustworthy creative credits. One is producer David Puttnam, the other director Bill Forsyth.

David Puttnam (1941-), of *Chariots of Fire*, has produced first features of a number of directors who have made important films. Though drawn to talent, he does not regard the director as the film artist, nor himself as an *auteur* for that matter. He began his career in advertising, but in the early 1970s he started to produce theatrical features, including Ken Russell's *Mahler* (1973) and *Lisztomania* (1975). Then in 1976 Puttnam formed his own production company, Enigma; its first release was Ridley Scott's *The Duellists* (1977), widely praised in the U.S. His first great international box-office hit was Alan Parker's *Midnight Express* (1978), followed by *Chariots of Fire*, *The Killing Fields* (1984), and *The Mission* (1986).

On the basis of his success he was named head of Columbia Pictures. Though Hollywood has long attracted and imported foreign talent, the appointment of a foreigner as head of a major studio was unprecedented. Given Puttnam's commitment to making films he cared about and his lack of experience with megacorporations (Columbia was a subsidiary of Coca-Cola), both the offer and its acceptance were surprising. His acceptance was announced in September 1986; his resignation in September 1987.

During that year Puttnam managed to commission a film by Bill Forsyth, *House-keeping* (1987), whose *Local Hero* (1983) he had earlier produced. Forsyth, a Scot, has worked within what can be described as a revival of the Ealing comedy tradition. Like many of the earlier Ealing directors, he began film making with documentaries. His first fiction feature, *That Sinking Feeling* (1979), is a comedy about a bunch of Glasgow slum urchins who engage in an elaborate and preposterous scheme to burgle some stainless steel sinks. His second feature, *Gregory's Girl*, concerns the adolescent infatuation of a gawky lad for a lovely lass who insists on playing soccer with (and plays better than) the boys' team. It also was set in Scotland, as was his third, *Local Hero* (1983). Shot on location in Fort William, *Local Hero* concerns the oil strike in the North Sea and a visiting agent for a Houston oil company. It is reminiscent of the situation in *Tight Little Island* (1949), with an American intruder replacing the earlier English one. In this case, however, the intruder succumbs to the charms of the villagers and longs to be one of them.

Comfort and Joy (1984) Forsyth described as a cross between *Alice in Wonderland* and *Sullivan's Travels* (the Preston Sturges comedy). Its protagonist is a popular disk jockey on a Glasgow radio station who uncovers an ice-cream war between factions of an Italian family: those who run fish and chips shops attempt to move in on those who are ice-cream vendors.

Housekeeping chronicles the *rite de passage* of two pubescent girls whose mother commits suicide and whose aunt, charming if a bit daft, attempts to look after them. It is narrated by the elder, who is more bonded to the aunt and less able to cope with the world as it exists outside her private universe of loss and pain which the aunt has somewhat ameliorated. It ends without resolution (though the voice over is that of a grown woman looking back) as the aunt wanders off down the railroad tracks on which she had ridden into town. Forsyth's only American film has much in common with his Scottish ones, except there is more sadness, less humor. It is in fact a sad film—bleak, like the isolated Pacific Northwest town and the lives lived therein which it portrays—but not without sweetness.

Except for *Housekeeping*, Forsyth's films have offered Scottish looks and Scottish ways with a knowing and affectionate humor. Like the work of Ealing Studios, his films manage to celebrate things British in the face of American competition.

Two other British directors who are currently highly regarded are Nicolas Roeg and John Boorman. Nicolas Roeg (1928-), who had become a topflight cinematographer (on, for example, Truffaut's *Fahrenheit 451*, 1966; Schlesinger's *Far from the Madding Crowd*, 1967; and Lester's *Petulia*, 1968), turned to direction with *Performance* (1970, codirected by its script writer, Donald Cammell). It features rock star Mick Jagger and a plot that intermingles music,

drugs, sex, and identity confusions. *Walkabout* (1971), filmed in Australia, is about a teen-age girl and her younger brother, who become lost in the bush. They are saved by an aboriginal youth but eventually become the occasion for his suicide, through failure in understanding and communication. *Don't Look Now* (1973), with Julie Christie and Donald Suthefiand in Venice, combines murder, illusion, and perhaps the supernatural somewhat in the manner of Hitchcock's *Vertigo*. *The Man Who Fell to Earth* (1976) is an eerie science fiction featuring rock star David Bowie as the alien being. In *Bad Timing* (1980), Art Garfunkel and Theresa Russell play two Americans in Vienna, he a diffident college professor, she an unrestrained hedonist. They meet in an art gallery; the Gustav Klimt paintings on exhibit suggest the fragmented style adopted by Roeg in this tale of tortured erotic love. *Eureka* (1983) is about a prospector (played by Gene Hackman) in northern Canada obsessed with finding gold who, when he does, buys a Caribbean island. The plot is concerned mostly with the miner's attempts to hang onto what he has achieved in the face of others' efforts to take his island away from him.

Insignificance (1985) is a close adaptation of a play that explores metaphysical issues through a cast of four characters brought into contact with each other in a Manhattan hotel room. The "characters" are in fact renditions of contrasting celebrities—Albert Einstein, Marilyn Monroe, Joe Di Maggio, and Senator Joseph McCarthy. They concern themselves with the nature of the physical universe and the likelihood of nuclear anihilation, stardom, love and its loss, and patriotism (which here is indistinguishable from madness).

Castaway (1986), too, is limited in cast and locale, and about ultimate philosophical, or at least psychological, matters. Its protagonist, who has a Robinson Crusoe-like fascination with living an isolated existence, advertises for a "wife" to live for a year on an island just off northernmost Australia. The film is devoted to the subtle intricacies of their sojourn, which passes through most of the permutations of male-female relationships, of aloneness and togetherness, of isolation and society.

Roeg's films present increasingly complex and dazzling mosaics of structure and style in which logic is transcended; the images, extrodinarily sensual, are cut together in pursuit of feeling, like the stories of Argentinian writer Jorge Luis Borges (who is in fact invoked in *Performance*). Roeg's ambiguities offer many readings, but the consistency of his disturbing vision—the threat of violence that we bring to each other through our mismatchings and misunderstandings—marks a film maker emotionally and artistically clear about what he is saying. His kind of film making, rare anywhere, is unusual indeed in Britain.

John Boorman's (1933-) connection with film began as a film reviewer. He then worked in British television, first as a film editor, eventually as a director of documentaries for BBC-TV (including one on D. W. Griffith). His first feature

direction was *Catch Us If You Can* (U.K., 1965; *Having a Wild Weekend* in the U.S.), which starred the Dave Clark Five pop group, and then *Point Blank* (1967) in the U.S. Subsequently, while remaining essentially an English director, he alternated between America and Britain—*Hell in the Pacific* (U.S., 1968), *Leo the Last* (U.K., 1970), *Deliverance* (U.S., 1972), *Zardoz* (U.K., 1974), *Exorcist II: The Heretic* (U.S., 1977)—before settling in Britain: *Merlin and the Knights of King Arthur* (1980), *Excalibur* (1981), *The Emerald Forest* (1985). In his films, even in the more realistic ones, Boorman has been drawn to mythic and fantastic material; quests, magic, and nature appear strongly in them, especially in his British films.

With *Hope and Glory* (1987) he draws some of the same sorts of themes out of his own remembered past as a nine-year-old during the Blitz in London and subsequently at his grandparents' on the Thames at Shepperton. Observation is concentrated on family members, their friends and acquaintances. The special charm of the film is the way in which it deals with life going on in the midst of bombs and wartime separations. In fact the blitzed London, with its collapsed buildings and rubble, becomes a kind of playground. And when his school receives a direct hit, permitting the boy to return to his grandparents' and the river, he mutters "Thank you, Adolf". It is as if the historical moment chronicled by the British wartime semi-documentaries is overlaid with the amused, gentle, and affectionate spirit of the Ealing comedies. It seems a very English film. If its international success inspires imitations, the model it offers is genuine sterling.

State of the Industry Adding support to the British film renaissance was a television channel, Channel 4 of the quasi-governmental BBC, named in reference to the other two BBC channels plus the commercial channel, ITV. Set up in 1980, Channel 4 went on the air in 1982. In that year it began to finance feature films in the manner of Italian (RAI) and West German (ZDF) television. *The Draughtsman's Contract* (1982, Peter Greenaway) and *Dance with a Stranger* (1984, Mike Newell) were made because Channel 4 was prepared to supplement monies obtained elsewhere as required. In 1984 ten out of twenty-eight British features had financial investment from Channel 4; several of the others were presold to the network (*Insignificance*, for example), In 1985 Stephen Frears's *My Beautiful Laundrette* was fully financed by Channel 4 as was most of David Hate's *Wetherby*. The British Film Institute, another partly-governmental agency, has also contributed to the financing and co-financing of a number of recent British successes.

What seems remarkable about the resurgence of British cinema in the eighties is not only that it has managed to retain a national identity, but that its success is due to its national flavor. Many of these films comment critically—directly or metaphorically—on the political, economic, and social stresses that have preoccupied Britain since the mid-fifties, and this current success seems even

more substantial than that of the earlier social-realist features. *Mona Lisa* (1986), *White Mischief* (1987), *Little Dorrit* (1988), *Cry Freedom* (1988), and *Dangerous Liaisons* (1988) are other recent examples. As American distributors have increasingly shied away from films with subtitles, the English-language British art film has become the dominant entry in the American art-house market. In addition, all of these films are released on video. There is now a continuity of financial support not seen since the heyday of Michael Balcon's Ealing Studios some forty years ago.

As regards Ealing's influence, it seems to have come full circle with the biggest British hit of 1988, *A Fish Called Wanda*, directed by former Ealing director Charles Crichton. As for the centrality of television in the current British film scene, Crichton's co-creator was John Cleese, preeminent star of the *Monty Python and Fawlty Towers* series.

But the question, what is a British film? isn't altogether answered by *Wanda*, as redolent as it is with reminders of *The Lavender Hill Mob* and *Fawlty Towers*. Creatively it may be British, but it was an M-G-M movie, financed in Hollywood. Whatever Britain looks like in the atlas, it is no island entire of itself but part of the main. Even its specifically national film types and most distinctive creators fit into an international economic context. As has been suggested, in some ways parts of British cinema are really American bases, like those of our military abroad. It is to the still-major force in the global industry that we now return.

2. 澳大利亚和新西兰电影

澳大利亚自1788年起成为大英帝国殖民地，英国文化一直主导着澳大利亚，而澳大利亚自身的文化认同则持续纠缠在白人文化和土著环境的巨大反差之中。事实上，是英国导演尼古拉斯·罗格（Nicolas Roeg）的《澳洲奇谈》最早将澳洲题材和视觉影像的魅力展示给全世界。澳洲本土导演布鲁斯·贝尔斯福德（Bruce Beresford）的《驯马人莫兰特》、彼得·威尔（Peter Weir）的《吊石坡的野餐》和《终浪》都将现代、理性和文明的白人文化与原始、自然和神秘的土著世界进行深刻和诗意的对照。80年代的"疯狂的马克斯"商业片系列创造出杂糅类型的未来幻象，而90年代巴兹·鲁尔曼（Baz Luhmann）《罗密欧与茱丽叶》和《红磨坊》则颠覆着传统的文化偶像。有趣的是，澳洲本土电影人大都成为好莱坞外籍军团的重要角色，拍摄出《温柔的怜悯》《目击者》《为戴茜小姐开车》和《楚门的世界》等杰出作品。

前英国殖民地新西兰，1947年独立，1978年电影委员会的建立促进了新

《钢琴课》

西兰电影的发展。新西兰的简·坎皮恩（Jane Campion）是电影史上最声名显赫的女导演之一，她的《钢琴课》曾荣获戛纳国际电影节"金棕榈奖"和多项奥斯卡奖。而另一位新西兰导演彼得·杰克逊（Peter Jaskson）则为世界电影贡献过家喻户晓的"指环王"三部曲，其令人叹为观止的电影场景就取自美轮美奂的新西兰。新西兰电影同样也关注现代文明与传统生活的冲突，《夕阳武士》就讲述土著毛利人适应大都市生活的艰难过程。

Other English-Language Cinemas

If the British film industry has been a Hollywood colony, rifled by the common language, the English-language film industries of former British colonies—from Australia to Canada (which also has a French-language industry) have faced even greater difficulty. While England possessed the resources to develop projects that Hollywood could not do at all or as well, the industries of the former colonies struggled to find the economic means and cultural distinctiveness to flourish as alternatives to both London and Hollywood.

Australia

Australia's film production problem paralleled that of any Third World nation—with important differences. Founded by the British as a penal colony in 1788 (which it remained until 1840) and not federated as a commonwealth until 1901, Australia has a population most of which descends directly from Britain. While an emerging country of Africa or Latin America could draw upon its own native culture, customs, and language that had been usurped by colonizers, the dominant customs and language of Australia came from the colonizers, from England, and it was this culture that would produce its films.

Given its direct British descent, Australian culture is not without its parallels to America's. As opposed to the verdant unity of the English countryside, Australia remains a largely untamed frontier continent with awesome topographical contrasts—plains, seas, mountains, deserts, forests. Like modern America, it has both vast modern cities and vast open spaces. Also like America, it has an indigenous culture that the European white settlers pushed back and pushed aside but could neither ignore nor assimilate. The clash of European immigrants and Australian Aborigines paralleled that between white pioneers and Native Americans. While some Australian films (notably Peter Weir's *The Last Wave*, 1977) set Australian whites in the context of Aboriginal culture, as colonizers who need to learn from or at least stop oppressing the natives, the majority (like Weir's *Gallipoli*, 1981) celebrate white Australian culture in itself and bitterly resent the ways Australians are treated by their imperialist oppressors, the stuck-up and sometimes cruel British. The Australian films of the 1970s defined their identity by combining local themes with models from both London and Hollywood: British traditions of literary elegance and polished acting (many Australian actors and directors have trained at the London dramatic academies and have apprenticed in British repertory companies) with the vitality of American images and Hollywood genres.

Before there could be films, there had to be budgets. Shot in Australia, Nicolas Roeg's British film, *Walkabout* (1971), was among the first to demonstrate the power of Australian themes and visual imagery (the contrast of white and Aboriginal children's worldviews in the frontier Australian Outback). If the British could make such films (or a Canadian—Ted Kotcheff's harrowing *Outback*, also 1971), why couldn't Australian directors make them as well? As in so many film production centers outside America, the stimulus came from governmental subsidies for feature films with "local content", consistent with international standards of technical expertise and stylistic polish, through the Australian Film Development Commission, established in 1970 (which became the Australian Film Finance Corporation, or FFC). Produced with just such support, one of the first Australian films to be shown at international festivals was John Power's *The Picture Show*

Man (1977).

Although many Australian films try to sort out modern Australian life (for example, Gillian Armstrong's comic rock-musical, *Star Struck*, 1983, or Stephan Elliott's *The Adventures of Priscilla, Queen of the Desert*, 1994), some impressive Australian films look back at the nation's history—particularly the two decades between the Boer War in South Africa and World War I, the very period of Australian confederation. Australian troops had fought for the British in both wars, with great loss of life and little Australian gain—except for clichés like defending the Empire, serving the Queen, or protecting the "race" against the "wags". Australians had been forced to fight British economic wars against colonial insurgents very much like themselves. Bruce Beresford's (1940-) *'Breaker' Morant* (1980) and Peter Weir's (1944-) *Gallipoli* are two powerful depictions of the Australian soldier as hero and cannon fodder, under the yoke of sneering British superiors.

"Breaker" Morant picks up the debate in John Ford's cavalry films between the laws of peace and the necessities of war. Morant's platoon had been specially trained to fight the Boer guerrillas by using the enemy's informal and improvisational tactics rather than the rules of British military protocol. But when Morant's Australian platoon performs one of the actions for which it was expressly created, the British disown it for political and diplomatic reasons, court-martial Morant and his fellow officers as criminals, and execute two of them on a beautiful morning.

The films Beresford later directed in America include several distinguished "small" films like *Tender Mercies* (1983) and *Driving Miss Daisy* (1989). With Beresford's move to Hollywood, the filming of "rough" Australian types was left to Paul Hogan and Peter Faiman, whose *Crocodile Dundee* (1986) was an international hit.

Gillian Armstrong's *My Brilliant Career* (1979), set in the same period as *"Breaker" Morant* and within the same visual enviromnent, is a *Bildungsroman*—the coming of age of Australia's first major woman novelist (Miles Franklin, played by Judy Davis). The film examines both the social disadvantages of women in colonial Australia and the cultural prejudices against Australian thought and art within the entire British Empire. The woman's lowly status in her patriarchal culture mirrors the country's lowly status in the Empire. Her growing maturity and confidence suggest the growth and confidence of Australia in the same period—and of creative, powerful women in any period. From *Star Struck* to her most popular American film, *Little Women* (1994), Armstrong's movies have continued to explore the ways her female characters learn to define and express themselves.

Both Peter Weir and Fred Schepisi have contrasted Australia's Europeanized culture with that of its Aboriginal natives. Schepisi's *The Chant of Jimmy*

Blacksmith (1978) is a study of a brutally disturbing incident in Australian history. Jimmy Blacksmith is a native Austrahan who gives up his values, his customs, even his name to serve the whites. When he discovers that he has been betrayed, he goes berserk and murders as many white settlers as he can find. He is of course sentenced and executed by white courts of law. Schepisi's film is both a political plea for the rights of Australia's exploited Aborigines as well as a warning about inevitable retribution—a persistent fear of British colonialism. Schepisi later made a number of fine films in America, including *Roxanne* (1987, with Steve Martin as Cyrano), *A Cry in the Dark* (1988, with Meryl Streep; a U.S.-Australian co-production based on an Australian infanticide case), and *Six Degrees of Separation* (1993).

Peter Weir's *The Last Wave* also envisions Aborginal retribution—not as overt violence but as a quietly subversive power, more psychic and metaphysical than conventionally political. In contrast to the modem man of law (Richard Chamberlain), Weir's Aborigines are in touch with the "dreamtime" and with supernatural influences capable of summoning a wave that will drown the puny white civilization. More than any other Australian director, Weir suggests the doubt beneath the surfaces of Australian culture—that "modern", "rational", "civilized" white European society is a mere shadow and delusion in the mystical eyes of Australia's original inhabitants—the ones who were there *aborigine*, "from the beginning". *Picnic at Hanging Rock* (1975) is a very elegant mystery—the inexplicable disappearance of three girls and a teacher from a proper boarding school during an outing, leaving no physical traces behind. Set in the same period as *"Breaker" Morant*, *Picnic at Hanging Rock* contrasts the rational, orderly appearances of repressive white European society (the school itself) with the operations of an inexplicable universe—just as *The Last Wave*, Weirs best film, does in modern dress.

Gallipoli and *The Year of Living Dangerously* (1982) were the last films Weir made in Australia. His American films have been well received (*Witness*, 1985; *Dead Poets Society*, 1989; *Master and Commander*, 2003), except when they depart markedly from Hollywood formulas (*The Mosquito Coast*, 1986).

George Miller's Mad Max films—*Mad Max* (1979), *The Road Warrior* (*Mad Max* 2, 1981), and *Mad Max Beyond Thunderdome* (1985, co-directed by George Ogilvie)—are futuristic fantasies that combine several genres and traditions while creating an original myth; together they constitute an epic. The central character, Max (American-born Mel Gibson, who emigrated to Australia with his parents), is an "enforcer" like Dirty Harry, a searcher and a loner like Ethan Edwards, a wanderer of the wasteland like an Arthurian knight, a founder like Aeneas, a fighter like Achilles, and a wily if not amoral survivor like Odysseus. He makes his own rules and establishes his own loyalties. Max is incapable of settling down

but makes vital contributions to the pockets of civilization that are humanity's only alternative to an age of barbarism. *The Road Warrior* tells how Max helps a besieged group—occupying a refinery that resembles a fort in a western but also echoes the tiny, walled city of Troy—escape to found "the great northern tribe" (much as the Trojans were said to have founded Rome), and *Thunderdome* ends with a foundation story that is also a creation myth. The Mad Max. films draw, then, on classic genres and images with uniquely modern and Australian issues: What would happen to an immense, isolated continent like Australia after an atomic war, in a world already plagued by oil embargoes?

Among Australian directors who did their first significant work in the 1980s and 1990s, Baz Luhrmann (*Strictly Ballroom*, 1992; *Moulin Rouge!*, 2001) is the most flamboyant stylist; Ray Lawrence (*Lantana*, 2001), the most intense choreographer of complex characters; and Rob Stich (*The Castle*, 1997), the most congenial and outrageous comedian. Paul Cox was born in the Netherlands but made his mark as an Australian filmmaker (*Man of Flowers*, 1983; *A Woman's Tale*, 1991; *Innocence*, 2000). And continuing the trend of those who, like Weir, direct their most original and daring works in Australia only to make what are for the most part less interesting films in America, Phillip Noyce left after the brilliantly realistic drama *Newsfront* (1978) and the fiercely tense *Dead Calm* (1989) to make such pictures as *Clear and Present Danger* (1994) and *The Bone Collector* (1999). He returned to Australia to make *The Quiet American* (2001, released 2002) and *Rabbit-Proof Fence* (2002), which are among his finest works. But not everyone leaves. One filmmaker who has bucked the trend and stayed to work in Australia is Rolf de Heer. Born in Holland and raised in Australia, de Heer became known for such domestic dramas as *The Quiet Room* (1996) and *Alexandra's Project* (2003) before making a breakthrough picture with a cast of Aborigines, *Ten Canoes* (2006). Narrated and performed in an Aboriginal language spoken today by 200 people and told in an Aboriginal style, *Ten Canoes* is set before the coming of the whites; it is a tale of the ancestors, a profound and entertaining tragicomedy of conflict and kinship that completely immerses one in its world. The Aborigines improvised much of the dialogue, though de Heer wrote the script; as he told a Time interviewer, "They're telling the stow, largely, and I'm the mechanism by which they can".

New Zealand

New Zealand was settled by the Maori, a people of Polynesian origin, in the 10th century and by Europeans in the 17th and 18th centuries. The Maori called the country Aotearoa—and still do. A British colony since 1840, it became selfgoverning in 1907 and has been an independent member of the Commonwealth since 1947. While the Maori continued to control their own lands, white New

Zealanders nurtured their Britishness along with their independence. The film industry, given a boost by the founding of the New Zealand Film Commission in 1978, is independent and original as well as linked with the industries of Great Britain, America, and Australia.

For some time, the most important filmmakers from New Zealand were from New Zealand and did their major work in England or the United States—notably Len Lye, whose *A Colour Box* (1935) made the first great use of painting directly on celluloid and is considered a British film. Beginning in the late 1970s, however, Roger Donaldson drew attention to New Zealand filmmaking with his *Sleeping Dogs* (1977) and *Smash Palace* (1981). Like Lee Tamahori's *Once Were Warriors* (1994), whose main characters are Maoris living in the big city, *Smash Palace* is a violent family melodrama about the conflict between the way things are and the way heroes and antiheroes think they ought to be: there is a tendency in both films to revert to the old codes in the face of tile wreck of everything important. The black comedies and outrageous horror films of Peter Jackson (1961-, beginning with *Bad Taste in* 1987) became cult favorites and prepared audiences for his horrific family melodrama, *Heavenly Creatures* (1994), the true stow of two infatuated, murderous girls. Jackson went on to make an authoritatively phony documentary about early film history, *Forgotten Silver* (1996, co-directed with Costa Boles), and his first big-budget horror film, *The Frighteners* (1996), in which he revealed a gift for managing large teams and a command of slick special effects, rich visuals, solid performances, and relatively good taste, all of which he put to use in his next major project, the three-part/three-year adaptation of J. R. R. Tolkien's trilogy, *The Lord of the Rings*. Its first part, *The Fellowship of the Ring*, was released in 2001 to critical acclaim and increased book sales. The second part, *The Two Towers* (2002), and the final part, *The Return of the King* (2003), were equally impressive. With each film, Jackson and his New Zealand effects teams broke new ground. Although produced with American money, the trilogy was made in New Zealand.

The hero of Niki Caro's *Whale Rider* (2003), a modern version of an ancient story, is Paikea, a young Maori whose brother, who was supposed to become the next leader, died at birth. Although the boys are educated in their culture and rituals, Paikea (Keisha Castle-Hughes), as a female, is barred from the teaching sessions. At the climax, she rides a whale, re-creating the journey of her ancestor, celebrated in myth, who rode a whale to bring his people to Aotearoa, and she is accepted as the new leader. A feminist film as well as a mythic one, *Whale Rider* brought another powerful woman director to world attention; she joined Jane Campion as one of New Zealand's vital artists.

Jane Campion (1954-) was born in New Zealand and made her first films in Australia: several shorts and *Passionless Moments* (1984); the TV film *Two Friends* (1986); and her first theatrical feature, *Sweetie* (1989). She returned to

New Zealand to make *An Angel at My Table* (1990, originally for TV) and to shoot the Australian-French-New Zealand co-production that made her famous, *The Piano* (1992, released 1993). Most of Campion's films are about women whose means of expressing themselves are met with rejection and incomprehension.

Sweetie is about a dysfunctional family dominated by a spoiled, obnoxious daughter who, the audience finally realizes, was probably sexually abused by her father and has been expressing, in her own way, all the tension and chaos the family denies. Her language is to explode. *An Angel at My Table*, based on the autobiographies of Janet Frame, who became one of New Zealand's most famous authors, tells how Frame's shy ways, coupled with a nervous breakdown, were misdiagnosed as schizophrenia and led to her being incarcerated for eight years of shock treatment. She was saved from brain surgery only when the stories she had been writing were published and the authorities around her realized that she had a rich and sane inner life. If the withdrawn person she presented to the world seemed hard to know, isolated in some private space, her language— written words—got through the barrer. The woman in *The Piano*, who can speak but until the end of the story does not (a decision she has held to since childhood), has her language too: music.

3. 加拿大

英国和法国两种殖民文化和语言并存、又与最强大的好莱坞为邻，成为加拿大电影最重要的背景。约翰·格里尔逊1939年创建的加拿大国家电影局（National Film Board of Canada）主导加拿大电影几十年，并扶持出诺曼·麦克拉伦（Norman McLaren）的《邻居》和《双人舞》等纪录片、动画片和先锋电影名作。

大卫·克南伯格（David Cronenberg）的电影在恐怖怪异的视听外形之下，执着地探索着人类的生存困境和精神空虚，《灵婴》《苍蝇》和《欲望号快车》等都是如此。而埃及出生的亚美尼亚裔加拿大导演阿托姆·伊戈扬（Atom Egoyan）则热衷于通过各种媒介偷窥介入他人的生活、寻求情感和精神的寄托，《色情酒店》和《意外的春天》涉及的人际关系就像冬日的加拿大，既隔绝又温馨。

无论是机智性感的风俗喜剧《美帝国的衰落》，还是反省性的市井讽刺喜剧《蒙特利尔的耶稣》，德尼斯·阿坎德（Denys Arcand）都代表着加拿大电影法兰西文化的优雅气质，而《野蛮人入侵》更让这种气质赢得了大批观众和奥斯卡评委的心。

《意外的春天》

Canada

If Australia and New Zealand struggled with or adapted to the cultural imperatives of British domination before developing original cinemas, they enjoyed the cultural oddity of isolation as Western societies in the oceans south of Southeast Asia. Even more severe have been the cultural handicaps on a Canadian cinema, not only a former British colony, but also a former French colony, a nation of two cultures and two languages, just across the border from the country with the West's most powerful film industry. The earliest Canadian feature was *Evangeline* (1913), directed by E. P. Sullivan; the earliest that survives is *Back to God's Country* (1919), directed by David M. Hartford and starring the woman who masterminded the project, Nell Shipman.

For decades, Canadian cinema was synonymous with the National Film Board of Canada, founded by the British documentarist John Grierson in 1939. Government-supported and famous for the experimental films of Norman McLaren (*Neighbours*, 1952; *Pas de deux*, 1967), the Film Board was committed almost exclusively to short films—documentary or animated, in English or in French. Canada's international prestige rested on its animated films and documentaries, as well as on the avant-garde films of Michael Snow (*Wavelength*, 1967), Bruce Elder (*The Book of All the Dead*, 1975-95), and others. Many feature-oriented Canadian directors (Norman Jewison, Arthur Hiller) and actors (Donald Sutherland, Christopher Plummer) left to work south of the border, as Mack Sennett had.

The changes in Canadian feature-film production began in 1978, stimulated (as usual) by government policy—seed money for film investment through the Canadian Film Development Corporation (established in 1967) and new tax laws that attracted film projects from outside.

Finding Canadian subjects for Canadian films has been more difficult. Ted Kotcheff's *The Apprenticeship of Duddy Kravitz* (1974), based on a best-selling Canadian novel and supposed by the Canadian Film Development Corporation, was the first thoroughly Canadian feature film to make a great deal of money outside Canada.

One of the first French-Canadian directors to reach an international audience was Claude Jutra with his small-scale *Mon oncle Antoine* (1971) and grand-scale *Komouraska* (1974). In the late 1980s, the most popular French-Canadian films were those of Denys Arcand: *The Decline of the American Empire* (1986), a witty, sexy comedy of manners, and *Jesus of Montreal* (1989), a reflexive satire about the production of a Passion Play; he also had great success with the sequel to *Decline*, *The Barbarian Invasions* (2003), in which the characters deal with a death.

Many of the newer English-language directors established their reputations with Canadian features and continued to pursue the themes of their early works in the films they made in the United States and elsewhere. Kotcheff left Canadian TV to make films in England (*Life at the Top*, 1965) and Australia (*Outback*, 1971—a richly atmospheric and disturbingly violent film) before returning to Canada to make *Duddy Kravitz*. His most successful American film, *First Blood* (1982), inaugurated the Rambo series. The heroes of all these films are at war with the world around them, either because they have been forced to fight groups they would rather ignore (*First Blood*) or because they have chosen to "conquer" groups they want to join (*Duddy Kravitz*).

The horror films of David Cronenberg (1943-) are even more tightly interrelated, taking for their essential subject the nature of evolution, both of "the flesh" and of consciousness. The changing body is a cancerous horror in some of his films, a paradox in others, and it is often accompanied by a scary but fascinating change in mental ability and sexual behavior. There is no thematic break between his major Canadian films (*Shivers*, 1975, released in the United States, with cuts, as *They Came From Within*; *Rabid*, 1977; *The Brood*, 1979; *Scanners*, 1980, released 1981, his first international hit.), his Canadian/U.S. co-productions (*Videodrome*, 1982, released 1983, and *Dead Ringers*, 1988), his American pictures (*The Dead Zone*, 1983; *The Fly*, 1986; *M. Butterfly*, 1993), and his Canada-based international co-productions that have included France, the United Kingdom, and sometimes Japan *(Naked Lunch*, 1991; *Crash*, 1996; *eXistenZ*, 1999). They all fit and advance together on a dramatic definition of the nature and psychology of flesh, the metaphoric and sometimes gory route he takes

into the study of people in bodies. In *The Brood*, the story of a woman whose angry thoughts cause her to give birth to little monsters who kill her enemies—so that they are the children of her angel, "the shape of rage"—the horror is characteristically mental and physical. The hero of *Videodrome* (Max) attains a new level of consciousness partly as the result of a brain tumor induced by a video signal, and the hero of *The Dead Zone* gains telepathic abilities, from brain injuries, that allow him to save the world. In the original version of *The Fly* (Kurt Neumann, 1958), the scientist ends up with the fly's head and arm immediately, as soon as the teleportation experiment goes wrong; in Cronenberg's version, the emphasis is on the scientist's slow evolution into a man-fly and on the way he learns to enjoy, as his body changes, the way a fly thinks. The characters in *Crash* attempt to merge flesh and metal, lust and death, through the power of sheer erotic will. And the end of *Scanners* shows two brothers in one body (one's mind and voice in the other's body), as *Dead Ringers* examines the problem of twin brothers with disturbingly separate minds in disturbingly similar bodies, who come together to die.

Of course, not every Canadian director has commuted or emigrated to Hollywood. Atom

Egoyan, born to Armenian parents in Egypt in 1960, remained in Toronto even after *Exotica* (1994), *The Sweet Hereafter* (1997), and *Felicia's Journey* (1999) made him famous. Egoyan's characters are always looking at each other, sometimes in person but usually through some kind of mediator: the phone, a video camera, a TV set, a surveillance camera, a movie, a movie on tape. They peek into others' lives, usually maintaining an excited, voyeuristic distance but sometimes involving themselves with the people they have met through the camera, whom they sometimes cannot even see without a camera (in *Family Viewing*, 1987, one character becomes introspective only when looking at herself on closed-circuit video). Some of Egoyan's characters depend on films and tapes to maintain their real or imagined relationships with the dead. In *Felicia's Journey*, a man whose late mother hosted a cooking show from her own kitchen keeps the kitchen just as she had it and watches her old shows on a TV set in that kitchen, following her instructions exactly in an effort at last to win-or at least be worthy of-her approval.

Transience is one of Egoyan's central themes: the ephemeral nature of commitments, relationships, places to live, and life. Capturing life with a video camera is a transient (erasable) way to stay partly in touch with all that one has lost or will lose. Nevertheless, the woman in *Family Viewing* (Arsinee Khanjian) who is given a tape of her mother's funeral, who was deprived of the ritual of the family viewing-strictly defined-and the chance to bury her mother in person, tosses the tape away, to the incomprehension of the youth who thought that she would be as comforted by watching the tape as by having been there; in other words, Egoyan

knows the difference between media and life, but some of his characters don't. Beyond video, another way to spy on life and create a record of it is to investigate: not to tape people but to question them, getting a thrill of connection from probing their wounds while doing all one can to restore their losses (*The Adjuster*, 1991; *The Sweet Hereafter*). The latter film-adapted from the novel by Russell Banks and the first of his pictures for which Egoyan did not write an original story-makes it especially clear that the ambulance-chasing lawyer is trying to get a life by getting other people's lives, that some secrets will always be kept private, and that some losses cannot be restored. When the Academy nominated Egoyan for an Oscar as best director for *The Sweet Hereafter*, it was, for once, not trying to lure a Canadian to Hollywood but honoring a major artist of the Canadian cinema.

第四节 亚非拉民族电影

1. 伊朗新电影与阿巴斯

亲西方巴列维王朝治下的伊朗曾经拥有相对完善的电影工业、拍摄过一千三百多部质量不错的电影。但1979年的霍梅尼伊斯兰革命和随后爆发的八年两伊战争使伊朗电影备受打击。20世纪80年代后期开始，伊朗电影首先在新现实主义风格的低成本儿童片方面取得成功，并在90年代形成朴实清新而又含蓄深远东方神韵，在国际影坛刮起伊朗电影旋风。

阿巴斯·基亚洛斯塔米（Abbas Kiarostami）是公认的伊朗新电影主将和东方电影大师，他长镜头纪实风格的《何处是我朋友的家》和《生生长流》引发国际影坛的瞩目，而融合诗意哲学和静观纪实的《樱桃的滋味》则破天荒地为伊朗电影赢得戛纳"金棕榈奖"。

伊朗新电影的其他代表作品还包括马吉德·马吉迪（Majid Majidi）的《小鞋子》、贾法·帕纳西（Jafar Panahi）的《生命的圆圈》、马克哈玛巴夫（Makhmalbaf）父女的《黑板》和《坎大哈》等。

Iran: Revoluton, Renaissance, and Retreat

Filmmakers fell under even more severe political constraints in a nearby state on the Arabian peninsula, In 1979, a revolt drove the Shah of the Pahlavi dynasty out of Iran, and the Ayatollah Khomeimi took over the government. While

《樱桃的滋味》的道路影像

Khomeini was consolidating a fundamentalist Islamic state, his country was attacked by Iraq, led by Saddam Hussein. The war split the Arab states and proved costly for Iran. At the ceasefire of 1988, Khomeini's leadership was shaken and Saddam had gained stature.

Under the Shah, Tehran boasted a major fihn festival and a commercial industry releasing up to seventy films a year. In the early 1970s, the mass-entertainment cinema was counterbalanced by a New Iranian Cinema (*cinema motefävet*), exemplified by such films as Dariush Mehrjui's *Gav* ("*The Cow*", 1970;). Some directors left the film workers' union to establish the New Film Group, which received limited government funding. Mehrjui's *The Cycle* (1976) and Bahman Farmanara's *Tall Shadows of the Wind* (1978) were among several films criticizing social conditions, even attacking the Shah's secret police.

After Khomeini's 1979 revolution, many filmmakers went into exile, and film production slackened. Only about a hundred features were made between 1979 and 1985. Censorship, confined largely to political topics under the Shah, now also focused on sexual display and Western influences. Foreign films were cut, then banned altogether.

Iran's theocracy condemned many Western traditions, and before the revolution devout Muslims had burned film theaters. Government officials, however, believed that cinema could mobilize citizens to support the regime.

Khomeini's government continued the annual Fajr film festival that had been created in 1982, and it financed filmmaking that reflected his interpretation of Iranian culture and the Shi'ite Muslim tradition. The Farabi Cinema Foundation, established in 1983, offered government financial aid to producers willing to back directors' first films. Although the war with Iraq was depleting the country's resources, the regime encouraged a new generation of filmmakers, and production rose steadily. Even women directors entered tee industry.

Most important was the Children and Young Adults' Unit of the Farabi foundation. Films about children could attract a large audience in a nation in which nearly half the population was under the age of fifteen. Supplied with funding, many of Iran's most talented directors turned to stories centered on young people. Soon a series of imaginative, affecting Iranian films began to appear at overseas film festivals.

The first filmmaker to gain wide acclaim was the veteran Abbas Kiarostami (1940-). *Where Is My Friend's Home?* (1986), an unpretentious but surprisingly suspenseful story of a child searching for his classmate in a neighboring village, convinced many viewers that something important was going on in Iranian cinema. Kiarostami's sequel, *And Life Goes On* (1992), shows a film director and his son driving through the regions devastated by the 1991 earthquake, searching for the boy who had performed in the previous film. Kiarostami, a master of imaginative composition, uses offscreen action to dedramatize the quake's horror and display the determination of the survivors, as when the son pours a drink for an unseen baby in an adjacent vehicle.

Kiarostami completed this boxes-within-boxes trilogy in 1994 with *Under the Olive Trees* (aka *Through the Olive Trees*), a film about a movie crew camping near a small village in the earthquake region. They are apparently making *And Life Goes* On. Kiarostami creates a humorously maddening scene: multiple takes of the same shot are spoiled when the young actress refuses to speak to the actor who is courting her in real life. Kiarostami went on to deal with the forbidden subject of suicide in *The Taste of Cherry*, the 1997 Grand Prix-winner at Cannes. His *The Wind Will Carry Us* (1999) took another media professional on a contemplative, faintly comic journey into the countryside. By the early 1990s Kiarostami was obtaining his funding from outside Iran.

Kiarostami's prominence drew the world's attention to other talents. Jafar Panahi (1960-), who had assisted on *Under the Olive Trees*, inspired Kiarostami to write *The White Balloon* (1995), which Panahi made as his first feature. Coaxing a remarkable performance out of the child lead, Panahi then cast her sister in *The Mirror* (1997), about a little girl who tries to make her way home from school in crowded Tehran. Along with *Where Is My Friend's Home?*, such films established what the Iranians called the "child quest" genre, in which a determined, not

necessarily, attractive child doggedly overcomes obstacles. The films taught a safe lesson for local viewers while also charming audiences abroad.

Like Kiarostami, Mohsen Makhmalbaf (1957-) had been directing since the 1970s, and he had been imprisoned for his anti-Shah activism. His international breakthrough was *Salaam Cinema* (1994), a good-humored documentary about film fans. He swiftly turned out many lyrical films, including *Moment of Innocence* (1996), a gripping film about the ways in which romance disrupts filmmaking; *Gabbeh* (1996), a mystical drama about a weaver of Persian carpets; and the rapturous *The Silence* (1998), centered on a blind boy who must find work. Makhmalbaf also appeared as himself in Kiarostami's *Close-Up* (1990), which investigates a bizarre real-life swindle. A film buff impersonated Makhmalbaf and ingratiated himself with strangers by promising to make them stars. Kiarostami intercuts documentary footage of the culprit's trial with staged scenes in which participants reenact the event.

Makhmalbaf took time off from directing in 1996 to form the Makhmalbaf Film House, a school for young filmmakers. It quickly became a private production house for the increasing number of filmmakers in his family. In 1997, his seventeen-year-old daughter Samira directed *The Apple*, using him as scriptwriter and editor. Basing her film on a true story of a couple who had never let their two twelve-year-old daughters out of the house, Samira Makhmalbaf recruited the family and social workers to reenact their story, which they do with remarkable naturalness and unconcern for the camera's presence. Her second feature, *Blackboards* (2000), used mostly non-actors to portray unemployed teachers on the roads near the Iraqi border, struggling to educate refugees too concerned with staying alive to respond. Mohsen Makhmalbaf's wife, Marziyeh Meshkini, worked as assistant director to her daughter and then took up directing herself with *The Day I Became a Woman* (2000), examining the situation of women in Iran through tales of three generations.

In comparison to its Middle Eastern neighbors, Iran was quite successful in building its film industry. While in 1980, the year after the downfall of the Shah, only twenty-eight features were made, by 2001 the number had risen to eighty-seven. Most of these were melodramas, crime films, and historical pageants. Producers had a captive audience, since American films were banned and few imports were allowed in. Nonetheless, bootleg videos of foreign films, mostly from Hollywood, circulated secretly. After pirated copies of *Titanic* appeared in Tehran, Leonardo DiCaprio's face popped up on magazine covers and T-shirts.

The films for international export, such as those by Kiarostami, Panahi, and the Makhmalbaf clan, were seldom screened domestically, but they gave Iran a positive image on the festival circuit. Quite attentive to world opinion, the Farabi Cinema Foundation tracked films and directors' careers, ranking them by

their successes at festivals and publishing an English-language magazine, *Film International*, to promote them. With the FCF now coordinating all national film activities, more money was poured into production. The average film budget rose from $11,000 in 1990 to $200,000 in 1998—still, of course, absurdly low by Western standards.

In 1997, Iran elected a more liberal president, Mohammed Khatemi. As a former minister of culture, he had played a role in helping filmmakers achieve some relative freedom. His desire to open Iran to a dialogue with the West was strongly opposed by more conservative officials, but Khatemi had a powerful ally in his country's cinema. Censorship and bureaucratic supervision of scripts loosened, and Iranian films, particularly by Kiarostami and Samira Makhmalbaf, continued to win international prizes. But things were changing.

After *The Wind Will Carry Us* (1999), Kiarostami declared that he would step aside in favor of a younger generation and would shoot only on video. The more political Mohsen Makhmalbaf, who was appalled by the draconian rule of the Taliban in neighboring Afghanistan, filmed *Kandahar* there. Released to international success in 2000, it exposed the horrific conditions encountered by an emigré woman trying to find her sister. Makhmalbaf decided to stay in Afghanistan and help in building schools and hospitals. His family joined him and made films about the country's plight: Samira's *At Five in the Afternoon* (2003), Marziheh Meshkini's second feature, *Stray Dogs* (2004), and eighteen-year-old second daughter Hana's first feature film, *Buddha Collapsed Out of Shame* (2007).

A younger generation of filmmakers benefited from foreigners' enthusiasm for Iranian films. Some provided what had become the prototypical "Iranian film." As director Bahman Ghobadi put it:"Too many people just imitate the greats like Kiarostami. One or two imitations is all right, but so many is senseless." Ghobadi was one of the most successful new directors, making child-quest stories that were emphatically not heartwarming. *A Time for Drunken Horses* (2000) and *Turtles Can Fly* (2004) showed the grim lives of children struggling during war and conflict. Mani Haghighi's *Men at Work* (2006) takes a different approach, dealing in comic fashion with four men's absurd decision to try to topple a huge rock they notice beside a road. Jafar Panahi, who had made *The White Balloon* and *The Mirror*, also turned to comedy in *Offside* (2006). The film centers on a group of young women determined to see a soccer game despite a men-only policy in the stadium. The aggressive girls, tricking the guards keeping them corralled outside, were a far cry from the waifs of the child quest genre.

Under Mohammed Khatemi, the years from 2002 to 2004 made the industry stable and flexible, but the situation changed when Mahmoud Ahmadinejad, a right-wing isolationist, was elected president in 2005. Strict Censorship was reinstated, with some films, such as Panahi's *Offside*, being banned. Filmmakers

were encouraged to keep submitting their work to festivals abroad, but they were ordered to avoid stylistic experiment and stick to national social and Islamic issues. By 2008, the government offered higher salaries to tempt filmmakers into television production, where they could be more closely controlled.

Kiarostami, who had long been working wholly with European backing, continued to live in Iran but made' his films abroad. Makhmalbaf stayed in Afghanistan. Samira Makhmalbaf initially tried to make a film in Tehran, but when she was told that the government did not want any of the family working in Iran, she joined the rest of the family and directed *Two-Legged Horse* (2008). Ghobadi also went into voluntary exile. Under Ahmadinejad, the Iranian cinema was less likely to foster creative filmmaking.

2. 韩国电影的异军突起

韩国电影兴起于20世纪60年代,"韩国电影教父"林权泽（Im Kwon-Taek）的艺术生命也从那时延续至今。既有《将军之子》这种深受观众欢迎的类型化武侠大片，更有《悲歌一曲》和《醉画仙》这种饱含民族文化精髓并大受国际电影节青睐的主流艺术片。

20世纪50年代初的朝鲜战争导致至今无法愈合的民族分裂、骨肉分离，韩国的军事独裁统治直到20世纪80年代末才被民选政府替代，而这也成为韩国电影在20世纪90年代一飞冲天的起点。在此后的十几年间，韩国电影不但在国内商业票房取得空前的成功，而且多次获得著名国际电影节和艺术院线的高度赞誉。

在主流商业片方面，韩国电影全面学习好莱坞电影的理念和手法，融入日本和香港电影的元素，并结合韩国民族性格和苦难历史，拍摄出姜帝圭（Je-gyu Kang）的《生死谍变》和《太极旗飘扬》、朴赞郁（Chan-wook Park）的《共同警备区》、奉俊昊（Joon-ho Bong）的《杀人回忆》和情感片《八月照相馆》、喜剧片《我的野蛮女友》、古装片《丑闻》等深受韩国观众欢迎的卖座电影，其中《生死谍变》更创造出击败《泰坦尼克号》韩国票房纪录的奇迹。

在艺术电影方面，留学法国、绘画出身的金基德（Kim Ki-duk）《漂流欲室》和《春夏秋冬又一春》在国际化的背景下对民族文化和人性本能进行极端性地呈现，作家出身、曾担任韩国文化部长的李沧东（Chang-dong Lee）在《绿洲》和《诗》尽显沉郁深刻、悲天悯人的定力和诗意，而最具先锋实验精神的洪尚秀（Sang-soo Hong）则以《江原道之力》等不懈地探索电影的另类叙事和视点变换。

《醉画仙》

《共同警备区》

South Korea

Hong Kong cinema had galvanized Asia in the 1970s and 1980s with comedies and action movies. During the 1980s, Taiwan and Mainland China had made their mark with outstanding festival films. In the 1990s and 2000s, South Korean filmmaking triumphed on both fronts. It won a regional following with lively genre of ferings, and it supported films that earned festival prizes and Western arthouse distribution. Even more remarkably, directors managed to make local blockbusters that competed favorably with Hollywood's. South Korea became the new century's most energetic Asian cinema.

The Industry Expands Like Taiwan, Korea had been a Japanese possession until the end of World War II, and it was divided at the 38th parallel when the Korean War (1950-1953) ended in a stalemate. North Korea's Communist regime maintained autocratic control over its populace even after the fall of the U.S.S.R. For decades, South Korea was aligned with the U.S. and ruled by military juntas; a moderately democratic system was not installed until the late 1980s. Economically, South Korea shot forward, its entry into electronics and computer technology steered by the family conglomerates known as chaebols.

Since the 1950s, the film industry had specialized in melodramas, historical spectacles, and, during the 1980s, films of graphic sex. Many film studios flourished. But in 1973, the government passed stricter laws regulating them, effectively giving a handful of companies control of distribution. Domestic production ran to 100-200 titles per year, supported by a ban on most foreign imports. In 1986, authorities bowed to U.S. pressure and allowed many more foreign titles to enter, which shrank the audience for local product.

One breakthrough came in 1993, when *Soponje*, a historical drama by the veteran filmmaker Im Kwon-taek (1936-) unexpectedly attracted over a million viewers. Investment began to flow into the production sector from chaebols such as Samsung, and soon major production houses and distribution companies were forming. A younger generation of filmmakers, wise to the production values of Hollywood and Japan, stepped up. The most striking result was *Shiri* (1999), an action thriller about military assassins from North Korea. It drew over five million viewers and U.S. $25.1 million in ticket sales, beating the local record set by *Titanic*.

Shiri started a cycle of action blockbusters that went on for a decade. In a country of only 50 million, 6 million viewers flocked to *JSA* (2000) and 10 million to *Silmido* and *Taegukgi* (both 2004). Domestic films routinely attracted about half the box-office income, a rare occurrence in most countries. This was partly due to a quota system, put into practice in 1996 and requiring that theaters had to screen locally produced films for at least 146 days per year. But the films' success

was also due to the audience's loyalty to homegrown product. In addition, a liberal censorship system allowed filmmakers to move in directions that Hollywood could not, toward quite graphic sex and toward unexpectedly downbeat stories.

Korea cinema proved highly exportable. Other Asian countries devoured, its comedies (such as *My Wife Is a Gangster*, 2001), romances (*My Sassy Girl*, 2001), horror films (*Memento Mori*, 1999; *A Tale of Two Sisters*, 2003), and crime films (*Nowhere to Hide*, 1999; *Friend*, 2001; *A Bittersweet Life*, 2005). These were the genres that Hong Kong had exported successfully, but Korean directors gave them an immaculate burnishing that reflected bigger budgets and technicians trained in film schools. Costume dramas such as *Untold Scandal* (2003) proved tremendously popular as well, as did cult movies with such titles as *Teenage Hooker Became Killing Machine in Daehakroh* (2000).

Art Films and Genre Crossovers While Hong Kong could not sustain an art-cinema sector, Korea could. Im Kwon-taek had made scores of costume films and melodramas since 1962, but *Sopyonje* gave him a fresh start on the festival circuit. *The Taebek Mountains* (1994) traced the impact of war on friendship and trust in a village. The often-told historical drama *Chunhyang* (2000) was rendered in lush, detailed sets and costumes. Im respects the story's roots in oral narrative by interspersing shots of the narrator's performance (*pansori*) with the filmed drama. Im became an embodiment of the new fortunes of the cinema he had served so long; special financing allowed him to finish *Beyond the Years* (2007), his one-hundredth film.

At about the same time, Jang San-woo was drawing attention on the festival circuit with daring sexual material. In 1999, the same year as *Shiri*, he finished *Lies*, a tale of an obsessive erotic affair between a student and her teacher. The explicit sex scenes made the film a scandal and brought it many foreign sales. Ever one to break taboos, Jang gave street kids and homeless people cameras to shoot *Timeless Bottomless Bad Movie* (1998). With *The Resurrection of the Little Match Girl* (2002) he went beyond *The Matrix* by fusing silent cinema, comic-book mythology, and videogame aesthetics. The most expensive Korean film made to that date, Resurrection failed to find a mainstream audience.

A more fastidious probing of narrative form was undertaken by Hong Sang-soo (1959-). In *The Day a Pig Fell in the Well* (1996) and *The Virgin Stripped Bare by Her Bachelors* (2000), Hong explored multiple-viewpoint stories, often presenting the same scene differently at two points in the film. *The Power of Kangwon Province* (1998) starts by following a female student traveling to a resort area with two girlfriends. Returning to Seoul, she tries to find her lover, a college professor. Then the film shifts to his viewpoint. He goes about his business in Seoul and decides to visit the resort with his friend. Aboard the train, the friend goes to get a snack and he passes the woman. Suddenly we realize that Hong has

started his story over. The two men's rambles through the countryside take place at the same time as the visit of the women, who are now sensed as perpetually offscreen. Throughout the 2000s, Hong became a wry observer of midlife careers, focusing on disaffected intellectuals somewhat in the manner of Eric Rohmer.

Lee Chang-dong (1954-) was more varied in his experimentation, moving in a fresh direction with each film. *Peppermint Candy* (2000) reviewed recent Korean history by tracing a man's life backward. *Oasis* (2002) presented an unsentimental story of a retarded man drawn to a woman with cerebral palsy. Lee's film won many international awards, as did his *Secret Sunshine* (2007). Here a widow's effort to adjust to small-town life is shattered by a brutal crime.

The most infamous director of the new Korean cinema was Kim Ki-duk (1960-). His films did not attract much of an audience in Korea, but they were staples of foreign festivals. Kim came to notice with *The Isle* (2000), a drama of desire that made memorably grisly use of fishhooks, and Continued with *Bad Guy* (2001), *Samaritan Girl* (2004), and *3-Iron* (2004). Kim took a respite from these psychologically punishing dramas with *Spring, Summer, Autumn, Winter... and Spring* (2003). It was a surprisingly meditative tale of a young monk who is tempted to abandon his vows when a woman enters his life.

Several directors straddled the boundary between genre cinema and festival filmmaking. Before *The Host*, a Spielberg-like monster movie, Bong Joon-ho (1969-) had made the offbeat romantic comedy *Barking Dogs Never Bite* (2000) *and Memories of Murder* (2003), a suspenseful police procedural that was the year's top-grossing film. Park Chan-wook (1963-) made the blockbuster *JSA* (2000), a political mystery set on the northern border, and followed that with the elegantly shot hyperviolence of *Sympathy for Mr. Vengeance* (2002), *Oldboy* (2003), and *Sympathy for Lady Vengeance* (2005). Mainstream audiences could enjoy Bong and Park's gripping plots, while international critics admired their genre tweakings and arresting imagery.

Korean cinema seemed unstoppable. The box office hit a thirty-year high in 2005, with nearly 150 million admissions. Domestic films claimed 60 percent of the market. Investment in film production doubled from 2003 to 2006. DVD sales were brisk, and Hollywood firms were buying remake rights to many titles. The annual festival in Pusan had become the top showcase and marketplace for Asian cinema. A year later, however, in response to demands from the government and the U.S. film industry, the quota was cut in half, mandating only seventy-three days for local movies. Filmmakers protested loudly, but the new rule remained firm.

Initially the quota did not seem to hurt. Attendance in 2006 broke yet another record, chiefly because two films, *The King and the Clown* and *The Host*, surpassed all box-office records and pushed the industry's revenues to over a billion dollars. Yet there were signs that the boom years were over. The two blockbusters drew

a quarter of tine year's total audience, which made the average income for other pictures sink. Worse, more films were being released than the domestic market could assimilate. Observers blamed the saturation on "listing fever", the emergence of new companies which, to justify being listed on the stock market, had to pump out a lot of product. At the same time, Korea's biggest foreign market, Japan, began to cool off, sending exports plummeting. In 2007, total box-office receipts dropped, local films lost market share, and the $70 million megapicture *Dragon War* (aka *D-War*) failed to become a global hit.

Major companies CJ and Showbox responded by canceling projects, seeking money from new sources, and exploring coproductions with Chinese and American firms. Whatever the industry's future, however, for a decade South Korea had shown that a small country's cinema could advance on many fronts—local, regional, popular, arthouse—and give Hollywood a run for its money.

3. 日本新电影

日本电影新浪潮之后的80年代是日本电影相对平稳的时期，伊丹十三（Juzo Itami）的《葬礼》和《蒲公英》、小栗康平（Oguri Kohei）《泥之河》、相米慎二（Somai Shinji）《鱼影之群》、柳町光男（Mitsuo Yanagimachi）《火祭》代表着日本电影这一时期的最高水准。

90年代日本电影再次崛起，而北野武（Takeshi Kitano）就是最杰出的代表，这位演员出身的导演以《那年夏天，最宁静的海》的睿智诗情和《花火》的暴虐凌厉征服了观众和评论家。而岩井俊二（Shunji Iwai）的《情书》、河濑直美（Naomi Kawase）《萌动的朱雀》和是枝裕和（Hirokazu Kore-eda）《下一站天国》等都是日本艺术电影的上乘之作。

同时，日本的主流商业电影也取得不俗的战绩，周防正行（Masayuki Suo）的浪漫轻喜剧《谈谈情跳跳舞》、三池崇史的另类动作片（Takashi Miike）《杀手阿一》和黑泽清（Kiyoshi Kurosawa）的惊悚恐怖片《报应》等不但国内票房大胜，而且也形成了一定的国际影响。

Japanese Filmmaking after the New Wave

Of the post-New Wave generation, several filmmakers have already achieved international profiles, including Yoshimitsu Morita, Kohei Oguri, Mitsuo Yanagimachi, Shinji Somai, Ishii Sogo, and Juzo Itami. Morita became popular

北野武式的暴力

for cheaply made, breezy comedies such as *Something Like That* (*No yonamono*, 1981) and *Boys and Girls* (*Boizu & gaaruzo*, 1982), but achieved his first major critical acclaim for *The Family Game* (*Kazoku geemu*, 1983)—a hilarious satire on contemporary Japanese family life and Ozu-style "home drama" films, as well as on the nation's educational system. Morita followed with *And Then* (*Sorekara*, 1986), an uncharacteristically serious adaptation of a period novel set in 1909.

Kohei Oguri (1945-) achieved something of a coup when his first feature, *Muddy River* (*Doro no kawa*, 1981), was produced and distributed privately before being picked up by Toei and winning numerous Japanese awards, as well as an Oscar nomination and the silver prize at Moscow. This unsentimental black-and-white film depicts the friendship between two little boys of the underclass in 1956 Osaka, and it harks back to the postwar humanism of Mizoguchi and Ozu. Four years in production, Oguri's second feature, *For Kayako* (*Kayako no tameni*, 1985), is a visually exquisite, formally stylized story set in 1957 of a love affair between a Korean man (Koreans are notoriously subjected to racial discrimination in Japan) and a Japanese woman. *Sting of Death* (1990), a study of the trauma of postwar alienation on a young married couple, won both the Grand Prix du Jury and the FIPRESCI critics award at Cannes in the year of its release, bringing Oguri's work to international prominence.

The focus of Mitsuo Yanagimachi's (1945-) work to date has been the way in which rapid technological modernization has alienated the Japanese from

nature, a major theme in a society that still practices a form of pantheism, which is associated with the religion of Shinto. His *A Nineteen Year Old's Map* (*Jikyusai no chizu*, 1979) concerns a deracinated student who wages displaced guerrilla warfare against urban chaos through his paper route, while *A Farewell to the Land* (*Saraba itoshiki daichi*, 1982) is about a disaffected truck driver who descends to drug abuse and murder in reaction to the sterile industrial landscape that surrounds him. But Yanagimachi received worldwide recognition for *Fire Festival* (*Himatsuri*, 1985), based on an actual mass murder that occurred in 1980 in the Kumano region of southern Japan. There, in an area sacred to Shinto, where gods are believed to occupy both the mountains and the sea, land developers are attempting to build a tourist resort and marine park; the protagonist, a forty-year-old woodcutter and avid Shintoist, attempts to fight modernization of the region and, failing that, commits the ultimate self-declarative act by killing his family and himself with a shotgun.

Shinji Somai's (1948-) first serious film was *A School of Fish* (*Cyoei no mure*, 1983), a documentary-style account of the life and work of an uncompromising Pacific coast tuna fisherman that employs extremely long takes. But his *Typhoon Club* (1985) brought him instant success when it shared the prize for the Young Cinema competition at the Tokyo International Festival for that year with Péter Gothár's *Time Stands Still* and Ali Ozgenturk's *Horse, My Horse*. Characterized, like his earlier film, by magnificently revealing sequence shots, *Typhoon Club* concerns four junior high school students who are stranded inside their school building by a seasonal storm.

Ishii Sogo has parallel careers making films and directing rock videos and commercials. He produced several chaotic gang war fantasies—*Crazy Thunder Road (Kuruizaki Thunder Road*, 1980); *Burst City (Bakuretsu toshi*, 1981)—before scoring both commercially and critically with *The Crazy Family* (*Gyakufunshakazou* [literally, "*Back-Jet Family*", 1987]), a ferocious satire on contemporary Japanese consumerism.

Certainly the best known of the post-New Wave directors is *Juzo Itami* (1933-1997), a former actor whose black comedy *The Funeral* (*Ososhiki,* 1984) won a Japanese Academy Award for Best Picture and numerous festival prizes for its mordantly hilarious depiction of how the rising middle class handles one of its culture's most elaborate, expensive, and important social rituals. Itami, who also writes and produces his own work, continued in this vein with *Tampopo* (1986), a comic film about sex, food, and eating, and *A Taxing Woman* (*Marusa no onna*, 1987), a satire on the intricacies of the Japanese tax system. More recently, Itami has directed the comedies *The Gangster's Moll* (*Minbo-no onna*, 1992) and *The Seriously Ill* (*Daibyonin*, 1993), the former dealing with *a yakuza* extortion ring and the latter with the vagaries of contemporary hospitalization based on Itami's

own experience (Itami's face and neck were slashed by *yakuza* thugs in retaliation for the critique of *Minbo-no onna*).

The 1990s and 2000s: The Punctured Bubble and a New Surge of Talent

Japan's boom decades were followed by a steep and prolonged recession, with falling stock prices and real-estate values bringing the economy to a halt. The long-ruling Liberal Democratic Party, repeatedly exposed as corrupt, could respond only by sinking more money into the construction industry. In this climate, the vertically integrated movie companies became even more ossified. They dominated the box office through superior distribution power and the tradition of forcing employees of the studios or of allied businesses to buy movie tickets. For the world outside Japan, the interesting films were largely independent products.

Although the industry was slumping, the 1990s gave Japan a new cohort of directors, many of whom started with 8mm student films. Shinji Aoyama's melancholy and disturbing *Eureka* (2000) galvanized festivals. The film begins with a brother and sister taken hostage on a bus, but the film is not a conventional action picture. Instead it focuses on the efforts of the bus driver to heal the teenagers' wounded lives after the crisis. Shunji Iwai (1963-) directed the offbeat romance *Love Letter* (1995) and the dystopian fantasy *Swallowtail Butterfly* (1996). The tirelessly self-promoting Sabu (pseudonym of Hiroyuki Tanaka) made post-Tarantino exercises such as *Dangan Runner* (1996), about three men chasing each other through Tokyo, and *Sunday* (2000), about a salaryman dragged into a gang war. Several filmmakers examined gay sexuality; Ryosuke Hashiguchi's *Like Grains of Sand* (1995) presented a sensitive study of schoolboys exploring their affection for each other.

Hirokozu Kore-eda (1962-) came to attention with *Maborosi* (1995), a subdued drama of a widow learning to love her second husband. The stately, distant compositions celebrate the beauty of everyday life and the forbidding but fascinating seaside landscape of the community in which the wife finds herself. Kore-eda became one of Japan's strongest talents, winning festival prizes and overseas distribution with heartfelt films—about what happens to people when they die (*After Life*, 1998), about three children neglected by their mother (*Nobody Knows*, 2004), and about the quiet tensions among parents and children (*Still Waiting*, 2008).

One sign of the opportunities opened up in the 1990s was the emergence of Japan's first major woman filmmaker, Naomi Kawase (1969-). Like many of her counterparts, Kawase attracted attention with a super-8mm project; a documentary

about her long-lost father. Her first fiction film, *Suzaku* (1997), won several major festival awards. When the building of a railroad line is halted, a family has to struggle to get by. One day the father, an unemployed construction worker, walks into the unfinished tunnel with a super-8 camera and disappears. Kawase's tranquil treatment of landscape is balanced by a quiet examination of each family member's response to the mystery. *Shara* (2003) and *The Mourning Forest* (2007) cemented Kawase's reputation as Japan's most honored woman filmmaker.

More in the mainstream was Masayuki Suo (1956-), who sought to revive early-Ozu comedy in a series of films about young people, notably *Sumo Do, Sumo Don't* (1992), centering on the adventures of a college wrestling team. Suo found international success with his wistful salaryman comedy *Shall we Dance?* (1995). After a long silence, Suo returned with *I Just Didn't Do'It* (2007), a harsh attack on Japanese legal procedures.

The most significant director of the 1990s was Takeshi Kitano (aka "Beat" Takeshi, 1947-). Japanese audiences loved him as a TV comedian but turned away from his movies. It was on the international scene that he won praise for harsh yakuza movies such as *Boiling Point* (1990), *Sonatine* (1993), and *Hana-bi* (1997). Kitano cultivated a deadpan style of performance and image design, with characters often facing the camera, lined up like figures in a simple comic strip. They speak seldom, stare at each other, and remain strangely frozen when violence flares up. Kitano's films compel attention by alternating brutality with almost childish poignancy, especially when he returns to his favorite motifs—sports, adolescent pranks, flowers, the sea. His sense of color has a naive immediacy, and he warms his spare visuals with the cartoonish tinkle of Joe Hisaishi's musical scores. The more lyrical side of Kitano's work emerged in *A Scene at the Sea* (1991), a wistful tale of a deaf-mute couple. Kitano also indulged in symbolic dramas (*Dolls*, 2002), period swordplay (*Zatoichi*, 2003), and slapstick comedy (*Takesbis'*, 2005; *Glory to the Filmmaker!*, 2007).

Many of the new directors followed Kitano toward downscale genres. Kyoshi Kurosawa (no relation to Akira Kurosawa, 1955-) loosed a barrage of enigmatic and shocking works, using crime plots or horror conventions in unpredictable ways. Takeshi Miike (1960-), Kurosawa's contemporary, also reworked pulp material, turning out shocking movies at a frantic pace. *Fudoh: The New Generation* (1996) centers on schoolboy gangsters and schoolgirl assassins. *Dead or Alive* (1999) is a hard-driving crime movie, while in *Audition* (1999) a salaryman who auditions women to be his girlfriend gets more than he bargained for. Miike enjoyed cult favor overseas with such hard-hitting items as *Ichi the Killer* (2001), but he also offered children's films, a musical, and *Big Bang Love, Juvenile A* (2006), a surrealistic account of a boys' prison. *Sukuyaki Western Django* (2007) featured Japanese cowboys and threw in a cameo appearance by

Quentin Tarantino.

Japan also moved further into the global market. *The Ring* (1998), which hinged on a videocassette that kills anyone who watches it, became an international hit and spawned sequels and imitations. "J-horror" was imitated by South Korea and Hong Kong. Even more popular was anime, of which Japan produced 250 hours each year. The new god of anime was Hayao Miyazaki (1941-). His charming features *My Neighbor Totoro* (1988) and *Kiki's Delivery Service* (1989) made their way to Europe and North America slowly, but they became perennials on video. *Princess Mononoke* (1997) blended Miyazaki's linear style of cel animation with selective use of computer techniques. Miyazaki's movies broke local box-office records, and *Spirited Away* (2001) became the first non-U.S, film to earn more than $200 million outside the United States. *Howl's Moving Castle* (2005) did nearly as well.

Partly because of the success of new directors and new genres, partly because of heavy investment from television and advertising agencies, the industry began to stabilize. Admissions inched to nearly 200 million. The government began supporting domestic production, while private investment increased. American films ruled the top ten, but a huge number of Japanese films filled in the lower echelons. In 2006, Japan released over 400 features, which claimed over half of box-office returns—something that had not happened since the mid-1970s. As in other countries, the bulk of receipts were claimed by a few topgrossers, typically TV spinoffs, anime franchises like Pokémon, World War II spectacles, and sentimental dramas that centered on animals and family life. There were also sprightly comedies such as *The Uchoten Hotel* (2006) and *Bubble Fiction: Boom or Bust* (2006). Mid-range pictures that couldn't achieve overseas distribution reaped income from DVD rights. Companies also benefited from Hollywood remakes of J-horror hits *The Ring* and *Ju-on* (*The Grudge*, 2003).

The directors of the 1990s became the ruling generation, while younger talents emerged in frankly crowd-pleasing films such as *Linda Linda Linda* (2005, Nobohiro Yamashita), *Kisaragi* (2007, Yuichi Sato), and *Tokyo Tower: Mom & Me, and Sometimes Dad* (Joji Matsuoka, 2007). At the other extreme, Japanese directors stayed active far into old age. At seventy, the master of the B yakuza movie Kinji Fukusaku had a career rebirth with *Battle Royale* (2000), a futuristic action film that became a video hit around the world. Shohei Immura, the most prominent survivor of the New Wave, and Yoji Yamada. patron of Tora-San, were directing into their late seventies. At age eighty-two. Seijun Suzuki showed with *Princess Raccoon* (2005) that he could still create outrageous delirium. When Kon Ichikawa died in 2008, he was over ninety; two years before he had released his eighty-eighth movie, *The Inugamis*—a remake of a film he had directed thirty years before. The scale of investments at home and abroad made Japan a major player in

the international business, while a flow of important films from filmmakers of all ages made it one of the world's most enduring national cinemas.

4. 拉美电影新浪潮

80年代，拉美电影受到魔幻现实主义（Magical Realism）文学的重大影响，加西亚·马尔克斯编剧的《埃伦蒂拉》（*Eréndira*，1982）就是典型例子。而进入20世纪90年代之后，在本土多厅影院兴起和美国投资发行的背景下，拉美电影再次焕发出勃勃生机。

在巴西，沃尔特·萨利斯（Walter Salles）好莱坞风格的温情故事《中央车站》赢得多项国际电影大奖并创造票房佳绩，费尔南多·梅瑞尔斯（Fernando Meirelles）反映城市贫民窟孩子绝望暴力生活的《上帝之城》更以其凌厉暴虐的视听震撼观众的身心，而揭露巴西社会对立冲突的《精英部队》在柏林电影节获得大奖，又处处可见美国电影业的幕后推手。

阿根廷电影在90年代中期后重新上路，女导演露西娅·玛特尔（Lucrecia Martel）的《沼泽》和《圣女》先后获得成功，追忆切·格瓦拉年少时代的《摩托日记》引发全球瞩目，而融合爱恨情仇与社会政治的《眼中的秘密》则为阿根廷夺得首座奥斯卡最佳外语片奖。

墨西哥著名导演阿方索·阿劳（Alfonso Arau）以《情浓巧克力》蜚声影坛，《没人写信给上校》《爱情是狗娘》《你妈妈也是》《潘神的迷宫》和《寂静之光》都相继为墨西哥电影赢得荣誉和票房，而与美国为邻的地利也使得墨西哥电影人更容易与好莱坞形成合作。

此外，哥伦比亚的《走私海洛因的少女》、智利的《女仆》和秘鲁的《伤心的奶水》等也是新世纪拉美电影的代表作。

South America and Mexico: Interrupted Reforms and Partnerships with Hollywood

During the 1970s, military governments took power in much of South and Central America. Brazil, Bolivia, Uruguay, Chile, and Argentina all felt under dictatorships. After 1978, pluralist democracy returned to most countries, but the new governments faced colossal inflation rates, declining productivity, and huge foreign indebtedness. The IMF imposed austerity measures on Mexico, Brazil, and Argentina. During the first half of the 1990s, inflation was brought down to more

《情浓巧克力》

reasonable levels, and film production recovered somewhat.

Latin America's screens had been dominated by Hollywood cinema since World War I. The region's film output had grown significantly between 1965 and 1975, but because most right-wing governments provided little protection against U.S. imports, productivity declined steadily over the next decade. Occasionally, however, local industries gained strength and some filmmakers won a place on the international art-cinema circuit. Moreover, during the 1990s, construction of multiplexes in the more important Latin American markets led to a rise in attendance, though in some cases imported films proved more attractive than local ones.

In 1999, Disney/Buena Vista International bought a 30 percent share in the Argentine company Patagonik, which has remained the largest producing firm in Latin America. It was the start of a trend toward U.S. studios investing in Latin American production. They did so partly because of the growing success of local films and partly because the North American Free Trade Agreement (NAFTA, 1994), combined with inflation in some Latin American countries, lowered the cost of investing. The goal was not always to release locally made films in the U.S. Rather, American studios distributed them in their home markets and other foreign countries. Diego Lerner, president of the Walt Disney Company Latin America, specified: "Our objective is to break even in the local country and skim off profits from international sales". In 2000, Patagonik produced a tricky heist film, *Nine Queens* (dir. Fabián Bielinsky), and Buena Vista Int. released it in Argentina—but sold it to Sony for its mildly successful release in the U.S.

Most other major American studios made production and distribution investments in Latin America. 20th Century Fox helped finance the Mexican international hit *Y Tu Mamá También* (2001) by prebuying the distribution rights for Mexico and several other countries. *Maria Full of Grace* (2004), which achieved American distribution and an Oscar nomination for its lead actress, was a U.S.-Colombian coproduction.

By 2006, international distribution by powerful American firms led to an increasing circulation of films across borders throughout the continent. Many filmmakers feared that so much Hollywood participation would dilute the local flavor of national cinemas, but they also recognized that export was necessary if films were to earn back their costs. U.S. distribution firms undoubtedly helped South American and Mexican films achieve a higher profile internationally. Later, countries set up their own coproductions, often with European participation. For instance, Lucía Cedrón's *Lamb of God* (2008) was an Argentine-French-Chilean project more and more, it became possible to speak of a unified Latin American film market.

Brazil

By 1973, guerrillas had clearly lost their struggle against Brazil's military government. A year later Gen eral Ernesto Geisel assumed the presidency and promised greater openness. In 1975, Embrafilme, originally a state distribution agency, was reorganized to create a vertically integrated monopoly over Brazilian cinema. The government also increased the screen quota, which cut down imports and created a demand for domestic films.

Embrafilme worked with independent producers and courted television and foreign countries for coproductions. Embrafilme's efforts helped double attendance and raise production to a level of sixty to eighty films per year. The agency's powers increased under the transition to democratic constitutional rule. Embrafilme was even able to support the controversial *Pixote* (1980), which presented an unflattering portrait of life in Brazil's cities.

The veterans of Cinema Nôvo retained their central roles in Brazilian film culture. Embrafilme was headed by two Cinema Nôvo directors, Roberto Farias and Carlos Diegues. Like their peers elsewhere, Brazil's director relinquished political militancy and formal experimentation in the name of more accessible strategies. Many directors, from Brazil and elsewhere on the continent, affiliated their works with the Latin American literature of "Magical Realism".

Other directors adapted to an international market. Carlos Diegues's *Bye Bye Brazil* (1980), dedicated "To the Brazilian people of the 21st Century", found success abroad. A tale of an itinerant sideshow troupe drifting through a poverty-stricken country full of discos, brothels, boomtowns, and tv antennas, the film had a boisterousness and sentiment reminiscent of the early Fellini. Another lucrative export was Bruno Barretto's *Dona Flor* and *Her Two Husbands* (1976), in which a man who returns from the dead shares his wife's bed with her second husband. After the success of *Pixote*, Hector Babenco (1946-) won U.S. backing for *Kiss of the Spider Woman* (1984). Also gaining access to international screens were the women directors.

Embrafilme went bankrupt in 1988 and was closed in 1990. A mere nine features were released the following year. Eventually, when Brazil recovered from a bout of hyperinflation, things improved. In 1995 the government tried to end the huge slump in production with state subsidies and tax credits for investors. The spread of multiplexes from 1994 provided a larger audience for Brazilian films. By 1997 Brazil claimed to be the ninth largest exhibition market in the world, and the prosperity attracted foreign investment in coproductions.

Hopes for a Brazilian film renaissance were raised enormously when Walter Salles's (1956-) *Central Station* (1998) won international success. The story deals

with a gruff ex-teacher who makes a living writing letters for illiterate people. Reluctantly saddled with a boy whose mother has been run over, she gradually grows to love him while the two wander the Brazilian countryside. *Central Station* boasted Hollywoodstyle production values, including a lush musical score and beautiful cinematography quite different from the handheld roughness of the Cinema Nôvo era. It won more than forty prizes, was nominated for Academy Awards, and ultimately earned an impressive $17 million worldwide.

Older directors also took advantage of increased investment. Diegues made *Orfeu* (1999), set during the Rio Carnival and featuring vibrant music, set and costume design, and cinematography. Guerra directed *Estorvo* (2000), retaining his political approach by obtaining Cuban cofinancing for a critical look at the gap between haves and have-nots in Brazilian society.

Financing was not difficult to find under the government subsidy program, and feature production rose to forty in 2001. The problem was distribution, since as in other South American countries, audiences largely ignored local fare in favor of imported Hollywood films. Moreover, despite a steady increase in the number of theaters in Brazil, there were still too few to accommodate such a high output. In 2001, only 9 percent of tickets sold in the country were for local films.

In 2001, the government added to its support by granting tax breaks to foreign companies producing locally. Sony, Warners, and 20th Century Fox all started to establish a presence in the country. They intended to make or buy local films for distribution at home and abroad. Brazil was a logical target; it had by far the largest filmgoing public on the continent, but since its primary language was Portuguese, it could not send its films easily to Spanish-speaking countries or get backing from Europe.

The Hollywood strategy succeeded; 2003 came to be known as the "legendary year", because seven Brazilian films sold over a million and a half tickets each. Local films commanded an all-time market share of 21 percent. Nine of the ten top Brazilian films were distributed by American firms like Warners and Fox, which had the money to publicize them widely. The year's biggest hit, distributed under Columbia auspices, was veteran director Babenco's *Carandiru*, a fictionalized account of misery and rebellion in the country's largest prison.

But the most widely seen Brazilian film of the 2000s internationally was Fernando Meirelles' (1955-) *City of God* (2002), distributed locally by the Disney subsidiary Buena Vista. Meirelles focused on teenage gangs in Rio's infamous "Cidade de Deus", a 1960s housing project that teemed with violent crime. Meirelles chose his cast after auditioning 2,000 slum kids, and he had to get permission from a jailed local drug lord so that his crew would not be attacked while filming in the streets. With a rapidly moving handheld camera that chased and circled the action, the film caught the wildness of young people who become

criminals by necessity.

After the legendary year, the local films' share of the market dropped off to around 12 percent. Within Brazil, American companies were content to support safe, conventional movies, often based on popular TV shows, while imported Hollywood product raked in large sums. By 2006, Brazilian filmmakers realized that to sustain the country's industry, films had to be exported, and the government encouraged foreign companies to support films that, like *Central Station* and *City of God*, could play in Europe and America. Gradually coproductions gathered strength. Meirelles directed an English-language German production, *The Constant Gardener* (2006), and his Brazilian film *Blindness*, also mostly in English, opened the 2008 Cannes Fihn Festival. His production company had a first-look deal with Universal/Focus Films. In early 2008, José Padilha's controversial *Elite Squad* (2007), unexpectedly won the Golden Bear at the Berlin Film Festival. Universal coproduced *Elite Squad*, and it was distributed by The Weinstein Company outside Latin America. By 2008, thirty-six coproductions aimed at export were underway.

Argentina and Elsewhere

Argentina, for decades the most prosperous and cosmopolitan country in Latin America, suffered extreme political dislocations after the coup that ousted Isabel Perón. During Argentina's military dictatorship that ensued from 1976 to 1983, thousands of citizens were arrested and secretly killed. The regime privatized state industries and cut tariffs, opening the country to U.S. films and encouraging cheap local production. What came to be known as the "dirty war" pursued artists, killing, blacklisting, or exiling them. The ill-judged campaign to capture the Malvinas Islands (aka the Falkland Islands, held by Britain) helped topple the regime and led to the election of a civilian goverment in 1984.

With the emergence of democracy, censorship was abolished and filmmaker Manuel Antín became a director of the National Film Institute (INC). The industry faced 400 percent inflation, but it attracted attention with several films, notably Luis Puenzo's (1946-) *The Official Story* (1985). The film's highly emotional drama—a woman discovers that her adopted child's mother "disappeared" at the hands of death squads—employs traditional plotting highlighted by symbolic incidents.

Soon a New Argentine Cinema was announced. Matía Luisa Bemberg explored women's roles in *Camila* (1984), *Miss Mary* (1986), and *I Don't Want to Talk about It* (1993). Most widely seen internationally, apart from *The Official Story*, was Fernando Solanas' *Tangos: The Exile of Gardel* (1985). Alternately amusing and mournful, the film celebrates the tango's place in Argentine culture

as exiles living in Paris stage a *tanguedia*, a comedy/tragedy presented through dance. Solanas, collaborator on the militant *The Hour of the Furnaces*, exploits art-cinema shifts into fantasy, wrapping his exiles in a cheerful, unexplained cloud of yellow smoke. Started in France during the "dirty war", *Tangos* was completed in Argentina and became a box-office hit.

As in Brazil and other South American countries, Argentina saw a crisis in film production during the first half of the 1990s. The turnaround came in 1995, with a new video tax funding loans for filmmaking. The INC became the INCAA (National Institute for Cinema and Audiovisual Arts) and converted an old Buenos Aires film theater into a three-screen showcase for local films. The spread of multiplexes drew wider audiences to films of all types, and a small arthouse trend developed. Box-office income for the most popular Argentine films was as high as for the biggest Hollywood imports.

These favorable conditions attracted foreign investment for such coproductions as the Argentine-Spanish project *Tango* (1998). Veteran Spanish director Carlos Saura staged the love story, with its numerous dance numbers, in a white studio bathed with vividly colored lights, creating dramatic widescreen images. Just as *Tango's* international success (including an Academy Award nomination) seemed to signal Argentine cinema's resurgence, the country plunged into another economic crisis, and the INCAA was forced to cut budgets by half. Argentine-Spanish coproductions continued to boost local production despite hard times. A record forty-three local films appeared in 2000, but fell again as the crisis persisted. In 2002, inflation was running 45 percent, and the peso was devalued to a third of its previous level against the American dollar.

Even as box-office earnings declined, however, local films were winning acclaim at international festivals and bringing the country's cinema greater prominence. Lucrecia Martel's *La ciénaga* ("*The Swamp*") was nominated for the top prize at the Berlin film Festival. While many local filmmakers focused on the problems of the working class, Martel's film was a study of the aimless existence of an extended wealthy family, captured more through an accumulation of closely framed details than through its slim narrative line. In the opening, a torpid batch of partyers lounge by a scummy swimming pool, oblivious to the decay around them.

Two more Argentine films gathered worldwide recognition. Brazilian director Walter Salles's *The Motorcycle Diaries* (2004; a U.S.-Argentine-Chilean-Peruvian coproduction) was shot in several South American countries. It follows the travels of the young Che Guevara as he witnesses the social injustices that will turn him into a charismatic revolutionary. In the same year, Lucrecia Martel's second feature, *The Holy Girl*, confirmed her as one of the country's leading filmmakers.

Buoyed by successes abroad, local production surged in 2004 and 2005. Then, despite the general recovery of the national economy, 2006 saw another downturn.

Although increased American investment helped sustain Argentine productions, primarily by distributing them abroad, Hollywood movies took nearly 90 percent of box-office receipts. However visible Argentine films were in film festivals, they made little money at home.

Argentina's situation was paralleled elsewhere. Many countries underwent comparable shifts from freemarket dictatorship to uneasy and economically precarious democracy. In Bolivia, after a period of repression in the 1970s, the populist Ukamau directors Jorge Sanjinés and Antonio Eguino returned to filmmaking. In Chile, the military coup that ousted Salvatore Allende in 1973 installed Augusto Pinochet in power for almost twenty years. His government sold off businesses to multinational corporations, bequeathing the country the largest per-capita foreign debt in the world. During Pinochet's reign, over fifty "Chilean" features were made in exile by Raul Ruiz, Miguel Littí, and other New Cinema veterans. Littín even returned in disguise to make a film. During the 1990s, the violent efforts to suppress the powerful drug trade led to a slump in theater-going and reduced local production.

Mexico

For decades, the Mexican government controlled the film industry, but during the 1970s and 1980s, the state's policies shifted drastically when regimes changed. In 1975, the liberal government bought the principal studio facilities and founded several production companies. The government also cut off credit to producers and took over distribution.

These measures encouraged production and fostered an auteur cinema. During the late 1960s and early 1970s, several young directors had called for a political cinema. Paul Leduc's reenacted biography of the journalist John Reed, *Reed: Insurgent Mexico* (1970) marked the official emergence of this group, which included Arturo Ripstein (*The Inquisition*, 1973) and Jaime Humberto Hermosillo (*The Passion According to Berenice*, 1976). The older director Felipe Cazals caused a sensation with *Canoa* (1975), the reconstruction of a 1968 lynching in a village.

Mexico was not ruled by the sort of military government that dominated Brazil, Argentina, and Chile, but it did move to the right in the late 1970s. A new president took steps to privatize the economy and oversaw the liquidation of the National Film Bank, the closing of a major production agency, and the return to private production. The state invested in only a handful of prestigious projects. Film output fell steeply, and only a few genres found success—chiefly fantasy films featuring the masked wrestler Santo.

Mexico depended on oil revenues, and soon a slump in prices forced the government to borrow from abroad. The results were hyperinflation, mass unemployment, and debt. Film culture suffered several blows. In 1979, police attacked the Churubusco studios and, charging the staff with mismanagement, jailed and tortured several people. In 1982, a fire at the nation's archive, the Cineteca Nacional, destroyed thousands of prints and documents.

The pendulum swung slightly back when, under a new president in the early 1980s, Mexico began an economic reconstruction that included more intervention in the film trade. A national agency was created to finance quality production and lure coproductions from abroad. Mexico became a popular spot for U.S. runaway productions, and the *sexycomedia*, a new genre derived from popular comic strips, began to attract audiences. Mexico also became a popular spot for U.S. runaway productions, though by the 1990s, bureaucracy and labor unions made the newly available facilities in Eastern Europe more attractive than Mexico. James Cameron built two multimillion-gallon tanks in Baja for *Titanic* (1997), but these facilities could be used only for water-related films, such as Peter Weir's *Master and Commander* (2003).

Many of the directors favored by state policy in the early 1970s became the mainstays of quality production in the 1980s. In *Doña Herlinda and Her Son* (1984), Hermosillo made the first explicitly gay Mexican film. Leduc attracted worldwide notice with *Frida* (1984), a biography of the Mexican painter Frida Kahlo. Leduc daringly omits dialogue and offers virtually no plot. Episodes from Frida's life, jumbled out of chronological order, present rich tableaux that recall motifs from her paintings.

During the 1980s, the government attempted to subsidize quality production, but inflation ate up this funding. In 1988, a new regime began liquidating government production companies, studios, and theater chains. Películas Nacionales, the major private company, collapsed soon after. In 1991, Mexican production shriveled to thirty-four films. At the end of 1992, however the government lifted a cap on admission prices in theaters. Income rose, and the industry grew a bit stronger.

Two firms, the government-supported Imcine and Televicine, the film wing of the giant media conglomerate Televisa, dominated production. Imcine fostered small independent productions. One result of this was *Like Water for Chocolate* (1991, Alfonso Arau, 1932-), a popular romance in the growing art-film genre of movies about cooking; it earned nearly $20 million in the U.S. alone. Guillermo Del Toro's (1964-) stylish horror film *Cronos* (1993) was also a hit abroad. Del Toro was immediately courted by Hollywood, where he directed *Blade 2 (2002)* and entries in the *Hellboy series* (2004, 2008). The film's cinematographer, Guillermo Navarro, also was lured away, filming such American movies as *Jackie Brown* (1997), *Spy Kids* (2001), and *Night at the Museum* (2006), as well as most of Del Toro's films.

Although production declined in the mid-1990s during another economic crisis, Arturo Ripstein reliably turned out a modestly budgeted feature a year, supported by French and Spanish investment. Ripstein was invited to compete at the Cannes film Festival three years running, for *Divine* (1998), *No One Writes to the Colonel* (1999), and *That's Life* (2000), For the last, he switched to digital video and afterward continued to direct low-budget prestige pictures.

In 1999, the government created the Fund for Quality Film Production to bolster Imcine. The number of films being made rose, but many of them never found a distributor. By 2000, Mexico was the seventh largest market for films in the world. It had over 3,000 screens, but most of the films being shown came from Hollywood. Mexican production continued to hover on the brink of crisis, and its films received little notice abroad.

As Argentina had attracted attention with the powerful twosome of *The Motorcycle Diaries* and *The Holy Girl,* a pair of films released in quick succession brought Mexican cinema fresh attention. In 2000, Alejandro González Iñárritu's (1963-) *Amores Perros* (aka *Life's a Bitch*) was an international art-house hit. A former director of advertisements, Iñárritu reversed his style and made a grim film with handheld camera and muted colors. It follows three storylines that intersect at only one point. Inevitably Iñárritu received offers from American studios, but he remained largely independent, solidifying his reputation with *Babel* (2006), which traced how a single rifle changes lives in Morocco, Japan, and Mexico.

By contrast with *Amores Perros*, Alfonso Cuarón's (1961-) *Y tu mamá también* (2001) was a sexy road movie centering on two young men traveling with an older woman. Unlike Iñárritu, Cuarón accepted a Hollywood offer, and directed Warner Bros.' *Harry Potter and the Prisoner of Azkaban* (2004). But as if to show he had not sold out, he followed that franchise entry with *Children of Men* (2006), a grim futuristic tale of a world where infertility threatens to wipe out the human race.

Despite these isolated successes, Mexican production remained in trouble. In 2003, its films occupied less than 9 percent of screen time, and in 2004 only eighteen of the thirty-six films produced even made it into theaters. Ironically, at this very time the exhibition scene was booming. In 2003, the two biggest theater chains filled the country with multiplexes. Following the pattern seen in Brazil and Argentina, this initiative attracted Hollywood studios. Columbia TriStar started to produce and distribute locally in 2003, and Disney and Warner Bros. followed in 2005. The idea was to make films for around $2 million, break even within Mexico, and earn a profit through export to other Spanish-speaking countries. At last, films from Mexican producers stood a chance of getting picked up for distribution by the U.S. Majors.

During this period Carlos Reygadas (1971-) emerged as one of the most distinctive and original filmmakers of the younger generation with the mysterious,

austere films *Japón* (2002), *Battle in Heaven* (2005), and *Silent Light* (2007). With their unflinching realism, unglamous sexuality, and wan spiritual aura, they definitely were not projects that would attract Hollywood, but they found success in the festival and arthouse world.

The pendulum swung again in 2005, when the government approved incentives for production: sales-tax rebates for foreign films shot in the country and incometax deductions for Mexicans investing in films. Those incentives went into effect in 2006, and the resulting films began to appear in early 2007. Although they were popular, they were also criticized for following Hollywood formulas. Still, the growing success of more ambitious Mexican films in foreign festivals and art-houses whetted the local audience's interest.

After making his first *Hellboy* film for Hollywood, Del Toro returned to Mexico for his most prestigious project, *Pan's Labyrinth* (2006). Drawing on the tradition of Magic Realism, it was set during the Spanish Civil War. An imaginative young girl who becomes the stepdaughter of a brutal fascist captain escapes into a fairytale fantasy that is both attractive and frightening. The film won both critical acclaim and awards, and its appeal to fans of fantasy assured its entry into American multiplexes.

Both Del Toro and Cuarón supported the cinema in their homeland by producing Mexican films by younger directors and pressuring the government to provide more funding. Del Toro remarked: "It's a grim coincidence that there is such visibility for a portion of film storytellers and film craftsmen while at the same time the Mexican industry itself has been in dire straits for decades and remains on the verge of disappearing". In May of 2007, he, Cuarón, and Iñárritu joined forces to create a Mexican production company, Cha Cha Cha. In early 2008, Universal, then expanding into production in several countries, formed a partnership with Cha Cha Cha.

By that point, the ongoing building of multiplexes had raised the country's screen count to 3,700, a total second only to the U.S. in the Western hemisphere. Hollywood-produced genre fare filled most of those screens, while local films found their most appreciative audiences in festivals. The health of the industry depended on the continuation of tax incentives and the rising generation pf Mexican filmmakers.

5. 中东电影

从1948年起，以巴冲突就是中东地区无法回避的核心问题，以色列最著名的电影导演阿莫斯·吉泰（Amos Gitai）就以其战地纪录片《战地日志》和

《赎罪日》之战

展现第四次中东战争的《赎罪日》获得国际影坛的瞩目。而受到广泛好评的以色列电影《天堂此时》《乐队造访》《以巴火药库》和《米拉尔》等也同样涉及犹太人和巴勒斯坦人冲突与和解的主题。

横跨欧亚两大洲的土耳其电影在 70、80 年代有尤马兹·古尼（Yilmaz Güney）的《希望》和《自由之路》（戛纳"金棕榈奖"）对于自由和希望的追求，近期则有努里·比格·锡兰（Nuri Bilge Ceylan）的《远方》和《三只猴子》代表的文化冲突与人性回归。

Filmmaking in the Middle East

 For nearly fifty years, Middle Eastern politics was dominated by the friction between Israel and the Arab states. Hostilities intensified after Israel's victory in a 1967 war with Egypt, Syria, and Jordan. The Yom Kippur war of 1973 pitted Egypt and Syria against Israel. U.S. President Jimmy Carter coaxed Egypt and Israel to accept a peace plan in 1979, but the assassination of Egyptian leader Anwar Sadat in 1981, as well as Israel's refusal to cede captured territory, assured continued conflict in the region. Arabs in territories under Israeli occupation carried on the struggle begun in the 1960s by the Palestine Liberation Organization, which sought an autonomous homeland

for Palestinians. Despite Jordan's recognition of the state of Israel, most Arab nations remained neutral or hostile. Palestinian militants in the West Bank and Lebanon continued their fight into the 2000s, while Israel refused to grant Palestine its own territory.

The cinemas of the region were very diverse. Egypt, Iran, and Turkey had mid-size industries, exporting comedies, musicals, action pictures, and melodramas. Other nations' governments created film production that would promote indigenous cultural traditions. Some filmmakers aligned themselves with "Third Cinema" developments, but after the mid 1970s many undertook to broaden their audiences, participating in the international art cinema of the West. In the new century, Saudi Arabia, Qatar, and Kuwait, which had had no traditions of filmmaking, began investing in Hollywood and Egyptian projects and even tentatively starting up domestic production.

Israel

Israel was a prosperous country and the Middle East's only democracy, but it had a very small film industry. In the 1960s, Menahem Golan and his cousin Yoram Globus began producing musicals, spy films, melodramas, and the ethnic romantic comedies known as *bourekas*. During the 1970s, Israel also hosted a "young cinema" that focused on psychological problems of the middle classes. Then, in 1979, the Ministry of Education and Culture offered financial support for "quality film", thus stimulating low-budget films of personal reflection (e.g., Dan Wolman's *Hide and Seek*, 1980) or political inquiry (Daniel Wachsmann's *Transit*, 1980). Soon the Quality fund was supporting about half of the fifteen or so features produced annually. The subsidy dwindled in the early 1980s but was revived and increased later in the decade. In the same period, the government founded a film academy, the Sam Spiegel School of film and Television, in Jerusalem.

As the Middle Eastern country most closely aligned with the West, Israel became part of that international market. The films of Moshe Mizraki and the teenage nostalgia comedy *Lemon Popsicle* (1978) proved successful abroad. There were coproductions with European countries, and Israeli directors shot English-language film's with U.S. stars. The Quality fund encouraged foreign companies to invest in internationally oriented projects.

Golan and Globus made a bid for international prominence in 1979 by acquiring control of Cannon Pictures, an independent production company. The pair produced both international entertainment movies (e. g., *Delta Force*, 1985) and films by Altman, Cassavetes, Konchalevsky, and Godard. Cannon also bought theaters and gained control over half of Israeli film distribution. In addition, Cannon helped bring runaway productions to Israel, bolstering

the local industry as a service sector. Although Globus left Cannon in 1989 to found his own company, the Israeli industry continued to have strong Western affiliations.

Throughout the 1990s, Israeli production continued to decline, averaging around ten films a year. The government slashed the budget of the Fund for Promotion of Quality Films in 1996, and many filmmakers sought work in television. By 1999, local films attracted only 1 percent of the national box-office, most of the rest going to American imports. But in 2002, long-promised government funding came through. Although local films' share of the domestic market scarcely grew, the new support boosted raised the annual output to about fifteen and supported the emergence of new talent.

The most prominent Israeli filmmaker, the documentarist Amos Gitai (1950-), ran afoul of government support. Thanks to funding from Canal Plus and other international sources, he was able to make a great many documentaries and fiction films that commented critically on Israeli history and society. Adhering to a long-take style, with some shots lasting several minutes, Gitai set himself against popular tastes and official policy. His *Kadush* (1999) was the first Israeli film to compete at Cannes in twenty-five years, but the Fund refused to reimburse its share of the costs. *Kippur* (2000), Gitai's graphic drama of helicopter rescue teams in the Yom Kippur war, was denied government funding and was not released in Israel. *Alila* (2003), funded by French and private Israeli companies, intertwined stories of foreign workers living in a run-down Tel Aviv housing complex. *Disengagement* (2007) was a French-Israeli-German-Italian coproduction.

Despite the government's initiatives, 40 percent of the money going into Israeli films came from abroad, chiefly France. This helped them find greater visibility in festivals and international markets. At the same time, the films were moving away from overtly political subjects toward a more general humanism. The biggest international success of the 2000s was *The Band's Visit* (2007), TV director Eran Kolirin's gently comic first feature. In a geometrical, Tati-like style, it presents an evening of fraternization between a stranded Egyptian police band and the residents of a small Israeli town.

Egypt

While Israel depended on European investment, other Middle Eastern countries were more closely tied to the Third World circuits of film export and personnel flow. In the early 1970s, Syria had a robust industry. There was a "new Syrian cinema" of social protest, as well as a biannual Damascus Film Festival showcasing Third World products. Lebanon also had a vigorous film industry before the outbreak of civil war in 1975 forced most personnel to

emigrate.

Cairo had once been the Hollywood of Arab cinema, making about fifty films a year, but in the late 1960s Egyptian production declined. Major directors went into exile; after making *The Betrayed* (1972) in Syria, Tewfik Saleh become head of the Iraqi film institute. The Egyptian industry's otput rose during the 1980s, chiefly because of hospitable Arab Gulf markets and the popularity of Egyptian films on video. Yet soon the industry fell on hard times. Video piracy ran rampant, and the government withdrew all financial assistance to producers. U.S. films conquered the market, leaving the local product to fend for itself.

Although some new Egyptian directors (including women) emerged during the period, the most famous filmmaker remained the veteran Youssef Chahine. An early proponent of Nasir's pan-Arab nationalism, Chahine later examined Egyptian history from a critical perspective. *The Sparrow* (1973) interrogates the causes of Egypt's defeat in the 1967 war. Later, his films became at once more personal and more transnational. *Alexandria, Why?* (1978) intercuts events of 1942 with Hollywood films of the era; in *Memory* (1982), a filmmaker facing a heart operation recalls his career over thirty years. Both films are autobiographical, but Chahine joined many political filmmakers of the era in seeking a broader audience with intimate dramas. Chahine continued to direct up to his death in 2008, offering festivals such films as *The Emigrant* in 1994 and *Silence... We're Rolling* (2001), another film about moviemaking.

Throughout the 1990s and 2000s, production spiked and slumped unpredictably. Egypt did not engage in coproductions, but many projects had the backing of Gulf region media conglomerates. These were Rotana, a Saudi company holding the leading catalogue of Arab music; Arab Radio and Television, another Saudi company; and Al-Arabia, based in the United Arab Emirates. All three also pursued vertical integration by buying and building theaters, As elsewhere, the emergence of multiplexes helped Egypt's ticket sales, which doubled to over 22 million in the mid-2000s. Apart from Hollywood films, the release schedules were dominated by slapstick comedies. A cycle starring local comedian Mohamed Saad yielded the biggest box-office returns in Egyptian film history.

Rotana, Al-Arabia, and ART were challenged by a domestic multimedia conglomerate, Good News. Its breakthrough was Marwan Hamed's *The Yacoubian Building* (2006), said to be the most expensive Egyptian film yet made. Based on a controversial novel, it links rich people living inside an apartment house to the poor people living in tiny storerooms on the roof. Its soap-opera plot commingles an aging playboy, an innocent young woman, a gay journalist, a drug dealer who turns politician, and a boy driven to terrorism.

Financing other successful productions and buying scores of theaters, Good News was credited with Egypt's 2006 box-office upturn.

Turkey

Turkish cinema came to international notice in the late 1960s with such films as Yilmaz Güney's (1937-1984) *Umut* ("Hope", 1970). Turkey already boasted the highest output in the region. Erotic films, comedies, historical epics, melodramas, and even Westerns drew in an audience of over 100 million per year. But production and attendance were already declining when a military contingent seized power in 1980.

The government included film directors on its enemies list, and Güney was the obvious target. A popular actor who had become a left-wing sympathizer, he fell under suspicion in the mid-1970s. When the military took power, Güney was already serving a twenty-four-year prison sentence. During his prison stay, he wrote scripts which were filmed by others. The most famous of these, *Yol* (*The Way*, 1982) follows five prisoners given a week's release to visit their families, and its forlorn landscapes hint at the oppressiveness of contemporary Turkey. In 1981, Güney escaped to France, where he made his last film. *The Wall* (1983) is a bitter, dispirited indictment of a prison system that oppresses men, women, and children alike. The prison wall, filmed in different sorts of light and weather, becomes an ominous presence throughout. When Güney died in 1984, the Turkish government sought to erase every trace of him. Police burned all his films and arrested anyone who possessed his photo.

Despite stifling censorship, the film industry gradually rebuilt itself, and production grew to almost 200 films. Only half of these, however, would get released to theaters; the rest were destined for the increasingly powerful video market. At the same time, the government sought to attract Western capital, and U.S. releases reappeared in theaters in the late 1980s. Their grip on the market drove production down to a mere twenty-five films in 1992, most made with European cofinancing.

During the 1990s, Turkey gradually liberalized, hoping to be the only Muslim country to join the European Union. In 1993, censorship was all but abolished. At the same time, however, a recession continued to push down production to around ten a year. The surprising local success of Yavuz Turgul's *The Bandit*, which beat out *Braveheart* for number one at the box office in 1996, inspired new attempts at production. In 1998, *Yol* finally received a commercial release in Turkey.

By 2000, a young generation of directors was emerging. Several of them collaborated on the fanciful network narrative *Istanbul Tales* (2005), which

presents intersecting stories based on Snow White, Cinderella, and other fairy tales. More demanding was the work of Nuri Bilge Ceylan (1959-). Ceylan won international acclaim with *Distant* (2002), an austere story of cousins reuniting in Istanbul and trying to reconcile. The use of nonprofessional performers and the director's apartment as the basic locale recalls Italian Neorealism, but the silences and the spare, static long takes continue minimalist trends of the 1970s. *Climates* (2006) and *Three Monkeys* (2008) confirmed his reputation as the most prominent Turkish filmmaker since Güney.

第五节　欧洲新电影

1. 回归俄罗斯传统：米哈尔科夫和索科洛夫

勃列日涅夫统治的苏联经历了又一次"冰冻"，诺贝尔文学奖得主索尔仁尼琴、诺贝尔和平奖得主萨哈罗夫和著名导演塔尔科夫斯基都遭到监禁、流放或自我放逐。但20世纪80年代仍然涌现过《莫斯科不相信眼泪》（荣获奥斯卡奖的苏联电影）、《悔悟》和《自己去看》等优秀影片。

1985年戈尔巴乔夫掌权后倡导的"开放新思维"以及1991年底的苏联解体，新一轮的"解冻"使俄罗斯电影在剧烈的动荡中焕发出复兴的光芒。早年成名的尼基塔·米哈尔科夫（Nikita Mikhalkov）以《烈日灼人》和《西伯利亚的理发师》延续他对于俄罗斯优秀文化传统的回归，而塔尔科夫斯基的传人亚历山大·索科洛夫（Alexander Sokurov）《母与子》和《俄罗斯方舟》传承俄罗斯式的心灵拷问和探索电影语言的诗化革命。

2000年之后，以《回归》为代表的俄罗斯新电影获得评论界的高度评价，而动作片《守夜人》和剧情片《海军上将高尔察克》等主流商业类型片则受到观众的热捧。

The U.S.S.R.: The Final Thaw

From 1964 to 1982, Leonid Brezhnev served as secretary of the Communist party of the Soviet Union. Opposed to reform, favoring rule by elderly officials, the

《俄罗斯方舟》

regime had an air of stability and prosperity. During the 1970s, citizens acquired televisions, refrigerators, and cars. At the same time, Brezhnev pursued a policy of military intervention by assisting revolts in Angola and Ethiopia and invading Afghanistan.

Although consumer comforts increased, culture suffered another "freeze". Aleksandr Solzhenitsyn, Andrei Sakharov, and other dissidents were silenced by exile or imprisonment. Goskino, the agency overseeing cinema, had become a bloated bureaucracy, encouraging popular entertainment in tune with the new socialist consumerism. The best-loved film of the period, *Irony of Fate*; or, *Have a Good Bath* (1975) was a romantic comedy based on a simple premise: a man from Moscow finds himself in St. Petersburg and discovers that his key opens a woman's apartment. Andrei Konchalevsky's epic *Siberiade* (1979) proved that a spectacle mounted on the scale of a Hollywood megapicture could attract audiences. Another film made for diversion was *Moscow Does Not Believe in Tears* (1980), the first Soviet film to win an Academy Award. There was even a crowd-pleasing Soviet western, *The White Sun of the Desert* (1970).

Despite the conservatism of the Brezhnev era, some slice-of-life films gave voice to the problems of daily existence, especially among Soviet youth. Dinara Asanova (*The Restricted Boy*, 1977), Lana Gogoberidze (*Some Interviews on Personal Matters*, 1979), and other women directors created distinctive psychological studies. The lyrical tendencies associated with the republics' studios continued in the work of Georgian director Tengiz Abuladze (1924-1994, most

notably in the banned *Repentance*, 1984).

Tarkovsky and the Ethics of Art In addition, several directors created idiosyncratic, self-consciously artistic works that reflected both European art cinema and Russian traditions. In *A Slave of Love* (1976) and *Unfinished Piece for Player Piano* (1977) Nikita Mikhalkov (1945-) experimented with reflexivity in the manner of Fellini and other European directors. Larissa Shepitkos films emphasize individual conscience and moral choice in the vein of Fyodor Dostoyevsky and contemporary anti-Stalinist literature. Her World War II film *The Ascent* (1977) shows two partisan soldiers captured by the Germans and forced to decide between collaboration and execution. The intellectual Sotnikov, having conquered his fear of death in an earlier skirmish, bears up under torture and accepts death with an eerie, Christlike gentleness.

The most visible exponent of an artistic cinema opposed to mass genres and propaganda films remainecl Andrei Tarkovsky. The science-fiction saga *Solaris* (1972) had somewhat mitigated the scandal of *Andrei Rublev* (1966), but the dreamlike *The Mirror* (1975) confirmed that he worked in a mystical vein fiercely opposed to the mainstream.

Considered a "reactionary", Tarkovsky insisted on family, poetry, and religion as central forces in social life. He declared himself against cinema with a political message and argued for a cinema of evocative impressions—a position that put him close to the sensibilist German directors. But his sombre films seek to engage the spectator in a more philosophical way than do those of Herzog and Wenders. *Stalker* (1979) presents an allegorical expedition through a wrecked postindustrial landscape into "the Zone," a region where human life can be fundamentally changed. Filmed in a blue murk, *Stalker* uses hypnotic camera movements to create what the director called "the pressure of the time" running through the shots.

Tarkovsky went to Italy to make *Nostalgia* (1983), a melancholy, virtually nonnarrative meditation on memory and exile. He decided not to return to the U.S.S.R. He directed some stage productions, and in Sweden he filmed the Bergnhanesque *The Sacrifice* (1986), which won the special jury prize at Cannes. By the time of his death in 1996, Tarkovsky had become an emblem of the cinema of artistic conscience. His prominence abroad had saved his films from shelving, and, even if they went unseen in the U.S.S.R., they were saleable foreign exports. He influenced the pictorialist strain of European cinema during the 1970s and 1980s, and his Soviet contemporaries gathered courage from his resistance to official policies. A self-conscious auteur on the European model, Tarkovsky demanded that art be a moral quest: "Masterpieces are born of the artist's struggle to express his ethical ideals".

During Tarkovsky's silence and exile, Soviet cinema was changing. Rolan gykov's *Scarecrow* (1983), a film about a village girl despised by her classmates, quietly celebrates indigenous tradition and historical memory over the harsh selfishness of the new consumerist Russia. Alexei Guerman's *My Friend Ivan Lapshin* (1983; banned until 1985) mixes newsreels and abstractly staged footage to criticize Stalinist conceptions of political crimes. The World War II genre was given a new savagery in Elem Klimov's *Come and See* (1985), a harrowing portrayal of the German occupation of Byelorussia. Based on an idea of Klimov's wife, the deceased Larissa Shepitko, *Come and See* presented the naïve young hero as something less than the Socialist Realist ideal. During the same period, Paradzhanov, now released from prison, returned to feature filmmaking. *The Legend of Suram Fortress* (1984) recalls *The Color of Pomegranates* in its stylized simplicity and vibrant textures. Even a "parallel cinema" shot on 16mm and super 8mm was beginning to lurk in students' apartments and artists' basements.

Behind the façade of Brezhnev's regime, the U.S.S.R. had stagnated. Agricultural and industrial production had declined, and so had health and living standards. Corruption, inefficiency, and overextended military commitments were draining the state's resources. Neither Brezhnev nor the two elderly general secretaries who succeeded him faced up to the challenges. A younger politician, Mikhail Gorbachev, assumed leadership in 1985 and revealed that the Soviet system was on the verge of financial collapse. His announcement that the U.S.S.R. would no longer sustain its satellites in Eastern Europe led to the overthrow of Communist regimes there. Gorbachev also called for a policy of *glasnost*, which was to initiate a long-overdue rebuilding of Soviet institutions, or *perestroika* ("restructuring"). Another "thaw" had begun.

Glasnost and Perestroika in the Cinema At first, Gorbachev sought to implement reforms through the chain of party command, but in 1987 he began to call for fundamental changes. Glasnost meant confronting the errors of the past. Stalin's regime was excoriated, and citizens were encouraged to discuss the failures of the economy, the rise of crime and drug use, and the sense that the Soviet system bred people to be brutal. ,

Glasnost gave filmmakers an unprecedented freedom. Stalin's policies were attacked in *The Cold Sumruer of '53* (1987), a variant of the Soviet Western that shows a village terrorized by a gang of released political prisoners. Valery Ogorodnikov's *Prishvin'sPaper Eyes* (1989) portrays the early days of Soviet television, with jabs at propaganda filming and a remarkable sequence that mixes newsreels and Eisenstein's Odessa Steps mas sacre to suggest that Stalin is selecting the victims from a balcony.

Youth films dwelt on student rebellion, often laced with rock music and a post-Punk anomie (e.g., Sergei Solvyev's *Assa*, 1988). *Chernukha*, or "black cinema", rubbed audiences' noses in the sordidness of daily life and predatory politics. Satiric films mocked party tradition and current fashions. Even mass entertainment exploited the new attitudes, as when the enormously successful gangster film *King of Crime* (1988) showed the KGB, the state, and criminals conspiring to defraud the public. Internationally, the hallmark of glasnost cinema was Vasity Pichul's *Little Vera* (1988). Vera's cynical selfishness and promiscuity deflated the myth of the virtuous heroine who could sacrifice all for the collective.

Most of these films would not have been made had not perestroika opened up the film industry. In May 1986, at the Congress of Soviet Filmmakers, Elem Klimov (1933-2003), director of *Come and See* and a friend of Gorbachev's, was elected head of the union. The same congress set in motion the restructuring of Goskino. Under the new policy, Goskino would serve principally as a conduit for funds and a source of facilities. Filmmaking would be in the hands of free creative production units on the Eastern European model. In addition, censorship was markedly liberalized.

One of Klimov's major reforms was the establishment of the Conflict Commission, aimed at the review and release of banned film. Soon critical works such as the humanistic war dramas *My Friend Ivan Lapshin* and *Commissar* (1967) and Tengiz Abuladze's surreal satire *Repentance* were taken off the shelf. In the year after his death, Tarkovsky was honored with a complete retrospective in his homeland.

Glasnost and perestroika gave more autonomy to the republics as well. In Kazakhstan, quasi-Punk directors offered films like *The Needle* (1988), a drug movie bearing the influence of Hollywood melodrama, Fassbinder, and Wenders's road sagas. In Georgia, Alexander Rekhviashvili made *The Step* (1986), a structurally adventurous, wryly absurd film about the meaningless routines of Soviet life. Before Paradzhanov's death in 1990, he directed *Ashik Kerib* (1989), a literary adaptation transformed by his ritualized treatment of Georgian legend and ethnic custom.

While international circles grew interested in the "New Soviet Cinema", Gorbachev's attempt to reform communism from the top down was proving unworkable. He pressed for a more rapid shift to individual initiative and a market system. In 1989, the government demanded that film studios become profitable and encouraged filmmakers to form private companies and independent cooperatives. Formerly Goskino had sole distribution power, but now independent producers could distribute their own products.

The decline in state funding came at a bad time, since technology was in disrepair. The thirty-nine Soviet studios badly needed renovation. Only one had Dolby sound equipment, a necessity for western markets, and Soviet film stock was still the world's worst.

Cinema and Market Bolshevism The free market was an anarchic one. No legislation regulated film activity. Video piracy flourished. Clandestine companies churned out pornography, often as diversions for black-market funds. Before glasnost, national production averaged 150 features per year; in 1991, 400 features were made. A year later, there were fewer than 100.

Very few completed films found their way into theaters. Attendance dropped to around one-tenth of theater capacity. The devaluation of the ruble increased production costs tenfold, and top directors coulcfnot get their films released. Although the Hollywood Majors refused to release new films until the U.S.S.R. took antipiracy measures, old or cheap Hollywood pictures dominated the market, capturing 70 percent of audiences.

The final years of Soviet cinema were nevertheless prestigious ones. Filmmakers joined writers and composers as representatives of a vigorous, eclectic culture. Not since the 1960s had so many Soviet films won praise in the West. *Taxi Blues* (1990, Pavel Lungin), a Soviet-French effort, portrays a decaying urbanism and amoral, rudderless characters. Vitaly Kanevsky's *Freeze, Die, Come to Life!* (1990), a "black film", suggests the savagery and spite pervading contemporary Soviet life by means of a story about children's corruption in a village during World War II. The Ukrainian-Canadian production *Swan Lake: The Zone* (1990), directed by the veteran Yuri Ilienko from a story by Paradzhanov, renders a political fable with Bressonian asceticism. An escapee from a prison camp hides in a gigantic, hollow hammer-and-sickle sign. The ponderous symbolism of the looming, rusting emblem is counterbalanced by a rich sonic texture and a painstaking rendering of the man's cramped, dark shelter.

The End of the Soviet System An aborted coup against Gorbachev in August 1991 triggered the dissolution of the Communist party. Boris Yeltsin ascended to leadership, and the U.S.S.R. was replaced by the Commonwealth of Independent States (CIS). Now Russia, the Ukraine, Armenia, and other former Soviet republics would function as separate nations. The cold war that had ruled world political strategy since World War II was ended.

Like their counterparts in Eastern Europe, CIS filmmakers were eager for co-productions with the West. Yet the "common European home" envisaged by Gorbachev, a huge market stretching from the Atlantic to the Ural Mountains, was not taking shape. The CIS had a collapsed economy, a steeply declining standard of living, and modern problems of crime and drug addiction. The European

Community proved reluctant to aid or assimilate CIS nations.

Communism may have failed as a political ideology, but well-connected party officials grew rich in the frenzy of privatization. In Russia, organized crime moved into government and major industries. Amid charges of corruption, Yeltsin was succeeded in 2000 by former KGB agent Vladimir Putin, who stepped up the war against the breakaway region Chechnya. As Russia defaulted on its debts and U.S. consultants made matters worse, the economy stumbled from crisis to crisis, crashing in 1998 and recovering only slightly in 2000. Buildings and streets were crumbling, and the population, among the sickest in the world, was dying off. In light of all this, foreign investors stayed out.

The CIS film industries moved in synchronization with the boom-and-bust cycle. British, French, and Italian film companies launched "international" pictures featuring prominent western stars in CIS locales. Mosfilm, Lenfilm, and other studios became service facilities for runaway productions. Because the studios attracted cash, the state resisted privatizing them, but it did foster tax concessions for film investment. Cowboy capitalism reigned. In the mid-1990s, Vladimir Gusinsky's MediaMost emerged as the dominant private force, funding several films and seeking, unsuccessfully, to take over the state-protected Mosfilm studios. Soon Gusinsky fled to Europe, reluctant to return home to face charges of fraud.

The Hollywood studios cautiously sent films in, but Russia hardly constituted a major market. Video piracy raged out of control. In 1999, even though Hollywood films dominated the theaters, they took in less than $9 million at the box office. Russian films were even less popular, most of them playing only at state-funded festivals. A few earned overseas attention, with several being nominated for Academy Awards and one, Nikita Mikhalkov's *Burnt by the Sun* (1994), winning. On the festival circuit Alexei Guerman's *Khroustaliov, My Car!* (1998) gained considerable attention. Returning to 1953, Guerman shows a doctor caught up in the paranoia of Kremlin leaders right after Stalin's death. With the camera squeezing through overstuffed parlors and kitchens, it presents a comic phantasmagoria of a bloated and decaying society.

Sokurov and the Tarkovsky Tradition The creation of the CIS forced regional studios to privatize. The struggle was acute, and it was best weathered by Ukraine, which fostered a lyrical but hard-edged cinema in the tradition of Dovzhenko. Kira Muratova, a veteran director since the 1960s, saw several of her shelved films return to circulation. She became the outstanding Ukrainian director, with *Asthenic Syndrome* (1989) emerging as a milestone of social criticism. She continued to make offbeat films, principally with Western funding, through the 1990s and 2000s.

The most important Russian filmmaker of the 1990s was another veteran. Alexandr Sokurov's (1951-) first feature, *The Solitary Voice of a Man* (1978; shelved until 1987), harks back to the 1920s avant-garde in its elliptical narrative and crisp montage, but it also has the disturbingly dreamlike quality that would typify much of his work. Sokurov initially became known for his literary adaptations, but after glasnost, thanks to foreign financing, he was able to develop his expressionistic side. *The Second Circle* (1990), a stark black-and-white exercise, examines the minutiae of a primal ritual: a son prepares his father's corpse for burial. *Whispering* Pages (1992) meditates on the works of Nikolay Gogol and Fyodor Dostoevsky, with a spectral hero drifting along murky canals and through cavernous tunnels. We glimpse the action dimly, through haze; occasionally white birches are superimposed on the scene.

Sokurov's most widely seen expressionist exercise was *Mother and Son* (1997). A companion piece to *The Second Circle*, it shows a young man visiting his ailing mother. He carries her out from her farmhouse and reads to her. He takes her back inside. He wanders out into a vast, phantasmic landscape. He returns to find her dead, and he lays his face on her hand. Almost completely without dialogue, *Mother and Son* creates a piercing sense of loss through the simplicity of its situation and Sokurov's daring use of distorting lenses and filters. He films the landscape through paintstreaked glass, a "special effect" that creates an unearthly realm halfway between realism and abstraction.

Sokurov shared Tarkovsky's commitment to a mournful spirituality. He maintained, however, that Tarkovsky's influence on his generation was not wholly beneficial: "A director [today] doesn't think of himself as a professional who can make a drama, a comedy, a thriller, et cetera.... It's called *Tarkovschina* [the Tarkovsky syndrome]—to be great philosophers and make unwatchable films". Sokurov may have thought that he would reach wide audiences with his emblematic dramas involving major historical figures (Hitler in *Moloch*, 1999; Lenin in *Tauris*, 2001; Emperor Hirohito in *The Sun*, 2005), but his arthouse hit proved to be a hallucinatory survey of Russian history by means of a tour of St. Petersburg's Hermitage museum. In a single shot lasting over ninety minutes, *Russian Ark* (2002) trails tsars, courtiers, and commoners through corridors and galleries, the pageant culminating in a ghostly ball and the stately collapse of the aristocracy. After brooding on the nation's follies and excesses, the shot ends on a nighttime view of steam rising from the rivet, implying that Russian history yields up a melancholy poetry.

Social Recovery, Political Repression, and the New Entertainment Cinema Vladimir Putin's ascent to the presidency in 2000 coincided with a rise in petroleum prices, and Russia's vast reserves of gas and oil fueled an economic

boom. Putin forced Yeltsin's oligarchs out of politics and transferred key industries back to governmental control. By bringing in foreign investment, he enabled his disciples, many of them former communists, to become fabulously wealthy. Ordinary Russians, who had known abject poverty under Yeltsin's bungled economic reforms, saw their wages double and stability return. But prosperity came at the cost of civil rights and free speech. Putin strengthened his control by denying opposition parties access to the media. Television stations criticizing official policies were shut down, and the government set up a 24-hour channel promoting the official line. Dissenters were found beaten or murdered. Putin stepped down in 2008, but two-thirds of Russians would have preferred him to remain in power. He maneuvered himself into the post of prime minister and picked a functionary as the next President. Putin frankly called his system "managed democracy".

Hollywood moved in to cater to the newly affluent audience. Several Western hits, like *The Lord of the Rings* and *Spider-Man* franchises, did extraordinary business. As chains of multiplexes proliferated, Russian companies managed to restrict Hollywood's investment in screens. Box-office income rose to over half a billion dollars in 2007, and VIP cinemas sold tickets at $50 per seat. Experts estimated that soon Russia would be the fifth largest film market in the world.

Local production increased, too, from about 20 releases in 1996 to over 100 in 2007. Occasional arthouse fare such as *The Return* (2003) and *4* (2005) won attention overseas, and Sokurov continued his solitary spiritual quest, thanks to foreign funding. Russia's private investors and TV stations preferred to finance entertainment along Western lines. After the success of the gritty action film *Brother* (1997), which centered on a soldier returning from Chechnya who becomes a hired killer; there followed a string of action pictures centered on avenging cops, adventurous soldiers, and heroic KGB agents. The crucial film of the era was *Night Watch* (2004), directed by Timur Bekmambatov, a veteran of TV commercials. Based on a fantasy fiction series and massively advertised on television, Night Watch offered a gothic purée of videogames, hard rock music, CGI effects, and plot premises taken from *Buffy the Vampire Slayer*. It cost $4 million and garnered an unprecedented $30 million across the CIS. The sequel *Day Watch* (2007) made even more. 20th Century Foxbought both for international distribution and financed a third installment, while Bekmambatov was hired for *Wanted* (2008) and other Hollywood genre projects.

Unlike its former satellites in Eastern Europe, and the "independent" territories in the CIS, Russia now had a flourishing film industry. Home-grown blockbusters ruled, and each year broke box-office records. *Irony of*

Fate: The Continuation (2007), Bekmambatov's sequel to the 1975 favorite, was promoted through a Westernstyle gimmick: viewers could enter a contest that awarded the winner an apartment in St. Petersburg. The film was shown on virtually every CIS screen, and it set a new box-office record. That record was broken shortly afterward by *Very Best Film* (2008), a spoof of *Day Watch* that, like Hollywood's *Scary Movie* franchise, was aimed squarely at teenage audiences. At the close of 2008, *Admiral*, billed as Russia's *Titanic*, became the new top hit.

So important had the film industry become that a Foundation for the Support of Patriotic Film was created by billionaires, members of Parliament, and veterans of the military and espionage agencies. In 2007, the Foundation began to bankroll films glorifying Russian history and Putin's regime. Late in 2008, Putin took personal control of the entire film industry. Russia now had a class of rich consumers and powerful patrons, and filmmakers were reaping enormous rewards with local variations of Hollywood formulas.

2. 北欧:"道格码 95"与拉斯·冯·提尔

"道格码95"(Dogma 95)是由拉斯·冯·提尔(Lars von Trier)等丹麦电影人1995年发起的电影运动,他们宣称电影并非艺术品、而是强迫真理从人物和场景中体现出来的一种手段,既反对"新浪潮"的个性主义、又反对好莱坞的技术主义。他们倡导实景拍摄、手提摄影、即兴表演和现场录音,反对古装戏、类型片、戏剧性、无声源音乐和电影特技等。"道格码95"钦定的典范作品包括《家庭聚会》《白痴》《敏郎悲歌》和《国王不死》等,其影响力遍及欧美、亚洲和拉美地区。

拉斯·冯·提尔具有强烈的自由思想和反叛精神,以其《欧洲特快车》《破浪》和《黑暗中的舞者》彪炳世界影坛,成为对抗好莱坞主流电影和欧洲精英电影的著名旗手。拉斯·冯·提尔将良心、牺牲、道德和伪善推向变态的极致,形成观众不忍卒看的战栗与震撼。而《狗镇》对于以美国和好莱坞为代表的主导价值的深刻批判,也受到拥有独立思想有识之士的热情称赞。

此外,丹麦影片《芭贝特的盛宴》借美食文化寓意人生价值受到奥斯卡奖的肯定,而芬兰导演阿基·考里斯马基(Aki Kaurismaki)则以《没有过去的男人》等展现独特的生存状态赢得电影节的首肯。

《破浪》

Back to basics: Dogme 95

Late one night in 1995, after serious drinking, Danish directors Lars von Trier and Thomas Vinterberg took twenty-five minutes to jot down a manifesto calling for a new purity in filmmaking. The new waves of the 1960s had betrayed their revolutionary calling, and emerging technology was going to democratize cinema. "For the first time, anyone can make cinema". But some discipline was necessary, so von Trier and Vinterberg laid down an "indisputable set of rules" for the new avant-garde: a "Vow of Chastity".

The vow required that the film be shot on location, using only props naturally found there. The camera had to be hand-held and the sound recorded directly, so music could arise only from within the scene itself. The film had to be shot in the 1.33:1 format, in color, and without filters or laboratory reworking. It could not be set in another period of history or be a genre film (apparently ruling out police and action pictures, science fiction, and other Hollywood genres). The film could not include "superficial action": "Murders, weapons, etc. must not occur". The director must not be credited. Above all, a director had to pledge that the film would be not an artwork but "a way of forcing the truth out of my characters and settings". Soon two other Danish filmmakers signed on.

The four created the Dogme 95 collective.

Distributed in a 1995 Paris symposium devoted to cinema's hundredth anniversary, the manifesto attracted little notice until 1998. That year the film labeled Dogme #1, Vinterberg's *The Celebration*, won the Jury Prize at Cannes, and Dogme #2, von Trier's *The Idiots*, won a critics' award at the London Film Festival. *Mifune* (1999), by Søren Kragh-Jacobsen, was Dogme #3. After winning a major prize in Berlin, it went on to gross $2 million internationally. Dogme began issuing certificates for projects that adhered to the Vow of Chastity, while directors who strayed from it (as most did) made public confession on the Dogme website.

Since the Dogme films were closely tied to von Trier's Zentropa company, many critics dismissed Dogme 95 as a publicity stunt. If it was, it succeeded spectacularly. Danish cinema became a center of critical attention. On New Year's Eve 2000, each Dogme director shot a live film and broadcast it on a different television channel. Viewers were encouraged to switch among the films and create their own Dogme 95 movie. One-third of Denmark tuned in.

The Dogme brethren insisted that they were serious. They held that film's increasingly complex technology and bureaucracy hampered genuine creation. One could, however, fight Hollywood's globalization by going back to basics; Kragh-Jakobsen compared the group to rockers rediscovering unplugged music. Like John Cassavetes and the Direct Cinema filmmakers, they sought to capture the unrepeatable here and now. The vow declared that the director must "regard the instant as more important than the whole".

Central to the movement was a collaboration between director and performers. In the typical Dogme film, the actors and directors worked out the scene, often without a script, and then shot it in catch-as-catch-can fashion. For *The Celebration*, the actors sometimes operated the camera, and all were present to witness each scene. Dogme directors favored digital video; Vinterberg noted that actors tended to forget the presence of small cameras. Dogme #4, Kristian Levring's *The King Is Alive* (2001), used three cameras so that the actors never knew when they were onscreen.

Von Trier claimed that the formal rigidity of his earlier films dissatisfied him, and the vow provided a rationale for the freer-form shooting that emerged in *Breaking the Waves*. Vinterberg agreed: "I had the impression that my way of filming was imprisoned by conventions: returning to standard techniques to make people cry, use artificial light for a night scene There are things in cinema that you're supposed to do, and you do them without asking questions". All the Dogme directors stressed that filmmakers had to start reflecting on why they made certain choices; by working under a self-imposed simplicity they could relearn how to tell

stories on film. Although the vow attacked the idea of the auteur, directors found their vow projects becoming highly personal.

Most Dogme films were structured as fairly traditional dramas (*The Celebration*, *The Idiots*) or romances. The most experimental early Dogme effort came from the United States. Harmony Korine's *julien donkey-boy* (1999) is a disjointed tale of a dysfunctional family. Overseen by a tyrannical father, the schizophrenic Julien tries to help his pregnant sister, who may be carrying his child. Korine filmed scenes with up to twenty consumer-level digital-video cameras, placing them on tabletops and in hats, even occasionally using infrared cameras. The digital imagery, blown up first to 16mm reversal and then to 35mm, yields radiantly unearthly colors and layers of abstract shapes, linking Korine with Stan Brakhage and other experimentalists. Korine claimed he wanted to "decompose" the image, "losing some details but finding a texture". Because it included nondiegetic music and many optical effects, *julien donkey-boy* seemed to stray from the vow, but the Dogme group agreed to certify it.

Filmmakers in France, South Korea, Argentina, Sweden, Italy, Switzerland, Belgium, Spain, and the United States launched Dogme projects. Lone Sherfig's *Italian for Beginners* (2001), the first Vow of Chastity film made by a woman, won a major prize at Berlin and became an international hit. *Does It Hurt?-The First Balkan Dogma* (Macedonia, 2007) was the seventy-third film certified. Reliant on video, promoted on the Internet, and consecrated by film festivals, Dogme 95 had launched something at once local and international a film movement suited to a global age.

3. 西欧：法国、西班牙、德国和意大利等

尽管受到好莱坞电影的强大的压力，法国在保持法兰西电影艺术的优良传统方面仍然为全世界做出了榜样。20世纪80年代以降，让-雅克·阿诺（Jean-Jacques Annand）的《火之战》和《玫瑰的名字》、吕克·贝松（Luc Besson）的《碧海情天》和《这个杀手不太冷》，以及让-皮埃尔·热内的（Jean-Pierre Jeunet）《天使爱美丽》都可以算作既体现法国电影文化内涵、又融入美国主流电影观念的杰出作品。

在意大利，朱赛佩·托纳托雷（Giuseppe Tornatore）曾以电影之爱的《天堂电影院》和纯情之爱的《西西里的美丽传说》风靡全球，罗伯托·贝尼尼（Roberto Benigni）的《美丽人生》则用喜剧的方式演绎苦难的死亡故事，而南尼·莫瑞提（Manni Moretti）的《亲爱的日记》则讲述着个人和家庭的温情

《火之战》

《天堂电影院》　　　《卡门》

《疾走罗拉》

和感伤。

德国青年导演汤姆·提克威（Tom Tykwer）的《疾走罗拉》因其非线性闯关游戏的叙事结构和多元杂糅的视听呈现而受到观众和评论界的热捧，土耳其裔的费斯·阿金（Fatih Akin）则以《爱无止尽》成为德国电影的希望之星。此外，《再见，列宁》《帝国陷落》和《窃听风暴》等都以对于德国命运多舛历史（战争、分裂和统一等）的回顾与反省获得充分的肯定。

拉丁式的激情和西班牙风格的辣舞是老牌导演卡洛斯·绍拉（Carlos Saura）的《卡门》和《探戈》等吸引观众的永恒亮点，佩德罗·阿尔莫多瓦（Pedro Almodovar）的《精神濒临崩溃的女人》和《关于我的母亲》从另类视角透视女性和同性恋的压抑和纠结，而西班牙新生代胡利奥·密谭（Julio Medem）的《红松鼠杀人事件》和阿勒加德罗·阿曼巴（Alejandro Amenábar）的《深海长眠》则继续向世界展现着西班牙电影持久地魅力。

此外，比利时的让-皮埃尔和吕克·达内兄弟（Jean-pierre and Luc Dardenne）的《美丽的罗塞塔》和《孩子》两度荣获戛纳"金棕榈奖"，奥地利的迈克尔·哈内克（Micheal Haneke）的《躲避》和《白丝带》也受电影节的高度赞誉，而荷兰影片《安东尼娜的家族》和《角色》还向后获得了奥斯卡最佳外语片奖，充分显示西欧电影依然实力强劲。

The Art Cinema Revived: Toward Accessibility

As the success of Luc Besson indicates, European popular genres maintained their stability throughout the period. Most filmmakers aimed at their local public, but strong genre traditions helped some films find international audiences. Exportable items included Italian comedies, from Franco Brusatti's *Bread and Chocolate* (1973) to Maurizio Nichetti's *Icicle Thief* (1990) and Roberto Begnini's *Life Is Beautiful* (1997). French sex comedies (e.g., *Cousin Cousine,* 1975) and British eccentric humor (e.g., the Monty Python films) also kept their place in both domestic and foreign markets. French cop films, with their drab routines and resigned melancholy, held perennial appeal, from *Police Python*, 3.57 (1976) and *L.627* (1992) to *36 Quai des orfevres* (2004) and *Le petit lieutenant* (2005). British crime films invoked their own shadowy tradition, as in *Mona Lisa* (1986), *Lock, Stock and Two Smoking Barrels* (1998), *Croupier* (1999), and *Sexy Beast* (2001). German comedies were usually not export material, but *Manitou's Shoe* (2001) and *Good Bye Lenin!* (2003) sold briskly around the world.

The Pan-European Film On the whole, the most exportable European films

were those that carried some degree of prestige—festival prizes, famous literary sources, or the name of a major director. One sign of the weakening of hardcore auteurism was the fact that established directors participated in the new Eurofilm by creating prestige pictures. Andrezej Wajda, in exile from Poland, made films in France and West Germany. Ermanno Olmi's *Tree of the Wooden Clogs* (Italy, 1978) marked a return to Neorealism, re-creating the life of nineteenth-century peasants in their original dialect but also giving them the dimension of legend. Carlos Saura's prodigious output drew on Spanish culture: *Blood Wedding* (1981), *Carmen* (1983), and *El Amor brujo* ("Love, the Magician", 1986) employed indigenous dance, while *El Dorado* (1988), a lavish coproduction with Italy, presented Spanish colonialism as a brutal political game.

Vittorio and Paolo Taviani, who had promoted a humanistic, populist political cinema during the 1960s and early 1970s, became acclaimed directors with the success of *Padre padrone* (1977). They sealed their reputation with a mythic recasting of the Neorealist tradition, *Night of the Shooting Stars* (1982), and a luxuriant adaptation of Luigi Pirandello stories, *Kaos* (1984). *Good Morning Babylon* (1987) returns in both theme and structure to the romantic simplicity of the American silent cinema. The Tavianis, along with many others, forged an international tradition of quality for the 1970s and 1980s.

The upscale Eurofilm could accommodate some political critique, though nothing as radical in subject or form as was seen in the era of politicized modernism. In the 1970s, once New German Cinema had won respect around the world, Rainer Werner Fassbinder came onto the international stage with a series of big-budget films featuring renowned stars. *The Marriage of Maria Braun* (1978) proved an international success, and Fassbinder moved quickly to largescale coproductions such as *Lili Marlene* (1980), *Lola* (1981), and *Querelle* (1982). These films all employ the resources of color, costume, soft focus, and spectacle to stylize the characters' worlds: unrealistic strips of pink light falling across a face (*Lola*) or a tangerine glow emanating from a wharf (*Querelle*). Extreme close-ups of historically exact details interrupt the action of *Maria Braun*.

Fassbinder's last films continued the vein of melodrama plus social critique he had explored earlier, but in far more muted and widely accessible form. Fassbinder sought to remind viewers that their country retained ties to its Nazi past. His late films presented an epic history of Germany, from the 1920s (*Bolweiser* and *Despair*, both 1977) through the Fascist era (*Lili Marlene*) to the rise of postwar Germany (*Maria Braun*; *Veronika Voss*, 1981; *Lola*). Yet Fassbinder did not wholly abandon his experimental impulses. Unlike Straub and Huillet, he preferred postdubbing, which allowed him to make his sound tracks no less baroque than the settings. In *a Year of 13 Moons* (1978) and *The Third Generation* (1979) overlaid

radio broadcasts, television commentary, and conversations to create dense acoustic ambiences.

At the other extreme, experimental political modernism did not entirely vanish. Alexander Kluge, after his more straightforward narrative *Strongman Ferdinand* (West Germany, 1975), returned to fragmented historical allegories that inquired into the continuing effects of Nazism and the war. Jean-Marie Straub and Danièle Huillet continued to make both static, text-centered films (*Fortini/Cani*, 1976; *Too Early Too Late*, 1981) and narratively oriented literar)' adaptations. The Straub-Huillet approach was revived by Pedro Costa, who documented the lives of the Portuguese underclass in the solemn long takes of *Ossos* (1997) and *Colossal Youth* (2006).

More playfully, the Chilean exile Raul Ruiz created labyrinthine modernist puzzles. *La Vocation suspendu* ("*The Suspended Vocation*", 1977) purports to present two unfinished films, one intercut with the other, about intrigues within a religious order. *Memory of Appearances: Life Is a Dream* (1987) drops a political agent into a dictatorship where police interrogate suspects behind the screen of a movie theater.

Of all directors in the tradition of political modernism, one gained prominence in the 1970s and 1980s. The Greek Theo Angelopoulos replaced Michelangelo Antonioni and Miklós Jancsó as the doyen of the longtake approach to film style. His distant camera emphasizes characters moving through landscapes, delineating the force of location on action or contrasting a milieu with the event (as when a lengthy, extreme long shot intensifies the shocking rape of the adolescent girl in *Landscape in the Mist*, 1988). Still prepared to play time-shifting games with history and memory, Angelopoulos represented a monumental version of the postwar modernist tradition.

Still, even Angelopoulos moved toward personal, psychologically driven tales. His frescoes of Greek history such as *The Traveling Players* (1975) gave way to more intimate dramas. *Voyage to Cythera* (1984) shows an elderly communist exile returned to Greece. Angelopoulos also took up the problems of European migration and the dissolution of national borders. In *Landscape in the Mist,* children leave home in search of the father they believe to be in Germany, while *The Suspended Step of the Stork* (1991) centers on a famous novelist who abandons middle-class comforts for the precarious life of a refugee.

Charming Rebels and a New Tradition of Quality The decline of attendance and export markets, the conservatism of investors, and competition from Hollywood drove many producers and directors toward more accessible filmmaking. European countries concentrated on films for local audiences, and even international filmmakers pulled back from experimentation. The cinema of

the 1970s-2000s was on the whole far less challenging and disruptive than had been seen during the era of political modernism.

For example, comedies could present social commentary and formal experiment in ingratiating ways. Ettore Scola's (1931-) *We All Loved Each Other So Much* (Italy, 1974) established him as an astringent commentator on the political disillusionments of postwar Italian history. With that film, *A Special Day* (1977), and *Le Bal* ("*The Ball*", 1983), he won international success. Each project wittily merges art-cinema modernism with accessible comedy. *Le Bal* is set entirely in a French dance hall during different eras, and the whole film is played without dialogue. Scola's close-ups heighten the caricatural performances, and he cleverly manipulates visual design, as when the Popular Front sequence drains all color from the shot save that of the Communist flag.

Another Italian talent, Nanni Moretti (1953-), began his career with anarchic, pseudo-underground comedies (*Ecce Bombo*, 1978) before developing a brand of bemused humor devoted to a generation disenchanted by the failure of left-wing ideals. Moretti typically plays a slightly neurotic hero encountering the frustrations of modern society. In *Palombella Rossa* (1989), a young Communist-party offcial suffers amnesia and must relearn correct doctrine; his naive questions satirize a spectrum of political opinions. To add to the humor, most of the film is set in a swimming pool during a game of water polo. In the poignant *Caro Diario* (*Dear Diary*, 1993), Moretti shares his pleasure in riding his Vespa through Rome and his fear in discovering that he has a mysterious disease. Like many filmmakers who started in the 1970s, Moretti turned from largescale politics to the intimacy of friendship and family devotion. *Aprile* ("*April*", 1998) celebrates the birth of his child as he is planning a new movie. He funneled his scathing attack on Berlusconi, *The Caiman* (2006), through the story of a mild-mannered producer trying to make a film on a media mogul.

A similar move to the mainstream was seen in the career of Pedro Almodóvar (1949-), who shifted from gay underground films to more mainstream productions that fused melodrama, camp, and sex comedy. In Almodóvar's world, nuns become heroin addicts (*Sisters of Night, aka Dark Habits*, 1983), a downtrodden wife slays her husband with a hambone (*What Have I Done to Deserve This?*, 1984), a newscaster confesses to murder on television (*High Heels*, 1991), a woman is attracted to a man because he slays bulls (*Matador*, 1986), and another falls for a man who has abducted her (*!Atame!, aka Tie Me Up! Tie Me Down!*, 1989). As in some Mexican works of Luis Buñuel, scandalous situations and imagery are handled with a casual, ingratiating lightness. Almodóvar also parodies ordinary movies, often through a film within a film, as in the delirious silent-film pastiche in *Talk to Her* (2002).

Almodóvar achieved notoriety with the sex farce *Women on the Verge of a Nervous Breakdown* (1988), but his later films turn toward melodrama. Like Fassbinder, Almodóvar admired Douglas Sirk, and he began to mount convoluted plots of erotic rivalries, both gay and straight, and pathetic twists of fate. *The Flower of My Secret* (1995) centers on an intellectual woman who secretly writes trashy romances. In *Live Flesh* (1997), a woman is sexually attracted to the criminal who has paralyzed her husband. *All About My Mother* (1999) builds an unlikely family out of a single mother, a pregnant nun, a transvestite prostitute, and an HIV-infected baby. Like Sirk and Fassbinder, Almodóvar decorated his scenes with ripe color design. In the 2000s, Almodóvar's visual inventiveness and his warm direction of female performers made him an emblem of the creativity of European cinema. The young Turk had become a benevolent elder statesman.

Across the same period, Finland's Aki Kaurismäki (1957-) won worldwide notice with the Wenders-like *Ariel* (1989) and the Bressonian *Match Factory Girl* (1989). His cruel deadpan mockery, born partly of a passion for hard-rock music, is most unadulterated in *Leningrad Cowboys Go America* (1989), while it is tempered with ironic sentiment in *Vie de bohème* ("*Bohemian Life*", 1991), *The Man without a Past* (2002), and *Lights in the Dusk* (2006). Kaurismäki's celebration of naïve, passive losers, his wide-ranging film references, and his satire of middle-class values made him a cult director across 1990s Europe.

Many European directors returned to the comfortable mode of prestige pictures, literary adaptations, and the milder modernism forged in the 1950s and 1960s. Critics pointed out that literary values and elegant style seemed to be creating a new French "tradition of quality". The success of Bertrand Blier as a novelist led him to adapt his own work in *Les Valseuses* ("*The Waltzers*", 1974). His *Get Out Your Handkerchiefs* (1978) earned an Academy Award, while *Too Beautiful for You* (1989) won prizes both at home and abroad. Similarly, the criti-turned-director Bernard Tavernier evoked the golden years of the postwar French cinema by hiring Jean Aurenche as scenarist and by making such films as *Un Dimanche à la campagne* ("*Sunday in the Country,*" 1984) in homage to Jean Renoir. *Tous les matins du monde* (*All the Mornings of the World*, 1991), by Alain Corneau, portrayed seventeenth-century court life through exquisite baroque music. Olivier Assayas, former editor of *Cahiers du cinéma* and son of a prestigious screenwriter, revamped romantic realism in films such as *Fin aoû, début septembre* ("*End of August, Beginning of September*", 1999). Even Raul Ruiz abandoned bizarre experimentation for a handsomely mounted costume picture, *Les Temps retrouvé* (*The Past Recaptured*, 1999).

Other directors contributed astringent personal dramas to the continuing

tradition of quality. The indefatigable Eric Rohmer alternated such Europroductions as *Triple Agent* (2004) with his trademark social comedies such as *Autumn Tale* (1998). Philippe Garrel, a practiced director of elegant, subdued studies of couples (such as *La Naissance de l'amour*, "The Birth of Love", 1993), attracted fresh attention with *Les Amants réguliers* ("Regular Lovers", 2005), which concentrated on young people caught up in sex, opium, and the revolt of May 1968. A newer talent, Arnold Desplechin, worked in a similar vein in *Kings and Queen* (2004). In all, the solemn psychological drama characteristic of the art-film tradition continued to be a staple of film festivals throughout Europe.

Socially Critical Naturalism As directors retreated from the radical extremes of politically critical modernism, several sought to reveal social conflicts in a more realistic way. In the early 1970s, the British Film Institute Production Board, which had been formed in 1966 and had concentrated on independent shorts, began funding features as well. One of the first was an autobiographical trilogy by Bill Douglas: *My Childhood* (1972), *My Ain Folk* (1974), and *My Way Home* (1977). In an elliptical, unsentimental fashion, these trace a boy's loveless life in a northern industrial town. At the same period, Ken Loach (1936-) began using nonprofessional actors, shooting in a quasi-documentary style on location in the industrial north for *Kes* (1969). The film depicts a boy who is miserable in school but becomes fascinated with training a falcon. Over the next forty years, Loach would stubbornly maintain the British tradition of working-class realism, winning particular notice with *Riff-Raff* (1990), *Raining Stones* (1993), *Land and Freedom* (1995), and *The Wind that Shakes the Barley* (2006).

The British Film Institute (BFI) also funded the frst film of theater director Mike Leigh (1943-), *Bleak Moments* (1971), a story of a female office worker living with her mentally handicapped sister. It mixed sad, amusing, and quiet incidents in a manner that was to become typical of Leigh's work. His subsequent dialogue-based depictions of working-class life, produced by the BBC and later Channel 4, balance humor and pathos in depicting social problems, as in *Life Is Sweet* (1991). *Naked* (1993) takes a much bleaker look at poverty in modern Britain through the eyes of an intelligent but violent and disillusioned man. In 2000, Leigh surprised his admirers with *Topsy-Turvy,* a ripe portrayal of London in the 1880s, when W. S. Gilbert and Arthur Sullivan were mounting the operetta *The Mikado*. Despite the musical numbers and lush design, however, Leigh stuck to realism by displaying authentic reconstructions of Victorian stagecraft and by injecting critical references to British imperialism, slum life, and the treatment of women. He returned to sympathetic depictions of working-class life with such films as *Vera Drake* (2004), about a kindly woman in 1950s Britain who happens

to be an abortionist.

In France, Jean Eustache offered a withering portrait of the self-centered young male, lying and quarreling his way through women's lives, in *The Mother and the Whore* (1972). Maurice Pialat's (1925-2003) *Nous ne viellrons pas ensemble* ("*We Won't Grow Old Together*," 1972) and *Passe ton bac d'abord* ("*First Get Your Degree*", 1978) harshly depict middle-class problems such as divorce, unwanted children, and cancer. Pialat's brand of domestic realism won international acceptance in *Loulou* (1980) and *À nos amours* (1983), a story of a girl's coming of age in an era of sexual liberation. Something of the elegant gravity of 1950s French Quality productions came through in his *Sous le soleil de Satan* (1987) and *Van Gogh* (1991), where sometimes shocking violence is handled unsensationally.

The continental tradition of naturalistic observation continued in Erick Zonca's *The Dream Life of Angels* (1998) and Bruno Dumont's *L'Humanité* (1999). The most successful new naturalists of the 1990s were the Belgian brothers Luc and Jean-Pierre Dardenne (1951-, 1954). The Dardennes focused on the bottom rungs of society, examining in unflinching terms how poverty, crime, and violence warp people's values. *Rosetta* (1999) shows a girl driven to crime by unemployment and an alcoholic mother. In *Le Fils* ("*The Son*", 2002) a lonely carpenter takes a teenage murderer as his assistant, while *L'Enfant* (2005) centers on a young thief who won't accept responsibility for his baby. Like many realists, the Dardennes favored the casualness of the handheld camera, so that loose, uncalculated framings affirmed the actuality of what was shown.

4. 东南欧：希腊、马其顿、波黑、匈牙利和罗马尼亚等

希腊电影因《别在星期天》(*Never on Sunday*, 1960) 等开始为世人所知，但真正引起国际影坛瞩目则是希腊国宝级的电影大师西奥·安哲罗普洛斯 (Theo Angelopoulos)，他以《流浪艺人》为代表的"希腊现代史三部曲"、以《雾中风景》为代表的"沉默三部曲"和以《永恒的一日》为代表的"巴尔干三部曲"将神话与现实、诗意与哲思、个人与国家、机缘与宿命等融会贯通，成就希腊电影的个性化史诗表达、让观众重见古希腊文明的惊鸿一瞥。

巴尔干半岛历来被称为火药桶，而前南斯拉夫分裂成六个独立国家的历程也极为痛苦和惨烈。马其顿导演米尔乔·曼切夫斯基 (Micho Manchevski)《暴雨将至》就以创新性的叙事探索了宿命的轮回与暴力的本能，而波黑影片《无主之地》也揭示出人性黑暗和自相残杀的荒诞和虚妄。

《暴雨将至》

20世纪90年代，一批匈牙利青年导演以辛辣笔调、迷局主题和沉缓运镜的黑白电影引发关注，贝拉·塔尔（Bela Tarr）的《撒旦的探戈》和《来自伦敦的男人》就是其典型代表。在60年代就以《重建》成名的罗马尼亚著名导演吕西安·平特莱（Lucian Pintilie）用《刑讯者的下午》续写罗马尼亚电影的传奇，而以克里斯汀·穆基（Christian Mungiu）的《四月三周两天》等为代表的新一代罗马尼亚电影正在铸造辉煌。

The Balkan States

Greek cinema came to international-attention in the early 1960s, thanks primarily to *Never on Sunday* (1960) and three films by the Cyprus-born Michael Cacoyannis: *Stella* (1955), which introduced Melina Mercouri in the role of a woman who loves deeply but defies marriage—a significant break with Greek social and artistic conventions; *Electra* (1961), which starred Irene Papas and remains the greatest cinematic adaptation of a Greek tragedy; and *Zorba the Greek* (1964), which was a popular hit based on a novel by Nikos Kazantzakis. Like *Electra*, the strongest of Cacoyannis's later films—*The Trojan Women* (1971) and *Iphigenia* (1977)—are Greek tragedies set not on the stage but in the rough natural

world. Cacoyannis creates a convincing picture of the ancient world in which the tragedies unfolded, an approach exactly opposite to the spectacular approach of the Hollywood "epic".

Never on Sunday, a comedy about a prostitute (Melina Mercouri) with a mind of her own, was a worldwide hit; its director, Mercouri's husband, was the blacklisted American Jules Dassin. If some directors, like Dassin, came to Greece in the 1950s and 1960s, others left—notably Costa-Gavras, who went to France, where he learned the trade and eventually made his great film about political assassination, fascism, and the struggle for truth in Greece, *Z* (1969).

The most stylistically rigorous of the new Greek directors is Theodoros Angelopoulos (1935-2012). Episodic, ambiguous, and slow-paced, his films present the "other Greece"—not the one of stunning beaches and crowded cities, the *Never on Sunday* Greece, but the rhythmically different land of peasants, refugees, nomads, and soldiers, a place where continuity (emphasized in the long takes and following shots) is the essential structure of life and perception, while the definitions according to which people attempt to organize their lives prove elusive and sometimes destructive. His works include *Days of '36* (1972), *The Traveling Players* (1975), *Ulysses' Gaze* (1995), and *An Eternity and a Day* (1998). History is vividly dramatized in his most important and challenging film, *The Traveling Players*, which tells the story of a troupe that travels through Greece between the years 1939 and 1952—years of war, of partisans, of fascists, of political betrayal—performing the pastoral drama, *Golpho the Shepherdess*. The leader of the troupe and his family live out a modernized version of Aeschylus's trilogy of Greek tragedies, the *Oresteia* (the murder—in this case the betrayal and execution—of the father, the son's revenge on the mother and her lover, the son's flight); the son is even named Orestes. It is as if the lives of the players were positioned between two determining texts: the *Oresteia*, which no one ever mentions, and *Golpho*, which never changes. The story is told out of chronological order in a manner that is architecturally masterful and compelling. During the time covered by the action, the players often return to the stone cities; that makes it possible for Angelopoulos to show them in the same places at different times, and for the film to start with the troupe in a ceftin city in 1952 and to end with them in the same city in 1939. So unusual is the treatment of time in this picture that in one shot several men walk down the street at dawn on New Year's, 1946, to a political rally taking place in 1952. So elegant is the camerawork that one shot shows the father ascending a staircase (one of two that reach the same level), going into the bedroom where his wife is waiting, telling her he's enlisted, hitting her when she laughs at him, then going out of the bedroom and down the other staircase, where he says goodbye to his daughter and leaves; then the camera pans back to the first staircase to watch the

lover come upstairs and go into the bedroom. *The Traveling Players* unites the mythical past and the political recent past into a radical picture that crosses and recrosses Greece in space and time.

第六节　数字化多媒体时代

1. 从机械复制到虚拟真实

　　20世纪60、70年代尖端科技的发展和科幻片的繁荣，极大地促进了电影新技术的开发，而乔治·卢卡斯创建的电影特技公司"工业光魔"（Industrial Light & Magic，简称ILM）就是执牛耳者（占有全球十大票房影片的八部）。成熟的电脑技术在80年代初制作出首部"电脑成像"（computer generated imagery，简称CGI）电影，而在其后的《深渊》《魔鬼终结者2：审判日》《侏罗纪公园》和《阿甘正传》等影片中得到越来越广泛应用并获得巨大成功。电脑成像技术为电影带来革命性的转变，电影这门百年艺术也由机械复制的记录逐渐过渡到虚拟真实的创造当中。

From Mechanical Reproduction to the Virtually Real

　　In an essay written in 1936, the Marxist critic Walter Benjamin described film (together with lithography and photography) as an art of "mechanical reproduction." However dismissive this statement may seem from a cultural perspective (though Benjamin did not intend it that way), from a material one it is absolutely true. Film is based on a photochemical process (photography) engineered to mechanically reproduce images of things in motion as that motion occurs in empirical reality before a camera lens. As the twenty-first century approaches, however, filmmakers are coming to rely increasingly on digital

technologies—especially computer generated imagery (CGI)—to shape and control their images beyond the limits of the mechanically reproducible. These technologies can create a "virtual" reality in the digital domain for integration with photographic images through the blue-screen process or for laser-scanning directly onto the film stock itself, without the intervention of photography. CGI is fundamentally a form of computer animation, the same technology used by broadcasters like Ted Turner to "colorize" black-and-white films from the studio era for video. It produces images frame by frame from thousands of discrete digital parts, each of which it calculates and positions precisely to create the illusion of a three-dimensional whole.

The first feature to use CGI for an extended sequence was Disney's *Tron* (1982), which contained approximately five minutes of high resolution digital imagery; and *The Last Starfighter* (Nick Castle, 1984) used CGI to produce twenty-seven minutes of deep-space special effects; but it was the integration of live action and computer graphics in James Cameron's *The Abyss* (1989) that announced the technoiogy's coming of age. The use of CGI to create that film's irregularly shaped, organic-looking water creature, or "pseudopod", demonstrated that complex digital effects could be both remarkably credible and as nearly cost-effective as optical ones (e.g., those created photographically for compositing in an optical printer). After this, there was a great out-pouring of films using digital effects, including *Total Recall* (Paul Verhoeven, 1990), *Toys* (Barry Levinson, 1992), *Terminator 2: Judgment Day* (James Cameron, 1991), *The Babe* (Arthur Hiller, 1992), *In the Line of Fire* (Wolfgang Petersen, 1993), *Death Becomes Her* (Robert Zemeckis, 1992), *Jurassic Park* (Steven Spielberg, 1993), *The Flintstones* (Brian Levant, 1993), *Forrest Gump* (Robert Zemeckis, 1994), *The Mask* (Chuck Russell, 1994), *True Lies* (James Cameron, 1994), and *The Shadow* (Russell Mulcahy, 1994). The most spectacular use of CGI is for special effects blending digitally created three-dimensional images (*Terminator* 2's silvery T1000 cyborg; the dinosaurs of *Jurassic Park*) with live action, but it can be used in much more mundane ways to economize on production costs. In films like *The Babe* and *In the Line of Fire*, for example, small groups of extras were randomly duplicated, multiplied, and fitted into various computer models of crowd scenes, saving a small fortune in extras' salaries and crowd control.

Another application of CGI is electronic compositing—the manipulation of film images in digital postproduction, using nonlinear editing systems to retouch shots (e.g., adding computer-generated color, removing support wires for stunts), composite synthetic images (including titles, overlays, and morphing effects), or integrate separate photographic elements into one (e.g., actor Tom Hanks' meetings with such historical figures as JFK, LBJ, and Nixon in *Forrest Gump*; the Harrier jet flight sequence at the conclusion of *True Lies*); nonlinear systems like the Avid

Film Composer, Lightstorm, and D/Vision-Pro are increasingly used in studio postproduction departments to edit entire features (e.g., Fox's *Mrs. Doubtfire* [Chris Columbus, 1993] and *Speed* [Jan De Bent, 1994]). Digital effects are also employed in preproduction—called "previsualization" in this case—to create storyboards, mock up sets, predict lighting, and work out complicated camera movements. At this writing, the leading digital effects producers in the American industry are George Lucas' Industrial Light & Magic (ILM), IBM's Digital Domain, and Pacific Digital Images (PDI) of Silicone Valley; they may soon become as important to film production as the studios they now work for.

In the realm of audio, digital technology has achived full frequency response, allowing sound engineers to move action convincingly off screen and to strategically isolate musical themes and instruments in the environment. A new frontier of digital sound design looms as fifty thousand theaters worldwide prepare to equip themselves with one of three competing digital playback systems (Dolby's SR.D., Sony's SDDS, and Universal's DTS). And theaters themselves may become obsolete when the delivery of digital multimedia (high-definition video, sound, graphics, and text) into the home by five-hundred-channel interactive cable becomes widely available, as predicted for the next decade. In 1993, Time Warner, the world's largest communications / entertainment corporation, and Telecommunications, Inc. (TCI), the nation's largest cable operator, joined forces to develop compatible hardware and software that would set the standard for the electronic superhighway of the twenty-first century, and other such *keiretsu*-like alliances followed. It would seem that in cinema, as in so much else, the digital domain stands poised to shape the future.

Whether or not the history of film and the history of digital computing merge in the nineties, it is certain that the technological evolution of both will continue to accelerate. It has been the main argument of this volume that film is a technological art form and that every revolution in its technology has produced and will continue to produce an essential change in the form itself. We have seen how the silent film is formally distinct from the sound film, and the widescreen film from them both—all on the basis of the technology available to filmmakers at any given point in time. The body of narrative conventions that Griffith worked a lifetime to discover is available today to anyone who can purchase a copy of *A Primer for Film-Making* or any of a score of similar instructional manuals. Eisensteinian montage can be found in every television commercial. Fluidity of camera movement, which once required all the brilliance of Murnau, Renoir, or Welles to achieve, can now be had for the rental fee of a Steadicam, the lightweight hand-held support camera that moves to record images as smoothly as if it were a crane or a dolly. In

fact, by 1985 anyone with a thousand dollars could buy a half-inch video camcorder that would provide a fidelity of image and sound beyond anything available to the great American studios in their golden age; ten years later, high-definition 8mm camcorders had become commonplace, and the price of half-inch technology was cut nearly in half. Technology obsolesces itself; art does not—that is the great paradox of a technological art form. To understand the true genius of Griffith, or Eisenstein, or Renoir, or Welles, or Hitchcock, or any other seminal figure in film history, we must think ourselves back to the technological limitations of their times, the limitations that they transcended to create an art of the moving photographic image—even as the integrity of that image itself is challenged by the wizardry of digital manipulation. Otherwise, someday in the not-too-distant future, as we sit before our wall-sized holographic video screens and watch images of unprecedented sensory refinement dance before our eyes, we will be tempted to forget how very much we owe these pioneers—not only for creating and structuring our most technological of art forms, but for keeping that form meaningful, significative, and humane. Unless that commitment to the humane call be maintained by succeeding generations of film and video artists, the audio-visual environment of the next century is likely to be as cold and alien as the landscape of the moon in *2001*, or the landscape of the soul in *The Shining*.

2. 数字技术与电影

1995 年，皮克斯公司（Pixar）推出首部全数字制作的《玩具总动员》标志着数字电影的真正诞生，而卢卡斯的《星球大战前传：幽灵的威胁》则首次实现全数字化的放映。

数字技术首先用磁带、碟片或硬盘替代了电影胶片，使电影拍摄变得更加经济、方便和平民化（《时间密码》和《俄罗斯方舟》这样单一长镜头电影成为可能）；其次是可以不依赖演员和场景而独立生成影像、甚至生成现实生活中并不存在的想象影像（《星球大战前传》和《阿凡达》）；第三是可以极大的强化实际拍摄阶段的控制力（科波拉《心上人》率先使用的现场录像监视系统）、方便剪辑阶段的选择（非线编）和丰富后期合成阶段的特殊效果；第四是数字技术为当代电影的叙事、形式和风格带来改变；最后，数字技术也引入了电影新的发行放映和观影方式、以及后电影相关产品新的开发理念和盈利手段。

《时间密码》的四分画面

Digital Thchnology and the Cinema

In May, 1999, George Lucas's *Star Wars: Episode I—The Phantom Menace* began its American run ill nearly 3,000 theaters. The press, however, paid more attention to a mere four screens in New Jersey and California. They were testing prototypes of digital projectors. Other "films without film" soon followed: Miramax's *An Ideal Husband,* Disney's *Tarzan,* and Pixar's *Toy, Story* 2 all played in a few digital theaters. Journalists declared that within a few years, digital would be the norm for exhibition.

The digital idea entered production as well. Lucas filmed the second *Star Wars* episode, *Attack of the Clones* (2002), with a new highdefinition camera. Robert Rodriguez did the same for *Spy Kids 2: The Island of Lost Dreams* (2002) and *Once upon a Time in Mexico* (2003). Both directors declared that they would never shoot on film again. Many cinematographers, directors, designers, and other professionals were upset at the prospect of the death of photographic film, as were many movie fans, but the rise of digital cinema seemed inevitable.

The reality turned out to be more complex. Many independent filmmakers had been using video for several years, initially analog and then digital, mainly for its low cost. In the early 2000s, the mainstream industry became more heavily dependent on digital technology. New tools took over special effects (aka FX), editing, and sound mixing. Still, most studio movies continued to be shot on 35 mm stock, and the final product was still shipping to theaters on reels of

film. Around the world, theater owners resisted the expense of outfitting their auditoriums with expensive new projection systems. Despite yearly predictions within the industry of an imminent roll-out of "D-cinema", as of 2008 only 4 percent of the world's screens had converted to digital projection.

Yet digital technology had changed filmmaking in nearly every domain, and at every budget level. Highly sophisticated cameras and programs were available to the big Hollywood studios and their equivalents abroad. Less expensive but complex "prosumer" equipment served the independent sector, where smaller budgets and crews made digital a major alternative to 35mm or 16mm. And the availability of inexpensive camcorders allowed amateurs of all ages to shoot movies and share them with others by posting them on the Internet, showing them in specialized festivals, distributing them on DVD via online sales, or making them available to download for a fee. These amateurs' work came to be known as "Do It Yourself", or DIY, cinema. These changes, while most salient in the U.S., were echoed in other countries across the world.

Digital Tools for Filmmking

Cinema's earliest digital technology involved, *motion-control systems*, computer-governed cameras that could repeat, frame by frame, movements over miniatures or models. The first extensive use of motion control was in *Star Wars* (1977), and the system quickly became vital to make special-effects shots more three-dimensional. Sound recording and reproduction became digital as well. Digital audio tape (DAT), which sampled and stored sound waves in binary form, emerged as the audio engineer's standard for both music and film sound. While digital sound was becoming normal for film production in the mid-1980s, it spread to the consumer market through the audio compact disc. Then multiplexes upgraded to digital multichannel systems, encouraging filmmakers to use evocative surround effects and greater dynamic ranges.

In the mid-1990s, the digital revolution began to have a far bigger impact, although not on every stage of the filmmaking process. The commercial cinema incorporated digital technology for special effects, sound design, and editing rather quickly, but there was resistance to abandoning film stock as the basis for recording images.

Shooting on Digital Media

Filming with digital cameras began in the television industry. Only broadcast networks could afford Sony's first digital video camera, which appeared in 1986. Its successor, Digital Betacam, was introduced in 1993 and became the standard.

Television programs shot on film could be transferred to digital tape through a scanning process called *telecine*.

Digital cameras were slower to enter theatrical filmmaking. Standard digital images were adequate for television transmission, but they looked faint and fuzzy when projected on a theater screen. During the 1990s and early 2000s, standard definition and then HD cameras improved video quality dramatically. They were embraced by independent and DIY filmmakers, though more slowly by commercial filmmakers.

A breakthrough came in 1995, when Sony set the standard for prosumer cameras, offering a digital video (DV) camcorder with a new level of resolution. The camera was also far cheaper than professional film cameras. Because it recorded sound and image at the same time, with a microphone positioned above the lens, a filmmaker could work on location without any assistance. Equally crucial was the Sony camera's capacity to transfer video information into either a PC or Mac computer. A few programs were already available that let individual filmmakers to do all post-production tasks digitally.

Arthouse indies soon experimented with digital. The successful first film from the Danish Dogma 95 movement, *The Celebration* (1998), was shot on digital and released on 35mm. It inspired indie Miguel Arteta to make *Chuck and Buck* (2000), one of the earliest digital films to be transferred to 35mm and shown in U.S. theaters. An American film adhering to the Dogma 95 rules, Harmony Korine's *julien donkeyboy* (1999), manipulated its low-resolution digital footage for release on 35mm. In 2000, Mike Figgis, whose most successful film was *Leaving Las Vegas* (1995), made *Timecode*. It splits the frame among four continuous takes, following loosely related stories. Richard Linklater, who moved between arthouse indie and mainstream projects such as *The School of Rock* (2003), used digital technology to develop a distinctive form of animation. For *Waking Life* (2001), Linklater shot live-action footage on prosumer digital cameras and turned the footage over to a team of animators to recast using 2-D computer animation. Linklater used similar techniques on *A Scanner Darkly* (2006).

Invited to contribute to a series of television films about the upcoming millennium, indie filmmaker Hal Hartley directed *The Book of Life* (1998), a story of Jesus Christ returning to a modern-day New York to unleash the Apocalypse. Hartley exploited the shortcomings of DV, moving the hand-held camera rapidly along streets, shooting 15fps to exaggerate the blur inherent in video, and allowing bright light to flare until it nearly erases the figures. Many shots isolate one figure among blurs of movement.

Eventually other independent American directors turned to digital. David Lynch, who had been making short films on standard-definition video for his website, used it for *Inland Empire* (2006). He declared: "For me, there's no way

back to film. I'm done with it. I love abstraction. Film is a beautiful medium, but it's very slow and you don't get a chance to try a lot of different things. With DV, you get those chances. And in postproduction, if you can think it, you can do it". Robert Altman shot his last film, *A Prairie Home Companion* (2006) on HD, mainly because hiring three cameras at a low cost allowed him to record onstage musical numbers. Cinematographer Ed Lachman expressed the kinds of reservations that kept 35mm film the choice for most projects: "I would want to work on these cameras again in very controlled situations, but they don't have the full range of a film negative, and you don't have the same kind of flexibility that you have with film equipment. Also, I still prefer the look and feel of film".

DIY filmmaking, which formerly would have used 8mm or 16mm film, has turned largely to consumer and prosumer digital filmmaking. Occasionally such films break into the festival and art-theater market, as *Tarnation* (2003) did. For amateurs and aspiring filmmakers, festivals devoted entirely to DIY films have grown up. One, the "48 Hour Film Project", originated in 2001; it challenges amateurs to make a short film in two days, with the results programmed in a festival that tours internationally. Second Life has its own 48 Hour Film Project.

Big-budget Hollywood productions were slower to shoot films digitally. Cameras that could produce an image comparable to 35mm demanded lengthy research and development. In 1996, George Lucas asked Sony to create a professional 35mm camera. One problem was that existing digital cameras shot 30fps, compatible with TV standards but difficult to transfer to film, which runs at 24fps. The new camera had to shoot 24 fps and be at a level of definition and resolution suitable for theatrical projection. Lucas hoped to shoot *The Phantom Menace* on the new camera, but no firm wanted to take the risk of developing lenses for such an untried technology. Eventually Panavision agreed to participate, and the new camera was ready for *Attack of the Clones* (2002). The first film actually to use the Sony/Panavision camera, however, was the French period fantasy-detective film, *Vidocq* (2001). Director Pitoff took advantage of digital's crisp focus and the ease of adding backgrounds, skies, and special effects in post-production. *Vidocq*'s somber style suited the new camera, since digital images tend to wash out detail in bright patches.

Although other manufacturers soon created 24fps HD professional cameras, most major films continued to be shot on 35mm. Prominent exceptions included *Sky Captain and the World of Tomorrow* (2004), *Zodiac* (2007), *Before the Devil Knows You're Dead* (2007), *21* (2008), and *Speed Racer* (2008). *Cloverfield* (2008) mixed high-end digital cameras with a prosumer one, which simulated footage shot by the characters as the action unfolds. Often, however, filmmakers who adopted HD mixed it with 35mm footage, as in *Collateral* (2004), *Mission Impossible III* (2006), *Apocalypto* (2006), *28 Weeks Later* (2007), and *Fantastic Four: Rise of the*

Silver Surfer (2007).

Established film industries in other countries also largely retained 35mm, but many filmmakers around the world turned to digital. Not only was it cheaper than film, but a tape or hard drive could record very long takes. A camera reel in 35mm could run a maximum of eleven minutes, but a digital tape could last two hours or more. Documentarists could now shoot much more footage of an event or interview, and experimental filmmakers created gallery installations that ran for hours. Iranian director Abbas Kiarostami declared after *The Wind Will Carry Us* (1999) that he would work in video. For *10* (2004), he fastened a camera to a dashboard and built his film around lengthy takes of conversations while driving. Aleksandr Sokurov used HD for *Russian Ark* because it allowed him to film a single ninety-minute take. Filmmakers in countries without significant film industries could expand production, as Nigerians did in making their low-budget video features.

Shooting on Film

Why did filmmakers resist replacing photographic film with digital formats? Video formats change every few years, but 35mm film had been the norm since the 1890s. Film remained a more stable medium for archiving movies for future generations. Most important for the look of the final product, film still had a greater dynamic range; digital tended to give good detail in dark areas but to flare and wash out in highlights. Film offered a richer look, and it allowed precise control of focus. Christian Berger summed up the problems he discovered in shooting Michael Haneke's *Caché* (2005) on HD. *"Everything you hear about 'beautiful HD imagery' is just propaganda. We ended up using six cameras because they kept breaking, and we still had focus problems two or three times a day.... It all worked out in the end, but shooting digitally was definitely not cheaper for the producer."* Digital video continued to improve, but so did film technology. The biggest manufacturers of 35mm cameras still released new models at intervals, and Fuji and Kodak did the same with film stocks. New Super 16mm cameras occasionally appeared, providing an option for indie filmmakers who could afford it.

The digital revolution did, however, provide many new tools for the production of films-on-film. Some simply made tasks easier, but others offered options for manipulating the image in ways that were never before possible. The industry blended the best of the two technologies.

Pre-production Computers touched almost every aspect of planning a film. Writers used programs to format their screenplay automatically. Digital spreadsheets helped budgeting and planning trips to locations. But the changes that most crucially affected a movie's look came in production design and pre-

visualization.

Designers had long done their work using drawings, scale models, and blueprints. As architectural and drawing software became more user-friendly, designers gained greater precision by creating 3-D virtual sets. (One program allowed designs to be fitted onto real terrain via Google Earth.) Such designs aided other aspects of preplanning. The choreography for the Oompa Loompa dances in *Charlie and the Chocolate Factory* (2005) was devised in virtual sets. A virtual 3-D version of the crucial newsroom set in *Zodiac* allowed director David Fincher to explore the room and to plot eyelines, ensuring that the adjacent conference room was visible from every desk.

Pre-visualization can mean any sort of image planning, such as sketches or blueprints, but it came to refer to preparing a simple, digitally animated version of a sequence or film. "Pre-viz" grew out of the practice of making *animatics*, which were a tool for cel animation. The storyboard images would be filmed and edited to a pre-recorded soundtrack. Filmmakers could determine the length of shots and the editing before embarking on the costly animation process. While filming *One from the Heart* (1982), Francis Ford Coppola brought the technique to live action by cutting video footage of rehearsals into a rough approximation of the film. Likewise, the cinematographer for *Return of the Jedi* (1982) made video animatics using *Star Wars* action figures.

During the mid-1990s, pre-viz techniques employed blocky figures and sketchy sets that would take relatively little time or computer memory to create. Pre-viz was expensive and used primarily to plan special-effects sequences. After collaborating on pre-viz for the futuristic cityscapes of *Judge Dredd* (1995), Colin Green started Pixel Liberation Front. It quickly grew into one of the top Los Angeles firms specializing in previsualization, working on blockbusters from *Starship Troopers* (1997) to *Iron Man* (2008).

Soon some filmmakers realized that big-budget films warranted complete pre-viz versions. A pre-viz contained far more information than a storyboard. Directors and cinematographers could plan camera set-ups, lenses, lighting, and staging; actors on a bare stage could see settings or monsters that would be added as FX. FX teams could get a head start on their work.

As usual, Lucas was a pioneer. *The Phantom Menace* was entirely planned in pre-viz. The sequences were so fully mapped out that the editor simply waited for the day's footage and fitted it into place. Lucas's methods were secret, but he shared them with two directors. After a tour of Skywalker Ranch, Peter Jackson established a pre-viz department, linked to both the art department and his FX house, Weta Digital, to create complete pre-viz versions of *The Lord of the Rings* (2001-2003) and *King Kong* (2005). Later Lucas convinced Steven Spielberg,

notoriously shy of digital technology, to adopt pre-viz for *War of the Worlds* (2005).

Pre-viz software was an early indication of convergence among digital media. The underwater sets ill *The Abyss* (1989) were pre-visualized using a virtual-reality engine from a video game. That engine became Virtus Walk Through Pro, a major pre-viz program. Antics, another program based on video-game technology, was released in 2005. It and other inexpensive programs of the mid-2000s put pre-viz within reach of independent filmmakers.

The Shooting Phase Even though most Hollywood directors were still shooting on 35mm in the late 1990s, many used digital tools extensively.

Video assist displayed shots as they were being made. Jerry Lewis originated the technique by placing an analog video camera beside the film camera for *The Bell Boy* (1960). Coppola used through-the-lens video assist on *One from the Heart*. The digital version employed a chip inside the 35mm camera's viewfinder to relay the image to monitors. A small monitor mounted on the camera aided the director of photography's assistants, while larger displays could be watched ahd reviewed by the director and other crew members.

Because *computer-generated imagery* (CGI) became so common, filmmakers created footage with an eye toward digital manipulation later. When settings, background action, or additional figures needed to be added, actors performed in front of blue or green screens. These stretches of flat color could be filled in digitally. Such blank backgrounds had occasionally been used in earlier periods, but they became so common that another purpose of pre-viz images was to provide actors who would be performing against a blank screen a sense of what the finished scene would look like.

Motion capture was also executed at the shooting stage. In this process, performers with dots attached to their bodies are captured by digital cameras. The dots become key control points in building a digital figure. Actors' bodies are also scanned. These records provide the starting point for animating CGI figures, such as fantasy creatures and digital stunt doubles. Similarly, motion control digitally records certain camera movements. These can be precisely replicated by other camera or computer-simulated movements; this procedure allows different elements of a complex effects shot to be joined seamlessly.

Post-production Digital technology became most widespread in the phase following principal photography. Editing, color manipulation, special effects, and sound design all became quicker and more flexible.

One of the most important ways of manipulating an exposed 35mm image is by *color grading* it. Color grading was traditionally used to even out the look of shots made in different lighting conditions so that they cut together smoothly. Grading was done in the laboratory, using tests, filters, exposure time, and lamp

temperature. The use of *digital intermediates* (DIs) made the process quicker and offered a great range of choice to filmmakers.

Digital scanning had been used for many years to transfer film to video via a telecine machine. With greater computing power, it was possible to scan a film into digital files, manipulate its color and other visual qualities, and then scan the resulting tiles back onto a new film negative. Initially, this process was expensive and took many seconds per frame. Typically only commercials, with their short running times and high budgets, employed DIs. By the late 1990s, new machines could scan more quickly to create high-definition video images, and DIs began to be used occasionally in film post-production.

Pleasantville (1998) was the first feature to use a DI for color manipulation. The story demanded it: the teenage protagonists magically enter a black-and-white TV world but retain their color; gradually other characters and objects gain color. The film was shot in color, and for about 1,700 shots, selective digital grading changed parts of the frame to black and white while other parts retained their color. Here the manipulation was a special fantasy effect, but for *O Brother, Where Art Thou?* (2000), the entire film was scanned in order to change lush green landscapes to a dusty brown that reflected the plot's Depression setting.

Both these projects involved considerable trial and error, but for *The Lord of the Rings*, a new system was devised that allowed the digital colorist to easily target precise areas of a shot to be changed, leaving the rest of the frame unaltered. The DI team added a green-gold glow to the Shire, an autumnal orange to the Elvish enclave of Rivendell, and desaturated gray and blue tones in the Mines of Moria. In early 2002, the new program went on the market as 5D Colossus (later renamed "lustre"). It quickly became one of the most popular post-production tools. By late 2003, DIs were becoming routine, and soon costs were low enough to allow independent and art house films to utilize them.

Pervasive as DI-based color grading became, the technique passed unnoticed by most spectators. To audiences, the obvious change that digital technology brought to films was CGI. The technology was slow to develop. Simple wireframe animation appeared briefly in *Futureworld* (1976) and *Star Wars*. In 1982 Disney released *TRON*, the first feature with significant amounts of CGI, but its failure discouraged the studio from pursuing such an expensive approach.

At first, CGI work was laborious and required vast amounts of computing power. Early programs also lacked sophisticated methods for *rendering*, which is the addition of surface texture, color, and lighting. The animation of living creatures was a particular challenge. But the division of Lucasfilm that later became Pixar developed RenderMan, a program that would revolutionize CGI. It was first used to animate a stained-glass figure in *Young Sherlock Holmes* (1985). In 1989, *The*

Abyss ushered in a new phase of CGI by inclucing alien beings taking shape as tubes of water with faces. At that point, rendering could not go beyond simple surfaces, so the next major use, in *Terminator 2: Judgment Day* similarly involved a character made of liquid metal that morphs to imitate people and things.

RenderMan was put on sale in 1989. Pixar used short films and features to upgrade the program to deal with complex surfaces like fur, cloth, and grass. Other computer-animation studios pursued the same goals, the ultimate one being to capture the elusive qualities of human skin and eyes.

In 1993, *Jurassic Park* revolutionized CGI with the realistic movement and skin of its dinosaurs. FX-heavy films proliferated. Some CGI was spectacular, creating fantasy worlds, like that in *The Fifth Element* (1997). Other uses were more mundane: adding a sign on a building or erasing the wires used to support the actors during martial-arts fights. The release of the Maya animation program in 1998 added enormous control over factors such as gravity, weather, and muscle movement. Maya was versatile, being compatible with most other programs and even with smaller proprietary ones devised for individual films. It quickly became the industry standard. The logos for Maya, RenderMan, and lustre appear near the end of the credits in innumerable theatrical films.

The Phantom Menace was the first live-action feature to contain a human-like character, but audiences' dislike of Jar Jar Binks overshadowed the accomplishment. Combining innovative motion capture and new methods of rendering, *The Lord of the Rings: The Two Towers* was hailed for its depiction of Gollum, which simulated the translucent look of skin and the glint of human eyes.

With the huge success of blockbusters and the increasing sophistication of CGI, films included ever larger numbers of special effects. *Jurassic Park* had about fifty effects shots. *Superman Returns* (2006) had 1,416. Although some techniques became cheaper, the rise in the number and complexity of FX shots drove up film budgets. CGI could consume half the cost of a movie.

Other post-production tasks were made easier and faster through digital technology. Originally, editing a film's shots into their final order meant making a positive work print of the footage and splicing it in the desired order. For the final cut, a duplicate of the original camera negative was then carefully cut and assembled to match.

In the mid-1980s, several companies developed *nonlinear editing* tools, which substitute a video copy of a film for the work print. Editors could quickly access any desired shot and could try out alternative versions without physically cutting footage. Lucasfilm put Edit Droid on the market in 1984, but its high cost, combined with many filmmakers' reluctance to switch to the unfamiliar technology, limited sales. In 1994, the underlying technology was sold to Avid.

At about the same time, another system, Lightworks, was introduced. Avid and Lightworks convinced Hollywood filmmakers to switch to nonlinear editing. In 1999, Apple released Final Cut Pro. At $999, it was a cheap and friendly program that allowed editors to work on desktops and laptops. Final Cut Pro was first used for a Hollywood feature on *The Rules of Attraction* (2002). After the respected editor Walter Murch won an Oscar for *Cold Mountain* (2003), entirely assembled with Final Cut, it surpassed Avid to become the most widely used system. Over the same period, advances in sound technology streamlined the editing and mixing of tracks.

Ironically, the ability to control so many aspects of a movie in pre- and post-production encouraged directors and cinematographers to continue using 35mm. With the richness of film stock and the possibilities opened by digital techniques, they could combine the best of both media.

Effects on Film Form and Style

The Rise of 3-D Animation Applied to traditional cel animation, the new computer technology simply blended in with the traditional look, speeding up production by executing repetitive drawing and coloring tasks. It also created more textured objects and intricate movements than would be feasible in drawn animation. Disney's *Tarzan* (1999) enhanced backgrounds with a program called Deep Canvas, and DreamWorks' *The Prince of Egypt* (1998) used CGI in fully half of its shots, including the parting of the Red Sea.

A more spectacular change in tile style of animated films came with the creation of 3-D CGI. Traditional cel animation was believed to look lat, with little sense of breadth or depth. The new CGI programs gave characters and settings a greater volume, somewhat similar to puppet or clay animation. (3-D in this context doesn't refer to audiences wearing special glasses to experience the illusion of stereoscopic depth.) During the 1980s and early 1990s, limitations in computer technology confined animators to smooth surfaces and simple shapes, so toys and insects were used as characters in early CGI films. As computer memory and flexibility grew, animators could add complex textures and control hundreds of different points on a figure. By the end of the 1990s, fur, waving grass, and human faces were becoming more realistic. The development of 3-D computer animation was pioneered largely by two firms: Pixar and Pacific Data Images.

Pixar began as an experimental special-effects unit owned by Lucas, but it became an independent company in the mid-1980s. It released an unbroken string of innovative shorts and hit features, including the two *Toy Story* movies, *Finding Nemo,* and *Ratatouille* (2007). Each pushed some aspect of CGI further, as when *Monsters, Inc.* displayed a spectacular mastery of moving fur. For years, Pixar's

only serious rival was Pacific Data Images, partially owned by DreamWorks. PDI's first film for DreamWorks, *Antz*, was overshadowed by Pixar's *A Bug's Life*, but the firm achieved success with *Shrek* and *Madagascar* (2005 onward).

As CGI animated fihns became popular, cel animation declined. Disney had its last 2-D success with *Lilo & Stitch* in 2002, but that same year saw the failure of its expensive *Treasure Planet*. In 2004, Disney closed its long-lived celanimation studios, and although it experimented with 3-D CGI (and 3-D stereoscopic exhibition) with *Chicken Little* (2005), it depended largely on its Pixar releases to maintain its tradition of animation. Disney instead concentrated on FX-heavy live-action films such as the *Chronicles of Narnia* series (2005 onward), the *Pirates of the Caribbean* franchise (2003 onward), and *Enchantment* (2007).

In 2004, approaching the expiration of its distribution deal with Disney the following year, Pixar declared it would nor renew. After lengthy negotiations, Disney ultimately purchased Pixar, appointing its creative leader John Lasseter the Chief Creative Officer overseeing all Disney animation. He vowed to revive the studio's cel animation wing.

During all this, Fox acquired its own animation unit, Blue Sky. It gradually won its way into a position as the third major CGI animation studio by launching the *Ice Age* series (2002 and 2006) and releasing *Dr. Seuss' Hgrton Hears a Who!* (2008).

Studio animation was extremely expensive, but independent and DIY filmmakers had access to cheaper animation programs that worked on their own computers. One genre of animation that emerged is *machinima* (*machine* plus *animation*), whereby repurposed game engines were used to extract characters from games and use them in a story. Other tools, like the Antics pre-visualization program, were turned to the same purpose.

The Revival of 3-D Filmmaking After the original cycle of stereoscopic films in the 1950s, 3-D productions were rare. In the 1980s, the large-format Imax system shot a number of successful documentaries in 3-D.

Another push to innovate 3-D filmmaking started in the mid-2000s, but by then the movies were being made digitally. The new technology offered three options: shoot live-action films with a stereoscopic camera; make an animated movie in 3-D using CGI; or use a computer program to convert an existing 2-D film into 3-D.

James Cameron, a major proponent of the new technology, had a live-action camera built to his specifications for a feature-length IMAX film *Ghosts of the Abyss* (2003). The film documented visits to the wreck of the *Titanic*. The same system was used by other filmmakers, including Robert Rodriguez for his *Spy Kids 3D: Game Over* (2003). In 2008, several portable 3-D cameras were used for

two concert films: *U2 3D* and *Hannah Montana/Miley Cyrus: Best of Both Worlds Concert Tour*.

CGI animation lent itself to stereoscopic presentation, since the 3-D effects could be programmed in from the start of production. The primary extra requirement was twice as much rendering for the twin images. Disney added 3-D at a later stage, with its 2005 CGI release, *Chicken Little*; from the start, *Meet the Robinsons* (2007) was planned for 3-D. Robert Zemeckis promoted another approach, using motion capture and digital animation to create a more realistic look for *The Polar Express* (2004) and *Beowulf* (2007).

The conversion of an existing film to 3-D was complex and expensive. *Tim Burton's Nightmare Before Christmas* (1993) received this treatment and was re-released as a Christmas classic in 2006, 2007, and 2008. Rumors persisted that live-action films, such as the *Star Wars* series and Peter Jackson's *Lord of the Rings* trilogy, would eventually receive a similar treatment.

Changes in Narrative Style Digital technology made documentar, independent, and avant-garde filmmaking easier and cheaper. It also gave nonprofessionals access to creative choices previously available only to high-budget filmmakers. On the whole, however, digital tools did not revolutionize the formal and stylistic strategies established within the avant-garde or documentary traditions. They made certain effects easier to obtain, but they did not introduce a radically new aesthetic.

Similarly, in mainstream fiction filmmaking, new digital techniques did not overturn established principles of form and style. Classical continuity editing, goal-oriented protagonists, and three-act script structure were still in place. And in most instances, the results of digital production blended seamlessly into the whole. The stadium crowds in *Forrest Gump* were created by repeating a few figures over and over. Green- and blue-screen work usually embedded the characters in a realistic-looking locale. Digital intermediates recast a film's color scheme to an extent that most audiences probably didn't notice.

Undeniably, however, traditional purposes could now be fulfilled in fresh and appealing ways. Audio software encouraged sound designers to build dense, crisp tracks. Now every noise could be sharply articulated. With a few mouse clicks, filmmakers could create those whooshes and rumbles, halfway between music and noise, which became common in mass-market cinema of the 1990s and 2000s. All these new effects could enhance classical storytelling.

In analog picture editing, editors had found it laborious to create passages of fast cutting, but the ease of digital editing allowed them make their shots very short—an imperanve in the style of intensified continuity. Cutting rhythms were speeding up even before Avid, Lightworks, Final Cut Pro, and other programs

came along, but these innovations accelerated the trend toward brief shots. Digital tools could also conceal cuts. The opening of *Snake Eyes* (1998) blended several tracking shots into a sinuous thirteen-minute take. In *War of the Worlds*, a camera movement gliding into, out from, and around a minivan was seamlessly assembled out of location footage and bluescreen shots made in the studio.

More obvious were the stylized effects that digital could provide. Tony Scott used new post-production techniques to create abstract, painterly images. Filmed on high-definition, video, *Zodiac* acquired a yellowish-amber cast as well as crisp deep-focus imagery. For *Collateral* (2004), largely shot on uncompressed high-definition video, Michael Mann gave film noir a new look, with phosphorescent color flaring up in a murky aquamarine night.

Filmmakers began to build specific qualities of digital video into their stories. *Déjà vu* (2006) and *Vantage Point* (2008) moved from scene to scene by mimicking fastforward and instant replay functions. As 1960s fiction films such as *The War Game* had purported to be 16mm reportage, so *Cloverfield*, *Alone with Her* (2006), the Danish film *Offscreen* (2006), and other films presented themselves as video records. Brian De Palma's *Redacted* (2007) incorporated fake online videos into its collage form.

Form and style were affected, if more marginally, by DVD consumption. Filmmakers could include alternate endings and even introduce a degree of interactivity. On DVD, Greg Marks' *11:14* (2003) allowed home viewers to follow its network narrative in a different order than that demanded by the theatrical version. Films made specifically for DVD release, such as *The Onyx Project* (2006) and *Late Fragment* (2008), with stories designed for random chapter access, offered viewers even more choice about what story threads to pursue.

3. 展望未来

综观世界电影的发展现状，可以预见的大趋势包括：第一，高科技大影院继续繁荣的同时，家庭影院、点播电视和网络下载更会占领越来越多的电影市场份额；第二，独立电影和个人电影的多元化电影制作将因为数字技术的经济便利而获得巨大的成长空间；第三，电影的国际化合作也将因为数字技术的介入而更加紧密和有效，电影这种世界语言将真正获得全球化的普及；最后，数字技术将最终解决电影资料保存的难题（截止2006年，1950年前制作的50%电影和1920年前制作的80%电影已经永远消失），而往昔电影历史的存续则是今朝电影艺术发展的必要前提。

《阿凡达》代表的电影未来

数字化多媒体的融合将传统的电影引入全方位的媒体洪流当中，虚拟真实和互动叙事已然实现，而迄今为止的"世界电影史"兴许有朝一日也会成为某种媒体的"前历史"。

The Look of the Future

In 1993 a company announced that it was perfecting the technology that would allow the image of Buster Keaton to star in a new comedy. In 2004 the image of Laurence Olivier was digitally made to perform a new role in Kerry Conran's *Sky Captain and the World of Tomorrow*. Olivier excepted, every actor in that movie performed entirely against a bluescreen and was composited with the digital effects that constituted the rest of the movie: Actors and effects were the whole package.

Now that anything can be constructed as a digital image, the narrative film and the animated film have come closer together. The cinema is at an interesting

crossroads, where it can explore the realism of the long take as readily as it can cut itself off from photographic reality. Acknowledging the importance of video and animation, as well as the fact that many movies may no longer be printed on celluloid, some Film Studies programs have renamed themselves Moving-Image Studies.

With 4K shooting and projection, the digital cinema is finally a complete system. It stands ready to replace 35mm film. What will happen depends on whether cinematographers and audiences embrace the new technology. Doubtless, many movies will still be shot and released on film, but many will avoid film entirely. Dual distribution will continue until one medium wins out, which could take a decade. The question is not how great a role video and computers will play in the cinema of the future, but how great a role film will play.

For it is clear that digital video and the other technologies described here have transformed the film industry and its product. It is equally clear, looking back, that cinema was the crucial art of the 20th century. But if the age of digital information is taken as license to store films on computer media and if film, which gave the silver screen its silver glow, becomes an obsolete medium for the presentation of movies, then the cinema as an art of projected films may end shortly after its first century. The dialectical conflict of film and TV, or the photochemical and the electronic, will have ended with a synthesis.

It may come down to an issue of what people get used to seeing. The brightness, sharpness, contrast, range, and dyes of the film image used to be recognized, respected, and considered among the essential and definitive characteristics of a unique medium. The film frame is an analog storage system. If it turns out that film is "warm" and the digital image "cold" in the same way that analog sound is said to have a fuller, richer quality than digital sound, then the digital image may lose something that is essential to film—some incalculable part of its visual range—no matter how "film-like" a frame or a color can be.

Digital cinema may be adopted simply because of its convenience. Reel-to-reel tape has better quality, is transported more evenly, has more surface area, and can run at a faster speed than a tape cassette, but the cassette made it obsolete as a consumer item.

The Lord of the Rings and *Citizen Kane* both look better in 35mm theatres than they do on the best TVs. One prediction that can be made with assurance is that full-sized theatres will continue to be patronized because of their big screens and auditorium-scale sound. It is equally clear that the home video market will become an ever more significant source of revenue for the film industry, continuing to take in more than the box office every year, and that people will continue to consider the home, or the home theatre, a convenient and satisfactory substitute for

the public theatre. Pay-per-view (video on demand) and Internet sales will become more significant distribution channels. It will become common to download a movie to a portable player via wireless technology. The future includes a nearly infinite library for download and display.

One can also predict that independent production will increase and that more new pictures will be shot on digital video and edited (as well as being put through the rest of post-production) on portable computers. HD will open the market to many new filmmakers, as DV already has, but at a higher level of quality and with theatre-ready product. Completely digital formats will challenge and perhaps replace digital video. Most significantly, comprehensive standards will be agreed upon for digital color and projection, and that will facilitate the transition to the complete digital cinema. Common video and DV standards and user expectations will expand to high-def as HDTV replaces standard TV, but 2K will begin to look shabby compared with 4K.

Certainly more women will write and direct features. This is a worldwide development led by such brilliant artists as Chantal Akerman and Agnès Varda in France, Samira Makhmalbaf in Iran, and a growing number of others.

The adoption of digital filmmaking is another expanding worldwide movement. Zhang Yimou fell in love with computer effects in *Hero* (2002), where he made, for example, a fighter run crashing through the rain—not a rainstorm, but the individual drops. In his next film, *House of Flying Daggers* (2004), whose digital effects are masterful, there is a wonderful moment when snow covers a fall landscape, as gorgeous as the most painterly CG effect—but what actually happened was that it started to snow, and they decided to keep shooting because they were out of time. There will always be a place for the natural cinema.

International co-production will continue to increase. It is simply working too well and creating too many great pictures to disappear.

The "Return of the Myths" is not over yet—and not just in Hollywood, if one considers pictures like New Zealand's *Whale Rider*. In 2003 and 2004, for example, the biggest hits included *The Return of the King*, the second Spider-Man film, the third Harry Potter film, and Mel Gibson's *The Passion of the Christ*, the highest-grossing independent film to date. There will be more "effects-driven $100 million digital extravaganzas," as the industry calls them, and more low-budget "talking heads" pictures, between which poles a narrative cinema of quality will find its way.

Speaking of predictions, Disney said it was through with 2-D animation as of 2004, and the trendy nature of some digital advances might have made it seem likely that all new animation, not just at Disney, would soon be 3-D. But any look

at a masterpiece like *Spirited Away* or *The Triplets of Belleville* makes it clear that 2-D animation is by no means finished.

One trend that shows strong signs of continuing is the interest in restoring classic movies. In this respect, the look of the future includes the look of the past.

Film preservation and restoration are urgent matters. As of 2006, 50% of the films made before 1950—and more than 80% of the films made before 1920—had been lost.

Restoration is the art of taking an old, perhaps damaged film, many of whose shots may be missing or out of order, and undoing the damage, finding and assembling the best surviving prints and fragments—and doing a staggering amount of research—in order to strike a new print that is as close as possible to the film as originally released. Ever since the enthusiastic reception of Kevin Brownlow's painstaking restoration of Abel Gance's *Napoleon* (produced and presented in 1981 by Robert A. Harris and Francis Ford Coppola), the commercial value of the pictures gathering dust and turning to nitrate soup in their vaults has impressed itself on film companies both in America and abroad. Harris's own restoration of *Lawrence of Arabia*, which took three years and resulted in the best possible 70mm print of the film as David Lean had intended it to appear—a good 20 minutes longer than the abridged version that had been in circulation, including every shot that had been cut at the producer's orders shortly after the picture first opened—was one of the most significant film events of 1989. Indeed, Columbia's re-release of *Lawrence* received as much public attention as its purchase that same year by Sony, the former as important in the history of the art as the latter is in the history of the business. Spectacularly visual, elegantly paced, sweepingly historic, intellectually and emotionally profound, and with a perfectly clean soundtrack, the restored *Lawrence* hit a generation of film students right in the eyes—students who had seen films projected in 70mm (like *Alien*, blown up from 35mm) but nothing *shot* in 70mm—that is, nothing with the perfect detail of the 65mm camera negative. In a time of action-adventure teenpix and little adult pictures with two characters who come to appreciate each other, *Lawrence* appeared like the conscience of narrative film.

In 1987, Paramount began to inventory and preserve its film and television archives— 200,000 cans of material. In 1990 it opened a building for the archive and announced a program of re-releases. By June 1990, both Warner Bros. and Columbia had announced their own film preservation campaigns, and eight filmmakers—Woody Allen, Francis Ford Coppola, Stanley Kubrick, George Lucas, Sydney Pollack, Robert Redford, Steven Spielberg, and the president of the board, Martin Scorsese—had formed The Film Foundation to raise at least $30 million for restorations to be carried out jointly by studios and archives. That same year,

Disney completed a restoration of *Fantasia* for the film's 50th anniversary, the first time in decades that it had been seen full-frame.

Many restorations are now done on computer, not on film. From 1998 to 2002, *Metropolis* was restored at 2K; it was released on both film and DVD, and the film version looked as good as a perfect 16mm print or an average 35mm print—except that it was longer, more coherent, more carefully motivated, and less silly. DI technology is becoming more important in digital restoration, and the result can be a new negative—whether or not new prints are struck and shown—as well as a video release that pays for the restoration.

In 1993, in the largest digital film-processing project yet attempted, all 120,000 frames of *Snow White* were cleaned in a computer, the dust removed and the scratches stitched together with excellent results. In the early 2000s, Charles Burnett's *Killer of Sheep* was restored by UCLA. The film had been shot on 16mm, and Burnett had never cleared the music rights; thus its 1977 "release" was underground. Cleaned despite considerable damage, blown up to 35mm, and with the rights finally cleared (a process that took years), *Killer of Sheep* opened in 2007, perhaps the first film to have been restored before it was officially released.

The more films are restored to their original look and length, and the more new movies appear, the more the art and history of motion pictures will live and grow. We can only hope that many of those movies will be shot and printed on celluloid, because we want all the information every one of those frames can give us.

The Present and the Past

"We should be wary of talking about origins," were the words with which this book began. As motion pictures celebrate their centennial, we should again be wary of making claims not only for beginnings but also for the present and the future. A hundred years of cinema comprise a remarkable epoch: they have witnessed the development of a vast commerce, a dazzling technology, Sophisticated forms of popular entertainment, many enduring works of art (and documentation), and untold social consequences. Yet the past guarantees no future. Film history (as was also noted at the beginning) may become some other medium's prehistory. "Virtual reality" images and interactive narratives are already at hand as the twentieth century comes to a close.

Nor does the present guarantee the past. History is never finished, and rarely stays the same for long. As the writing of this book comes to an end, film history

looks different than it did when the work was started. Countries and their film cultures have disappeared, lost or suppressed films have reappeared. The past is not a seamless whole, to be packaged and put away, but a site to be rediscovered, struggled over, and reshaped. This book has sought to lay the groundwork for readers to participate in the invigorating and unending task, the remaking of film history.

附录

世界电影史一百部重要影片（按时间顺序）

（1）　《火车进站》《工厂大门》《婴儿的午餐》和《水浇园丁》（卢米埃尔兄弟，1895）

（2）　《月球旅行记》（梅里爱，1902）

（3）　《火车大劫案》（鲍特，1903）

（4）　《党同伐异》（格里菲斯，1916）

（5）　《卡里加利博士的小屋》（维内，1919）

（6）　《北方的纳努克》（弗拉哈迪，1922）

（7）　《贪婪》（斯特劳亨，1924）

（8）　《战舰波将金》（爱森斯坦，1925）

（9）　《将军号》（基顿，1926）

（10）《母亲》（普多夫金，1926）

（11）《日出》（茂瑙，1927）

（12）《大都会》（朗格，1927）

（13）《爵士歌王》（阿兰·克罗斯兰，1927）

（14）《圣女贞德》（德莱叶，1928）

（15）《一条安达鲁狗》（布纽埃尔和达利，1929）

（16）《带摄影机的人》（维尔托夫，1929）

（17）《璇宫艳史》（刘别谦，1929）

（18）《土地》（杜甫仁科，1930）

（19）　《蓝天使》（斯登堡，1930）
（20）　《亚特兰大号》（维果，1934）
（21）　《一夜风流》（卡普拉，1934）
（22）　《神女》（吴永刚，1934）
（23）　《意志的胜利》（里芬斯塔尔，1935）
（24）　《摩登时代》（卓别林，1936）
（25）　《雾码头》（卡尔内，1938）
（26）　《乱世佳人》（弗莱明，1939）
（27）　《游戏规则》（雷诺阿，1939）
（28）　《关山飞渡》（福特，1939）
（29）　《公民凯恩》（威尔斯，1941）
（30）　《马耳他之鹰》（休斯顿，1941）
（31）　《北非谍影》（柯蒂斯，1942）
（32）　《罗马，不设防的城市》（罗西里尼，1945）
（33）　《沉睡》（霍克斯，1946）
（34）　《偷自行车的人》（德·西卡，1948）
（35）　《大地在波动》（维斯康蒂，1948）
（36）　《小城之春》（费穆，1948）
（37）　《乡村牧师日记》（布列松，1950）
（38）　《罗生门》（黑泽明，1950）
（39）　《雨中曲》（唐恩和凯利，1952）
（40）　《雨月物语》（沟口健二，1953）
（41）　《东京物语》（小津安二郎，1953）
（42）　《恐惧的代价》（克鲁佐，1953）
（43）　《码头风云》（卡赞，1954）
（44）　《阿普三部曲》（雷伊，1955，1956，1959）
（45）　《野草莓》（伯格曼，1957）
（46）　《钻石与灰烬》（瓦伊达，1958）
（47）　《迷魂记》（希区柯克，1958）
（48）　《热情似火》（怀尔德，1959）
（49）　《宾虚》（惠勒，1959）
（50）　《四百下》（特吕弗，1959）
（51）　《广岛之恋》（雷乃，1959）
（52）　《精疲力尽》（戈达尔，1959）
（53）　《奇遇》（安东尼奥尼，1959）

(54) 《夏日纪事》(让·鲁什,1960)
(55) 《青春残酷物语》(大岛渚,1960)
(56) 《阿拉伯的劳伦斯》(大卫·利恩,1962)
(57) 《八部半》(费里尼,1963)
(58) 《安德烈·鲁伯廖夫》(塔尔科夫斯基,1966)
(59) 《被严密监视的列车》(门采尔,1966)
(60) 《邦妮和克莱德》(佩恩,1967)
(61) 《红军和白军》(扬索,1967)
(62) 《武士》(梅尔维尔,1967)
(63) 《西部往事》(莱昂内,1968)
(64) 《2001,太空遨游》(库布里克,1968)
(65) 《侠女》(胡金铨,1971)
(66) 《教父》(科波拉,1972)
(67) 《巴黎最后的探戈》(贝托鲁奇,1972)
(68) 《天谴》(赫尔佐格,1972)
(69) 《恐惧吞噬灵魂》(法斯宾德,1973)
(70) 《唐人街》(波兰斯基,1974)
(71) 《纳什维尔》(奥尔特曼,1975)
(72) 《飞越疯人院》(福尔曼,1975)
(73) 《星球大战》(卢卡斯,1977)
(74) 《安妮·霍尔》(伍迪·艾伦,1977)
(75) 《锡鼓》(施隆多夫,1979)
(76) 《愤怒的公牛》(斯科西斯,1980)
(77) 《外星人》(斯皮尔伯格,1982)
(78) 《天堂陌影》(贾木什,1984)
(79) 《黄土地》(陈凯歌,1984)
(80) 《爸爸去出差》(库斯图里卡,1985)
(81) 《童年往事》(侯孝贤,1985)
(82) 《蓝丝绒》(林奇,1986)
(83) 《英雄本色》(吴宇森,1986)
(84) 《柏林苍穹下》(文德斯,1987)
(85) 《雾中风景》(安哲罗普洛斯,1988)
(86) 《十诫》(基耶斯洛夫斯基,1988)
(87) 《红高粱》(张艺谋,1988)
(88) 《性谎言录像带》(索登伯格,1989)

（89）　《天堂电影院》（托纳托雷，1989）
（90）　《循规蹈矩》（斯派克·李，1989）
（91）　《低俗小说》（塔伦蒂诺，1994）
（92）　《阿甘正传》（赞米基斯，1994）
（93）　《暴雨将至》（曼彻夫斯基，1994）
（94）　《樱桃的滋味》（阿巴斯，1997）
（95）　《疾走罗拉》（提克威，1998）
（96）　《黑暗中的舞者》（拉斯·冯·提尔，2000）
（97）　《指环王》三部曲（彼德森，2001-2003）
（98）　《俄罗斯方舟》（索科洛夫，2002）
（99）　《杀人回忆》（奉俊昊，2003）
（100）　《阿凡达》（卡梅隆，2009）

图书在版编目(CIP)数据

电影史双语读本·全二册：英、汉 / 游飞主编. —— 北京：北京大学出版社，2016.10
（培文·电影）
ISBN 978-7-301-27086-8

Ⅰ.①电… Ⅱ.①游… Ⅲ.①电影史 – 世界 – 英、汉 Ⅳ.①J909.1

中国版本图书馆CIP数据核字(2016)第086958号
本书为国家级双语教学示范课程《世界电影史》建设项目

书　　名	电影史双语读本（上、下册）
著作责任者	游飞　主编
责任编辑	姜贞　丁超
标准书号	ISBN 978-7-301-27086-8
出版发行	北京大学出版社
地　　址	北京市海淀区成府路205号　100871
网　　址	http://www.pup.cn　新浪官方微博：@北京大学出版社 @培文图书
电子信箱	pkupw@qq.com
电　　话	邮购部62752015　发行部62750672　编辑部62750883
印刷者	三河市国新印装有限公司
经销者	新华书店
	710毫米×1000毫米　16开本　39.5印张　850千字
	2016年10月第1版　2016年10月第1次印刷
定　　价	88.00元（上、下册）

未经许可，不得以任何方式复制或抄袭本书之部分或全部内容。
版权所有，侵权必究
举报电话：010-62752024　电子信箱：fd@pup.pku.edu.cn
图书如有印装质量问题，请与出版部联系，电话：010-62756370